I REALIZED
I WAS GOOD AT CHOOSING
THE RIGHT THINGS!

THAT I WAS IN TUNE
WITH WHAT
PEOPLE LIKED.

I FELT THE
NEED TO MAKE
THINGS BECAUSe
I COULD SEE THAT
THOSE AROUND
ME UNDERSTOOD THEM.

DEAR ELIO

A FANTASTIC JOURNEY INTO THE WORLD OF FIORUCCI

EDITED BY
FRANCO
MARABELLI

RIZZOLI
NEW YORK

New York · Paris · London · Milan

FIORUCCI

Elio Fiorucci

GALLERIA s.r.l. - Gall. Passarella, 2 - 20122 MILANO
Tel. +39 02 760911 - 76021811 Fax +39 02 76014675
E-mail: elio.fiorucci@fiorucci.it

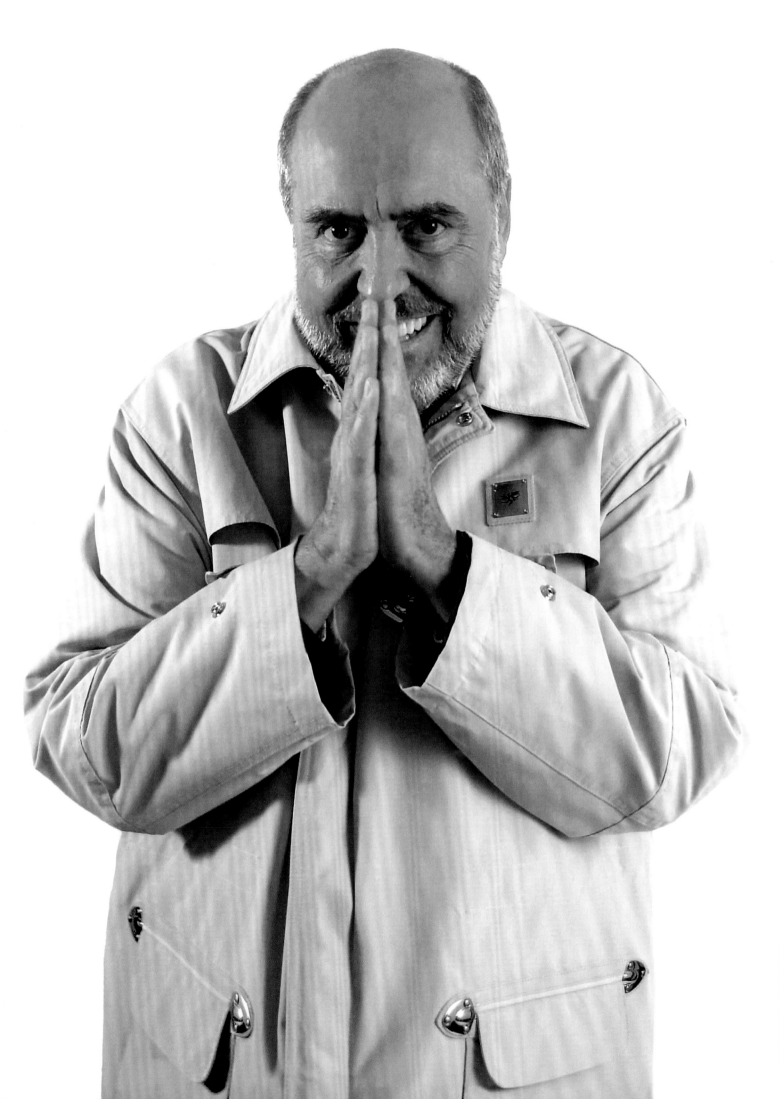

ELIO FIORUCCI
A CREATIVE ENTERPRISE

Elio's innate curiosity led him to explore
the unknown, expanding his viewpoint
to include new trends in freedom of
expression. He understood the importance
of going beyond the borders of his own
country, of seeking out other approaches
to life, different energies. This is the story
of a creative enterprise that brought
together people of different backgrounds;
absolute beginners and professionals alike
who, thanks to Elio, found themselves as
part of a truly multifaceted project. The birth
of a joyous new world, irreverent and free.
An unconventional concept of clothing that
exploded in a conformist, bourgeois world,
turning the rules upside down. Establishing
a sense of femininity that was sensual,
ironic and uninhibited, scandalizing
traditionalists, and creating shock waves far
and wide.

Franca Soncini

A FRANCO MARABELLI PROJECT
IN COLLABORATION WITH FRANCA SONCINI
ART DIRECTOR PIER PAOLO PITACCO
CONSULTING BY RENATA MOLHO

The only principle that does not inhibit progress is:
ANYTHING GOES.

Paul Karl Feyerabend, *Against Method*

He's very much like Ulrich, the protagonist of Robert Musil's *The Man Without Qualities*. Uncomplicated in appearance, portly and wearing his ubiquitous loden coat, he has a way of moving among people as if he were there by chance, but he's actually a sophisticated *bon vivant*, skilled at perceiving the nuances of feelings and turning them into visions of style. Elio Fiorucci is much more than the man commonly remembered.

I speak of him in the present tense because, although we can no longer see his smile, he not only remains in the hearts of those who traveled even a small part of his path alongside him, but he also has the stature of a modern-day literary character. Much has been said of his talent in anticipating fashions and style idiosyncrasies, and, in this book, we'll retrace some of that story. But here we're more interested in sketching a portrait of the man he was.

Making his name three-dimensional, getting in touch with the essence that made him so special, that lay behind his iconic angels or his idea of covering the wardrobes of teenagers in the 1970s and 1980s with stickers.

What stood out most about him was probably his passion for life. He valued everything about life: its contradictions, its nonsense, its tensions and its potential for infinite combinations. He acted on instinct; he'd say one thing followed by the exact opposite. He'd take up a cause and, when he'd gotten

everyone onboard, he'd go off in another direction. He had the gift of confusion, of lack of method. He took no notice of hierarchies and never feared judgment. He was a free man.

I never worked with him, but we were on panels together as judges in fashion contests, and I often bumped into him at public events or in the street. And every time we'd launch into surreal little conversations, about animalism, the misunderstood nature of eccentricity, the need to listen to young people. And what always struck me about him was his way of making the person he was talking to feel like the center of the world. As if that particular moment and that particular conversation were infinitely valuable. You could call it empathy; Stanislavsky would define it as the "magic if," the process of identifying with other people's situations or lives.

But then he'd go off on a tangent. Because he was there... and not there at all.

We'd like you to think of this project—so enthusiastically and lovingly conceived by Franco Marabelli—as a large sketch to be completed by connecting many dots: voices, memories and images to tell the story of Elio's creative process and his relationship with the world. As if we were following in his wake, attempting to catch the tail of a comet. Does that sound impossible? Of course it does, but it's the only way to honor his style.

Renata Molho

Interview with Franco Marabelli · by Renata Molho

The designer and creative director of the Fiorucci stores in the 1970s and 1980s.
He helped create the most important and iconic stores in Italy and the world

R. M.: Several books have already been published about Fiorucci. Why did you decide to publish another, and how does it differ from what's already been written?

F. M.: It's a question of viewpoint. It's the difference between seeing a building from the outside and living inside it. I can't tell you how exciting it was for me, contacting people who had known or worked with Elio, after so many years. We met up and it was like no time had passed at all. We've changed, naturally, but we're still ourselves. Everyone had wonderful memories of him, and they told me their stories with a sense of great nostalgia.
Every person I met up with gave me the strength to continue with the project, which I'd thought up and wanted to do, without knowing what it really means to make a book, create and organize an archive. At times, I felt a little confused and alone, but thanks to the many friends who helped me, I made it to the finish line.

R. M.: What was your main goal?

F. M.: To share at least some of the emotions and feelings Elio inspired during his time on earth and to describe his complexity as a man. I believed that the most authentic way to do this was to collect the stories of the people who were close to him and worked with him. I also wanted to write about the creative team Elio put together, thanks to his sixth sense and his magnetic personality.

R. M.: Do you think you've succeeded?

F. M.: I hope so. So many things happened with him and thanks to him that the hardest part of this anthropological project was deciding what to leave out.

R. M.: Let's start at the beginning. Tell me how you met Elio.

F. M.: He found me. Even before Fiorucci existed, in the 1960s, I'd designed a really avant-garde boutique, the Drogheria Solferino in Milan's Brera neighborhood. It was the result of a collaboration between the owners of A&B (Aldo & Bruno), a store in the Milan suburbs that had made a name for itself selling shirts made from dishcloths, and Equipe 84, Italy's most famous band at the time. The Drogheria sold really alternative clothing. Designing the store was a lot of fun. We covered the walls with sawn-off drawers and different styles of door frames painted in psychedelic colors, which were used as hangers for the clothes.
The multicolored, striped carpet had rails for a little train, with old carriages used as display cases.
We used to hunt for materials in demolition yards, with pieces from houses and churches, and we'd find all kinds of Baroque and liberty

(Italy's take on Art Nouveau style) elements that we'd combine as if they belonged together. We had five stores furnished that way in Milan, and I later designed others in various Italian cities.

In those days, there were only traditional stores with a limited selection of products and a sad range of colors.

And the Drogheria was also fantastic because of the people who worked there; unconventional characters who attracted customers.

Elio knew of the Drogheria Solferino—he was intrigued by its unusual window displays. So he called me, through Mirella Clemencigh, who had recently started working with him.

We met up and he asked me to design the jeans area in the San Babila store. We created a Wild West section all in light wood, like an authentic saloon. It was a kind of revolution in those days. This was the early 1970s, and Elio asked me to work with him as creative director of the store. I agreed, because I realized he was someone whose ideas were all over the place, a bit like mine. I couldn't have worked anywhere else but Fiorucci. With him, I had absolute freedom. We made decisions together. I was motivated, and I met loads of people; there was a great exchange of ideas going on. And the creative group was being formed, with graphic designers, designers, researchers, and the press office. There was an incredible buzz about what was to come.

R. M.: Gillo Dorfles called him "Our own Duchamp of fashion." And it's true that he marked a watershed between eras: is there such a thing as before and after Fiorucci?

F. M.: Of course, he was instinctive, conceptual, nonconformist. He introduced canons that had never been seen before, turning the rules upside down.

R. M.: Can you tell us an anecdote about his private life?

F. M.: Elio loved to be surrounded by tons of people. In 1975, he spent the summer holidays in Roccamare, near Castiglione della Pescaia, in a villa surrounded by a pine forest. There he met Maurizio Costanzo, who lived in the villa next door. Costanzo was with Flaminia Morandi; they had two children. Elio and Cristina (Rossi, *ed.*) had a daughter, Erica. They became close friends, and saw each other every year. Then there was the time in the Uccellina mountains, in a big square house with access to a private beach and room for lots of people. Cristina fell in love with the place; she used to make jam, and she had a big vegetable garden, which was often ransacked by wild boars. The whole Costanzo family were regular visitors. You'd go to see him and there were always visitors, both on holiday and at his house in Milan, a turn-of-the-century villa with a garden. In a way it was like being in the store.

R. M.: What was it like to work with him?

F. M.: A nonstop adventure. He'd get fixated on something and you had to run fast with the idea and get it done as quickly as possible, before he changed his mind the following day. If he was in the mood for yellow, everything had to be yellow. In his mind, it was easy, everything had to be the way he'd imagined it. Not everyone could understand this freedom

he had in everything. But when he showed up with his smile and that unique way he had about him, you'd give in to whatever he wanted. He was extremely generous with everyone. The wonderful thing about Elio was that he'd introduce you to anyone, and he trusted everyone. He had his fickle obsessions, his highs and lows, often so high and so low he'd astonish you. In general, Elio left you free to work, he never stopped you. He was curious about everything, and if someone suggested something it made him happy. There was no other business in the world like Fiorucci: if you worked hard, had ideas and got on well with the group, it was great; but even when things went wrong—because sometimes they did—we all have great memories of working there, because it was a place of freedom and positivity.

R. M.: Let's talk about your first consulting job; that was when you started working with Elio, and also traveling.

F. M.: Many of us traveled the world in search of new styles, emotions and trends. Although my job was more connected with the store, whenever I traveled—often with Mirella Clemencigh, who worked in design and accessories—I'd buy items of clothing or other goods to sell in the store. I remember in Egypt we bought these two-tone vests that had fifty tiny buttons instead of the usual three. In Peru, we found the softest alpaca cardigans in earth colors; in Guatemala, exquisite fabrics with wonderful embroidery, all things that had never been seen in Italy. It was constant discovery: anything that was unusual, new or interesting, we'd buy it.

It was usually just a handful of items, and when they went on sale they'd be snapped up in a flash. For Fiorucci, all of this traveling was crucial because the store, like Elio himself, was in constant movement; it never stood still.

This was a store where every department was almost immediately outdated, so we were always moving things around and changing the style. This was exactly what I was doing at the beginning: renewing sections within the store. At the same time, I was designing eye-catching window displays. This daily contact with the goods helped me to understand the various problems that come with a unique store like Fiorucci. I remember one of the first window displays: there was a wagon just like the pioneer ones, surrounded by a true stage set, complete with straw bales, wooden trunks and other accessories, creating a real Wild West mood. Elio's famous Buffalo jeans on mannequins or arranged on the floor completed the display.

Another time we created an eighteenth-century scene, with Baroque decor and a five-meter table set for a Versailles-style banquet.

A lot of Fiorucci windows were purely theatrical, and often the clothes themselves didn't even appear. They were designed to attract a different kind of attention than the simple invitation to buy. In addition to the window displays, we were constantly introducing new things, like the vintage section: it was the first time a mainstream Italian store had sold second hand clothes and objects. We searched for goods in both Europe

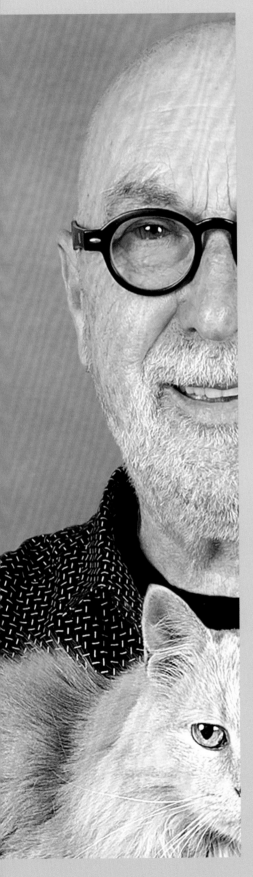

and America. There was a huge amount of work to be done in the office, and I had a staff of three; we also developed projects for clients who wanted to open a Fiorucci store. So we were always on the move, in Italy and abroad. I traveled half the world with Elio; he was always fun to be with and he liked to buy everything, but sometimes it was hard to keep up with him.

R. M.: Then in 1974 you opened the store on Via Torino.

F. M.: It was a real adventure. I went with Elio to the United States to look at the shopping malls in the suburbs outside big cities. They were designed with the most spectacular concepts, enormous spaces and long walkways; they had glass ceilings so you could see the sky, and relaxation areas with waterfalls and tropical plants. We were in awe, so much so that we brought some of those elements to the concept store in Via Torino. We created different departments: clothing, jeans, trousers, imported records, shoes and boots, accessories, home and furnishings, plants and fragrances, bath products and cosmetics, art and photography books, a travel agency and—for the first time in a store—a bar/restaurant that was open until 2 a.m. We also put on exhibitions—like one that showcased Walter Albini's drawings—and music and art performances; we even had an in-house series of video art, which was really exceptional in those days. As for the restaurant, Elio got in touch with Alfredo, the owner of the famous El Toulà in Milan, to manage it. He accepted the offer. He was a very kind and sensitive man, and I worked with him to create a space where every detail was customized: plates with the logo and a gorgeous menu designed by our graphics department; the kitchen was set up as he wanted, and we even chose the pots and pans together. Alfredo wanted the restaurant to be run by someone he knew and trusted, but a few days before the opening, Elio told me he'd decided it would be headed up by Angelo Careddu, a twenty-three-year-old from Sardinia. Alfredo wasn't happy with the last-minute change, and he left. Elio changed the menu too to include hamburgers—which were unheard of at the time—and baked potatoes. Elio used to fly the potatoes in from England because he said that was the only place they were the right size.

R. M.: How did the idea of opening the New York Fiorucci store come about?

F. M.: It was the period when Standa was involved in the company and was planning investments in the brand. Since there were already stores in Europe, I think it was natural to expand into the United States. I'd been in New York with Elio in 1972 and 1973, and I had Fiorucci consultants there. In the 1970s, New York had taken over from "Swinging Sixties" London. You could walk around the city and get ideas and inspiration everywhere you went, from the Village to Soho or Uptown. There were thrift stores, great shops selling secondhand goods, where you could find items from every period for pennies, and enormous warehouses full of so-called bales of clothing, which Fiorucci bought up. They contained all kinds of things, from Hawaiian shirts and cowboy shirts to work overalls, all kinds of jeans and much more.

When the Via Torino store was finished, I headed back to the United States because Anita Paltrinieri, who lived there and did research for Fiorucci, had found the perfect space for the new store.
So I went to New York with Sottsass and Branzi to plan it.
I spent several months going back and forth, contacting the various suppliers and overseeing cost estimates, in collaboration with Ulla Sallovara, who was Ettore's assistant at the time. We opened in 1976.
Initially the store was headed up by an American manager who was extremely professional and good at the job, but her methods and vision were very different from the Fiorucci approach. Because of this, the new store, which was supposed to be a calling card to present the brand's style and spirit, struggled to get off the ground.

R. M.: So you went back to New York.
F. M.: Elio wanted the store to pick up, so he asked me to move there. I became the creative director, with full responsibility and decision-making power for all activities and initiatives.
To liven up the store we rented spaces to young designers and artists so that there was always something going on, always something new.
They were very special people who helped to make the store unique. It was our adviser Antonio Lopez—a fantastic designer—who first had the idea of live window displays with well-known models like Pat Cleveland, Donna Jordan and others. When Studio 54 asked Fiorucci to help with its opening party, Antonio did that. He stayed with us for a couple of years.
The store changed every day. It was like a film studio: the goods and the furniture were moved around to create constant surprises. That was Fiorucci's strength: just as Elio's creativity never stood still, the stores were always changing too. Thanks to the huge space available and the possibility of moving the different sections around, we were able to hold parties, performances and extraordinary events like the one with Andy Warhol, who really liked the store and everything that happened there. He chose it to promote *Interview* magazine. We threw a huge party to mark the occasion. Warhol and Truman Capote were signing copies of the magazine, while two dancers in the window performed without music, with wild movements that delighted passers by. We also hosted other artists and celebrities, sometimes at the start of their careers.
The artist Colette personally set up the window display and then slept there for seven nights, foreshadowing the reality TV phenomenon. This was followed by a performance by Klaus Nomi, who sang soprano three nights in a row in an Op art stage setting.
The parties and performances actually served to boost the novelty value of the fashion, which was changing constantly; like gold-colored bags and jeans, which had never been seen before and were incredibly successful.

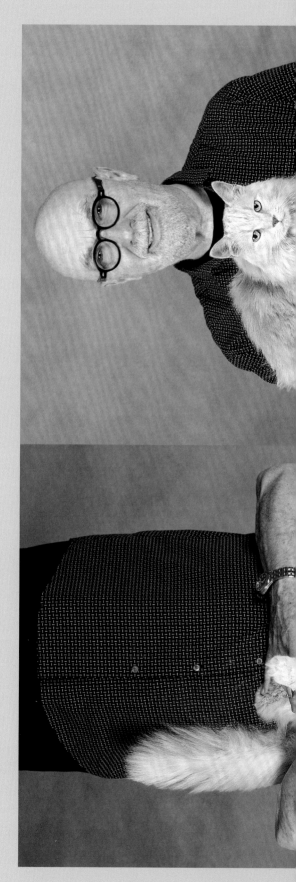

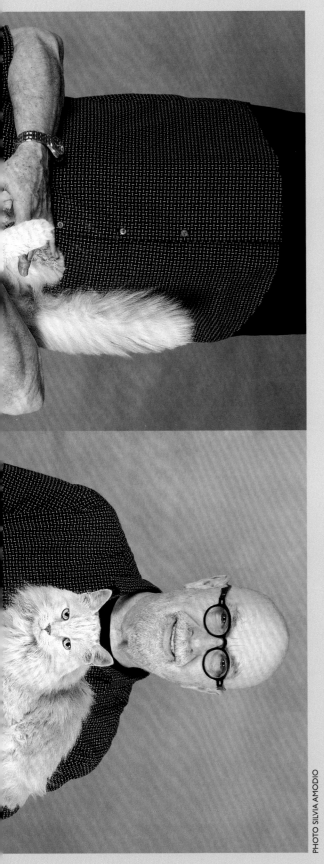

PHOTO SILVIA AMODIO

R. M.: Is it true that there came a point when Fiorucci had a crisis due to excessive expansion?
F. M.: Yes, unfortunately. The problem with Fiorucci was the speed it all happened. In just a few years, it became a global phenomenon, and this caused difficulties because frenzied product turnover meant that it wasn't possible to restock all the stores scattered around the world. Four major stores opened in the U.S.: New York in 1976, Boston in 1977, Los Angeles in 1978 and Chicago in 1979. These were stores that caused a great stir because of the locations and their images, but which weren't run as they should have been, so they closed down after a short time. Even the Milan store in Via Torino closed in 1979. Two Fiorucci stores in Milan were perhaps too much and, although the San Babila store was less attractive than the Via Torino one, it was still the magical place where it all began.

R. M.: Then, in 1981, along came Benetton.
F. M.: Elio was fascinated by Luciano Benetton's managerial style, which ensured that everything worked, while at Fiorucci, it was the opposite. Little by little, everything changed.
The creative department in Galleria Passarella was moved to Corsico, and the plans for new stores were canceled. The corporate philosophy had shifted. Exploratory travel was visibly reduced, and the original store manager, Enrico Baroni, was replaced.
I didn't see eye to eye with the new management. So, in 1981, I resigned, as did Cristina Rossi, the head of the style office, shortly afterward, along with a number of stylists, graphic designers, PR people and other members from the original creative team. As for me, I continued to collaborate from the outside; between 1984 and 1985 I planned the renovation of the San Babila store, the stands for MilanoVendeModa, the Miami store and, still in the same period, designed modular elements for retail corners in American department stores, a project that never got off the ground. Finally, in 2007, I curated the Fiorucci space for the *annisettanta* exhibition at the Triennale di Milano.

R. M.: But your relationship with Elio continued.
F. M.: We spoke and saw each other frequently. Without realizing it, both of us became animal rights supporters and vegetarians. I told him about my plans for an exhibition focused on animals. The idea was to raise public awareness of the various forms of suffering we inflict on animals, by forcing them to live in impossible conditions, filling them with drugs and treating them without respect, all for the sake of the food we eat. He liked the idea very much and we wanted to plan it. Sadly, there wasn't time.
Perhaps after we've done this book, with Elio's help, I'll be able to do it.

15

Janie and Stephen Schaffer
Co-founders for the relaunch of the Fiorucci brand

One of my all-time favorite memories is going to Milan
and visiting the Fiorucci store.
It was a marketplace full of beautiful things, from
angel T-shirts in iconic tins to vintage clothing and
knickknacks from all over the world.
A shop full of color, optimism and happiness!
It was always too wonderful to disappear,
but sadly it had, some 25 years ago.
We were fascinated by the idea of trying to bring back
this incredible brand for a millennial customer that
might never have seen or heard of it before. Since buying
the brand, we continue to discover more amazing
archive pieces and learn more about Elio and his
inspiring journey. Seeing Franco's beautiful book takes
us on that journey with someone who was there from
the very beginning and was so integral to Fiorucci's
huge success and its artistic direction. *Janie*

We were always inspired by Fiorucci from a very early
age, and were surprised and saddened that a brand
with such a rich and relevant history had
disappeared from the retail landscape. Fiorucci's is
such a wonderful story of fashion and pop culture
that Franco's book is hugely important to validate
each chapter of the Fiorucci story over the past
50 years. Franco's part in Fiorucci was incredibly
important, so it's wonderful to see this book celebrating
the history of this groundbreaking brand. *Stephen*

To Cristina

You had big blue eyes and a genuine, happy smile.
When you and Elio met, he was fascinated by you,
and you later became a couple.
That led to the birth of Fiorucci. With you in
London and Elio in Milan, both of you constantly
traveling to restock the newly created store that
was already causing a stir.
You were tireless, full of energy, a headstrong
character who was sometimes intimidating, but
only in self-defense.
Because working at Fiorucci and running the
style office was no easy task, though it was
fascinating and exciting.
You had to deal with all the people who turned up
at the office, all different personalities and often
with problems that were not easy to handle...
But you did it; you did your job with tenacity
and great love. You traveled the world with the
designers in search of samples, ideas, excitement
and everything each country had to offer.
In your private life, you were an attentive
and caring mother to your daughter Erica.
It wasn't easy to be Elio's partner in work and
in life, but you threw yourself into it. Elio was
unpredictable, a free spirit, and sometimes being
tied down made him agitated, even at work.
You loved your family, you loved cooking, always
surrounded by friends, and when your many
grandchildren came along, they filled you with joy.
We had some wonderful times together at work
and our private lives, as well as difficulties, and we
comforted each other. You created a circle of dear
friends around you who will never forget you.
This book is dedicated to you as well.

Franco

CRISTINA ROSSI

Elio and Cristina founded Fiorucci. Cristina was later head
of the style and accessories office for almost fifteen years

I met Elio when I was barely nineteen; I'd just finished at Brera and I
was studying at the Academy of Communication. One day a friend told
me about meeting an interesting person who wanted to do some adver-
tising and who had a shoe store in Via Torino. And that's where I met
him, always wide-eyed, looking at me as if I were a goddess.

He was very friendly, and told me he wanted to do a promotion for
preschools, with discount vouchers for slippers. So I did a series of pink
and blue drawings of children, which he distributed. And we continued
working together. I remember he'd bought some wild flip-flops with
daisies to give to journalists; then there were the first shoes with cork
wedges and others, very different from the shoes most people were
wearing then.

He also commissioned me to do some posters to display in the shop
windows. It was 1965, I was nineteen and he was thirty; Elio didn't tell
me he was married and had two young daughters. We became friends
and, even though he was courting me, our relationship was platonic.
I had a boyfriend and was planning to get married. We spent entire
days together at the store in Via Torino, and he would tell me about the
changes taking place with young people who wanted to break the rules
just like what was happening in London and the United States. After
that we didn't see each other for about a year. He called me in the spring
of 1967 to tell me about a store he'd taken over in Galleria Passarella,
and the plans he had for it. He was really brave to take on that venture.
So we met again and began working together and became a couple. Elio
had called me often, but I didn't want to get involved with a married
man with children. But things were going badly with my fiancé, so I
decided to see Elio again, and relationship began in 1968, although it
had its problems.

The decor for the new store was done by Amalia Del Ponte, all in white
and blue.

It was almost all shoes, which were in the basement; at the entrance to
the store there was a very small raised mezzanine protected only by a
curtain. On the third day, a child fell off it; luckily he didn't hurt himself,
but Elio was terribly angry with Amalia.

Clothes were only sold at the entrance. After that, the mezzanine
became a space for secondhand clothes. Adriano Celentano, who was
very young at the time, was often in the store. Elio and I were always
traveling to London and Paris, because the clothes were selling really
well and we could find new stock very quickly there. We had to restock
constantly, so, in 1969, I moved to London, where we opened an office. I'd
send goods over every week; there wasn't much money, but we always
got by. And that's how Fiorucci got started.

We had some enormous suitcases made—120 cm wide—in super-light-
weight nylon with steel reinforcement inside. Every week I'd search the
various markets and stores—Big Market, Biba, Mary Quant, Mr Freedom
and others. I discovered that children's kilts were cheaper because they

didn't have pockets, so I'd buy them and they'd be miniskirts for skinny girls and women. I bought lots of clothes from Biba, so I tried to persuade Barbara (Hulanicki, *ed.*) to give us a discount, but I wasn't successful. The second Biba store was on two levels; it was a magical place where you could always find all kinds of things and new ideas. The walls were completely black, with colorful clothes and accessories on display.

Before we started production in Milan I spent two years buying goods in London. Every Friday I'd turn up with these enormous suitcases; we'd pay crazy amounts in excess luggage. At the airport, I'd declare that the contents were my personal effects, thanks to a friend of mine who worked in the customs.

On Friday nights in the office, they removed all the brand labels, and the clothes went into the store; by Saturday evening they were all sold and I set off for London again. Those two years were really tiring, but full of enthusiasm and new discoveries. Despite my traveling, there was never enough stock, so we extended the offices in Galleria Passarella and began production in Milan.

We set up a separate distribution company with Clino Castelli, which didn't last long but was a great experience. There was also Nanni Strada, who created extraordinary things, fabrics with crumpled and ripped paper; one time we went to the notary to register a patent for a fabric made with the fake hair used for wigs, in all kinds of colors. We used to buy them in London; with that curly fabric, we wanted to make coats and other bizarre inventions.

When we began manufacturing, Sara Nannicini worked with us too, researching textiles. We were constantly hiring new people.

Meanwhile we'd found a house in Largo Corsia dei Servi. It was our first home, and we stayed there for many years.

After a while, we extended the store by taking over the Rayito de Oro nightclub, and Enrico Baroni came on board as manager. I remember Mirella Clemencigh too—she was a consultant—and Franco Marabelli, who was in the office where we planned production; Sauro Mainardi, the graphic designers and the PR office. We moved the offices to the other side of the road; I worked there and others arrived, including Tito Pastore, Paola Comolli, and Mirella Landi. I remember Franca Soncini, Alessandra Rigo, and others in the PR department.

After a while, the children's line Fioruccino was launched, but it was made in the Corsico branch. We had the famous Mario Morelli, the designer who'd helped us invent the Fiorucci jeans, which molded women's bodies and made them sexy. Then came the gold, on everything: jeans, shoes, short-sleeved men's jackets.

Of our travels around the world, I remember going to Afghanistan, before the Russians invaded. I bought and filled containers of rugs, clothing and all kinds of accessories. We used the fabrics to make quilted jackets with brightly colored flowers. In Mexico, there were fabulous markets with incredible handcrafts. Every region had its own type of embroidery,

all different. There were tin boxes in a thousand colors. It was very difficult to ship the goods, because we bought them in the markets, which weren't set up for it. Another fascinating trip was to South Africa, where we discovered the beads used for traditional decorations. I was with Anita Paltrinieri, and we toured all the missions in search of these beads, which we sent to Milan. We used them for belts, necklaces, decorations on jeans; we made collars for T-shirts, monokinis and other things. The wonderful thing was that every tribe had its own colors and designs, different from the others.

All this was before 1975. After that I went to Madagascar to look for straw bags. Then to India with Salvo Moschella; we opened a branch in New Delhi so we could make some of our garments there and understand the Indian market.

The conditions in India were hard because of the heat, the lack of preparedness in the buildings and the horrifying workplaces. Those poor people, working in 45 degrees Celsius and with unbelievable humidity. I remember the smell when we opened the containers; but in spite of that, they were full of fantastic things.

We began going to China after 1976. I remember the first trade fair I went to; the Chinese were still wearing blue overalls.

Then after 1979 it was Japan and Thailand, where we found samples to give us new ideas. Tito Pastore, Mirella Clemencigh and other designers went on those trips.

We also made ready-to-wear fashions using fabrics that were sitting in the warehouse: the designer Juan Salvado created some really saleable garments by dyeing the fabrics.

For Fiorucci, the invention of jeans was complicated; the problem was the fabric itself. Denim has the consistency of cardboard when it's new, but the jeans we wanted to make had to be soft. Later came délavé jeans and denim in all colors: green, pink, striped... And in all forms: long and short, skirts, jackets. Then there were jeans in lightweight poplin, like muslin, in all colors, with appliquéd cherries. All this happened in just a few years, as we tried to keep up with demand from our other stores, which was growing all the time. We needed to buy increasing amounts of fabric, and other products too.

In the style office we had Jean Paul Gaultier, Franco Moschino, Enrico Coveri, Gianni Versace and Juan Salvado, who all worked with us at various times. Manolo Blahnik—a truly lovely person—created some footwear collections. My department consisted of Rini Van Vonderen, Cristina Bagnoli—who did some modeling—Dina Vielmi, Pupi Solari for Fioruccino, Mimma Gini and many others. And Be Khanh, who was really good at textile research.

I ran the buying department too, and supervised more or less everything, including accessories. It was a massive amount of work, but what wonderful memories; so many people have been part of Fiorucci! It was a unique experience, and during that busy period I also had Elio's daughter.

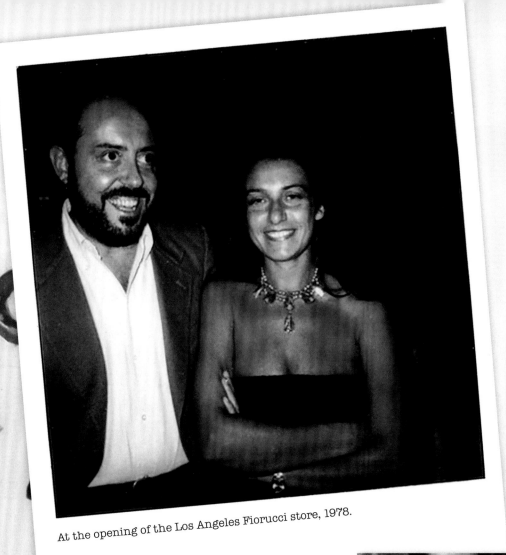

At the opening of the Los Angeles Fiorucci store, 1978.

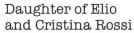ERICA FIORUCCI

Daughter of Elio
and Cristina Rossi

I remember how tender and caring my dad was in rescuing and looking after animals that needed help. During a trip to Ischia, he was so gentle in trying to save a baby bird that had fallen out of the nest. He carefully picked it up and made a nest for it with twigs and cotton wool, and little bowls with water and bread-crumbs. Taking care of the bird became our full-time job during that holiday; from our hotel room, we watched it and listened to its gentle cheeping. One day we woke up to find the nest empty, and Dad—always a dreamer—said its mother must have found it and they'd flown away together.

CONTENTS

STA

RT

MARIA GIOVANNA ELMI

ROMINA POWER TARYN POWER

ADRIANO CELENTANO ELIO FIORUCCI TITO PASTORE GLORIA GUIDA

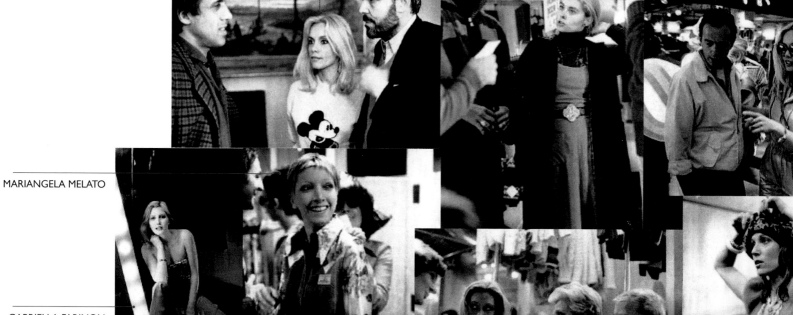

MARIANGELA MELATO

GABRIELLA FARINON

BICE VALORI
AND PAOLO PANELLI

ELSA MARTINELLI

SORELLE BANDIERA
AND LEONARDO PASTORE

MARIO MARENCO

SAN BABILA MILAN

MARIOLINA CANNULI

RITA PAVONE

TARYN POWER

CATERINA CASELLI

LOREDANA BERTÈ

1967

Opening of the
San Babila store
in Milan

Design by
Amalia Del Ponte

MIA MARTINI

SORELLE BANDIERA

SABINA CIUFFINI CATHERINE DENEUVE

GABRIELLA FARINON

ORNELLA MUTI

The San Babila store in Milan

Amalia Del Ponte's initial design underwent some modifications to be in line with London fashions and the emerging mood of change.

It was the first store to play music and diffuse fragrances. The changes began in the jeans section, which was all made of wood in the style of a Wild West saloon, and went on to impact all the other sections: jewelry, clothing, knitwear, shoes, and ornaments.

There were two spaces downstairs that were rented out to people launching new products.

Lina Sotis and Silvia Tofanelli, who had discovered the new London fashion for petit point, rented a space to sell wool and canvases to create bespoke designs.

The store was used as a film set by the Italian directors Carlo Lizzani and Lina Wertmüller.

F.M.

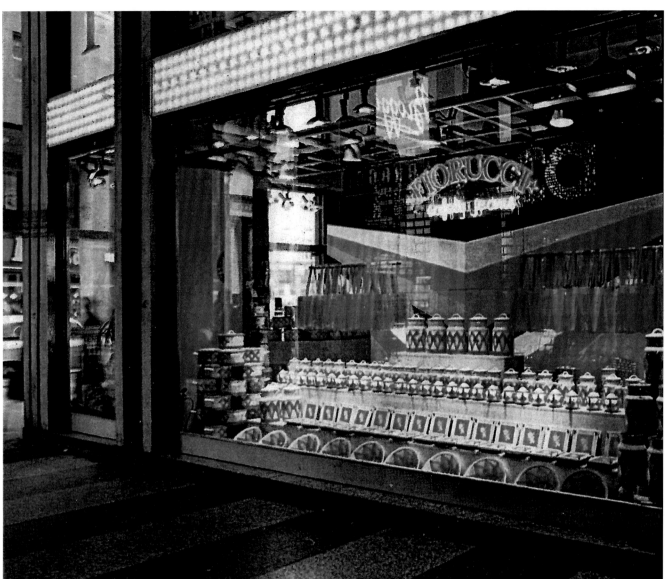

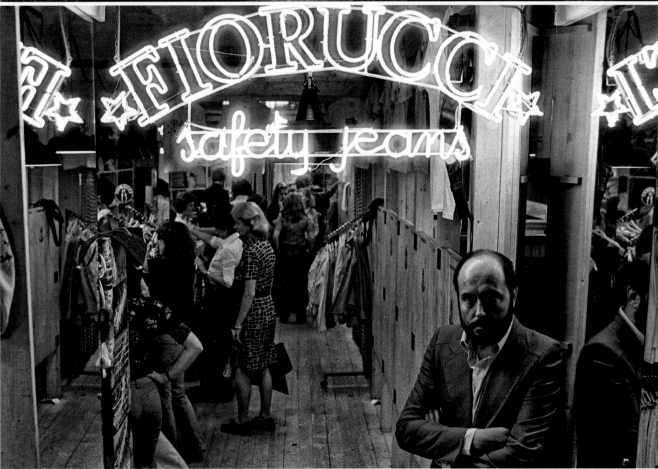

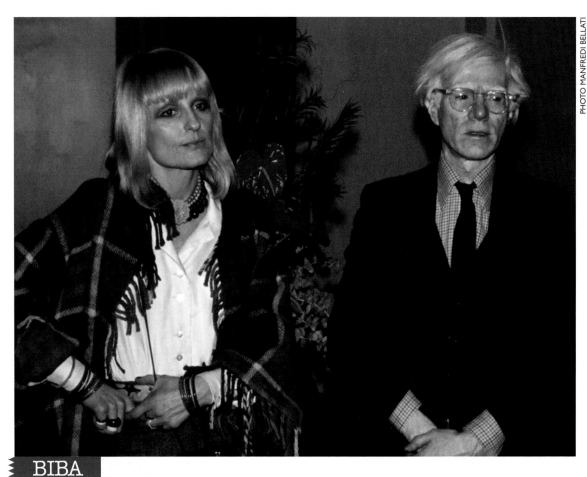

BIBA

BARBARA HULANICKI,
AKA BIBA,
PHOTOGRAPHED
WITH ANDY WARHOL.

THE FIRST BIBA STORE
OPENED IN LONDON
IN THE 1960S AND
REVOLUTIONIZED THE
WORLD OF FASHION.

BELOW, A DECK
OF CARDS WITH
A PINUP GIRL.

On a busy day in our shop, the third Biba store, a man with a large suitcase and a young girl asked to see Fitz or me. It was very strange, as I was mostly in the design studios up the road, but this time I was fiddling with the stock and I was still in the shop. That day Fiorucci and Nally Bellati introduced themselves, and Elio told me he had been buying Biba clothes in London and reselling them in his Milan store for the past year. He said the clothes would fly off of the store shelves and he wanted to do a special collection with us. That meeting was the start of a very long partnership with Elio. First the clothes, and then we opened a Biba cosmetics branch just around the corner from his wild store in Galleria Passarella. That man had such an abundance of energy, optimism and Italian flair. His shop was always a joy in Milan and a big tourist attraction. Fiorucci was Milan! After Biba, Elio asked me to join his design team in the head office. Which was a designer's dream come true! There were departments for the latest buttons, branded fabrics, zips and anything you might need to finish the designs. I used to go there once a month. He also curated a marvelous modern museum with early Biba items and all the 1960s looks from London. Also, there were collections of the latest Japanese clothes, which were all the rage at the time. I met some interesting people, such as Ettore Sottsass, who was at the start of his new Memphis project and designing small Fiorucci stores in the UK, Europe and New York. Elio flew fifteen of us to see the new store in NY and to meet Andy Warhol, as he was keen for him to design an original Fiorucci poster. There was never a dull moment with Fiorucci; he was always inventing new merchandise categories and open to new ideas. Italy should be so proud of his genius and entrepreneurial spirit.
Now there's a Fiorucci store in London, but without Fiorucci.

34

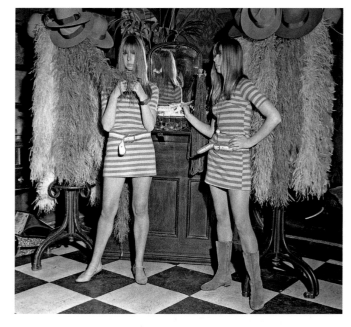

The first Biba store opened in September 1964 in Abingdon Road, in the heart of London.

I went to London with Elio and we visited the second Biba store in Kensington High Street. It was an incredible surprise; I'd never seen anything like it. It was all in Art Nouveau style. Black walls, black-and-white check floor and the clothes on racks with bags, colored ostrich feather boas, necklaces... There was no security; people could easily have stolen things. The displays for the accessories were giant versions of the objects. There was an enormous shoe with shelves inside to display products. They sold food too; I remember a huge sardine tin with the classic key, the metal rolled back to show display shelves. There was music and neutral or colored lighting (which we'd never seen before) from spotlights. On the top floor there was a large oval room set up as a restaurant; the ceiling had plasterwork cornices concealing different-colored neon lights, so it was bathed in yellow, then purple, blue and pink. It was unexpected and wonderful. There were girls in black mini skirts/tutus, white aprons and maid-style headpieces. They circulated among the customers carrying colorful feather dusters, as if they were cleaning.　　　　　　　　　　*F. M.*

ELIO CHOSE TO START
HIS ADVENTURE
WITH THIS
TEAM

CRISTINA ROSSI/fashion designer
MIRELLA LANDI/fashion designer
FRANCO MARABELLI/artistic director
SAURO MAINARDI/graphic designer
MIRELLA CLEMENCIGH/accessories
PAOLA MARINI/shirts
KAKI KRONER/knitwear

SARA NANNICINI/press office
TITO PASTORE/press office
ALESSANDRA RIGO/press office
ENRICO BARONI/store manager

1970

POSTER BY SAURO MAINARDI BASED ON AN IDEA BY ITALO LUPI.

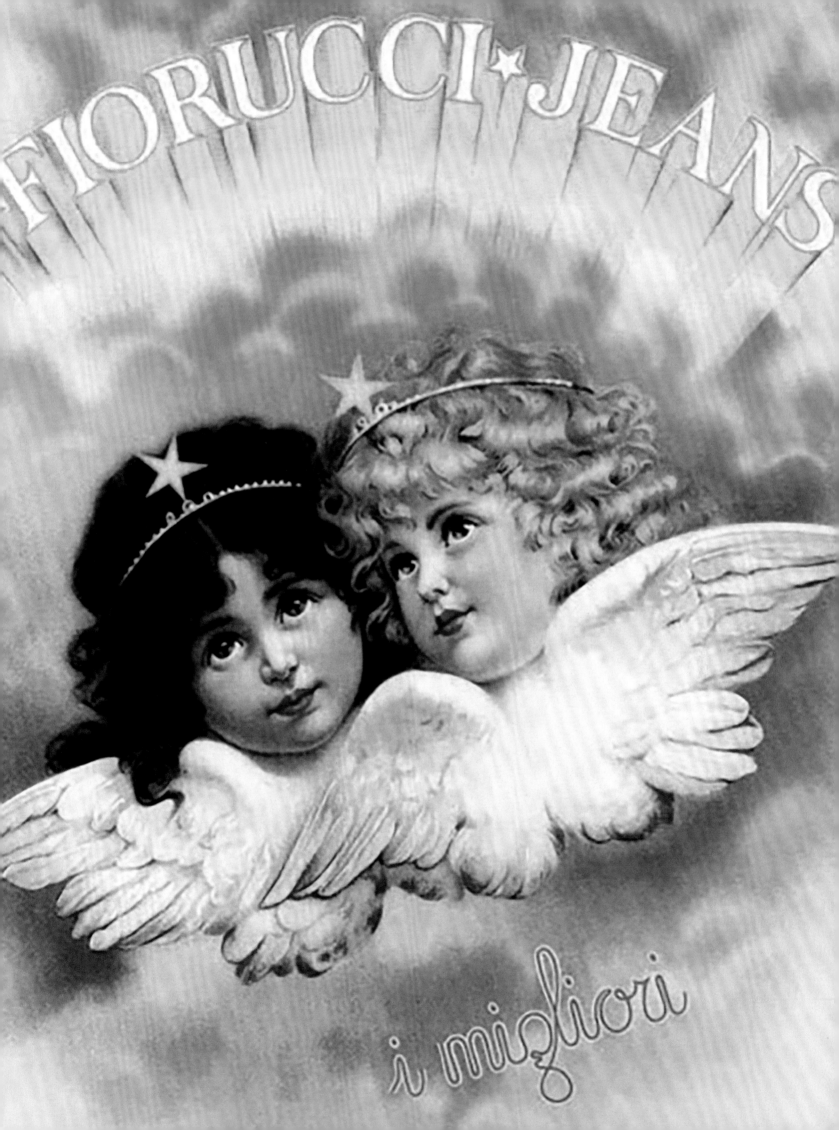

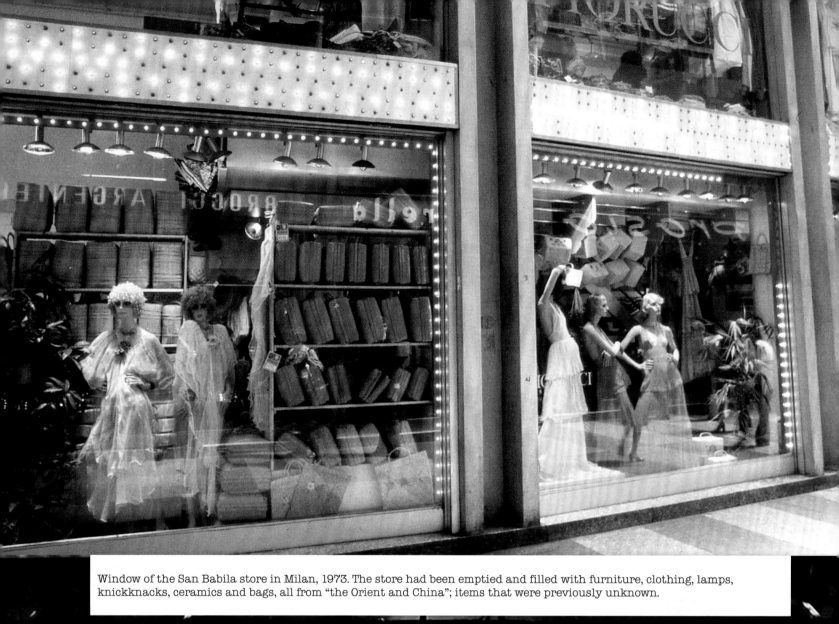

Window of the San Babila store in Milan, 1973. The store had been emptied and filled with furniture, clothing, lamps, knickknacks, ceramics and bags, all from "the Orient and China"; items that were previously unknown.

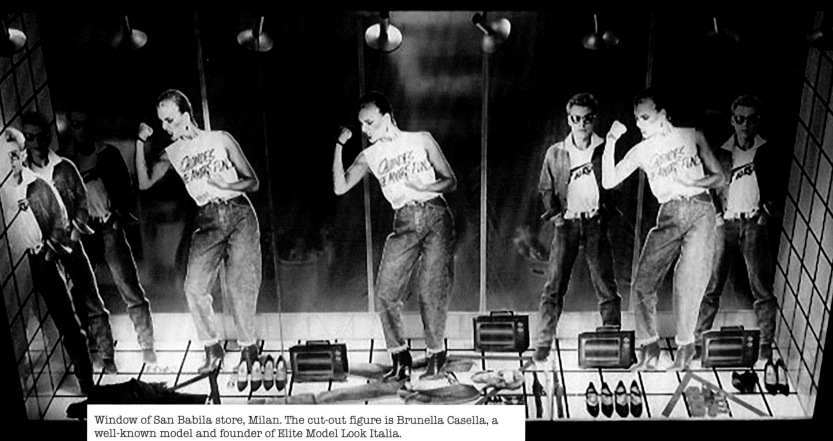

Window of San Babila store, Milan. The cut-out figure is Brunella Casella, a well-known model and founder of Elite Model Look Italia.

RENZO PERONI
Displays window Director

Elio introduced me to Renzo Peroni, a cheerful and enthusiastic young man from Florence, and I immediately saw his creative skills and window-dressing abilities. And that's how his adventure with Fiorucci began, working with me on the store's image. He was extremely good with his hands and always came up with interesting ideas.
He worked at Fiorucci for a long time, and I also took him to the New York store for a while. His ideas for the New York window displays were brought back and repeated for the Milan stores. It was a great partnership, which I remember with affection. *F. M.*

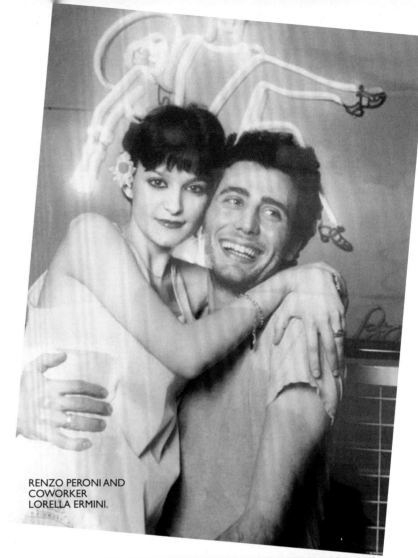

RENZO PERONI AND
COWORKER
LORELLA ERMINI.

Window of the San Babila store in Milan, 1974. The window displays did not only have clothes. There were furnishings and decorative objects as well. This particular display featured French Jieldé lamps, used in factories, and metal-reinforced cardboard boxes made by a Milanese firm. These materials were used to create containers for jeans for the New York store.

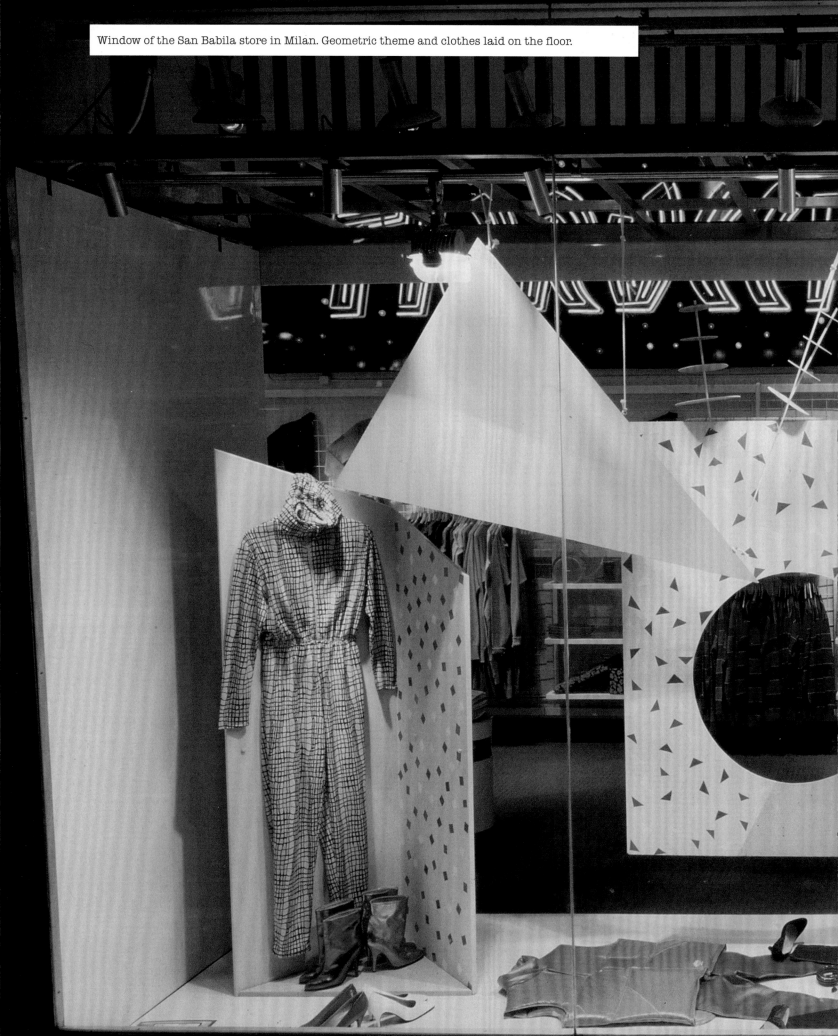

Window of the San Babila store in Milan. Geometric theme and clothes laid on the floor.

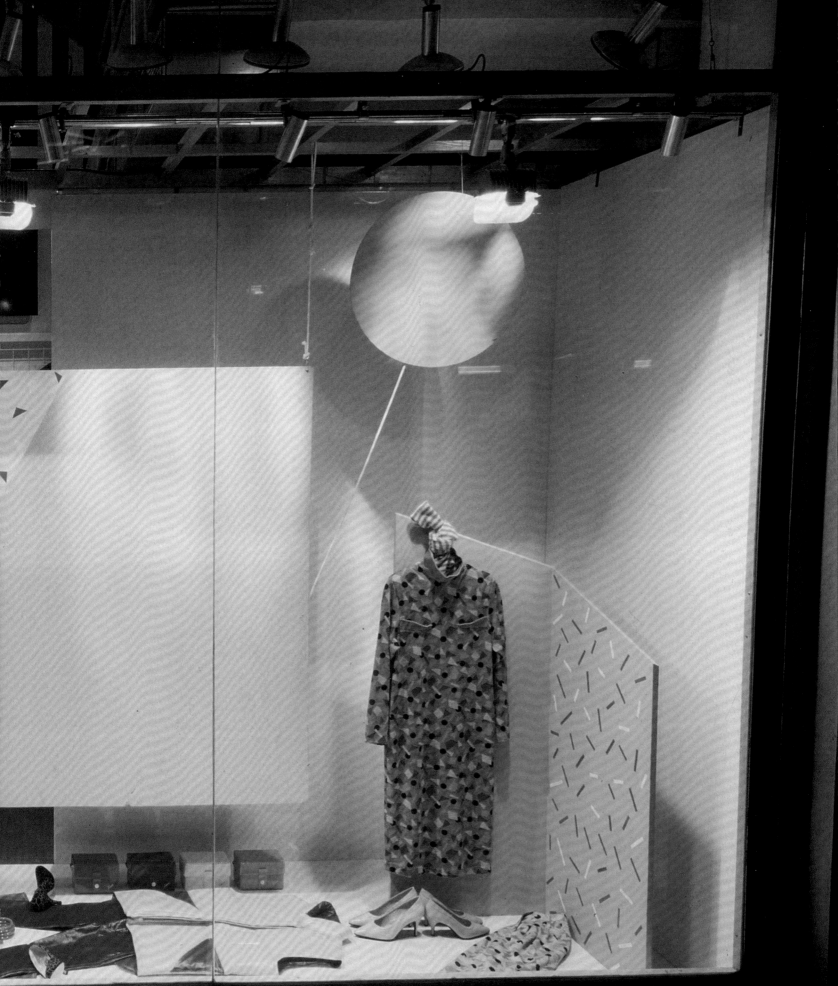

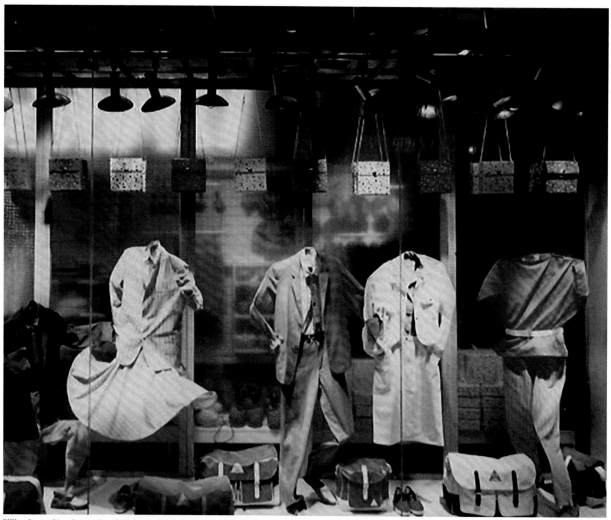

Window displays in the San Babila store in Milan, approximately 1975–80.

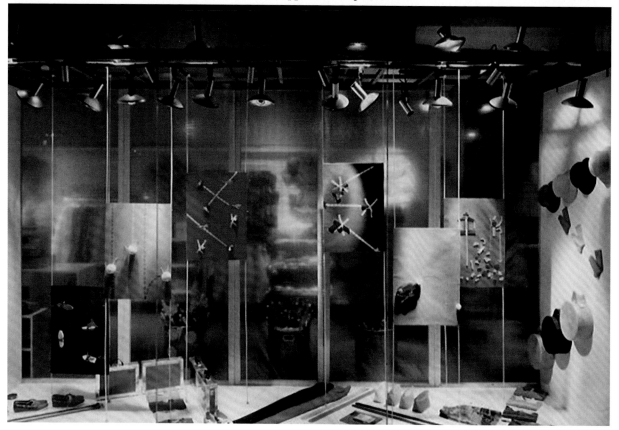

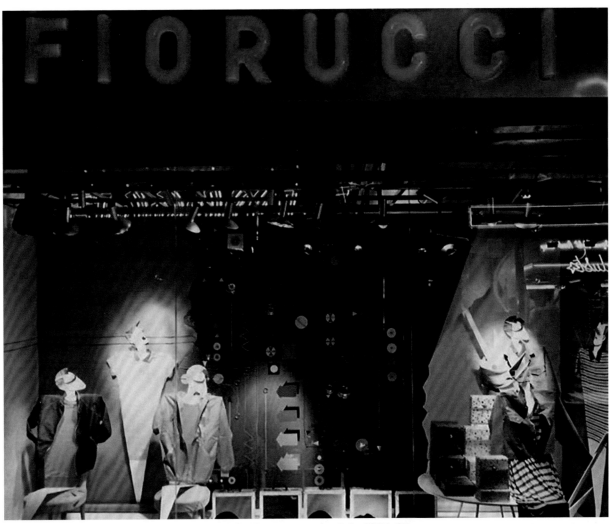

Window displays in the San Babila store in Milan, approximately 1975–80.

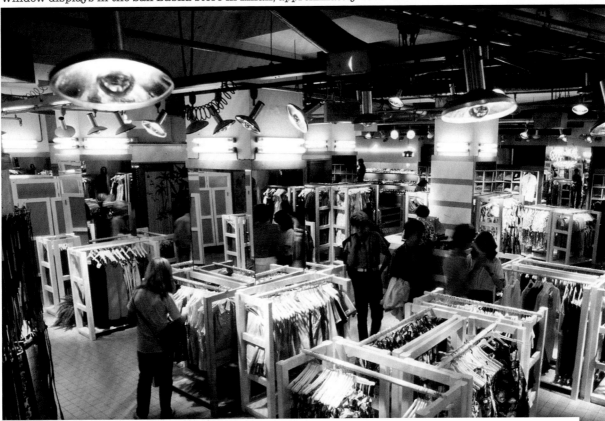

Interior of the San Babila store in Milan, 1973–74, clothing department. The decor featured elements that could be used as both shelving or hanging racks, and were easy to move around. This made it simple to change the image inside the store.

San Babila store, Milan, 1978–79 . Elio loved the drawings of Alberto Vargas, depicting sexy girls.
So he wanted to create display stands for the stores, which could be used both as shelving or for hanging clothes.
The first pinup displays appeared in the New York store, and later in Milan.
Design by Pippo Rondolotti.

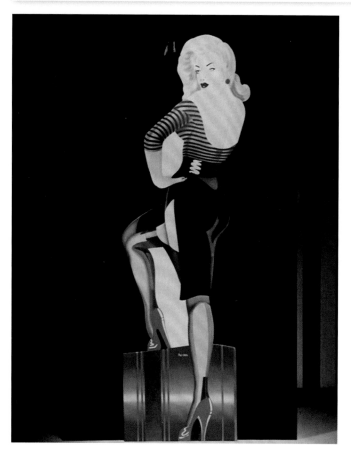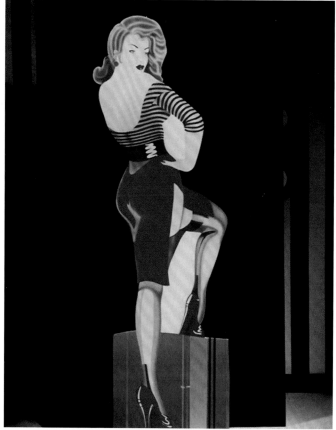

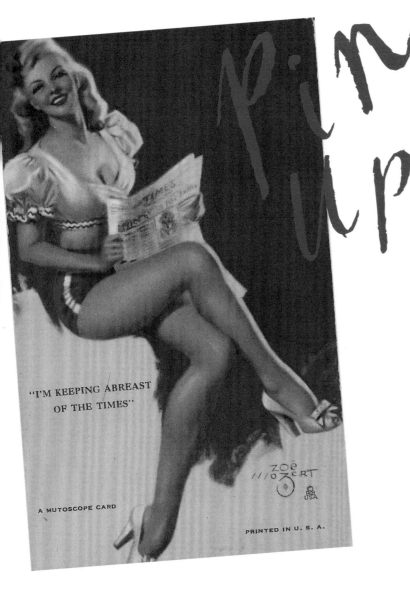

"I'M KEEPING ABREAST
OF THE TIMES"

A MUTOSCOPE CARD

PRINTED IN U. S. A.

Pin Up

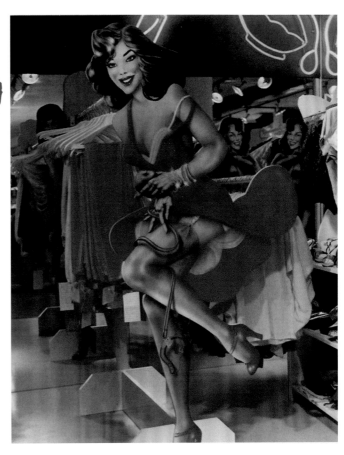

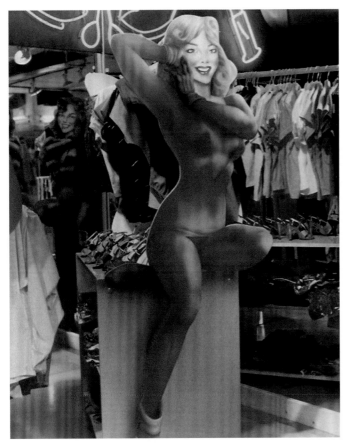

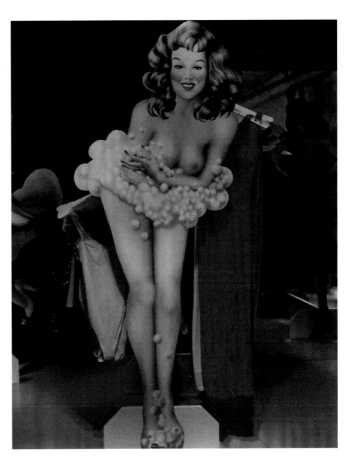

I remember... the time I got my first paycheck—I was still a student. I made my first naive attempt at rebelling against respectability and bought a pair of flashy red plastic boots in Via Torino; I was served by the bearded young store owner. The boots broke immediately. I don't know whether I didn't take care of them or they were defective to start with. Though I was very shy, I went back to the store to do something about it, but I wasn't very hopeful. Elio was really friendly—he came over and listened to what I had to say. We had a chat and he replaced the boots with a bright yellow pair, and threw in a belt too. When we met again, in the fashion world, we were already friends.

I remember the afternoon I saw him with Cristina; she was beautiful, so "normal" and in love, with a long braid that went down her back. He liked young, sexy girls, and she wasn't the first one I'd seen him with. But I recognized a chemistry between the two of them, very similar to what I had with Flavio (Lucchini, *ed.*), who wasn't yet my husband. We often ran into one another, the four of us, at the countless events going on in Milan in those exciting times. There was the fabulous trip to New York to visit the magical Fiorucci store designed by Franco Marabelli; all of Manhattan was talking about it, it was a treasure trove of curiosities, seduction, weirdness, desire and hypnotic characters. And every evening we set out from there to explore New York's nightlife. At Club 54, with its pounding music and strobe lights, you could spot all kinds of young artists, including Andy Warhol, Basquiat and Madonna.

There was the time Elio planned his first fashion show and asked me—as the young editor of *Lei* magazine—to advise him; as I was putting together all kinds of garments and colors, I was thinking that it was me learning from him, not the other way around. The electrifying energy of his great store—the forerunner of the concept store—which succeeded in bringing together generations, reconciling beatnik daughters with pearl necklace-wearing mothers, all of them bowled over by the colorful, new, irreverent and sexy fashion. Going up and down the stairs in his "Ali Baba's cave," he looked so happy and amazed, like a child who's broken the impenetrable sound barrier of taste and style. Our work meetings in his incredibly busy office above the store in Galleria Passarella, a mix of objects, accessories, hearts, mouths, clothes, dwarves, sweaters, angels, colors, trial graphics, sketches, fabric samples, motley buttons, books, girls, laughter and words that eventually ended up as collections. Our conversations about love and eroticism, in which he argued for joy and freedom and I was much more prudish. He adored the porn star Moana (I liked her too); he considered her a kind of modern-day madonna, a champion of freedom. The first unforgettable Fiorucci party for the launch of Superstudio 13, the photographic studio that opened in 1983 at Via Forcella 13 in Milan and would later become the center of Via Tortona's explosion as a fashion and design district. There was a cosmopolitan atmosphere and fabulous people: artists, musicians, fashion people; it didn't feel like Milan, but like London, Paris or New York.

The enthusiasm he poured into everything he did. The way he stuck with new projects, even the most difficult or risky ones, and if we were involved, he encouraged us. As we did in 2000, when we launched the Superstudio Più, the first private hub for events and creativity. He was the first to arrive at exhibitions, shows, visits to White or our Fuorisalone Design event. He was always positive, optimistic, full of ideas.

His phone calls asking for our opinion, the way he would help someone deserving, a project, a comment or a view, a book to show us and a thousand small things that were really important for us. And the time in summer 2015, I was abroad on holiday and I got a phone call telling me Elio had gone, alone, in the night. I didn't want to believe it, it seemed like a cruel joke, an impossible thing, so sudden. Unfortunately, it was true, and I never saw him again.

FLAVIO LUCCHINI
Art director, entrepreneur and artist

I'd recently persuaded the American bosses to publish *Vogue* in Italy, in addition to the Paris and London editions. I was the designer and art director. The fashion world was buzzing. Rome was all about "High Fashion" with its grand sartorial tradition, but in Milan, London and Paris, young designers were emerging and coming up with clothes that were different, just as the Beatles were doing for music.

A new generation was coming on the scene. These designers weren't finding what they wanted in the shops, so they designed it themselves and started small, eventually expanding.

Milan saw Missoni, Walter Albini, Krizia, Caumont, Cadette and many others come onto the scene. I was always fanatical about fashion, believing it was crucial to affirm an individual's personality. In the pages of *Vogue*, I aimed to be an authoritative voice for all of these emerging creatives, who were soon recast in the new definition of "designers."

I met Elio with Nanni Strada at his store in Via Torino. That was in 1966. Nanni was an avant-garde designer and passionate about fashion. As for me, with my background studying art at Brera and architecture in Venice, I was focused on the graphics and design side; I'd recently founded the Art Directors' Club with Giancarlo Iliprandi and others.

I decided it was time to get designers of graphics and objects involved in fashion, along with other intuitive, creative individuals.

All of them could make a great contribution to sharing innovation and culture. With Nanni and Elio—who was clearly no ordinary shoe store owner—I came up with some purely research-based features for *Vogue*.

Nanni designed and Elio produced some fabulous transparent shoes using new materials, paving the way for explosive change in clothing too.

In summer of 1967, I decided to go to London, and, from there, to New York with Clino Castelli, a designer at Olivetti. Elio provided the funds to buy everything we thought was interesting. Given this freedom, we came back with a huge bag full of all the new things we'd found; they ended up either in Fiorucci's windows in Galleria Passarella or in the fashion features of *Vogue* or *L'Uomo Vogue*, captioned "courtesy of Fiorucci." They were exciting products and not available at home, so the unusual window displays attracted attention.

Then Elio started financing and supporting young researchers and trend-hunters who had caught his passion for everything that encouraged change.

Fiorucci turned out to be a great innovator and an extremely important witness to that period, becoming a theorist and philosopher who enlisted artists, graphic designers, architects and creatives of all kinds. And they all made a contribution to his fashion, which was the product of diverse experiences brought together by his unique, original vision and has left its mark and driven young people crazy all over the world.

CLINO CASTELLI

Architect and designer

I met Elio Fiorucci at his shoe store in Via Torino in early 1967. He immediately struck me as a brilliant salesman. I'd been working for at least three years for Olivetti, in Ettore Sottsass's studio. For a couple of years, I'd been friendly with Flavio Lucchini, who had recently been appointed art director of *Vogue* Italia. The story of my friendship with Elio has two beginnings: one through Lucchini and the other through Nanni Strada, whom I'd met at *Vogue* at a special editorial meeting set up by Flavio himself, with several people he wanted to involve in Milan's emerging fashion scene. Nanni told me about Fiorucci and the strappy sandals she'd designed for the Via Torino store.

Following a trip with Lucchini to New York where, thanks to Grace Mirabella (later editor of *Vogue*), we met many of New York's top photographers and artists like Andy Warhol, I was keen to do something in fashion that would take into account design and the way it worked. Nanni was ready and willing to get involved—she was a very talented woman and already a successful designer. But the crucial thing was the meeting with Elio, who immediately came on board. I told him I didn't like fashion styling as it was then; thanks to Sottsass I'd discovered a design culture that could become a model for the development of new fashion "languages." At the time, I was about to leave Sottsass's studio, and he wasn't too happy.

When he found out I was planning something new with Fiorucci (who was not well-known at the time), he thought I was going to "design buttons." Some time later—maybe in 1970—when I introduced Elio to Ettore and Nanda (Fernanda Pivano, *ed.*), they immediately became good friends.

When the new Fiorucci store in San Babila opened on May 31, 1967, I suggested we give away the Pill Plan as a freebie; it was a red-and-white plastic bracelet designed to help women take the birth-control pill on time. An article by Camilla Cederna appeared in *l'Espresso*, describing it in detail, and some people remember a photo of Gisella Borioli wearing it. The pill had just arrived in Italy, but it was still illegal to advertise it.

Elio and I founded Intrapresa Design in October 1967. The offices were across from the new Fiorucci store in Galleria Passarella. Elio and I had great respect for each other, but our interests diverged somewhat: he wanted to design clothing for young people, while I wanted to research trends too. And when the store started to become successful, Elio was increasingly absent.

We closed after a couple of years. I went back to Olivetti, working in corporate identity, which was my first and most important professional endeavor.

A few years later, Fiorucci asked me to collaborate with Massimo Morozzi and Andrea Branzi at the Montefibre Design Centre, where there was the opportunity to design with new materials.

It was a fascinating field in design that was not well-known at the time, but I was already very much committed to it in both theoretical and practical terms.

Going back to Elio, there was a very funny episode when we dissolved the company; aside from a bit of money to split between us, there were various assets in the form of patents. The liquidator, the lawyer Fantinelli, read out the eccentric titles in his serious voice: "Flip-flop sandals with integrated daisy," "Production method for hairy objects," "Self-waving flag"... at that point Elio and I started laughing and we couldn't stop, as the lawyer looked at us, perplexed.

I remember Elio as a sincere person and not at all pushy. We often bumped into each other in the strangest places, and all it took was for one of us to say the name of one of our patents in a serious voice to begin laughing like crazy again.

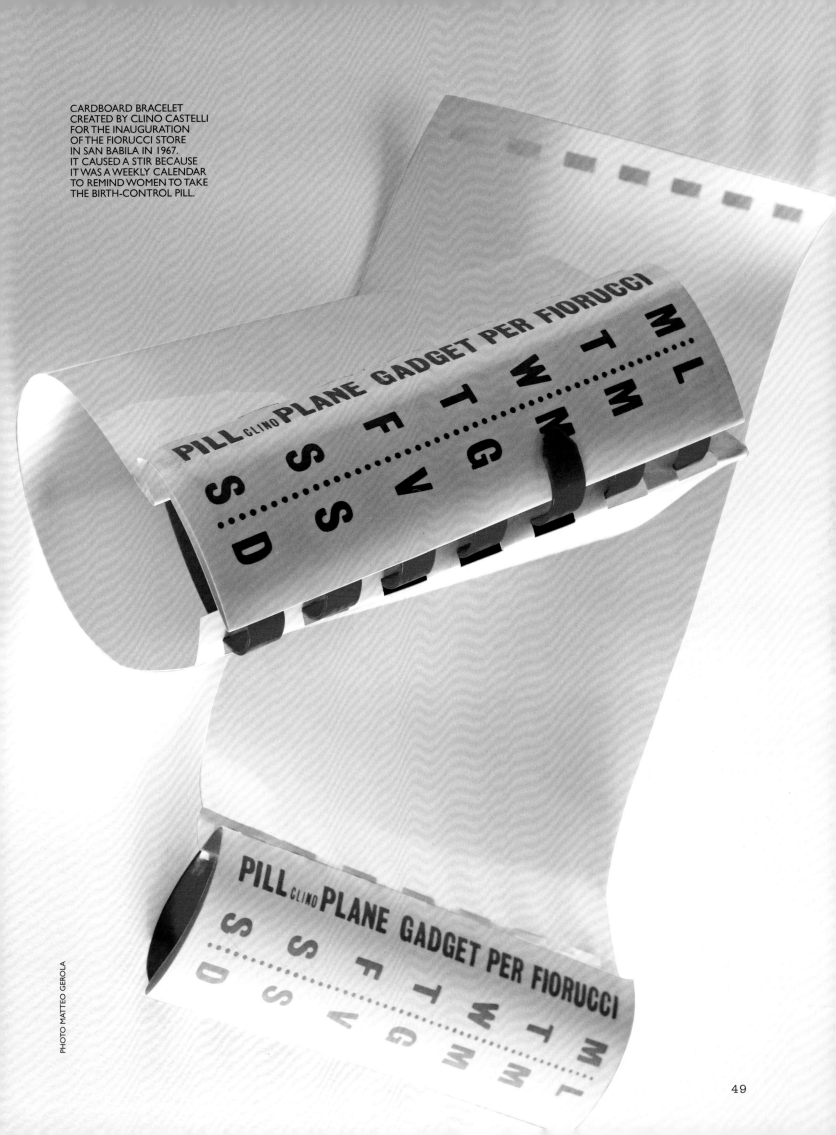

CARDBOARD BRACELET
CREATED BY CLINO CASTELLI
FOR THE INAUGURATION
OF THE FIORUCCI STORE
IN SAN BABILA IN 1967.
IT CAUSED A STIR BECAUSE
IT WAS A WEEKLY CALENDAR
TO REMIND WOMEN TO TAKE
THE BIRTH-CONTROL PILL.

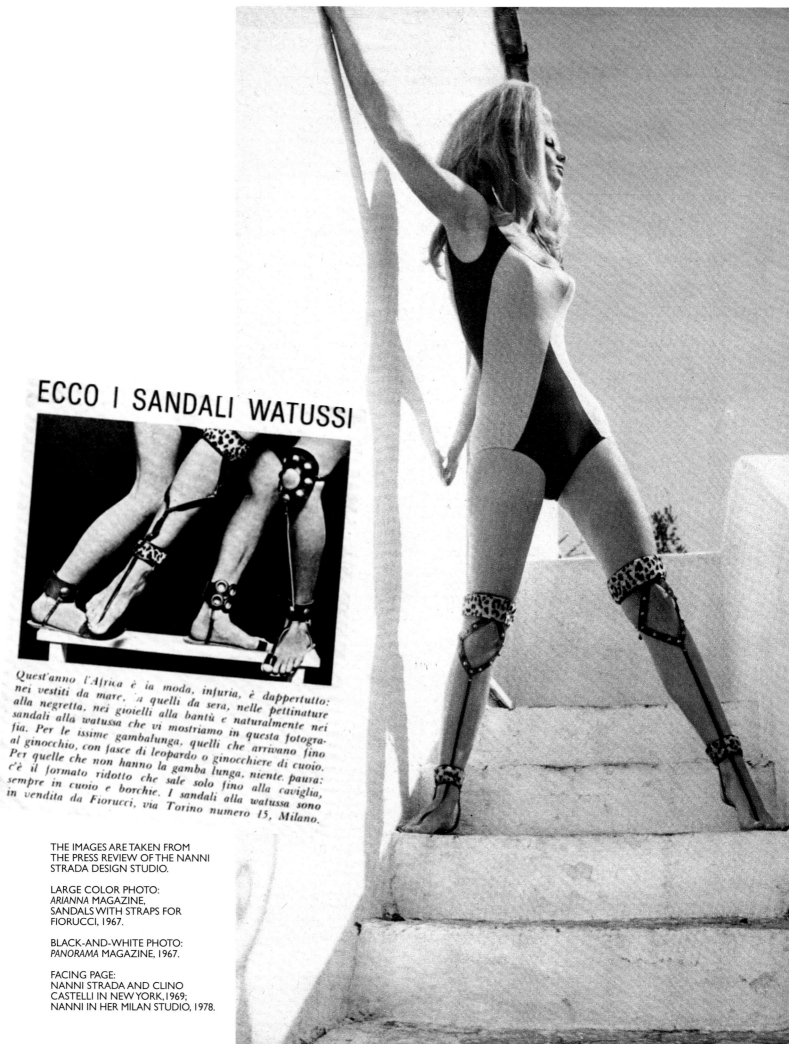

ECCO I SANDALI WATUSSI

Quest'anno l'Africa è la moda, infuria, è dappertutto: nei vestiti da mare, a quelli da sera, nelle pettinature alla negretta, nei gioielli alla bantù e naturalmente nei sandali alla watussa che vi mostriamo in questa fotografia. Per le issime gambalunga, quelli che arrivano fino al ginocchio, con fasce di leopardo o ginocchiere di cuoio. Per quelle che non hanno la gamba lunga, niente. paura: c'è il formato ridotto che sale solo fino alla caviglia, sempre in cuoio e borchie. I sandali alla watussa sono in vendita da Fiorucci, via Torino numero 15, Milano.

THE IMAGES ARE TAKEN FROM
THE PRESS REVIEW OF THE NANNI
STRADA DESIGN STUDIO.

LARGE COLOR PHOTO:
ARIANNA MAGAZINE,
SANDALS WITH STRAPS FOR
FIORUCCI, 1967.

BLACK-AND-WHITE PHOTO:
PANORAMA MAGAZINE, 1967.

FACING PAGE:
NANNI STRADA AND CLINO
CASTELLI IN NEW YORK, 1969;
NANNI IN HER MILAN STUDIO, 1978.

NANNI STRADA
Fashion designer, creative and researcher

I met Elio at the Casa della Pantofola shoe store on Via Torino in 1964 or 1965. In those days, I was wearing miniskirts. In the window, along with the slippers, I noticed some pink leather boots. It was the year of the boot; everyone was wearing long boots with miniskirts. But that pink was off the charts. I barely

had enough money for my tram fare, but I went straight in and saw a guy behind the counter—it was Elio—and he said "Hey, you're so cool." Because in Milan at that time there were very few girls going around in miniskirts. I don't remember if I bought the boots; I certainly couldn't afford them. I mostly wore secondhand clothes. And I'd inherited the wardrobe of the American girlfriend of one of my friends, who modeled for *Seventeen* and was the same size as me. I started working in fashion with Alfa Castaldi; we did features for the magazines. The models would show up with their beauty kits and do their own makeup. It was all just getting started and, aside from Walter Albini, there weren't any fashion designers.

So that's how I met Elio, and I remember he said "Listen, we need to get together," and I don't know how, but we stayed in touch. I was designing accessories for Anna Piaggi, and a few years later (1967, *ed.*) I created these strappy sandals that came up to the knee, the ones that caused such a stir in the press. That was when our relationship got stronger, because Elio started Intrapresa Design with Clino Castelli (also in 1967, *ed.*). It was an agency for promoting designers, creativity and the concept of professional fashion design. They had offices in Galleria Passarella, before Elio opened the store there. Before that, Clino worked for Ettore Sottsass, and he was something of a favorite with Nanda too (Fernanda Pivano, *ed.*). I don't know how he met Fiorucci—maybe I introduced them—and it was his idea to set up this agency which,

to a certain extent, would influence fashion, because, in those days, there was only one trend bureau, and that was in Paris. It was because of the agency, and thanks to Elio's knowledge of the footwear industry, that I designed some shoe collections: tennis shoes in patterned fabric and sandals with perspex heels and ankle supports, which were featured in the new *Vogue Italia*, edited by Flavio Lucchini.

I met Clino with Flavio Lucchini at *Vogue Italia*. It was an incredible encounter, because I got to meet Flavio and Clino at the same time. Flavio was an amazing art director—I believe he's the greatest Italy's ever seen—and a dear friend of mine. Soon after that, Clino became the love of my life.

Journalist

In the 1960s I was working as a stylist (in those days it was called fashion editor) at *Amica* magazine, which started in 1961, and much of my work involved researching shoes, jewelry, hosiery, hats, scarves, and so on, as accessories for fashion shoots to go with the clothes we selected from the manufacturers' samples. One time I had to find some unusual gloves, which had to be attractive, exciting and youthful. Walking around central Milan, I came across a store in Via Torino with some interesting gloves in the window.

I went in and there was a friendly lady at the till. I asked her if they would be interested in a partnership with the fashion press. She called her son and Elio Fiorucci appeared; he was about my age, twenty-seven or so. I explained my problem and he said, "Don't worry, tell me what you want and I'll have it made." I thought I was dreaming, because before that nobody had ever offered to give me samples so easily. Everything went well, and I got some fabulous, colorful gloves. I went back to see Elio a few months later. I had to do a feature on furs and the model was the wonderful Donyale Luna. However, there was a "but." Donyale was over six feet tall, and all the fur coats we'd chosen looked like miniskirts on her, not elegant at all. After a lengthy discussion, Elio had the extraordinary idea of making some soft, colorful boots that went all the way up to the thigh; they were so gorgeous he started producing them. The shoot was a great success. Elio obviously realized how important it was for his products to appear in the press, the power of his name in a caption and how many people went shopping carrying a copy of *Amica*.

The following summer (it was 1964), *Amica* decided to offer its readers a free gift, so I went back to Elio. We decided

on flip-flops and, to give them his own personal touch, Elio suggested making them special by adding a large plastic daisy. It was wildly successful.

So I got to know Elio and began to discover the talent in that shy, smiling young man who did his job with passion, flair and creativity.

I've followed and loved Elio all my life. He was an extraordinary person with a very special gift: an underlying innocence that made him unusual and different from anyone else in the fashion world. I had long conversations with him about the ways of the world, more than the ways of fashion. For him, fashion wasn't about clothes. It was about a series of things that were part of life, from everyday objects to books, and he was always very interested and attentive to upcoming trends. I always told him he had an "angelic" vision of women, men and what was going on, and he was extraordinary precisely because he had this vision of a world without limits. In his view, everything was possible! And to think that these days people live in fear... He was the exact opposite. He would stop and listen to you because he was intrigued by all the things he hadn't thought of, and—in his opinion—might have occurred to you.

There's one thing I really think is true of Elio: he was a real disruptive phenomenon, and that's what made him famous all over the world. What's more he was a free spirit, one of the very few I've come across, and incredibly generous. His ingenuity was certainly needed to conceive and open Milan's very first concept store in 1974, in Galleria Passarella. For years, the store was a cult destination, a meeting place, a landmark for thousands of young people who learned to love jeans thanks to Elio! In the meantime, I'd moved from *Amica* to *Corriere della Sera*, but I continued to keep an eye on what he was doing and to see him too, because he was the best thermometer to take the temperature of fashion! The last time I saw him I'd invited him to Rome to a seminar at the Academy of Fashion and Costume, where I was teaching. He was amazed when all the students bombarded him with questions. He said to me: "You know what a great job it is you're doing?" I answered: "If we always do what we do in life and never teach others, it's a very sad thing. Wikipedia is one thing, but a person like you or me, who's lived through these exciting times that today's youngsters will never experience, is a different thing." And Elio was an iconic figure of the age.

I ♥ JEA

NS!

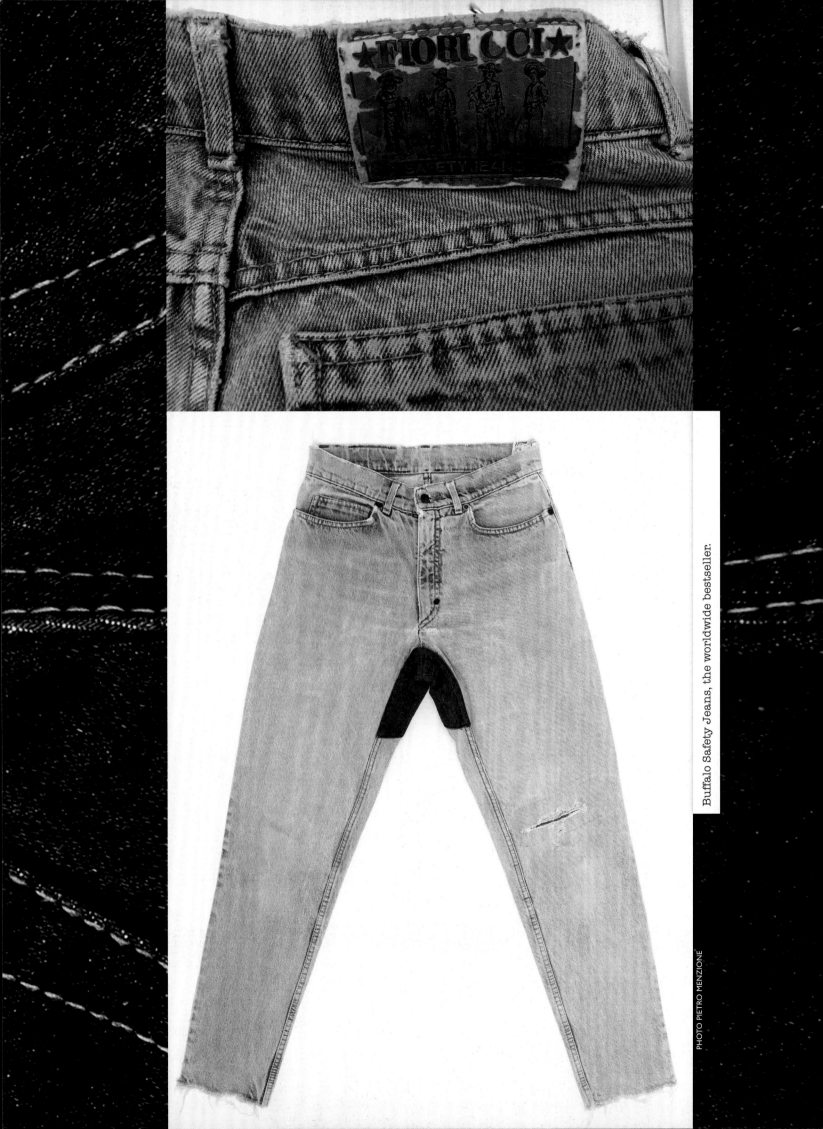

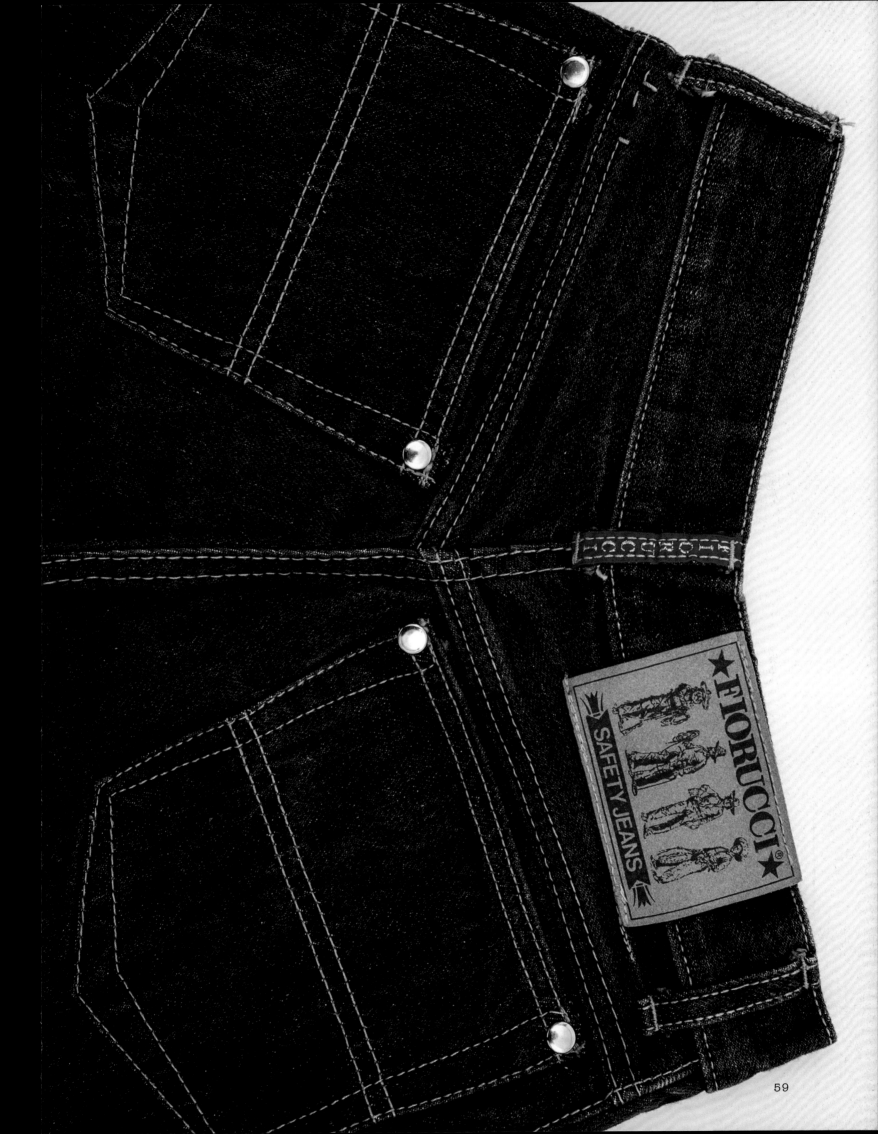

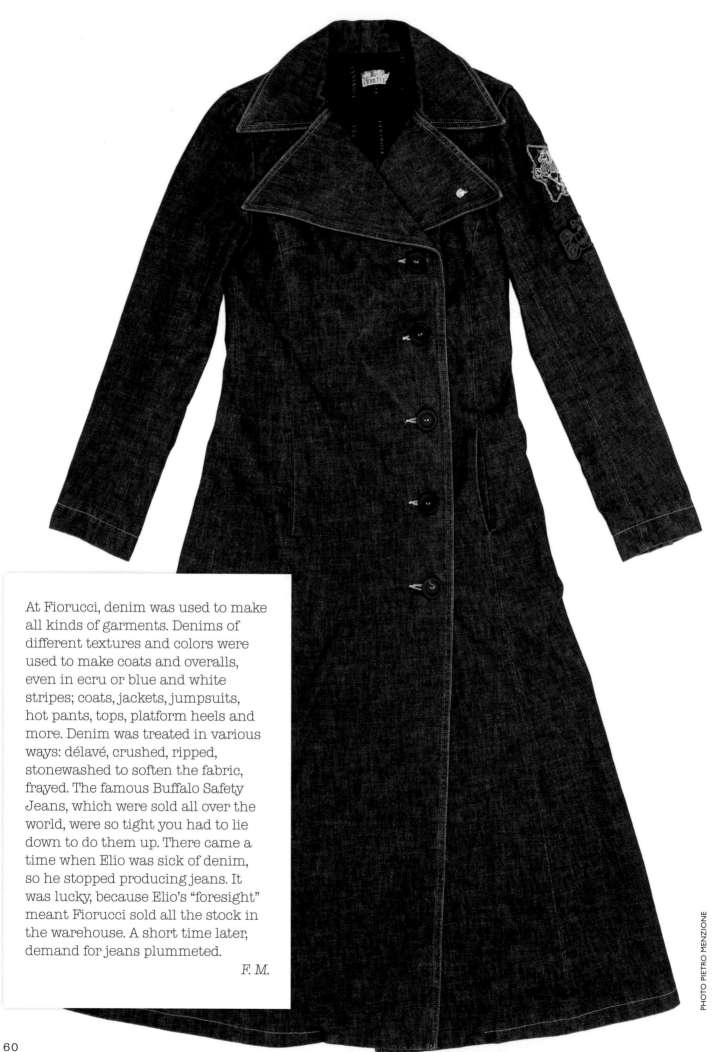

At Fiorucci, denim was used to make all kinds of garments. Denims of different textures and colors were used to make coats and overalls, even in ecru or blue and white stripes; coats, jackets, jumpsuits, hot pants, tops, platform heels and more. Denim was treated in various ways: délavé, crushed, ripped, stonewashed to soften the fabric, frayed. The famous Buffalo Safety Jeans, which were sold all over the world, were so tight you had to lie down to do them up. There came a time when Elio was sick of denim, so he stopped producing jeans. It was lucky, because Elio's "foresight" meant Fiorucci sold all the stock in the warehouse. A short time later, demand for jeans plummeted.

F. M.

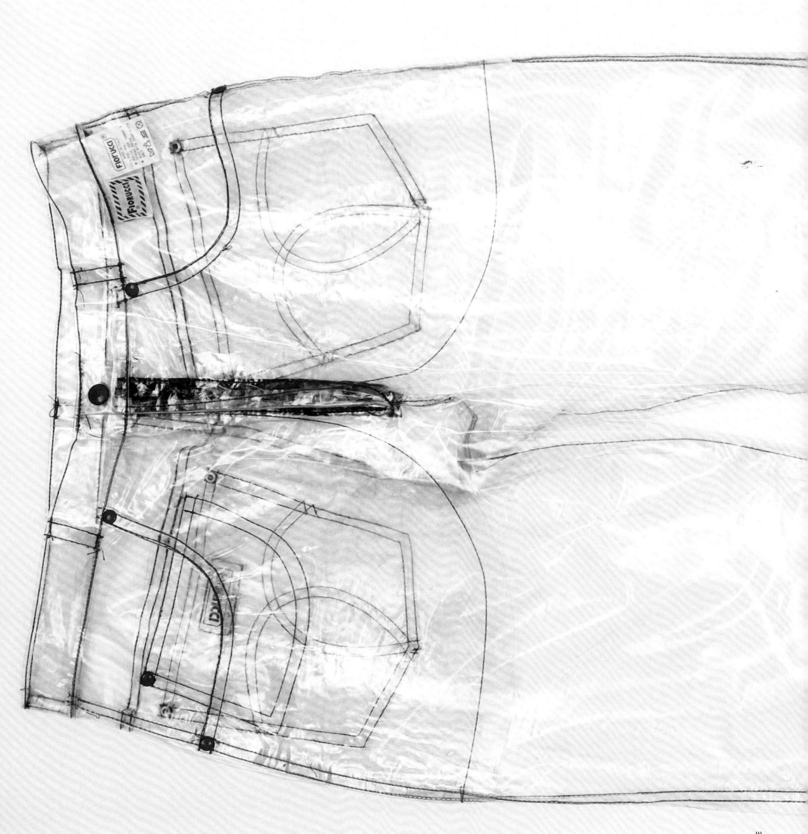

A "UNIQUE AND TOTALLY WILD" idea: transparent plastic jeans with red stitching. In New York, they could be seen in nightclubs like Studio 54. They had to be worn with appropriate underwear, although while dancing, sweat caused the plastic to become opaque; the other difficulty was getting the jeans off at the end of the evening.

Denim jacket with stitching similar to that in the dungarees
featured in the poster, right. Graphic project Spago (Vittorio Spaggiari).

ISABELLA SASSO

Telephone operator and model for the creation of jeans

I was about thirty, I weighed 99 pounds and I couldn't find a job. I was so thin, I was a model for samples for teenage girls. One day in 1974, I met Giò Mariotti, who worked at Fiorucci, and I happened to mention that I had very little work because I was the wrong size. He invited me to Fiorucci, and made me an appointment in the San Babila offices with Cristina Rossi, the head of the style department. At the time they were using a skinny sales assistant with narrow shoulders as a model, so the jackets were very small. I tried on the clothes and they told me I was too thin for them too, but I had the Fiorucci style. I had to put on some weight and come back in a few months. When I got to 112 pounds, they gave me a consultancy contract, because I didn't have Italian citizenship as I was born in Panama.

I started working with Cristina, and one day Elio Fiorucci said to me, "With a backside like that, we need to make jeans that fit you." So they sat me on a stool in just my underpants, as if I was riding a motorbike, because Elio wanted the trousers to lie on the body with the motor-bike effect, in other words with the backside sticking out. As I sat in that position, the model-maker Morelli marked me up with red pen. When I got home that night, my mother had to scrub the marks off. That's how Buffalo jeans were born—the absolute bestsellers, because they molded and accentuated the shape of the body. I remember they made me wear the jeans every day, to check their texture and resistance; since I went dancing frequently, I used them as they were intended.

We went to a lot of trade fairs abroad too. We'd go to France twice a year; that's where we launched Tyvek, a fabric that was a type of paper. We wore white jumpsuits with the logo. The stand was all in red and blue squares and set up as a gas station, complete with pumps; there were no clothes for sale (a design by Franco Marabelli, ed.). We'd walk around the fair giving out Fiorucci T-shirts; our stand was always packed, and we never had enough T-shirts. I remember a wonderful show in a hangar in Berlin, I think it was in 1978. It was such fun. They decided to hire the models on the spot; Sara Nannicini and I chose them, each was different from the next. There was even a Marilyn Monroe lookalike, which had nothing to do with Fiorucci. She couldn't get the shirts on because they were too tight and her bust too big, but the jeans clung to her body, really tight. In the center of the hangar, they built a ring, and the audience sat around it on stools, cushions or on the floor. Tito Pastore was often with us and organized almost everything, from makeup to clothes and music. Lots of people came in their own private aircraft; it was a truly avant-garde event.

Elio was an extremely likable person, and very changeable: one moment he was one way, the next he was different. He'd come into the cutting room when there was something new, look at the samples, and in the end it was Cristina who decided. Fiorucci was always a fun place to be, and different from anything else. It was a wonderful time.

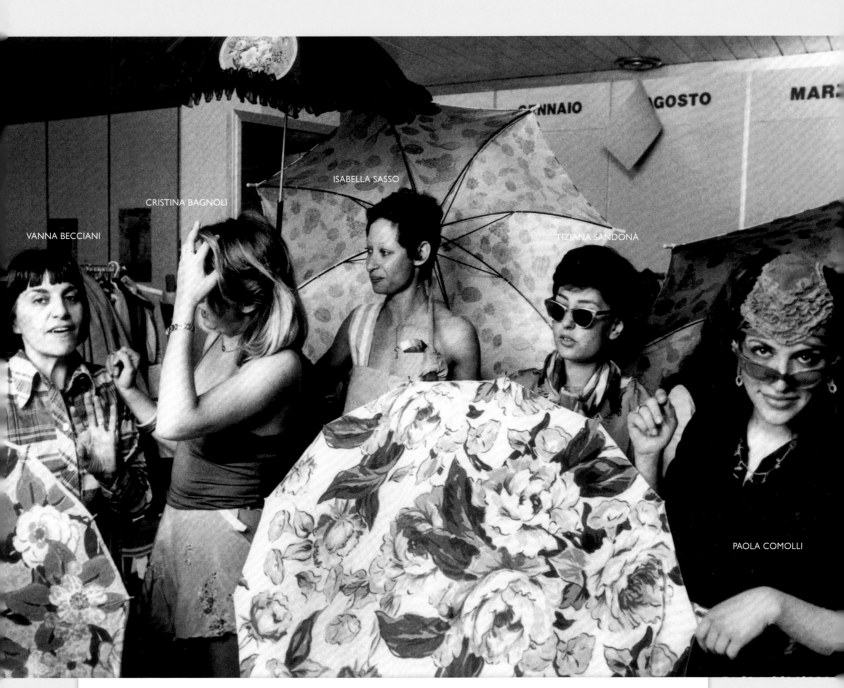

VANNA BECCIANI CRISTINA BAGNOLI ISABELLA SASSO TIZIANA SANDONÀ PAOLA COMOLLI

GENNAIO AGOSTO MAR

The style office in Corsico was a hotbed of activity: young creatives would arrive from all over the world, fascinated by the new world of Fiorucci and wanting to present their ideas and be admitted to the group. Jean Paul Gaultier, Gianni Versace, Franco Moschino and Enrico Coveri all passed through that office; then there were designers of shoes, knitwear and travelers from all over bringing their samples...

1967–81

The Fiorucci creative team in that period

STYLE
Cristina Rossi, head
Alberto Vivian
Be Khanh
Cristina Bagnoli

Dina Vielmi
Eliette Amar
Juan Salvado
Kaki Kroener
Lorella Colacicco
Mario Morelli
Mimma Gini, style
and Fiorucci school
Mirella Landi
Mirella Clemencigh
Monica Bolzoni
Paola Comolli
Paola Marini
Pinky and Dianne
Pupi Solari
Rini Van Vonderen
Sara Nannicini
Tea Scopinick
Tito Pastore
Vito Notaristefano
Vittorio Spaggiari

**GRAPHICS
DEPARTMENT**
Sauro Mainardi
Carlo Pignagnoli
Guglielmo Pelizzoni
Augusto Vignali
Vittorio Spaggiari
Maurizio Turchet

PRESS OFFICE
Franca Soncini, coordinator
Karla Otto
Alessandra Rigo
Sara Nannicini
Daniela Sacerdote
Angelo Careddu
Leda Favalli
Anny Talli Nencioni
Leonardo Pastore
Rosanna Zoia
Mauro Pregnolato

Store design
and image

Franco Marabelli,
head
Anita Bianchetti
Stefania Sartori
Evelyn Zurel

Furnishings
and objects

Anna Silei
Maurizio Brunazzi

Dxing

interdisciplinary body
for research into
fashion consumption
Giannino Malossi

Apologies if I've forgotten anyone

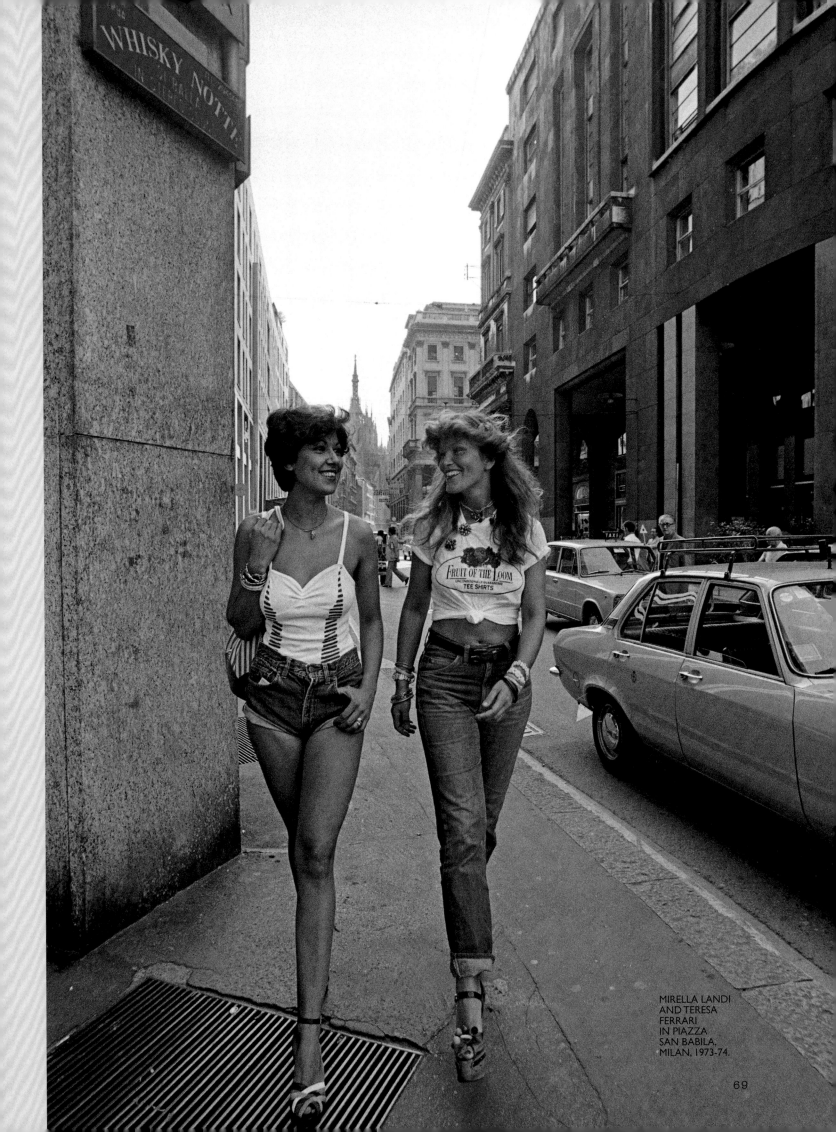

MIRELLA LANDI
AND TERESA
FERRARI
IN PIAZZA
SAN BABILA,
MILAN, 1973-74.

69

TITO PASTORE

Stylist

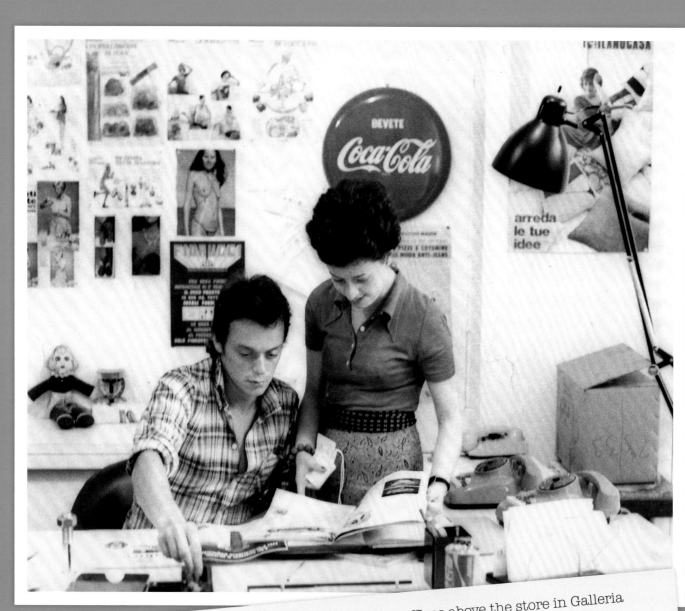

Tito Pastore and Sara Nannicini in the offices above the store in Galleria Passarella, Milan

Along with Mirella Landi, Tito was one of the more eclectic and bizarre Fiorucci stylists.
Having begun as a sales assistant, he was moved to the press office, thanks to his interpersonal skills.
He worked with Sara Nannicini and Alessandra Rigo, and was then transferred to the style office, where he stayed almost until the closure of Fiorucci.
Tito was Elio's right-hand man, and Elio was very fond of him, despite his somewhat difficult personality. Gifted with an intuition few people were aware of, he was a pioneer of ideas.
Constantly traveling, he was a great friend of Anita Paltrinieri—who lived in New York at the time—and traveled the world with her.
His brother Leonardo worked in public relations for Fiorucci in Italy and the United States.

F. M.

10月・1 2 3 4 5 6 7 8 9 10 11 12 13 14 15 16 17 18 19 20 21 22 23 24 25 26 27 28 29 30 31

10 OCT 1977

17 MON/月 先勝

18 TUE/火 友引

19 WED/水 先負

20 THU/木 仏滅

MIRELLA LANDI

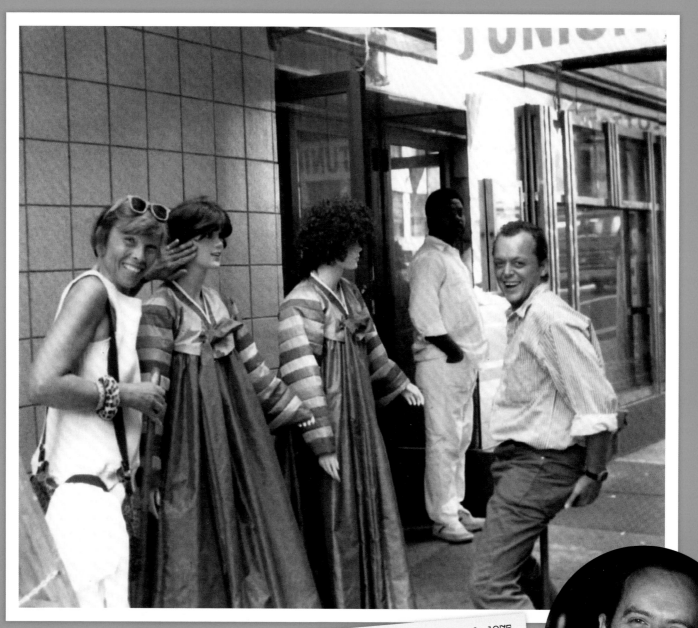

Tito Pastore and Anita Paltrinieri in New York, 1975.
In the circle: Leonardo Pastore.

SARA NANNICINI

Worked at Fiorucci from the outset, staying many years and covering numerous roles

In 1968–69 I was working for Pierre Cardin in Via Montenapoleone, and Fiorucci came to the opening of the store. As soon as he arrived I was struck by his big eyes, full of curiosity. I realized he was a special person, with extraordinary intelligence.

My mother had read in the paper that in London, dyed clothes were back in fashion, so she dyed some cotton scarves with Super Iride and I decided to take them to Fiorucci. I left them in the store and went back a week later: the manager told me they weren't interested and wanted to give them back to me, but he couldn't find them. He called the office, and the scarves were there; they told him to send me upstairs. That's how I met Elio. He was interested in the scarves and wanted to know who'd made them. "My mom." I was wearing a coat and Gucci shoes, with a Hermès scarf tied onto my bag; I was totally different from the Fiorucci style. Elio asked me if I could dye some T-shirts. He gave me ten white Indian shirts, which I tie-dyed. They sold immediately, and I was given fifty more. My mother had no time for cooking, she was so busy dyeing, and my dad was furious. Then Elio asked me to go and work for him. In one office was Pia Borghini, the head of public relations, in another were Rosanna Bosoni and Ilio Mangili, who was Elio's partner. I began to supervise the production. Cristina Rossi was in London sending over samples; I looked for similar fabrics and took them to the workshops. The work was increasingly busy, so I asked Elio to get me an assistant, so we found Tea, and later Paola Marini. Pia Borghini came from Biba to do PR. Franca Soncini arrived, with her press contacts. When Cristina Rossi came back from London, Elio appointed her head of the production department. We didn't get on well with her, and all three of us quit. I found myself unemployed.

One evening, toward the middle of the 1970s, Elio called me and asked me to come back and take charge of press relations because I had a nice way of dealing with people. I would be the head of the office. I'd never done that job, but I accepted the offer: Elio understood before I did that it was the role for me, as he did with so many other people. And it worked out fine. There came a point when I couldn't do it alone any longer. I had meetings with five or ten journalists a day, I was running back and forth with boxes and packages: it was a wonderful job but exhausting, so I asked Elio for help. I chose Tito Pastore, who was a sales assistant at the time. He'd recently arrived from London, he was really friendly and spoke very good English.

Like many others, I left Fiorucci in late 1981, when Benetton came along. Before I left, Elio and Cristina put me in charge of the style office along with Spago (Vittorio Spaggiari, *ed.*): that job lasted about a year.

I remember many, many trips with Elio: Paris, New York, London, Los Angeles, all over America and the Far East. We'd travel together for workshops, to buy goods or attend events; and people looked at us as if we were a bit strange. We looked like an accountant and his secretary. We wore ordinary clothes and never worried about our non-Fiorucci appearance. He often wore a dark blue round-necked sweater, a blue and white striped shirt and jeans. I always admired and loved him very much. He was a unique person, a genius with a very special sensibility. He was always kind, attentive and affectionate. Always.

It was 1965, and I was running the promotion and PR office in the advertising department of the *Corriere della Sera* group. My duties involved finding sponsors for competitions and promotional initiatives of *Amica* magazine, in order to reward the readers and create loyalty. One of these initiatives was "The Shopping Club," which was sales by mail order. In Italy, these schemes hadn't been very successful, but, in this case, the loyalty was guaranteed by *Amica* and the *Corriere della Sera* group. It was fun going round looking for items to sell in the Club. One day in 1965, I was walking down Via Torino in Milan when my eye was caught by a window display with children's slippers in the shape of animals: dogs, lions, crocodiles and so on.

It seemed like a fun item for the club. I went in, and there was Elio Fiorucci. I asked him if he'd tell me who the supplier was, to find out if they could produce and deliver a large number of items. Fiorucci replied that he could take care of it, and guarantee delivery in a short time. And so a few weeks later the slippers went on sale in the Shopping Club, without Fiorucci's name attached. The magazine's policy was never to reveal where they came from. The scheme was a success: I think we had several thousand requests, which were promptly fulfilled by Elio Fiorucci. Another of my responsibilities was to act as a go-between for fashion editors and clothing manufacturers. In 1966, Adriana Mulassano asked me if I could get hold of a pair of baby blue shoes at short notice for an Oliviero Toscani photo shoot. I thought of Fiorucci, who said he could produce the shoes in a few days, on the condition that the name of his store was mentioned. Because of the urgency, the editor of *Amica* agreed. Fiorucci could really see the big picture and understood the importance of getting his name into fashion magazines. When he opened the store in Galleria Passarella in Milan in 1967, he created a special office for communications with the fashion press, and he would provide them with articles, obtaining editorial publicity free of charge.

Meanwhile I'd left *Corriere della Sera* to join an independent PR firm.

Fiorucci was very clear about what he wanted, but he was also shrewd and modest enough to ask for opinions and advice from people he respected. He invited me to visit the store as it was being set up. I realized he was creating a store that was completely new for Italy. I was particularly struck by the fact that he'd opened a style office and employed several young designers, new grads, who were tasked with creating new and youthful products; he committed to producing a number of items to display in the store and see the reaction.

In late 1969, I decided to move to New York. Before I left, I went to say goodbye to Fiorucci and left him my address. In mid 1972, I was walking down Fifth Avenue when I heard my name being called. It was Fiorucci, who'd lost my address and was looking for me. His store was extremely successful, especially because he brought new products in weekly. He told me that in Milan there were quite a few models—Americans particularly—who were going around in ripped or decorated jeans, Hawaiian, cowboy or Boy Scout shirts, baseball caps, multicolored tights and Indian scarves with beads; often the clothes were second-hand. He asked me if I'd like to be his agent in the United States, sourcing unusual items to send over to Italy. I agreed, and it was great fun for a few years. Every two or three weeks I filled a couple of suitcases and took the goods to Milan, trying to dodge customs. Then the buying office got itself set up more formally, and I could ship goods the normal way.

Fiorucci came to New York often, eager to explore the places where young people were—stores, nightclubs, schools. His days were so busy that he usually went

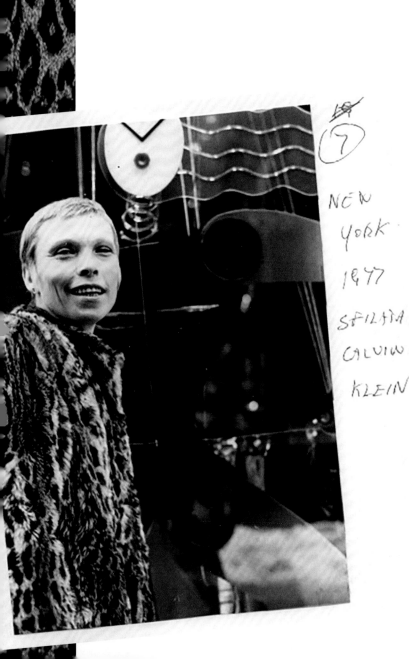

NEW
YORK
1977
SFILATA
CALVIN
KLEIN

to bed early. But, one evening, he asked to see the Continental Baths, a place frequented mainly by homosexuals; he fell asleep in the middle of Bette Midler's exuberant performance.

I took a number of trips to the United States on Fiorucci's behalf, trying to find warehouses of jeans, dungarees and other garments which Fiorucci would then adapt, color and reproduce in a more creative way. One thing that stands out is the trip to South Africa to buy beads for a summer clothing collection, and the ones to India, Hong Kong, Taiwan, Thailand, the Philippines and Japan. I sent samples of local products from everywhere, which provided inspiration for new collections.

In 1976, Fiorucci told me he'd been invited to meet with Marvin Traub, the president of Bloomingdale's, and he asked me to set it up. We met in Traub's office, and he came straight to the point: he wanted to open a Fiorucci space in his department store. Elio asked for time to think about it, and he soon decided to open a store in New York. It was to be located in the Parisian restaurant Le Notre, which had closed, between 59th Street and Lexington Avenue, practically next door to Bloomingdale's.

I took care of negotiations with the landlord and communication with the American architect who would do the design—along with the Italian architects Ettore Sottsass, Andrea Branzi, and Franco Marabelli—and relations with the construction companies, who were constantly threatening to stop work because the money was late coming from Italy. I was also involved in choosing the manager. Finally, on April 25, 1976, the Fiorucci store opened, and quickly won the hearts of New Yorkers.

After the opening, my dealings with Fiorucci tailed off and eventually stopped. I didn't want to be involved in the management, and in any case the buying was now done in-house.

My professional and personal relationship with Elio Fiorucci was one of the important moments in my life. I've always been grateful for the trust he placed in me and the opportunity to travel all over the world in search of ideas and objects that were unusual, creative and borderline surreal.

JUAN SALVADO

Worked in the style office for several years and later
founded Moschino with Franco Moschino

A friend of mine who worked as a designer at Fiorucci had told
me they were looking for stylists and designers, so I went for
an interview with Cristina Rossi, head of the style office. Not
knowing how people dressed there, I decided to wear a suit for
the occasion, and I borrowed some clothes from friends. Classic
but high quality: a Dior coat, a shirt from Albini, a Basile jacket,
pants and necktie from Lanvin. I presented my work and was
told I could start the very next day. That was a surprise, but I
said no, although I was free. But I said I could start at the end of
the month. I didn't have a desk, and my workplace was next to
the samples room, with a bar table and fruit box where I kept
my pencils and other things. In the style office I worked with
Tito Pastore, Mirella Landi, Rini van Vonderen, Eliette Lamar,
Cristina Bagnoli, Patrizia Rotondo, Pupi Solari, the coordinator
Lorella Colacicco and Cristina's secretary Vittoria Lombardini. I
was given great books with leftover fabrics and told to see what
could be done with the offcuts.

There were 4,000 meters of white poplin with black stripes. I had
it dyed in different colors—red, yellow, green and purple—and
created a mini collection, mixing up the colors. As a Spaniard,
I took inspiration from my country, partly because Yves Saint
Laurent had done a collection inspired by Spain. The collection
went into the Galleria Passarella store one morning, and sold
out immediately. They repeated it, using all the fabric.

I used many fabrics from the warehouse to create various col-
lections, and my trial period was extremely positive: a month
later I was hired. I traveled a lot to research fabrics and super-
vised the collections made in India. I also did some collections
in Hong Kong: Salvo Moschella, who coordinated manufactur-
ing, had his offices there.

Working at Fiorucci was a fantastic learning experience. There
was plenty of freedom and creativity. I met a lot of people who
are still my friends today.

I wasn't close to Elio, but I admired him greatly for the revolu-
tion that was solely due to him and his magnetic personality.

PHOTO FABREGAS GOMIS DIMAS

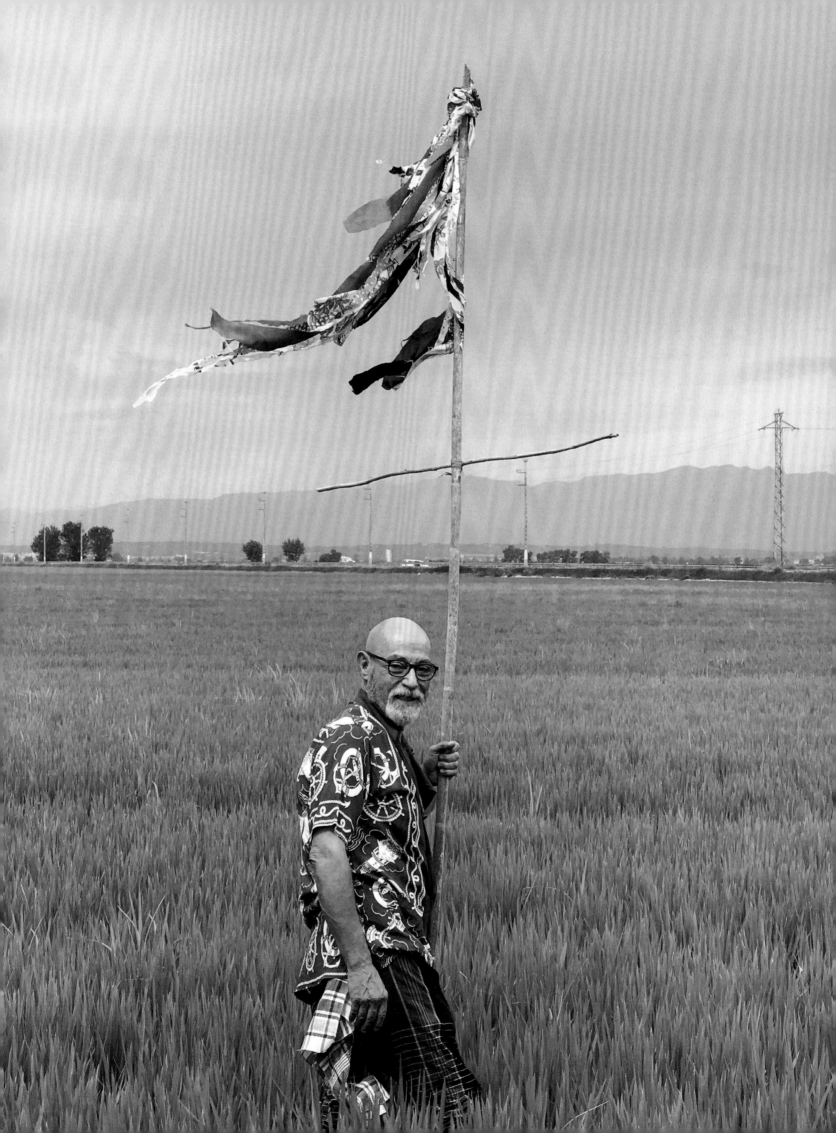

SALVO MOSCHELLA
Head of imports

I met Elio under strange circumstances. In 1970, I was deputy head of customs at Linate airport. Every two weeks, always on a Sunday, the customs officers brought to my office this polite man who arrived from London with his partner Cristina. They carried enormous suitcases and canvas bags: their "loot." When we opened them they were full of all kinds of clothing, all colorful and unconventional. In the 1970s, Italy was still very traditional and often snobbish: in normal terms, the clothes Elio was bringing to Milan were just rags. The customs duties were paid after long waits, and this man, always smiling, would leave my office satisfied and with a spring in his step. One day I asked him why he didn't plan things in a more conventional way. To import goods, you just needed to order them abroad and wait for them to be flown over. Elio smiled and said: "But going around the stores in London is the best part. Seeing what they're displaying and how, the smells, the excitement I see in the streets; all that I want to give my customers in San Babila, and most of all I want those who come into my store to be excited." Elio was the first to understand the atmosphere of Swinging London and recreate it naturally and simply. He took all that and turned it into a way of life right in the center of Milan. His intuition was spot-on, and San Babila quickly became the heart of this excitement in Italy, which didn't stop at ever-changing goods or simple fashion, but pervaded communication, advertising, the decor and art of the stores.

Elio also told me something else: "I don't want to be seen as cheating the system. I want to comply with the conventional import systems. It's just that I need to move faster, partly because I have another idea: to expand the research I do in London to the whole world. I need an expert to help me with that, so that everything can be brought in quickly and legally. Are you available?" It was a shock. He was asking me to quit my job and work for him. He was a sweet, courteous person, and the way he talked about his dreams won me over. But I was a guy from the south with a secure job... I agreed. He sent me to London to learn English, and, two months later, I was in San Babila, which was the hub of energy, people, ideas and goods: initially just clothing, but later much more. New things arrived from somewhere in the world almost every week. Very early on, Elio had anticipated a strategy that, 25 years later, would be successful for Amancio Ortega of Inditex-Zara: speed up the flow of goods to the store and always offer customers something new so they keep coming back for more.

One of my first trips with Elio was to New York. Both of us could just about get by in English, but we managed to make a great deal: we bought a million meters of denim to be cut,

shaped and stitched into Fiorucci jeans, designed specifically for women. It was the first and most powerful image the brand gave of itself. In New York I discovered that Elio didn't just import clothes from the places he visited. He observed the people and their behavior; he tried to find everything that was different and outside the box.

I started to travel around the world with him, Cristina Rossi, Mirella Landi, Mirella Clemencigh, Juan Salvado, Franco Marabelli, and others.

I have one special memory of Elio, and the idea he had when he heard, in 1973, that the Russians were supporting the Afghan revolution and the removal of the king. At that point, the Russians began trade with Afghanistan, importing opium for the pharmaceutical sector and paying for it with cotton fabrics with gorgeous floral prints. Elio sent me, Cristina Rossi and Mirella Landi to Kabul. And there we began the production of patchwork garments—more out of necessity than choice, because the panels were 90 centimeters wide, so to make a dress or a skirt we had to sew the fabrics together. We also began importing braided leather belts, and we were among the first to import kilim rugs; I'll never forget our meetings with the heads of the various tribes. Of all the trips we took, that one to Afghanistan has stayed with me the most.

Travel was a great source of inspiration for Elio. He had one of his most important ideas in 1976 in Hong Kong, which in those days, was the gateway to China. Elio had been invited as the guest of honor and to chair the jury of the "HK Young Designer Contest," during the first big event held in the industry—"Hong Kong – Ready to Wear." I went with him, and Elio truly realized the potential of that culture, and China in particular.

He decided to open an office—the first Italian one, and among the first in the world—to start new research and develop the market. I was sent to run it and the first imports began: embroidered shirts in linen and silk, then Hawaiian shirts and bomber jackets, and countless other products, At the same time, several stores were opened: Hong Kong, Manila and Tokyo.

By the 1980s, Fiorucci had many stores all over the world. It was a network created by an intuitive pioneer, a bold philanthropist; anyone who knew Elio will tell you about his incredible ability to engage and involve young people from all backgrounds and cultures in his adventures.

Although Elio never taught in a conventional sense; he never said "do this," but he gave you an idea, a starting point, and then left each person to develop with their own imagination, abilities and mistakes.

TRAY. FIORUCCI GRAPHICS DEPARTMENT.

NADIA BARONI

Wife of Enrico Baroni, the first store manager
at San Babila, Milan

My husband started working at Fiorucci in the 1960s. At that time, Fiorucci was an innovative cultural revolution for everyone. Enrico managed the store with passion because he shared this spirit; he also collaborated with Elio in researching clothes and other things. This was in 1967–68. In those days, Elio's mom, Argentina, was at the register. She was a cordial lady. There wasn't much space: shoes were in the basement and clothes (which Fiorucci sourced in London, *ed.*) on the mezzanine. It was the age of the Beatles, Mary Quant, Biba… A time of disruption and radical change. When they realized they were selling more clothes than shoes, Enrico and Elio decided to move the clothes downstairs near the entrance. Sales went so well that there weren't enough assistants. Enrico selected them, choosing beautiful women who were all special, but there were also older women, even retired. In response to an ad in the paper, a hundred women turned up: all different, some with heavy makeup and others without, gray-haired women and classy women. Five were hired, and they were really something else because they competed to see who could sell the most. They always treated customers politely, and their strength lay in their great patience. These lovely and distinguished ladies were forever grateful to Enrico and Mr. Fiorucci, because the job gave their lives meaning.
Even Franco Moschino worked as a sales assistant at Fiorucci for a short time; but he wasn't very friendly, and Elio told him he wasn't suited to that type of work and he should find something else to do, which he did! Fashion people and celebrities—some international—often came to the store. Audrey Hepburn, Jane Birkin, Catherine Deneuve, Monica Vitti, Renato Zero, Mariangela Melato, Elsa Martinelli… When Enrico died, Renato Zero was very kind, he called me and told me my husband was a special person. He was very important for the store. And he had a wonderful friendship with Elio.

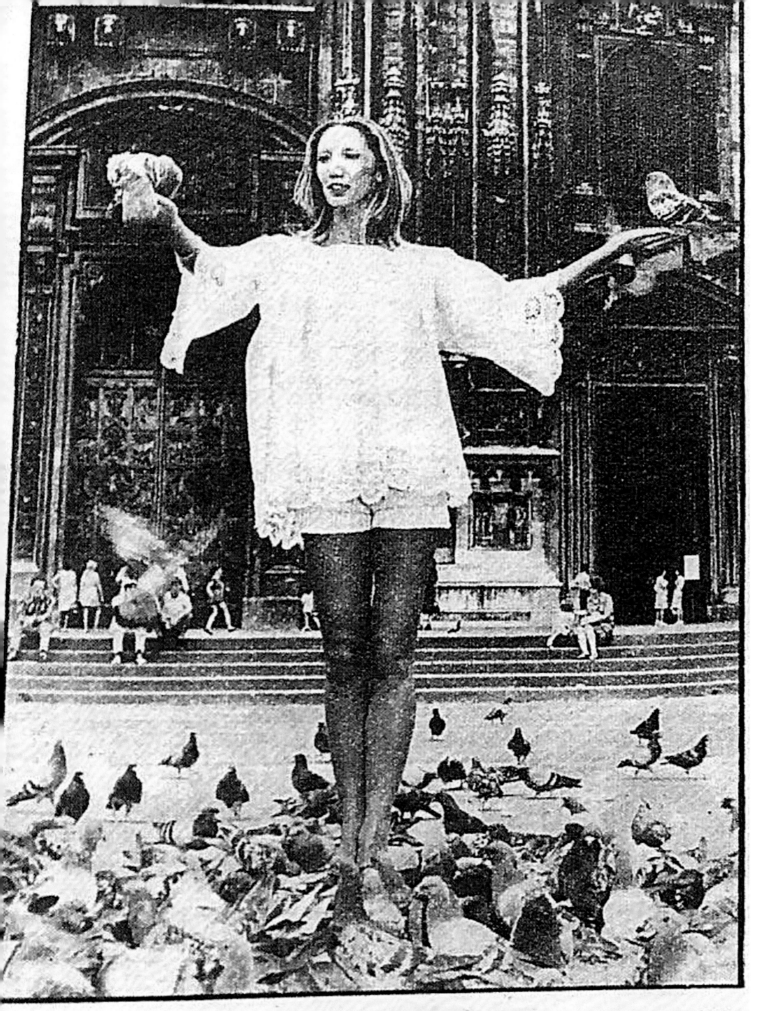

ECCO LA "CHIERICHETTA" Milano.
tra le
rime ad adottare la nuova moda «a chierichetto». Eccola
n indosso un'autentica tunica da chierichetto su hot-pants.

PHIC
VER

GRAPHICS ENT Department

Carlo Pignagnoli

Augusto Vignali

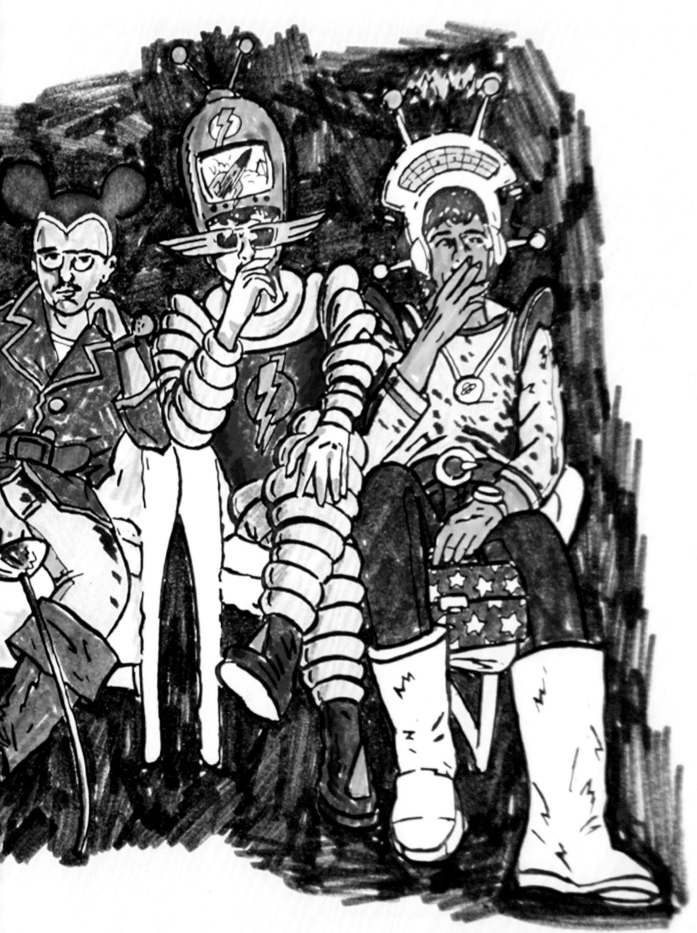

Sauro Mainardi Guglielmo Pelizzoni

DESIGN BY AUGUSTO VIGNALI.

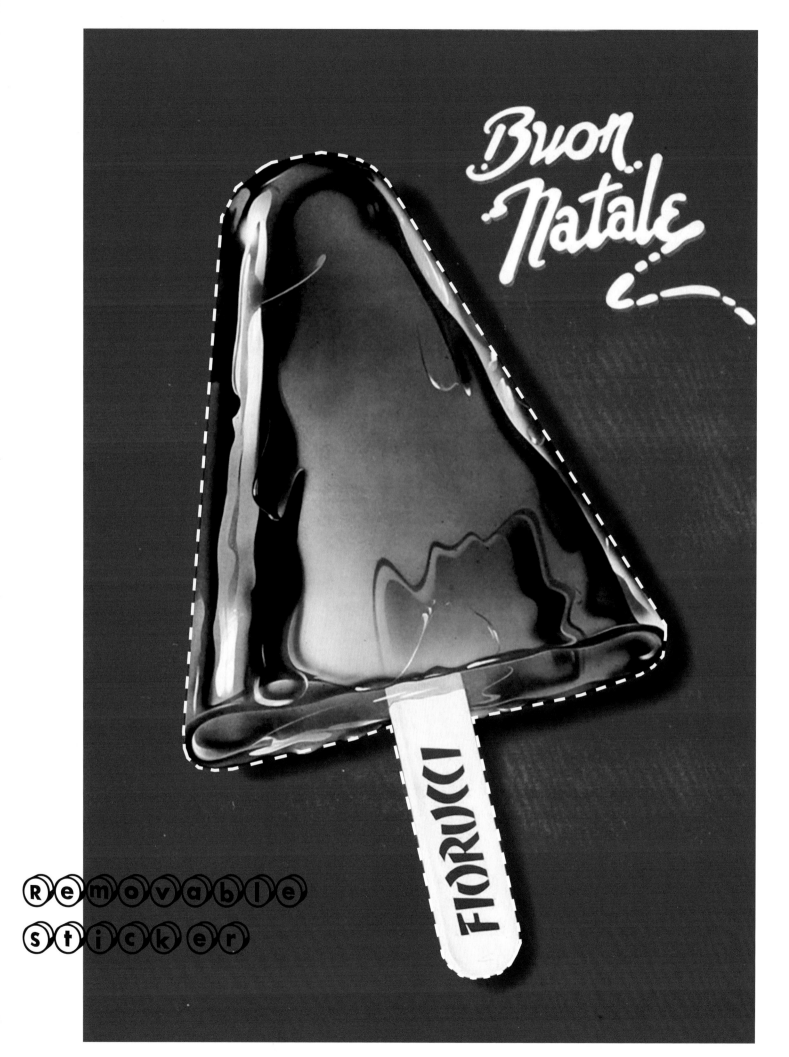

Augusto Vignali

Guglielmo Pelizzoni

Carlo Pignagnoli

The graphics department consisted of young guys from Parma. The first to arrive was Sauro Mainardi, who Elio entrusted to me, asking me to show him the world to broaden his horizons. We traveled together and that inspired him a lot, so he began working at Fiorucci. He was joined by a series of friends: Carlo Pignagnoli, Vittorio Spaggiari aka Spago, Guglielmo Pelizzoni, Augusto Vignali and another guy who wasn't from Parma, Maurizio Turchet. Their way of creating was instinctive: they'd do everything on the basis of their own taste and then present it to Elio, who valued their free-wheeling methods.
F. M.

At Fiorucci the graphic design work was nonstop: posters, stickers, postcards, Panini trading cards, Stiassi notebooks and diaries, Sperlari candy wrappers, labels for garments, jeans and pants, designs for T-shirts, price tags, shopping bags, boxes, plates, cups, sales points, scales, matches, Fiorucci Time watches, Metalflex displays and glasses cases, fragrances, beauty products, business cards, magazines, motorcycle helmets and so much more...

AUGUSTO VIGNALI

Graphic designer

I met Elio Fiorucci in 1974 through Sauro Mainardi, who was already working at Galleria Passarella with Carlo Pignagnoli. It was like meeting some kind of alien, but I discovered he was a really nice person and, because I was also a bit of a clown, we got on well from the start. I was twenty-five years old. In the beginning, I commuted from Parma, and I was in good company, because on the train to Milan, I also saw Guglielmo Pelizzoni, who worked at *Vogue*, and Alberto Nodolini, who was the editor. Guglielmo was later won over by Fiorucci and joined our team, along with Vittorio Spaggiari and Maurizio Turchet.

The atmosphere in the department was somewhat strange, but there was no aggressiveness, although sometimes our ideas differed. In terms of the image, there were no campaigns to develop, and no strategies. Carlo Branzaglia, a professor from Bologna, called us graphic designers at Fiorucci "creators of uncoordinated image." Our graphics were the opposite of all the logic and strategy of communications agencies, which tend to have an always recognizable brand and a corporate image. We were constantly changing the direction of the image and the logo. The graphic designers were the planners of everything: letterhead, stickers, garment labels, jeans labels, posters, shopping bags and everything needed for communication. In fact, I'd say that was actually Elio Fiorucci's style of communication: he never used conventional channels, in the sense that he never placed ads in newspapers; it was the papers who came to him, because he was always available and happy to talk to them.

At one point, Andrea Branzi showed up, but he wasn't with us for long. Fiorucci had given him the job of art director. Later on, that role was taken by Vittorio Spaggiari, who was responsible for some of the important graphic designs. We also worked with Terry Jones, on the project of the Panini trading cards.

While we were there, some Japanese magazines, including one called *Brutus*, published articles about our work at Fiorucci. Then there were the journalists from *100 Idées*, who came to Milan to do a special on Fiorucci, the *Europeo*, which did a feature about Fiorucci and us... There was plenty of press attention; I think Fiorucci had piqued the interest of the press all over the world.

I remember a funny story, when Elio got mad because I'd designed a poster made of a collage of postcards. The poster went to England too, and there it caused problems: I'd used an image of Queen Elizabeth with a tin of Simmenthal corned beef in her lap. I didn't know whether Elio was really angry or secretly very amused by that.

My experience with Elio was wonderful. Above all, there was this freedom thing. You could do what you wanted and felt, using all the images you liked, often without any logical sense, and it all came together in a consistent result. Elio very rarely interfered. He gave the graphics department complete freedom, because he knew it would work better that way, than by having meetings every week.

SHOPPING BAG.
FIORUCCI
GRAPHICS
DEPARTMENT.

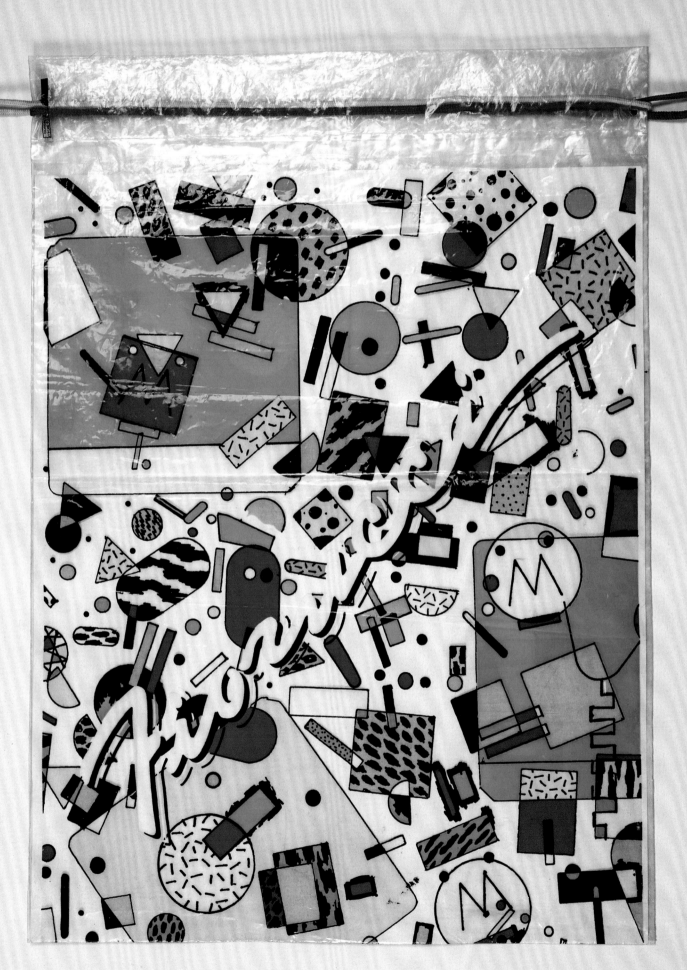

L'EUROPEO – DECEMBER 15, 1984

LOOK/HOW THE FIORUCCI IMAGE WAS BORN

With sex and plagiarism. Four guys from Parma and a debaucherous designer: this is the team that marked an era in fashion history. Now an album of trading cards is rekindling interest in them. We went to ask them: How did you do it? Simple...

by Manuela Grassi

"Fiorucci would arrive and place on the table the things he'd picked up: photos, books, objects. He encouraged us to work with them, reinvent them," says Sauro Mainardi. "Just as the fashions ironically echoed past years, we did the same with the graphics."

The benchmarks are ambitious. There's Kandinsky, of course; and most of all there's the pop art of Allen Jones, Lichtenstein and Peter Phillips, the Englishman who paints sections of engines with pinup legs sticking out; there are the acid colors of Andy Warhol. Thinking about Allen Jones's pinups, the guys took an unknown underwear model, Lory Del Santo, dressed her in fluorescent jumpsuits and had her photographed tripping about on a black-and-white chessboard; the same girl seems to be many different girls: one, two, three, four... there was a touch of irony about the myths of eroticism, but there was also a healthy dose of eroticism plain and simple. That one was given the go-ahead by Elio Fiorucci in person.

"References to sexuality and eroticism were always a thing with Fiorucci," Sauro says. 'Guys, let's see a backside, make it more appealing,' he'd say. And for two years, he followed us around with a book whose cover showed a woman seen from the back, with a magnificent bare ass. 'This is what you should be doing,' he told us, smacking the cover with his hand. We obeyed because essentially we agreed with him. But every so often, we tried to something different. For Christmas 1979, for example, in our great efforts to produce something new, we came up with the mint-green Popsicle on a dark red background, a classic Fiorucci poster. But Elio was never completely convinced by it." His response wasn't long in coming: he commissioned Oliviero Toscani, a photographer with an eye for the explicit, to create another Christmas poster, guaranteed to scandalize Catholics: Santa Claus seen from the back as he straddles an attractive naked girl. And on he went, always provocative.

POSTER BY THE GRAPHICS DEPARTMENT: THE MODEL LORY DEL SANTO IS SEEN IN A SERIES OF LYCRA BODYSUITS. PHOTO ATTILIO CONCARI.

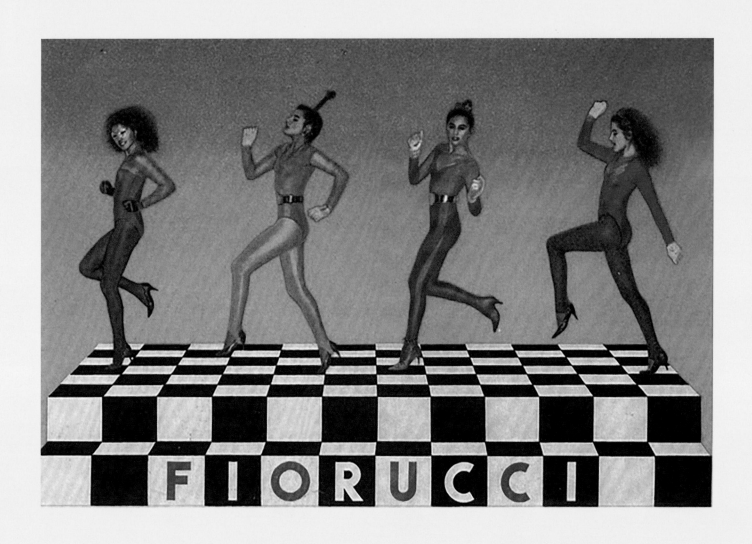

"SPAGO" VITTORIO SPAGGIARI

Graphic designer and art director

PHOTO FRANCO MARABELLI

Graphic designer and art director of the graphics department for a brief period, later head of the style office with Sara Nannicini.

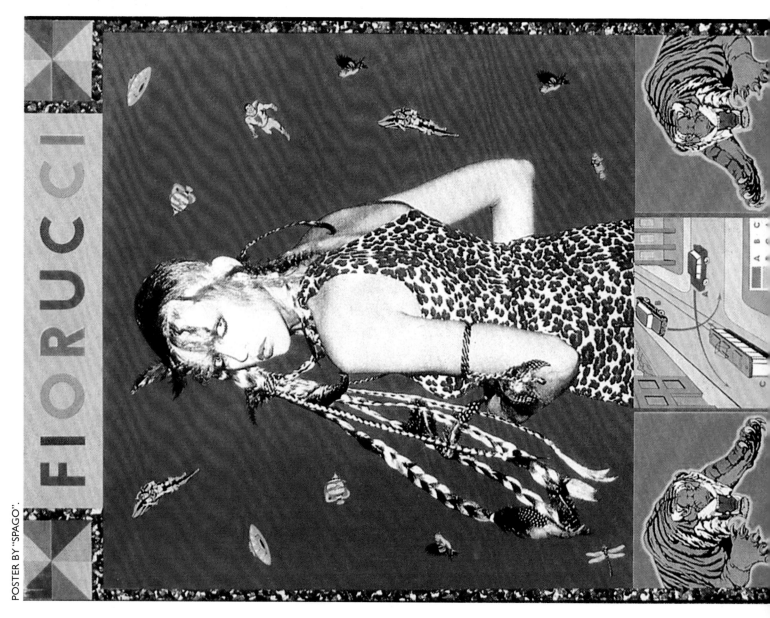

POSTER BY "SPAGO".

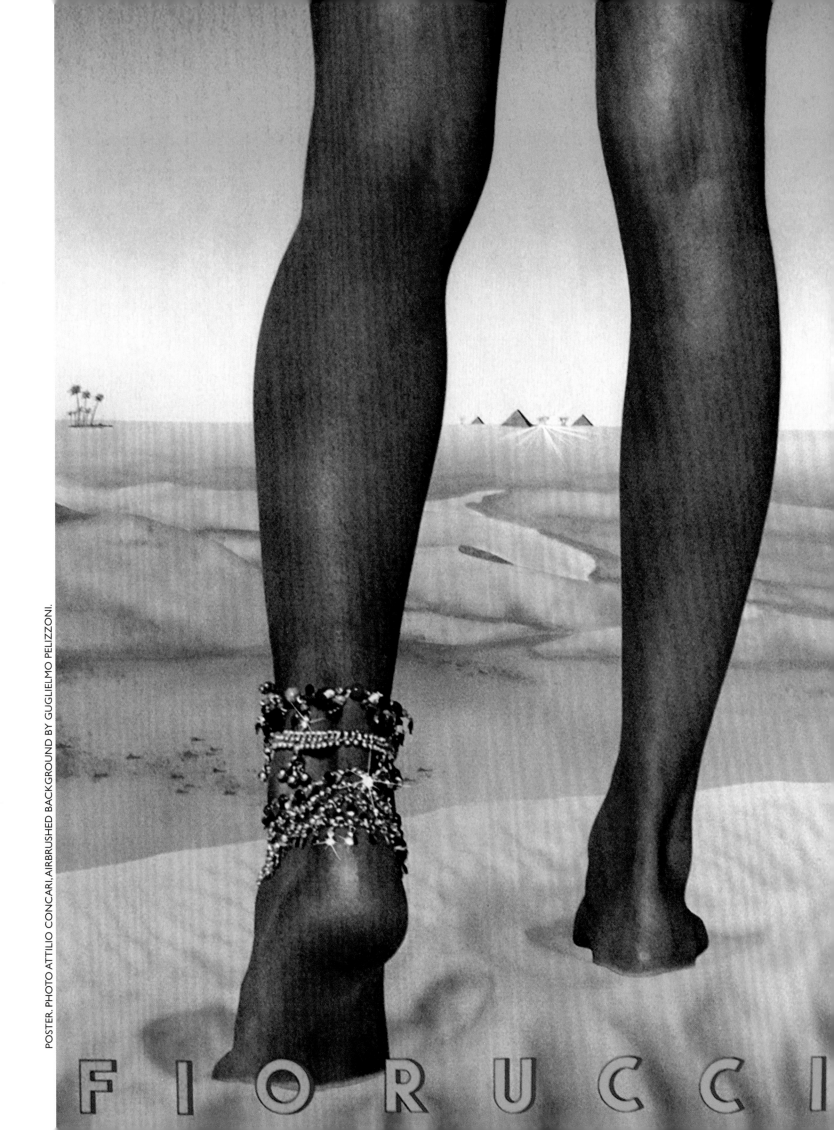

FIORUCCI

MAURIZIO TURCHET

Graphic designer at Fiorucci

Elio had all the charisma of someone who had founded an important business and made it his life's work, but he treated people as equals and as friends, with warmth. In the graphics department, we were trusted and free to do our work; he intervened very rarely, just to remind us that "Fiorucci means joie de vivre." That was his philosophy, and we had to abide by it.

In 2013, I had the joy and privilege of being invited by Nicoletta Branzi and Matteo Guarnaccia to introduce Elio Fiorucci at NABA—the New Academy of Fine Arts in Milan. The auditorium was packed with young people. I hadn't seen Elio for many years, and it was really moving to remember episodes in his life we'd experienced together, and others I hadn't been involved in. One of them was his meeting with Andy Warhol. He told me he felt intimidated when he found himself face to face with the artist he admired more than any other. Warhol said nothing, which was the norm for him. Finally Elio plucked up the courage to break the embarrassing silence and told him that despite being so modern, Warhol's work reminded him of the classics; then he felt this was inappropriate. Warhol didn't reply at the time, but, at a later meeting, he invited Elio to breakfast at his house, which was full of classical paintings. Warhol confirmed Elio's observation and added that until then nobody had noticed the importance of his relationship with classical art. Elio wasn't just intelligent; Elio was a genius, and like all great geniuses he had the gift of "not knowing."

After the talk at NABA, I didn't see Elio again. I attended his funeral a few years later. The church of San Carlo, opposite the former store in Galleria Passarella, was packed with friends, citizens and ordinary people, but what was striking was the absence of celebrities, particularly the most famous designers; some of them had sent their PR people to represent them, out of politeness. I wasn't surprised. Elio had created that world but he wasn't part of it.

Fiorucci was a wonderful adventure that left its mark on history, lifestyles and society, and we're still seeing its legacy today. It's a privilege to have been a part of it.

FIORUCCI

MAURIZIO TURCHET, PROTOTYPE MIRROR, 46 X 35 CM.

ITALO LUPI
Architect and designer

I met Elio at his office in Piazza San Babila. I immediately felt a great bond and a sense of kinship with him, and I think I can say without conceit that he felt the same toward me. I was amazed that a famous man like him, someone who still strikes me as a shining example of generosity and intelligence, was willing to meet me. I couldn't say who put us in touch. Perhaps because in those days there weren't many of us in the field, so it was word of mouth. I remember that, at the time, I was working with the photographer Maria Vittoria Backhaus, a great friend of Mirella Clemencigh, who did the settings for photo shoots and collaborated with *Vogue* and *Elle*. Maybe it was Mirella who mentioned me to Fiorucci.

I think Elio was curious about some of the projects I'd done as a young graphic designer; I was already working as art director for the magazine *Abitare*. One day he invited me to go and see him; I was really excited because I knew very well how good he was: he wasn't inexperienced, his brand didn't yet have a logo, but his graphics were really strong and really well-known to me. He was a bit like the guru we all looked to for inspiration. When I showed him my work—some of which, looking back, was not exactly fabulous—he seemed very interested. He asked me to work on some characters, hand-drawn sketches, ideas that were innovative and new for the time. I followed his suggestions excitedly, until the pivotal moment when I came up with the angel logo. I was fascinated by the uninhibited women in the photos of the Fiorucci catalogs and by the philosophy behind his fashion revolution, so I suggested to Mirella that we go for something completely different, the opposite direction to Fiorucci's campaigns, with the image of two little Victorian angels, "contrasting Victorian angels." I had quite a lot of material with those types of themes. I've owned a house in London for over forty years and, in any case, I liked being a nonconformist. I'm always a little hesitant to say the angels are mine, because the logo is, but all the interpretations and updates have been done by other designers: Sauro Mainardi, Carlo Pignagnoli, Guglielmo Pelizzoni, Augusto Vignali, Vittorio Spaggiari, and Maurizio Turchet.

I kept in touch with Elio over the years, and we'd see each other at social gatherings. Whenever I saw him, I was always touched by his kindness and amiability. I still remember how open he was when he looked at my designs. Compared to him I felt like a child, although we were almost the same age, but at the time he was already a successful businessman, and maybe his beard made him look older. I've worked with many important clients, but Elio was special. It was obvious there was a genius inside him. To me Elio had almost similar status to my greatest inspiration, Achille Castiglioni. I began my career as an assistant to Achille's brother Pier Giacomo, and after he died I continued working with Achille, doing the graphic design for his shows. For me, the two—Achille and Elio—had a similar talent: the ability to work while having fun. It was wonderful to have fun at work, and we were very lucky to have clients who were always really nice.

DESIGNS
PRESENTED
TO ELIO BUT NOT
EXECUTED.

CAPPELLO

SCIARPE

Intimi

GONNA

CALZE

SCARPE

I USE ONLY
FIORUCCI

PIN-UP
CALENDARIO

FIORUCCI
Bagni vittoriani in
contrasto

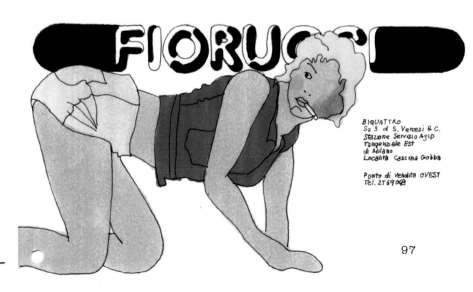

BIQUATTRO
Sa S di S. Vercesi & C.
Stazione Servizio Agip
Tangenziale Est
di Milano
Località Cascina Gobba

Punto di vendita OVEST
Tel. 2569068

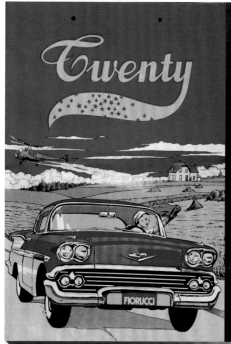

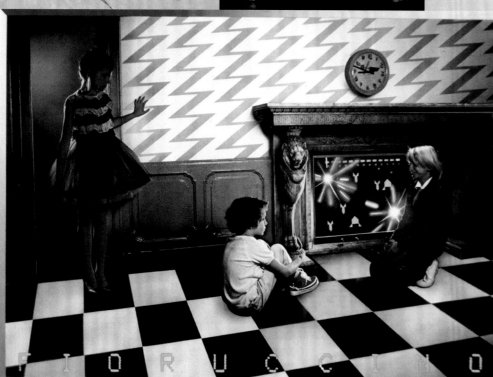

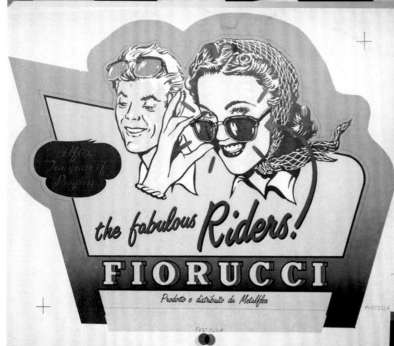

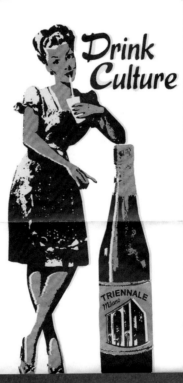
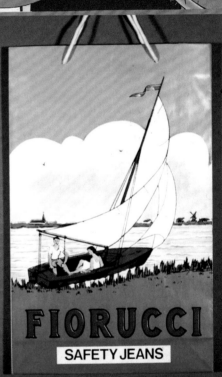

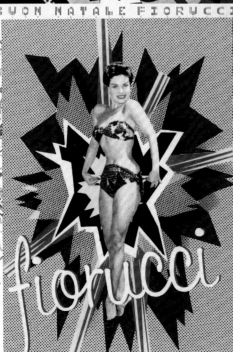
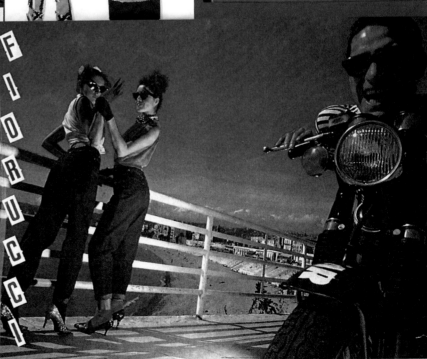

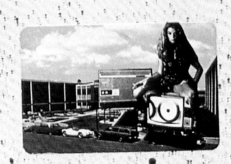

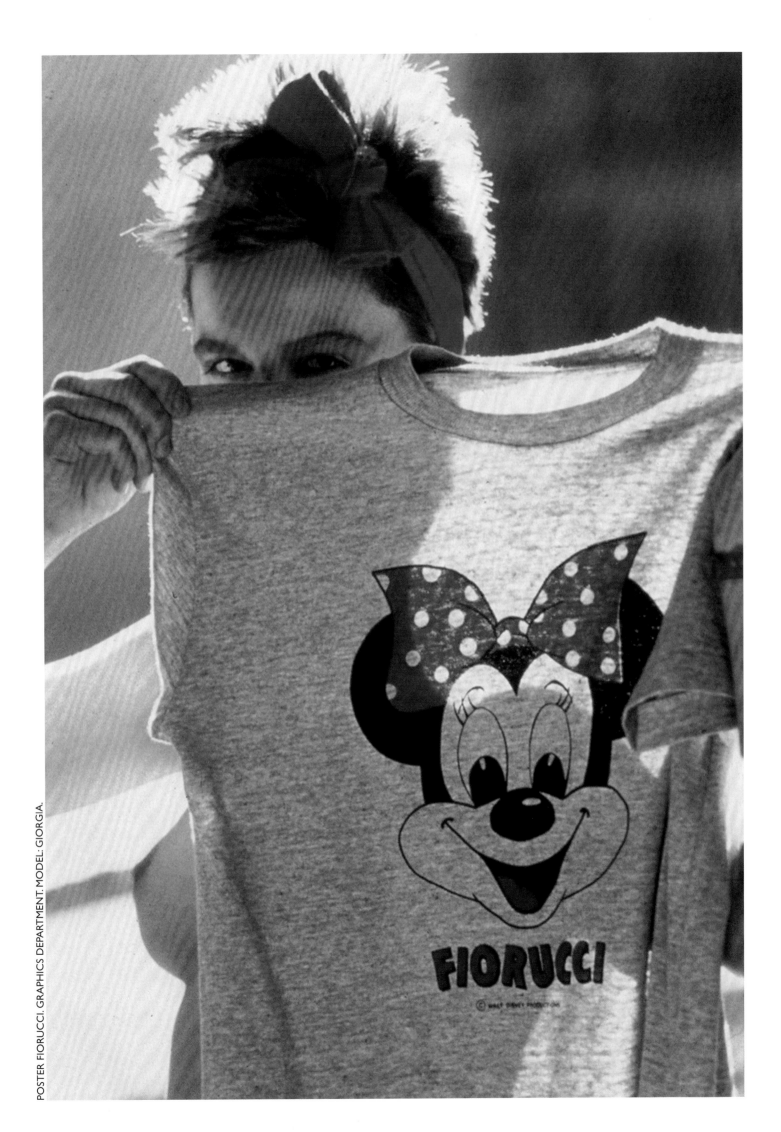

OCEANO b	BANDIERA e	ROSSO r	GREGGIO x
BIANCO n	CELESTE j	TURCHESE s	VIOLA i
GERANIO r3	PERLA p	ROSA a1	ALBICOCCA l
CARMINIO r4	CANARINO g6	NERO z	ROSA TEA a9
VERDE MING v7	BLUETTE u	PORCELLANA σ	TERRA DI SIENA β
VERDONE v8	ACQUA f	GIALLO g	COBALTO y
ELETTRICO c	COPIATIVO t	VERDE v	SHOCKING a0
SOLE w	PETUNIA a5	SCARLATTO k	ARANCIO o
FUXIA d	MARASCA h	GRIGIO m	ROSA LACCA a2

PHOTO ATTILIO CONCARI
ART DIRECTOR FRANCO MARABELLI
FASHION COORDINATOR KARLA OTTO
GRAPHIC PROJECT MARCO ZANINI MARCO MARABELLI - SOTTSASS ASSOCIATI

FIORUCCI INC 127 EAST 59(TH) STREET NEW YORK N.Y.10022

PHONE 212-7511404 TELEX 7105816032 FIORUCCINYK

Fall/Winter 1980–81 Collection catalog, exclusive for the United States.

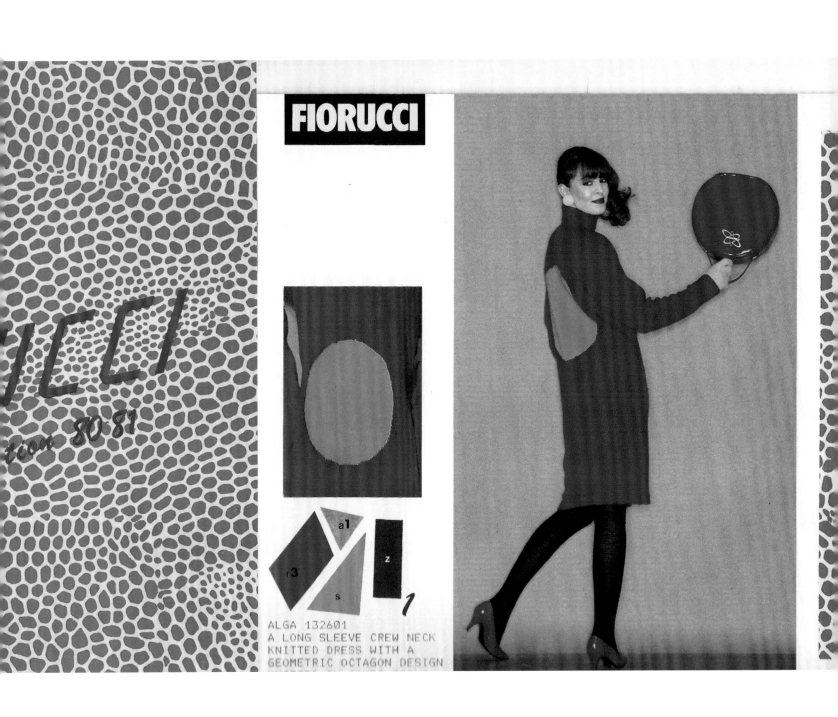

FIORUCCI

ALGA 132601
A LONG SLEEVE CREW NECK
KNITTED DRESS WITH A
GEOMETRIC OCTAGON DESIGN

stickers

Fiorucci designed the poster
and stickers.
Graphics department
Fiorucci, 1972–75.

VICTORIA AND ALBERT MUSEUM

© Crown copyright Printed in England WPL

Fiorucci carrier bag. 1978.
Screenprint
Reproduced by courtesy of Fiorucci

E.896-1978

E.220

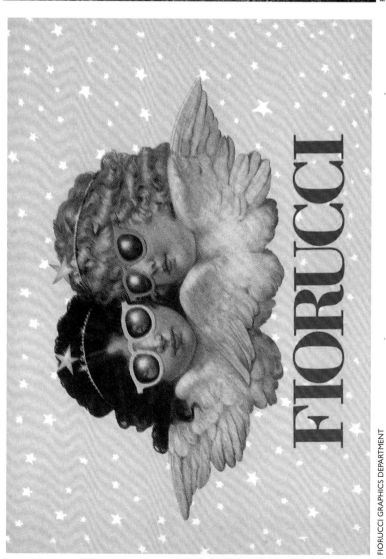

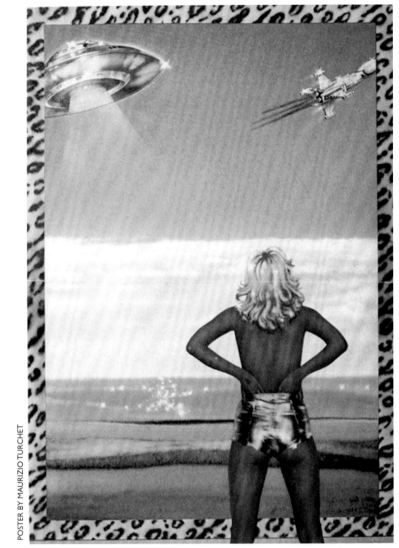

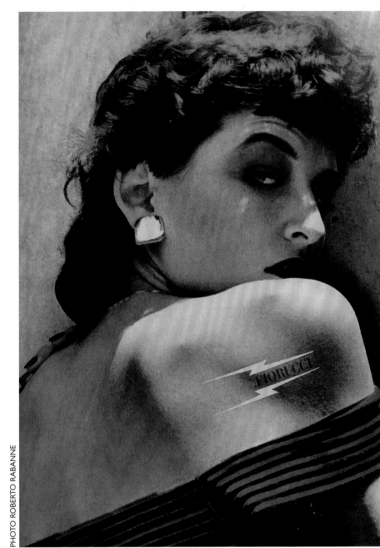

Yellow writing paper with pink computer-style pattern.
Gray envelope with white pattern. Graphics by Carlo Pignagnoli.

FIORUCCI INC. 125 EAST 59TH ST. NEW YORK, N.Y. 10022 212/751-1404 TELEX 666768 FIORUCCINY

pubbliche relazioni galleria passarella 2
20122 milano tel.792452/799649

FIORUCCI FLIGHT

Fiorucci Flight Via Giuseppe di Vittorio, 32 20094 Corsico - Milano Tel. 4482

FIORUCCI

PUBBLICHE RELAZIONI ALLESTIMENTI E GRAFICA
galleria passarella 2-20122 milano tel.792452/3/4-796666

FIORUCCI INC. 125 EAST 59TH ST. NEW YORK, N.Y. 10022

FIORUCCI

pubbliche relazioni 20122 milano galleria passerella 2 tel. 792452/799649

GALLERIA PASSERELLA 2 20122 MILANO TEL.792452/3/4-796666

I heard about Fiorucci from Paul Dyer, a colleague of Franco Marabelli's, who called me about doing an airbrush poster he'd been discussing with Fiorucci. I'd worked in a Paris studio where they used the technique, so I traveled to Milan from Amsterdam. I stayed there a month and came up with several posters, including the one of the girl in the denim hot pants, from a photo by Paul Dyer, and another for shoes.

I didn't know Elio very well, but I liked him. He seemed charming and friendly.

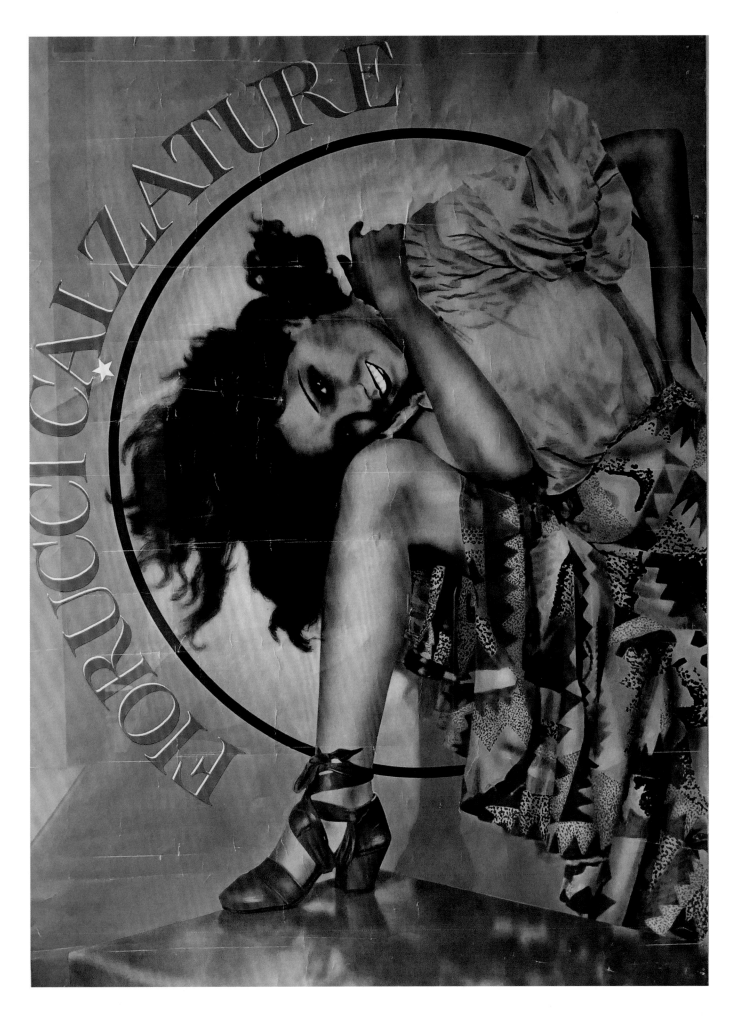

FIORUCCI CALZATURE

ECTS

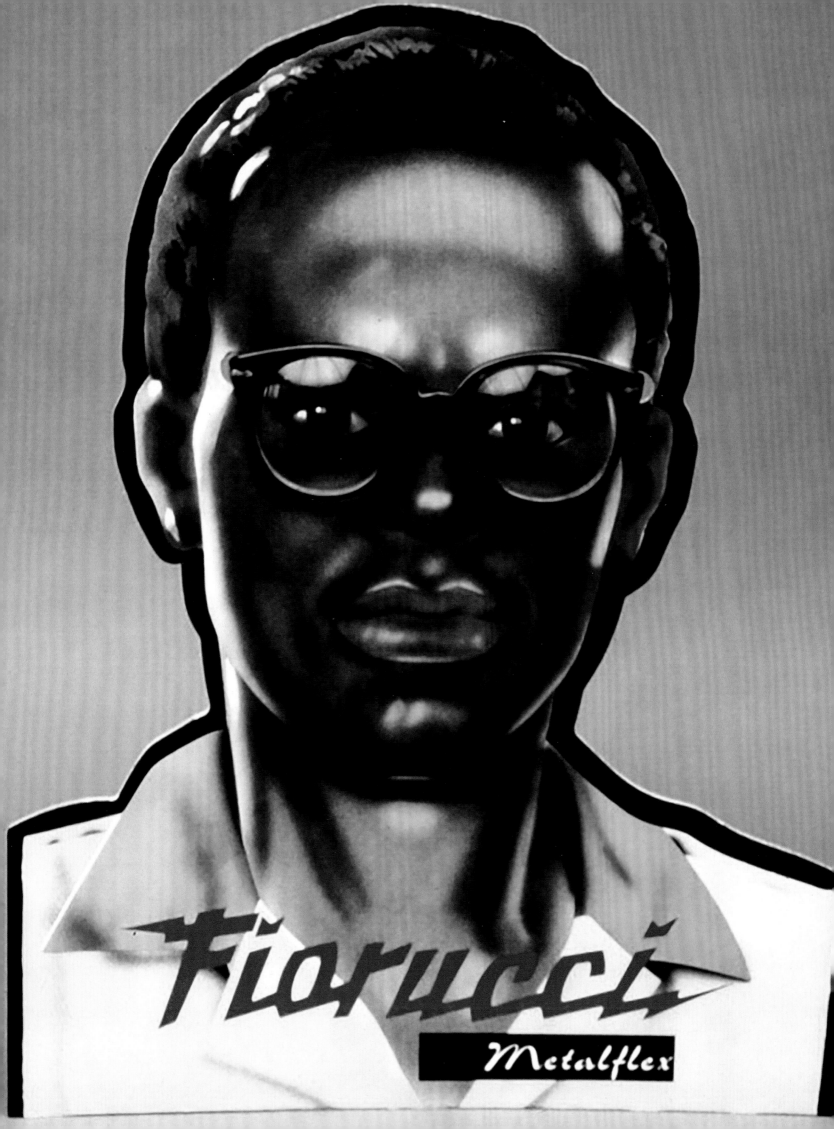

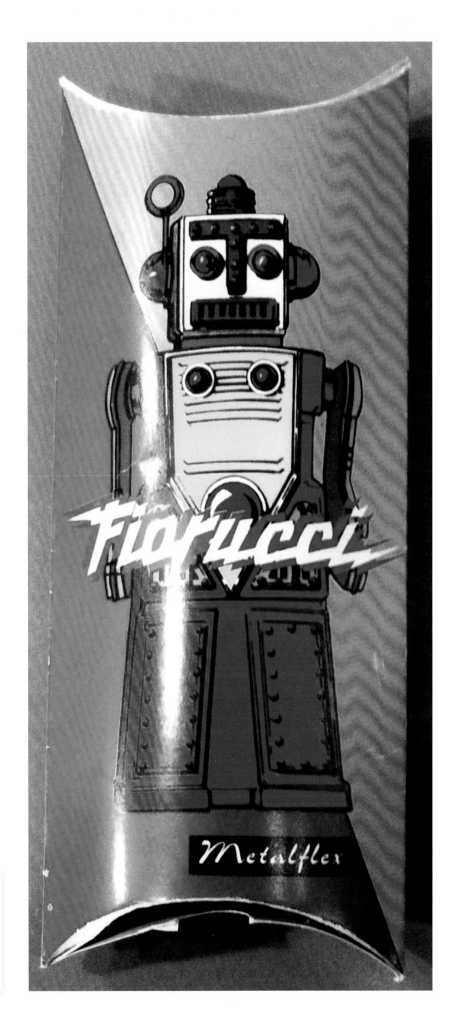

Left, Fiorucci
Metalflex display
stand for glasses.

This page,
cardboard glasses
case.

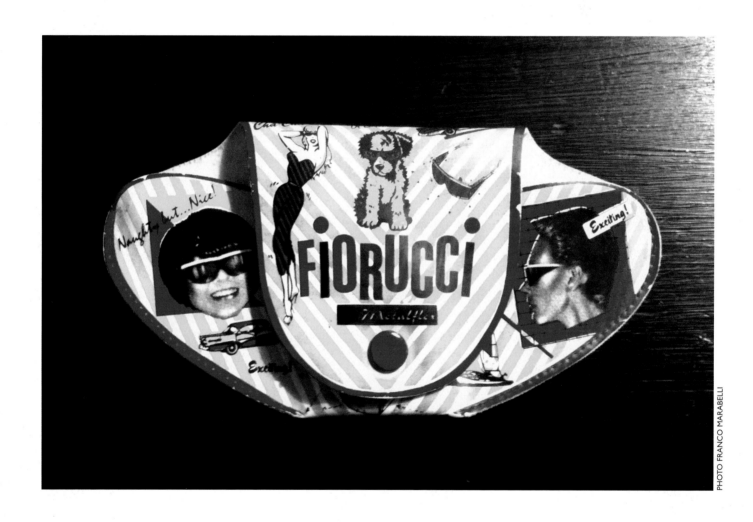

Above, Fiorucci Metalflex glasses case in plastic.
Right, cover of Fiorucci Metalflex catalog, idea by Guglielmo Pelizzoni.

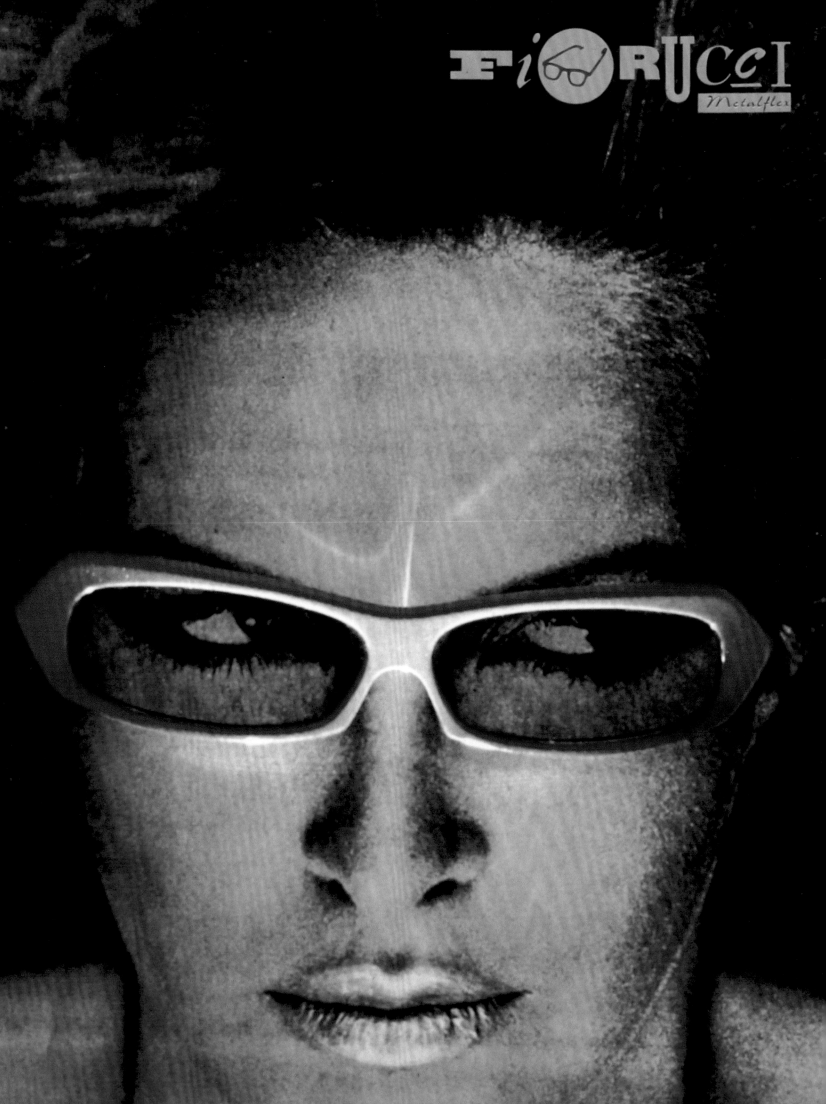

Fiorucci Time watches in fluorescent plastic.
Top right, Fiorucci Time watch in white plastic.
Bottom right, watch with metal dial and black strap, idea by Guglielmo Pelizzoni.

FIORUCCI TI:ME

Fiorucci perfume and makeup.

PHOTO PIETRO MENZIONE

128

PHOTO STEFANO BOGGIATO

OLIVIERO TOSCANI

Photographer and Elio's close friend

I started working in Milan in 1965 after finishing art school in Zurich. In 1968, my photos appeared in the first editions of *Vogue* and *Vogue Uomo* magazines, headed up by Flavio Lucchini. It was in the *Vogue* editorial offices that I met Elio Fiorucci, because he used to bring us clothes and accessories he'd found around the world, perfectly choosing what at that time was the youth counterculture of the 1960s.
We became friends immediately.
We started creating images for his brand. Posters that are famous today: the ones of Donna Jordan in the diner and with the graffiti. Or the one with the model in black leather jeans, bending over and looking between her legs...
We often met up in New York, where at least half of my work was based.
I went with Elio to the opening of Studio 54 on April 22, 1977, and he acted as my assistant to photograph the people going in. I have a lot of photos of him with various trendy people in those years.
But we didn't only meet up in New York. He often came to see me in Tuscany. He was happy at my house, and I did everything I could to please him. I installed an outdoor shower, because he liked to get clean surrounded by nature. I still use it.
We also set up a creative consultancy which is still going—it's called Cucù. He was Cu and I was Cù. We had a lot of fun.
Fashion designers and creatives all over the world should have a portrait of Elio Fiorucci on the walls of their studios. They should all know and understand why. Everyone knows it was Elio Fiorucci who started the great revolution and overturning of modern fashion, with all its cultural and economic implications. Fiorucci has been a worldwide Italian institution for more than forty years, and Elio's creative contribution was decisive in the shaping of the "Made in Italy" movement. Before him, the concept of "Made in Italy" in fashion didn't exist.

POSTER. PHOTO OLIVIERO TOSCANI

So Elio Fiorucci set the stage for the cultural and economic wealth of many designers who followed, and, consequently, of the cultural and economic wealth of Italy itself. His work was creating, designing and inventing new things that nobody had imagined before.

Elio Fiorucci gave the world's girls and women the possibility of expressing their beauty in a way that was individual, joyful and imaginative; he did the same with the objects he created and designed. Exquisite objects that still make people happy today.

Elio Fiorucci was not only a fashion designer but a modern-day sociologist. Young creatives from all over the world wanted to work with him so they could learn his philosophy and his art.

Elio Fiorucci is an artistic legacy that is part of Italy's recent history.

We had a deep friendship rooted in mutual regard and a shared desire to design the future.

We traveled together and had dinner together very frequently. He often came to see me in my Milan studio while I was shooting, then we'd go eat at the Torre di Pisa, the Vecchia Pesa or the Carbonara in Viale Bianca Maria. We often went with our sisters, his and mine. He loved Fiorentina steaks before he got into animal rights!

To me he wasn't just a friend; he was a brother who knew how to give me a hard time when I needed it. He was unique. A great man, a star with vision and imagination; a kind and sensitive man of the future. To me, he was truly a big brother.

He'd just turned eighty, and I called him on that Friday as I was traveling to Rome. The weather was gray, and he sounded a little off; his voice worried me. I called Luciano Benetton and said, "I've spoken to Elio, and he didn't sound so good. He said he'd like to see us. I'll see him Tuesday and arrange a get-together." He died on Sunday, alone. He was alone, and that makes me very sad!

Top model

Elio Fiorucci was wonderful. He hired so many young people to work with him, with fresh new ideas. He listened, and, in his stores, he created a world of fun objects... He targeted a much younger audience than the typical Italian clientele at the time. A new era and a new trend was on the scene: disco. And he ran with it, creating the crazy fashions of that period.

His vision was revolutionary and his stores became real destinations. We'll always have wonderful memories of Elio, who was, above all, a gentle and genuine man.

PHOTO CHRIS CARONE

OLIVIERO TOSCANI POSTERS WITH DONNA JORDAN, 1970–75.

132

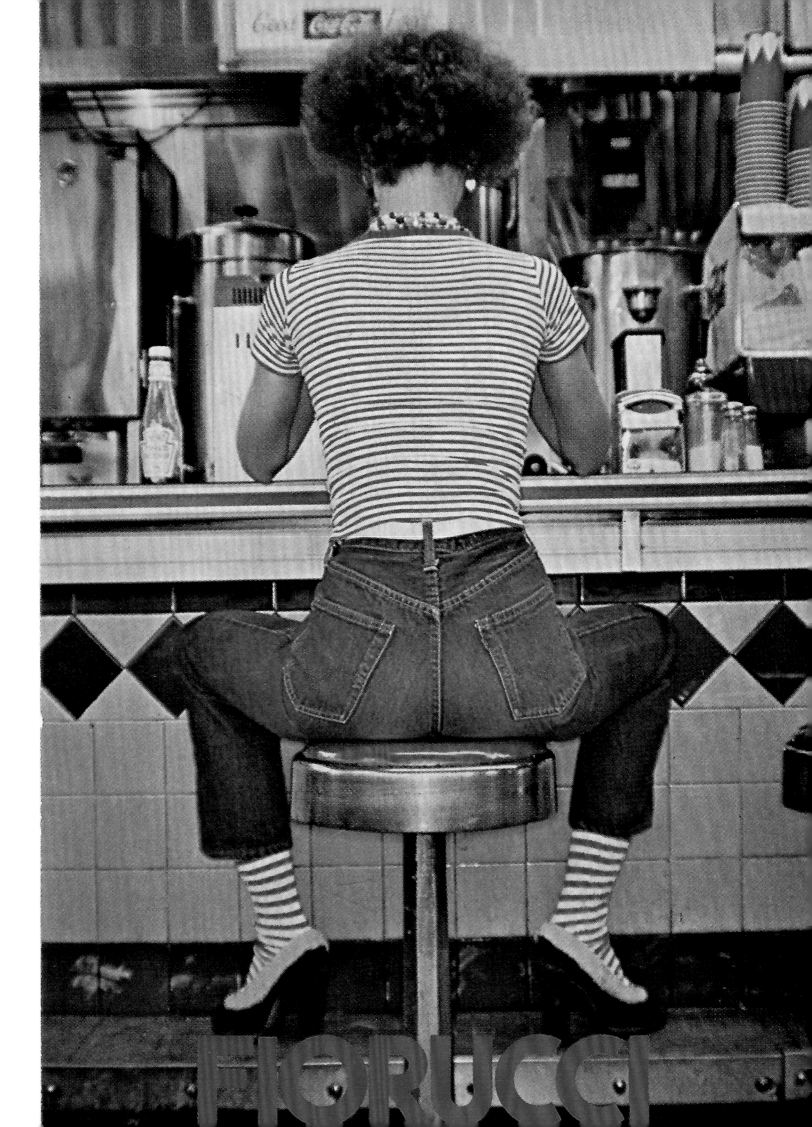

Photographer and film director

It was the early 1970s. That's when I met Elio. My girlfriend was Mirella Clemencigh, Fiorucci's designer/buyer/consultant and a friend of Elio's. She was the one who introduced us.

You couldn't tell how old he was. He was young, but he seemed older, his look was ordinary and invisible. Which was actually the case, or maybe it was the people around him, so colorful and eccentric, who made him seem that way.

His appearance was the opposite of the fashion he created. But it was his imagination that he translated into his creations: color, shape and craziness, and that's why Fiorucci "rags" became fashion, style, examples to be followed.

Africans, Americans, Japanese, straight, gay, lesbians and bisexuals: everything was taken on, shook up and transformed by Fiorucci.

The so-called "creatives" were a rabble of people who would never get on in polite society because of their way of seeing life and work—very different to the ways of "normal people."

At night, we'd have dinner in a trendy restaurant, then look for some unpopular disco to liven up with our freaky crowd's energy and desire for fun.

A look, a color, a knotted scarf, some makeup. They told us the world was our oyster and we were in the right place.

We drank, smoked and talked about what was going on at that very moment in New York City or San Francisco, or in remote villages in South America or Tibet, because for Fiorucci the world was globalized in the sense of feeling like a citizen of the planet wherever you found yourself.

Fiorucci was a magnet for brilliant people from all over the place.

Sometimes his studio looked more like an international airport than the office of a businessman.

POSTER.
PHOTO ATTILIO
CONCARI.

MIRELLA CLEMENCIGH WORKED IN THE STYLE AND ACCESSORIES DEPARTMENT FROM THE OUTSET. SHE TRAVELED WIDELY IN SEARCH OF SAMPLES AND HAD A NOSE FOR TALENT.

FRANCA SONCINI
International talent scout and PR guru

I was a wild, rebellious girl living in the Milanese boondocks. From the age of fourteen I'd worked for a small metalworks firm, doing various jobs from laborer to general gofer. I decided to change jobs.

I replied to three jog ads, and the last one said "Fiorucci seeks secretary."

I didn't have a clue who Fiorucci was, and the only place I knew in Milan was Piazza Castello, where I went to art evening classes. I got there and the first thing I saw was the store in Galleria Passarella, with all the music and gorgeous girls in shorts and miniskirts, and I was smitten. That was in 1968. Elio Fiorucci was dressed all in dark blue, wearing a turtleneck. He was really friendly. After a ten-minute interview, I was hired. But a month later I got angry with him because he insisted on asking me for something that didn't exist, but that he thought existed, and I quit. He asked me to change my mind; he didn't want me to leave, and he got some of his family members who were working there to try and persuade me, but I was too stubborn to go back on my decision.

A couple of years later I bumped into him in Corso Vittorio Emanuele; in the meantime I'd had my daughter Sara, and I had her in a carrier. I was happy to see him and he was friendly and respectful in spite of everything. He asked me to come back and work for him. I replied that although I needed the work, my baby was too young, and I couldn't leave her. He said, "Bring her with you; we'll find a solution. There are young people in the office who'll be delighted to have a little one crawling around." No sooner said than done. A few days later my daughter and I were in the office. The person who ran the press office was leaving, and Elio asked me to replace her, even though I knew nothing about the job. He was convinced I'd be good at it. That's what he was like. If, for some reason, he liked you, even if you came from a completely different background, he'd give you a try. Although there weren't really experts in the field at that time, as everything was just getting started. But his way of choosing people was mostly based on the feelings he had about them. You might have had one kind of job (or even no job at all), and he'd give you another. HR didn't exist. In those days it was Elio himself who hired the staff.

I stayed there two years and then, as was my (in ways, bad) habit, I left again. I needed new experiences. That time, leaving was painful for me too, but I "had to" go. We stayed in touch and remained friends. Two years later he called me and offered me a job as head of the press office and coordinator of graphics, also in charge of planning and producing

DESIGN BY
GIANNINA ZEDDA.

events. My time in that job was extraordinary. We worked like crazy, but we had so much fun too.

We were all in our mid-twenties, incredibly energetic and bold. We were constantly embarking on new projects and initiatives. Elio gave us a lot of freedom and we responded with enthusiasm and loyalty. Every so often there were disagreements, especially with him. I remember I once got so angry I organized a strike!

But I have to say lucky us, to be able to express ourselves and enjoy our freedom, but also lucky Elio, to have people who could stand on their own two feet and who understood the "when, where and how" without betraying the spirit of the times and of Fiorucci. During that time the store in Via Torino opened. This was the first-ever concept store.

The restaurant was a meeting place for intellectuals, artists, singers and musicians, all very special people. I often worked right up until closing time, taking care of customers and guests, but I had the privilege of spending a lot of time with extraordinary people; I absorbed everything and "regurgitated" it.

There was so much going on: we organized an in-house series of video art works (almost impossible to find in those days), a travel agency—which actually never got started because the person meant to run it wasn't there or couldn't do it—and meanwhile we were ready to roll with the Magic Bus. Our plan was to take trips where we knew (more or less) the departure date and the route, but not the exact return date.

And with one of the graphic designers (Mizio Turchet), we held performances with Nova Musica artists, from the Cramps label. The artists were Demetrio Stratos (Area), Juan Hidalgo, Walter Marchetti and Franco Battiato.

For the first performance—it was Juan, or maybe Walter, if I remember correctly—we invited a middle-school class. The performance began with the artist hanging what looked like balloons on a string, then opening a bottle of champagne, filling up the "balloons," one by one. As they filled up, the balloons turned out to be condoms. The Fiorucci managing director was there—appointed by Montedison—and I could see by the look his eyes that he wanted to kill me, or at least fire me.

After three years, I once again gave into my "bad habit," and I left Fiorucci definitively to open my own agency.

But I never really left Elio. He was a wonderful person who changed my life.

With all my gratitude, forever in my heart, dear Elio.

PROTOTYPE PIN NEVER PRODUCED, COMMISSIONED BY FRANCO MARABELLI FROM A JAPANESE DESIGNER, NEW YORK.

PHOTO PIETRO MENZIONE

SARA SONCINI PHOTOGRAPHED BY DAVIDE MANFREDI.

142

A CHE COSA È SERVITO:

ad ottenere tutti questi Redazionali

→

FIORUCCI RELAZIONI PUBBLICHE

text by

Nora Scheller

In the text on the side, Nora Scheller, who was very young at the time, describes the days and work of the press office.
Relations with the fashion editors were extremely friendly, and their needs were prioritized. F. M.

PHOTO FRANCO MARABELLI

PERSONE:

- LA SIGNORA CEREDA CLAUDIA È ARRIVATA IL 14 GENNAIO, E SARÀ RESPON SABILE DELLA SEGRETERIA E, UFF. P.R. —

- Nora Scheller ha iniziato una corrispoundenza con Tutti coloro che ci scriveranno da Tutto Italia per acquistare i nostri prodotti, o, per avere i nostri adesivi e posters o semplicemente x dimostrare la loro simpatia. Quanto prima avremo una carta da lettere che, Sauro Mainardi studierà x questo scopo, e una macchina da scrivere con caratteri SPECIALI. NORA inoltre aiuterà Sara E Sandra nel lavoro di contatto con le REDATTRICI, ed è res ponsabile delle bolle di carico del materia le in uscito dai negozi x LE REDAZIONI.
- Rosanna Zoia Terrà in ordine il libro Fiscale ed avrà l' responsabilità del ricevimento, conTrollo BOLLE ed inoltre al megazzino di CORSICO di tutto il materiale restituito dalle redazioni

VIA VAI P.R.

- SARA E SANDRA Hanno ricevuto in Gennaio: 97 visite di redat trici.

- che hanno scelto 2055 capi.

- che PierCarlo ha consegnato alle varie sedi dei GIORNALI, oltre che ha svolgere gli altri incarichi a Lui affidati.

EMANUELA ha risposto a cen Tinaio di TELEFONATE, si è occupata del disbrigo della corrispoundenza e delle spedizio ni con CORSICO, E ha preso 105 appuntamenti.

Was in charge of foreign public relations, later becoming a world-renowned PR expert

I met Elio at the Torre di Pisa (a well-known restaurant in Milan, *ed.*). He was sitting at the next table. I was with my boyfriend and my dog, he was with his girlfriend, Cristina Rossi, and his dog. There we were, three and three. We chatted all evening, and when we left the restaurant, he told me he'd like to employ me in the PR department, to focus on the foreign press. I'd never done that work, but Elio said, "It doesn't matter, as long as you speak the languages. You know about fashion because you're a model."
In fact, this was 1979 and there weren't many people with international experience in the fashion industry. I spoke Italian, German, English and Japanese; I'd lived in Japan and started modeling when I was a student. That was my entry to the world of fashion. After that I went to Paris and Milan, but I was already wondering, "What next?" Elio's offer seemed like a good opportunity, and I accepted.
Basically Elio found me the job that would become my future career. He opened a door I'd never considered, because in those days international PR didn't exist, or at least it wasn't so well-defined.

GLASSES STICKER
DESIGNED FOR
CHRISTMAS 1972.
GRAPHICS BY
FRANCO MARABELLI.

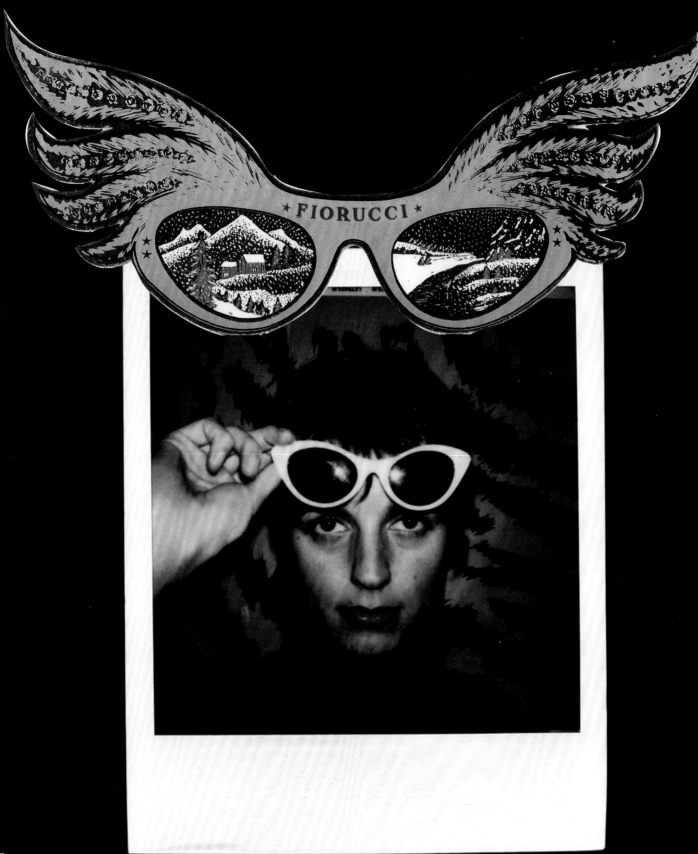

PHOTO FRANCO MARABELLI

NALLY BELLATI
Photographer

It was the artist Nino Bini who introduced me to Elio. I arrived in Milan in the summer of 1968, and I remember the song *Azzurro* by Adriano Celentano was playing in the Galleria Passarella store. There was a sense of a whole new vitality in the city. At the time, I was one of the few "Swinging London" people in Milan, and Fiorucci asked me to go to London with him to buy clothes, as his interpreter. And that was the beginning of our relationship as colleagues and friends. We were both inexperienced buyers; we bought stuff in the shops in Carnaby Street and King's Road or at Biba, not from wholesalers. And we stored the clothes in my dad's dining room, before packing them into suitcases and military rucksacks; we definitely attracted attention at the airport. When I married the photographer Manfredi Bellati in 1971, Fiorucci invited us to the Waldorf Astoria in New York for a week as a wedding present. My friend Barbara Hulanicki, who founded Biba, came too—he was a big fan of hers. He was just about to open his first store in New York. In those days we were friendly with Andy Warhol, whom we'd met at the Venice Film Festival, so we took Elio to the Factory to meet him. During those years we traveled to New York a lot... every so often Elio would call me and say "Do you want to go to New York tomorrow?" Eight or ten of us would meet up at the airport—all invited by him—and that's how I got my passion for the city that never sleeps. Among many memories of the Galleria Passarella store is how, in 1983, we'd go after dinner to see our friend Keith Haring, furiously painting his graffiti from floor to ceiling. Elio Fiorucci was a talented man who had vision and intuition, and who always had an inquisitive little smile, like a kid let loose in a toy store.

LEDA FAVALLI

After starting out as a sales assistant, Leda moved to the press office until Fiorucci closed

In 1970, I was nineteen, and I saw an ad in the *Corriere della Sera* so I applied at the Fiorucci store in San Babila for a sales assistant's job. I was interviewed by the manager, Enrico Baroni, who told me he'd get back to me.
That afternoon they called me and offered me the job, and that's how my career at Fiorucci started. It lasted until 2007. Elio Fiorucci came into the store several times a day; he asked us if we were happy working there, what items were selling best and whether any famous people had come in. We sold wedges on the mezzanine level—they were all the rage at the time. Clothes were displayed by the entrance and in the basement. When the store expanded to what used to be the night club Rayito de Oro, the clothes were separated into departments for jeans and various different areas like knitwear, jewelry, etc. In those days we also sold Biba faux fur coats. When the printed T-shirts with the angels came out, they would sell out before we could even put them on display.
Plenty of famous people used to come in, from Catherine Deneuve and Mastroianni to Romina Power and Al Bano, and Loredana Bertè, who was friends with Tito Pastore and his brother Leonardo. Then there were others like Mariangela Melato, motorcycle racer Giacomo Agostini, Isabella Biagini, Milva, Rita Pavone and Caterina Caselli. Enrico Baroni was a wonderful man who worked closely and professionally with Elio to develop the store and look after the staff. After some time in the store I was transferred to the press office, where I worked with Rosanna Zoia and Mauro Pregnolato; Elio's eldest daughter, Ersilia, worked there for a short time too.

VITTORIA LOMBARDINI

She knew everything about everyone. A trusted friend
of the Fiorucci business and family

I met Elio Fiorucci in 1972. I was working for a clothing company that had decided to fire all its staff for family and business reasons. A colleague of mine worked in textile research at Fiorucci, and she told me they were looking for people, so I went for an interview and was offered a job. I was due to start a month later, but I found out I was pregnant, so I went back to Fiorucci and asked to speak to Cristina Rossi, because I was embarrassed to discuss it with Elio. I told her everything, and she beamed at me and said, "Now we'll call Elio and tell him." Fiorucci's response was amazing, "Motherhood is the most beautiful thing in the world, so come to work now, and stay at home when your baby's born." When I left I said to my husband, who was waiting with our two children "This can't be Earth. We must be on Mars." It was unheard of for a boss to hire a pregnant woman. So I began work.

Along with Cristina Rossi, I managed and oversaw the designers: Kaki Kronen, Rini Van Vonderen, Michelle and Dina Vielmi. There were also Mirella Landi and Tito Pastore, who were important for Cristina and for Fiorucci, as they were definitely the most creative. I had to coordinate them all, each with their own individual personality; it was a lot to handle. I did that job while Cristina was in the United States after the birth of her daughter Erica in 1975.

After that, I became Elio and Cristina's right-hand woman. One of my jobs was to listen to people's problems; so much so that the general manager, Francesco Balduzzi, used to say "Vittoria, your office is a confessional."

I would intervene in delicate or tricky situations. Elio gave me so much and involved me in his family affairs, which I handled with love. He was a very important person in my life. My feelings for him go way beyond admiration; it's difficult to describe.

THE USE OF NEON SIGNS DISTINGUISHED FIORUCCI FROM EVERY OTHER CLOTHING STORE. THERE WERE DECORATIVE MESSAGES AND SIGNS FOR THE DIFFERENT SECTIONS OF THE STORE.

The idea of using neon came from the United States, and we were the first in Italy to use it for decoration and to delineate areas of the store. All the messages and designs made for a colorful and joyous atmosphere. We used neon for everything, "Angel Safety Jeans," hundreds of fixed or moving "Fiorucci" signs, shoes, dancers, trucks, pinups, spaceships and missiles, ice-cream cones, food and drinks...

For the New York store, we called Rudi Stern, who designed all the neon signs for the interior and the flashing neon lights outside.

Neon became a recognizable symbol of every Fiorucci store in the world.
F. M.

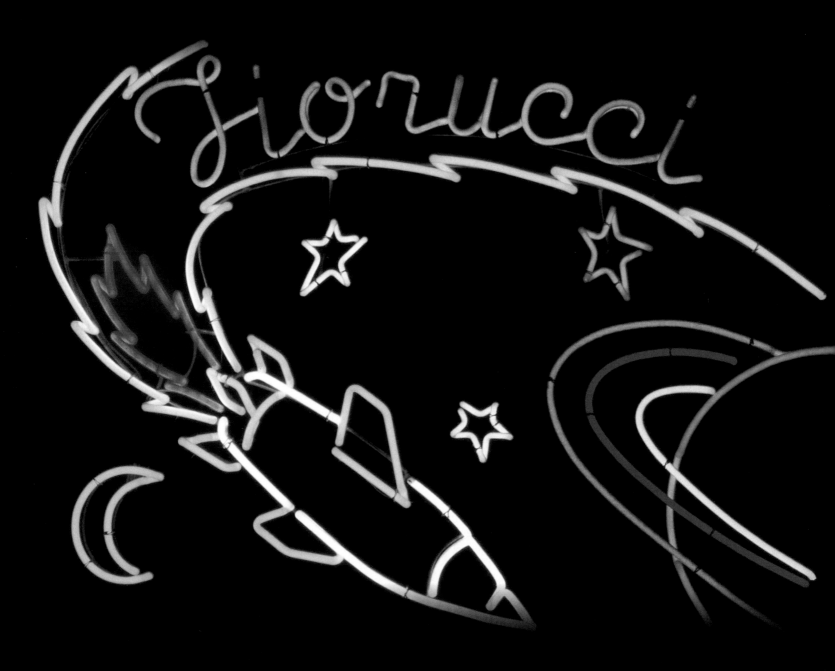

Above, neon missile in the San Babila store. Right, neon Fiorucci logo in the San Babila store.

Fiorucci
Space

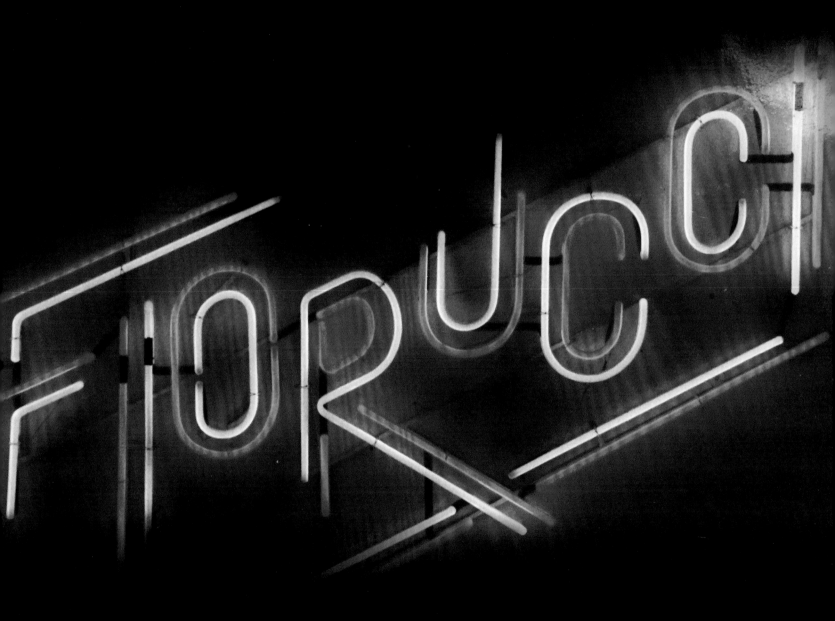

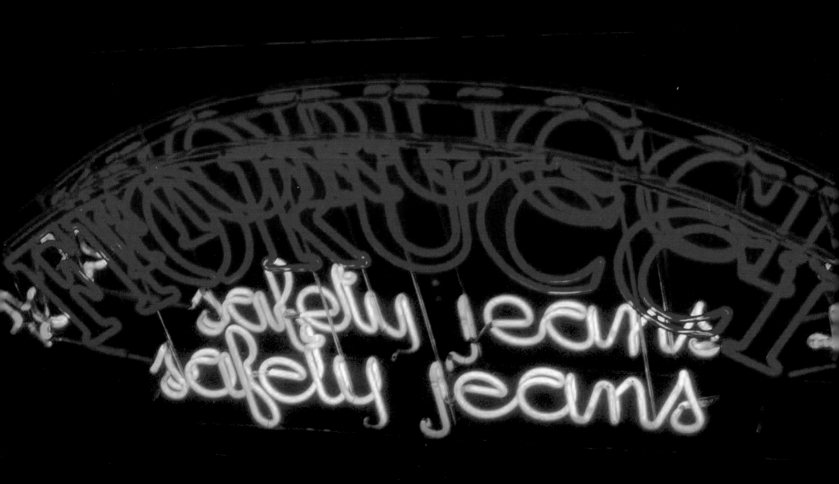

Fiorucci
Space

Above, neon Fiorucci Safety Jeans in the New York store.
Right, neon coffee cup above the bar in the New York store.

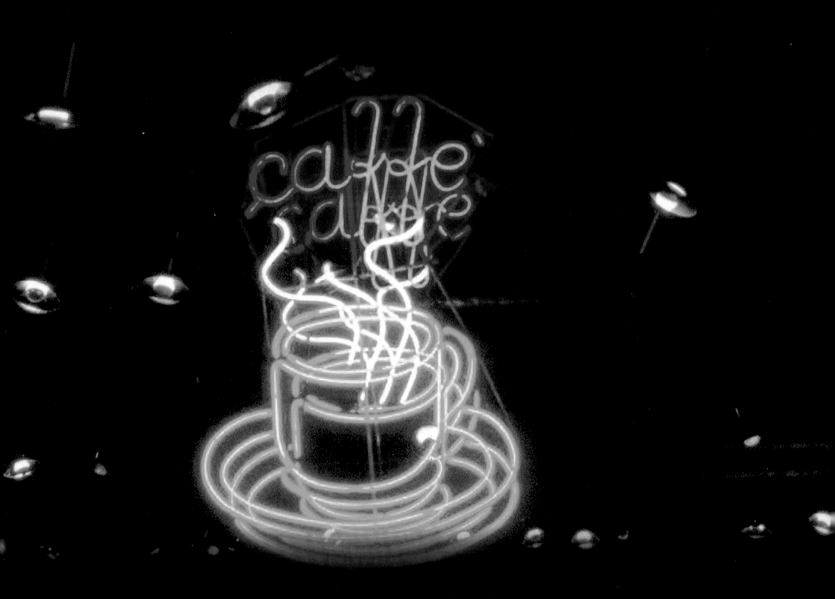

Fiorucci Space

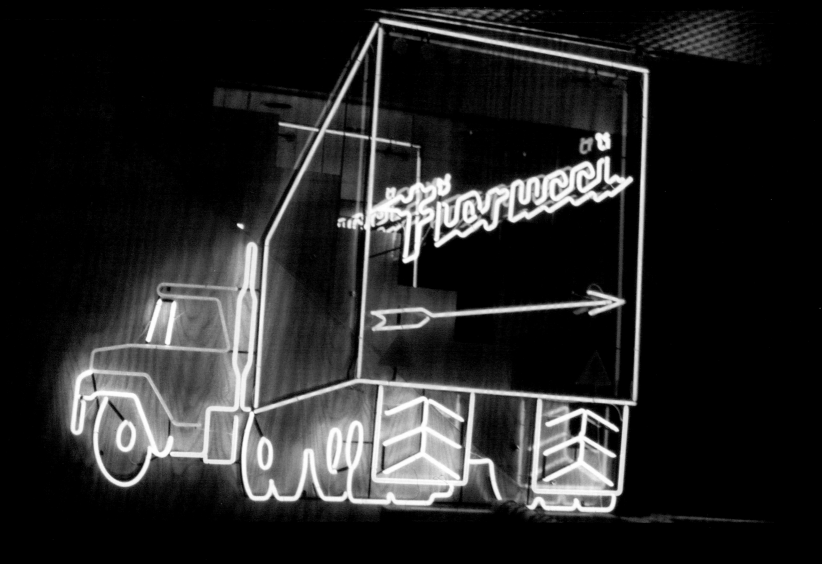

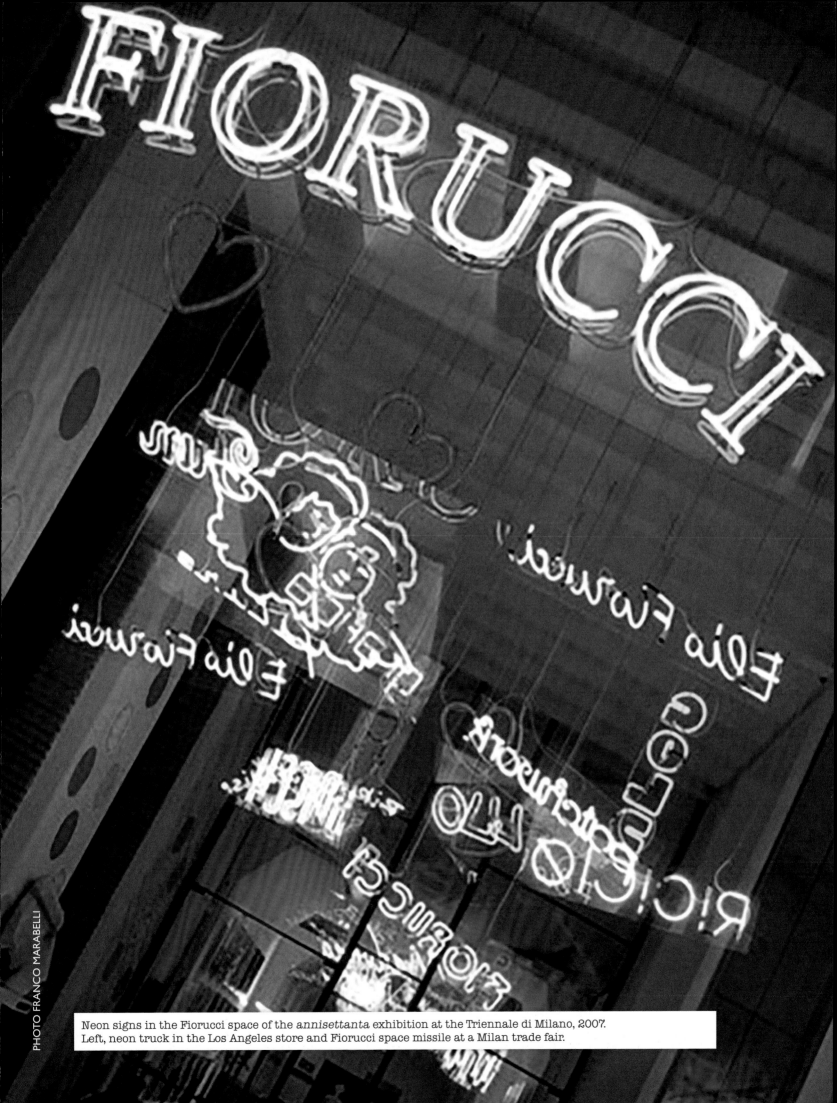

Neon signs in the Fiorucci space of the *annisettanta* exhibition at the Triennale di Milano, 2007.
Left, neon truck in the Los Angeles store and Fiorucci space missile at a Milan trade fair.

Neon signs designed by Franco Marabelli for the *annisettanta* exhibition at the Triennale di Milano, 2007.

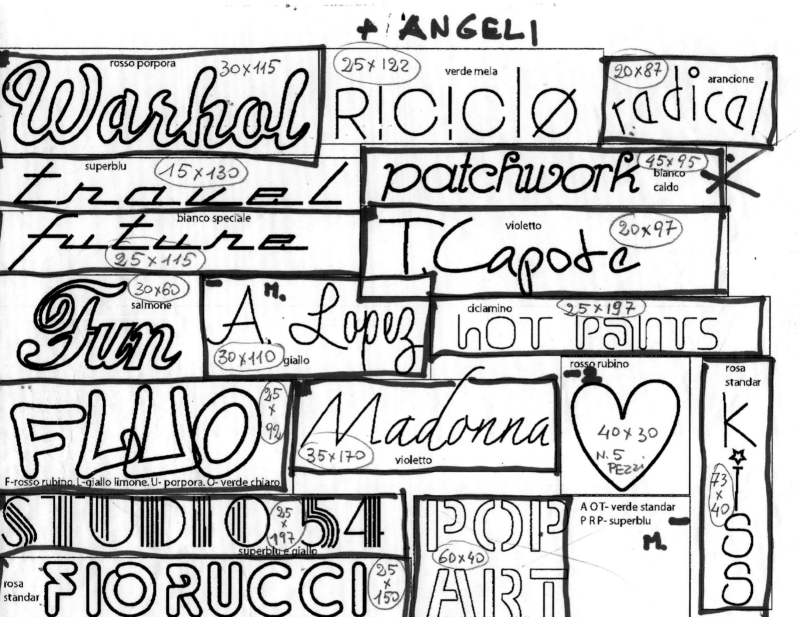

+ ANGELI

ROBOT

NÉON

TUBE A

D

MÉTAL

Le même alphabet, toujours basé sur le principe de l'articulation, mais élevé au rang d'objet d'art. Augusto, Guglielmo, Sauro et Carlo (les graphistes Italiens que vous rencontrerez un peu plus loin p. 142) ont exercé leur dextérité, leur application et leur précision. Les différents graphismes de cette page ont été peints par leur soin à l'aérographe. Chacun représente de manière hyperréaliste un métal ou une matière, une consistance ou une atmosphère. Entre la physique - "robot" - "tube" et "néon", le spécial gourmands pastilles en chocolat et imitation gaufrette, le "Métal Hurlant", et les cataphotes clignotants, déterminez-vous.

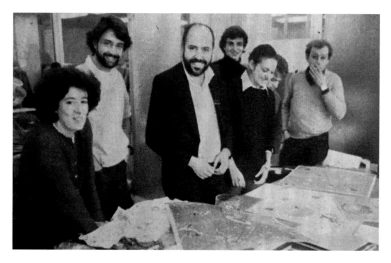

The French magazine *100 Idées* commissioned the Fiorucci graphics department to create new fonts that were colorful and fun. In the photo, Elio Fiorucci with colleagues.

A LA LETTRE

26 lettres et 9 chiffres chignotent pour vous. C'est le nouvel alphabet meccano qui danse, saute hors des marges et agrandit le vocabulaire. Vous en ferez des ouvrages, des jeux, des accessoires : sur sa construction, toutes les inventions peuvent se greffer. Et puis - c'est notre surprise de printemps - vous trouverez, p. 145 en offre spéciale, un sac "alphabétisé", et juste à côté, le portrait des quatre graphistes de Fiorucci qui ont créé ces belles lettres.

A B C C D D E F G

H I J K L M N

O P Q R S T U

V W X Y Z 1 2

3 4 5 6 7 8 9

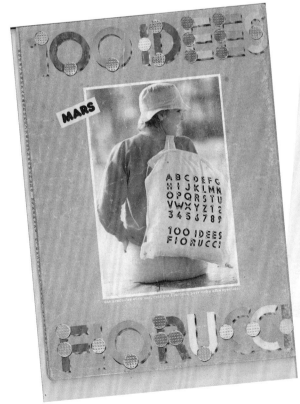

PIECI
CLOT

GUARANTEED

FIORU

FOR LIFE

MADE IN ITALY

CCI

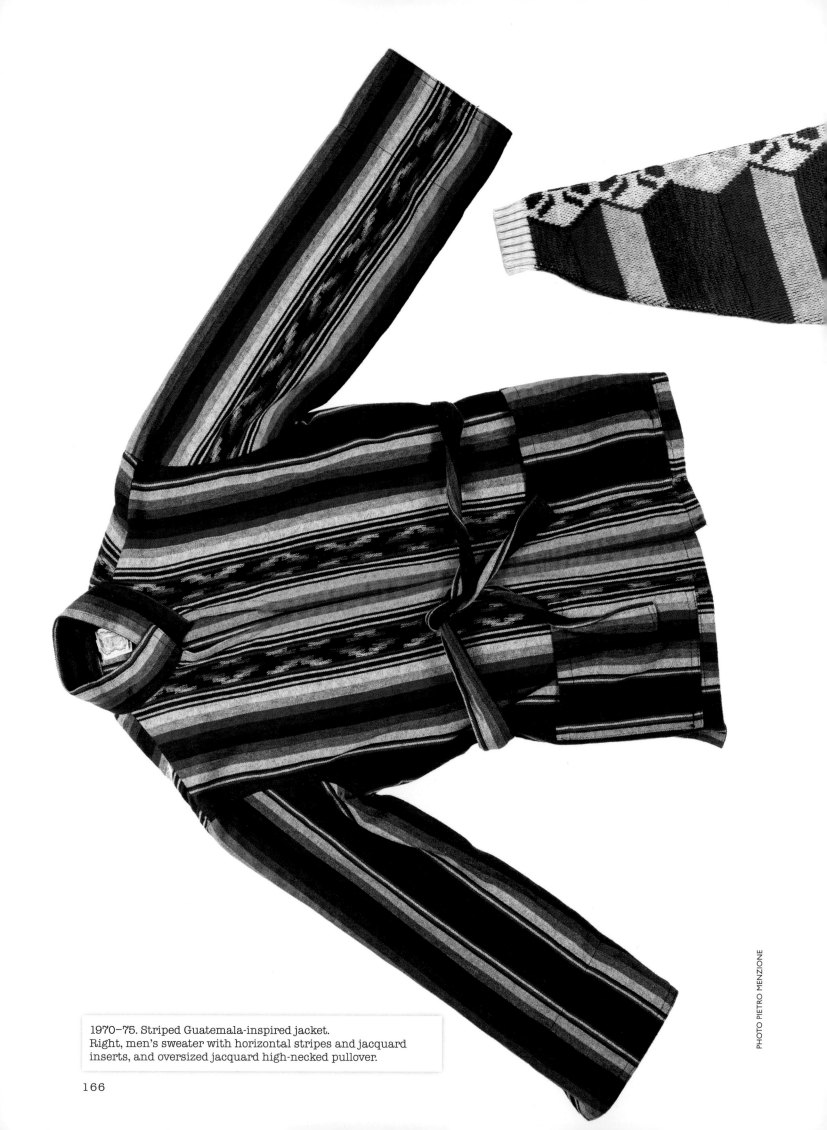

1970–75. Striped Guatemala-inspired jacket.
Right, men's sweater with horizontal stripes and jacquard inserts, and oversized jacquard high-necked pullover.

PHOTO PIETRO MENZIONE

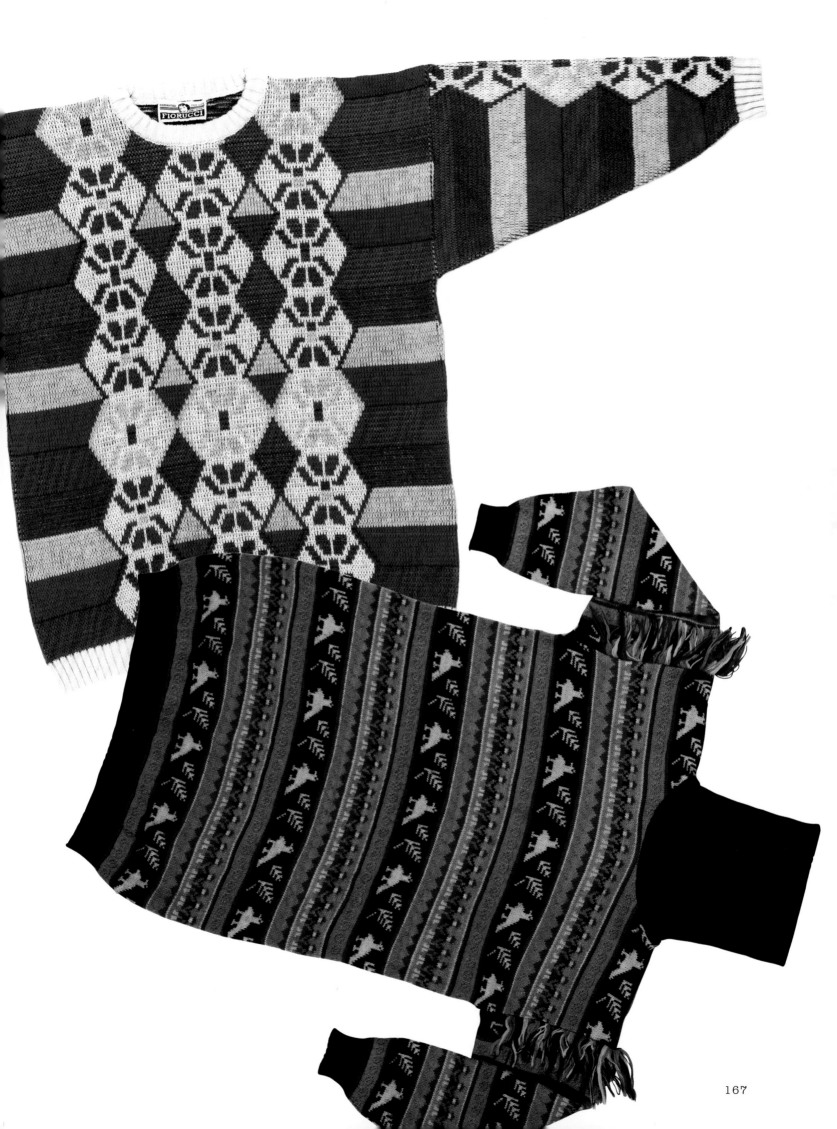

1975. Faux fur with Mickey Mouse and Minnie print.
Right, wool sweater with jacquard Mickey Mouse design.

1978/79. Shiny plastic travel bag with Mickey Mouse and Minnie design.

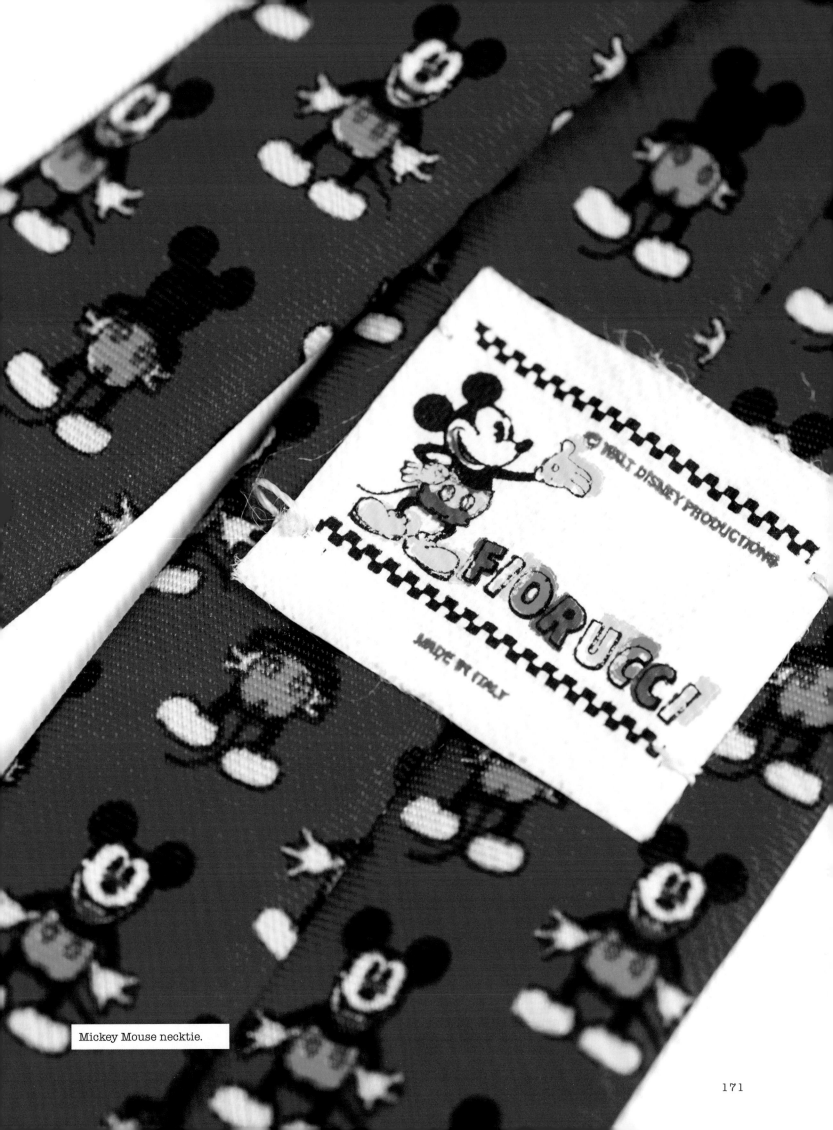

Mickey Mouse necktie.

WALT DISNEY PRODUCTIONS

FIORUCCI

MADE IN ITALY

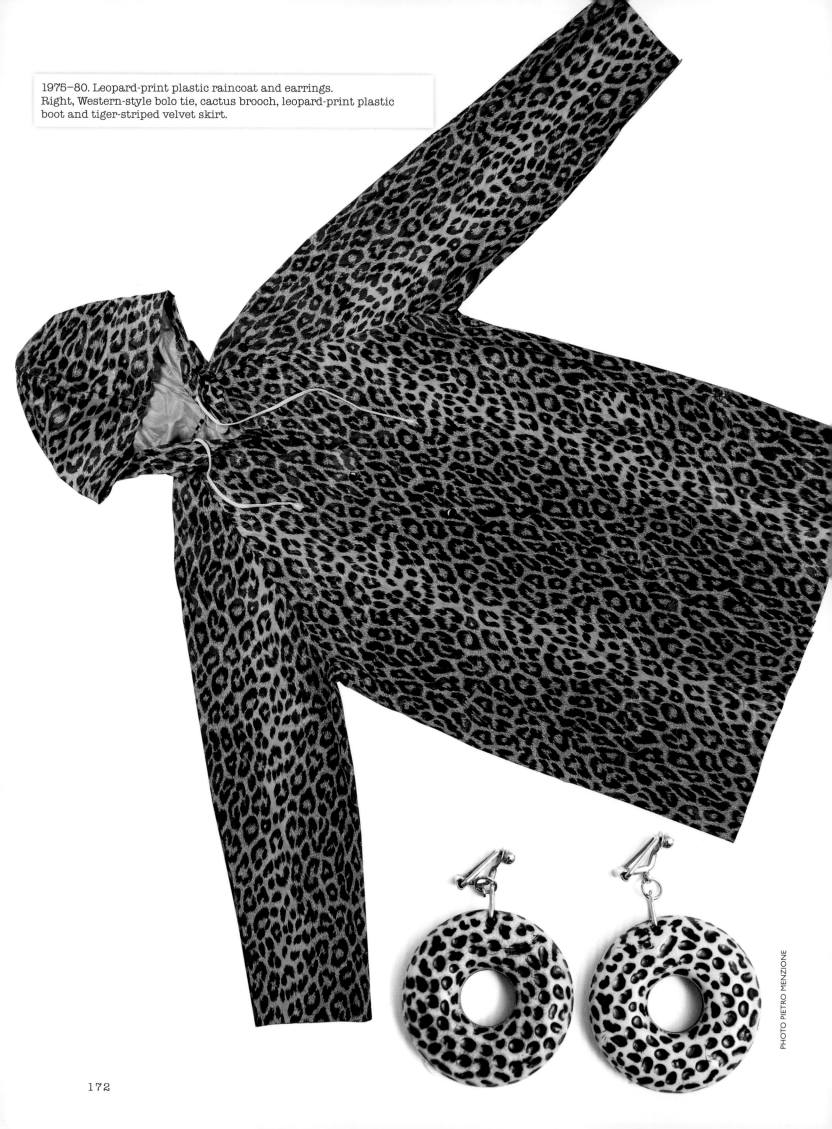

1975–80. Leopard-print plastic raincoat and earrings.
Right, Western-style bolo tie, cactus brooch, leopard-print plastic
boot and tiger-striped velvet skirt.

172

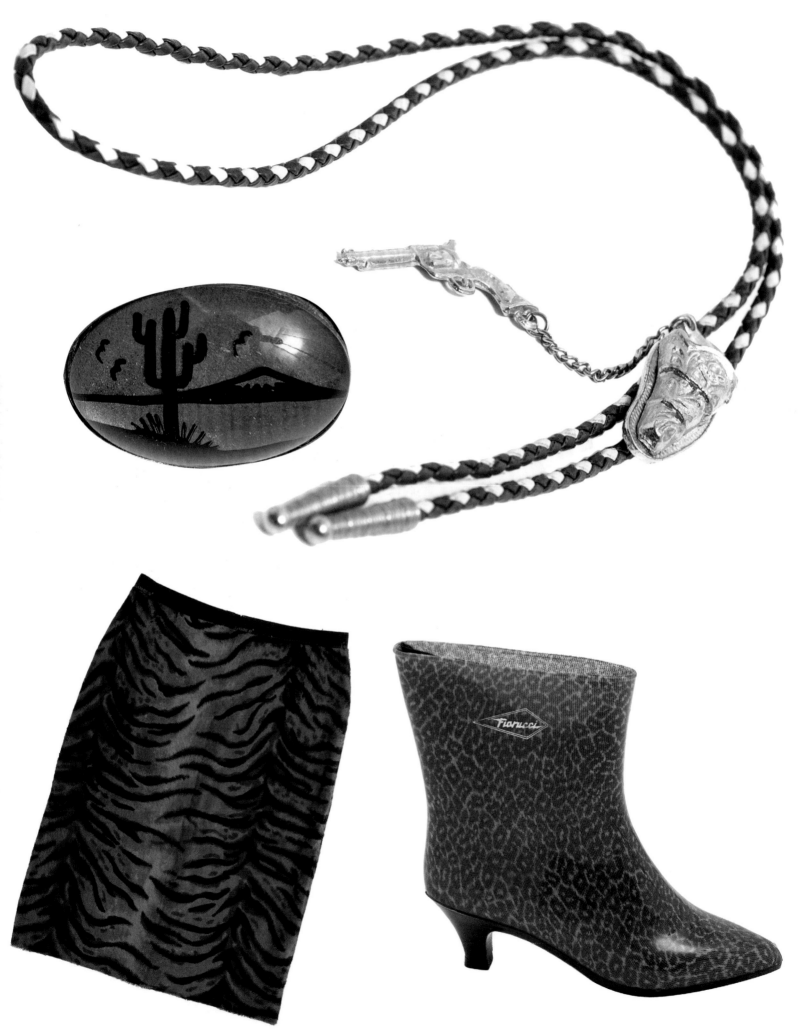

1975–80. Red leather cowboy jacket with fringe.
The jacket came in three colors: black, red and electric blue.
Right, Western-style pants in beige leather with fringe.

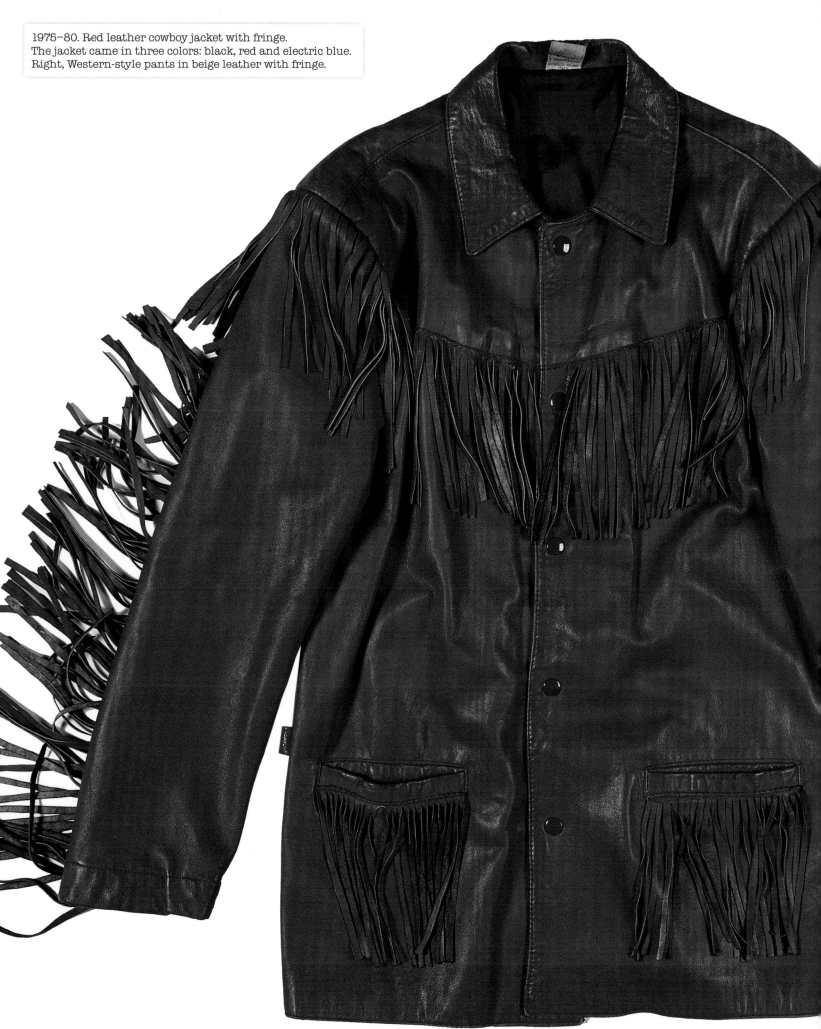

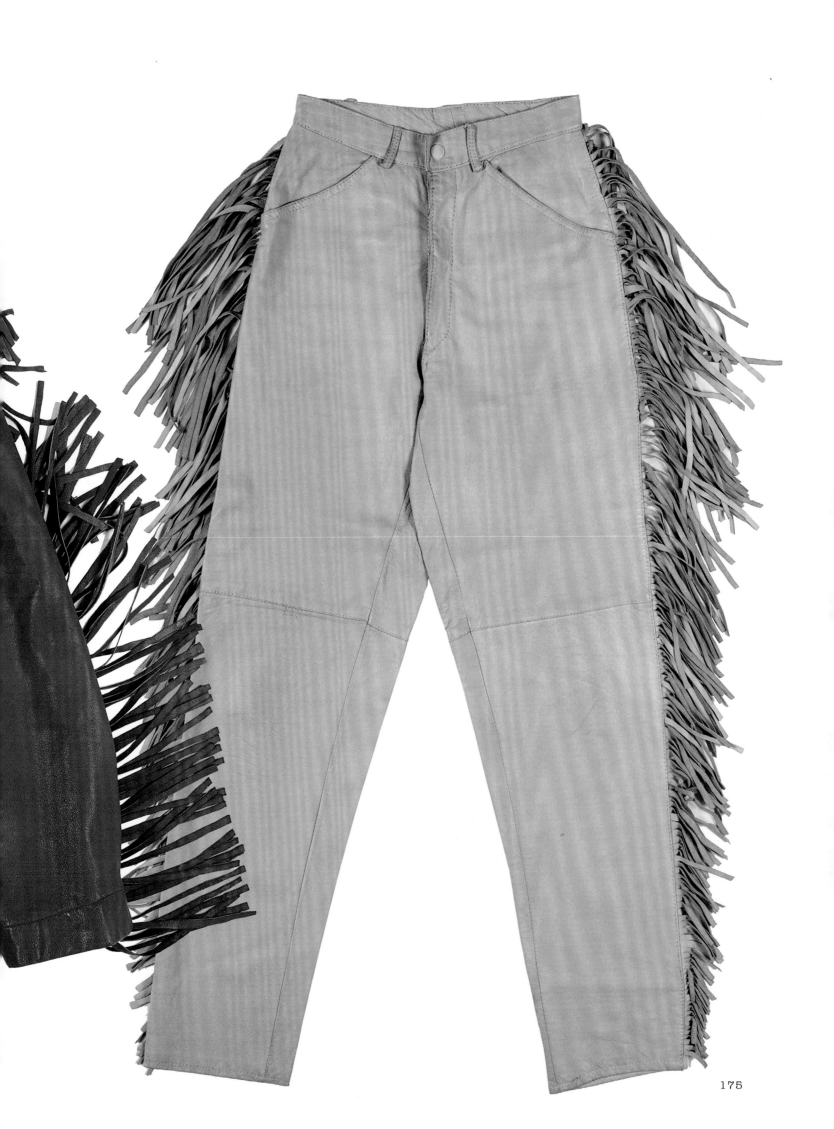

175

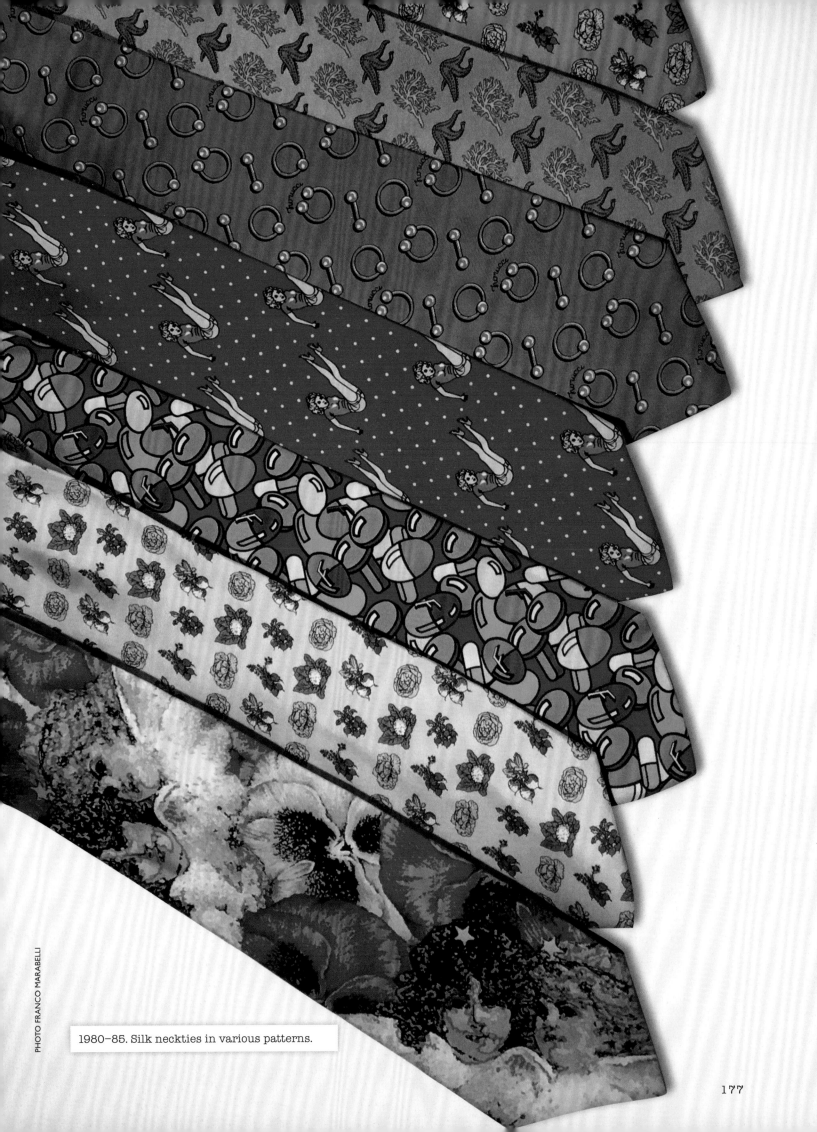

1980–85. Silk neckties in various patterns.

MIILAN
VIATO

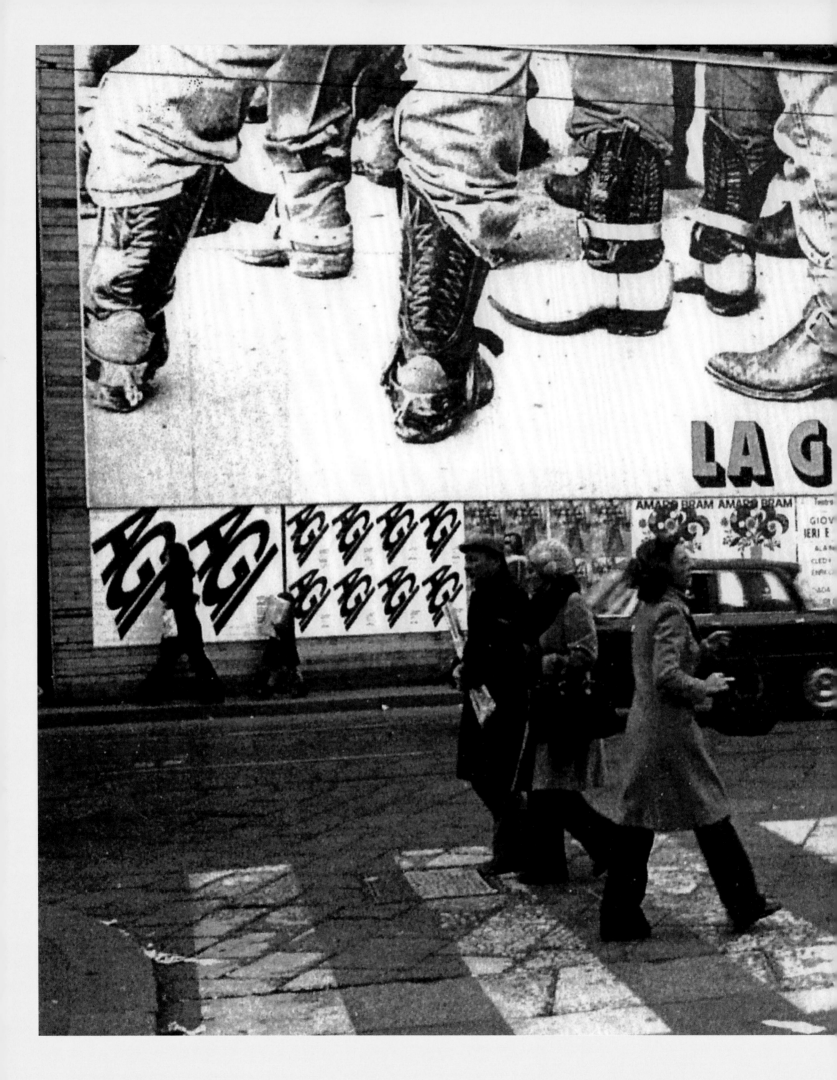

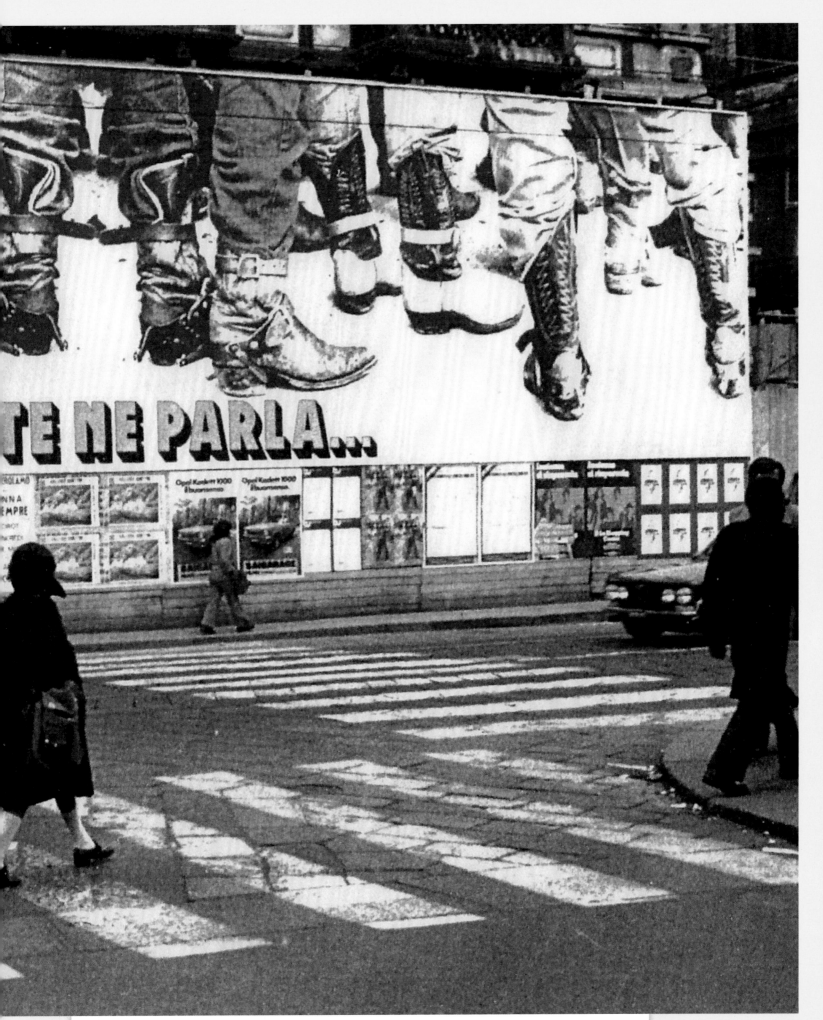

Billboard in Via Torino to promote the opening of the new Fiorucci concept store, 1973.
The ad did not mention the brand or the subject, as Elio believed that the mystery would make people all the more curious. And he was right. Photo by David Kent Hall.

1974
VIA TORINO
MILANO

ITALY'S FIRST "MULTI-STORE" WITH RESTAURANT

Creative direction by Franco Marabelli, technical plan by
Alessandro Ubertazzi and Alain Quesnard, Intec studio

SHOPPING BAG.
DESIGN FRANCO
MARABELLI,
LAYOUT FIORUCCI
GRAPHICS DEPARTMENT.

In 1974, Standa joined forces with Fiorucci, and the increase in capital led to the growth of the brand.

The original plan for the concept store was given to architect Tomás Maldonado, who later withdrew, recommending two of his architects for the technical plan. And so Elio appointed me as artistic director; I worked with Alain Quesnard and Alessandro Ubertazzi on the technical design.

The store had a large jeans department with shelves up to the ceiling and rolling ladders to reach the highest shelves; there was a section for imported disks, a range of bath products created exclusively by Borsari of Parma, and sections for clothing, accessories, housewares and furniture, which I'd created myself, buying products all over the world. The first floor had the Idea Books area and a bar/restaurant that overlooked the interior patio.

The restaurant was open until 2am, which was unheard of in Milan in those days.

We introduced industrial materials to the store, such as the pressed metal used in factories and trucks.

The housewares department was created using wooden crates piled up to create surfaces of different heights and sizes. The fitting rooms had a huge image of a cowgirl on horseback, which became an emblem of the store and was later reproduced on bags.

The restaurant became trendy; it was frequented by journalists, actors, singers and designers, who also displayed their work there. It was furnished with simple square modular tables topped with 10 x 10 white tiles, and lit by aluminum streetlights. The plates were Richard Ginori, heavy and classic, with a pattern round the edge and the words "Fiorucci Ristorante." The menu cover featured a black guy in a white sailor's uniform carrying a pinup girl.

The venue lent itself beautifully to performances and music events, and hosted the very first vintage market.

The patio, with its glass ceiling, had a vertical fountain with basins in different sizes.

The space was available to rent for the display of new and original products; it was used by the young Donatella Pellini with her costume jewelry and by Porlezza Taroni, who had a plant nursery, with plants and fragrances. F. M.

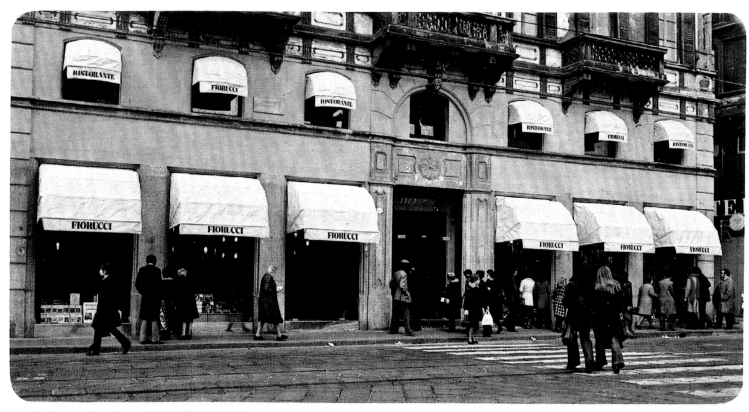

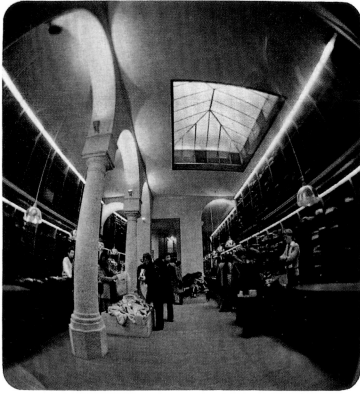

The exterior and some departments of the store.

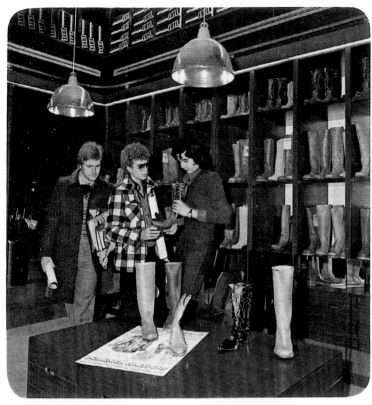

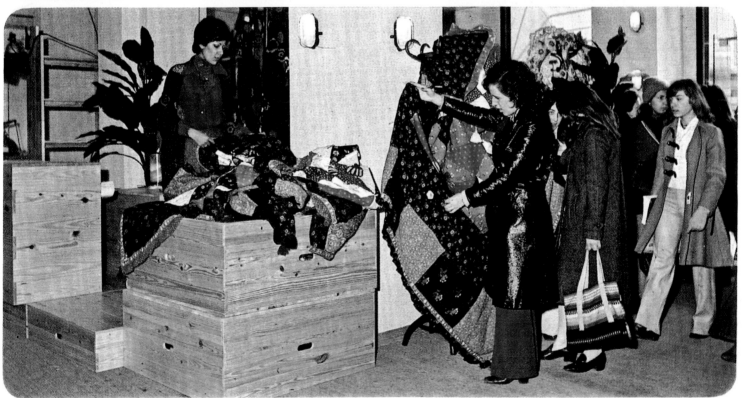

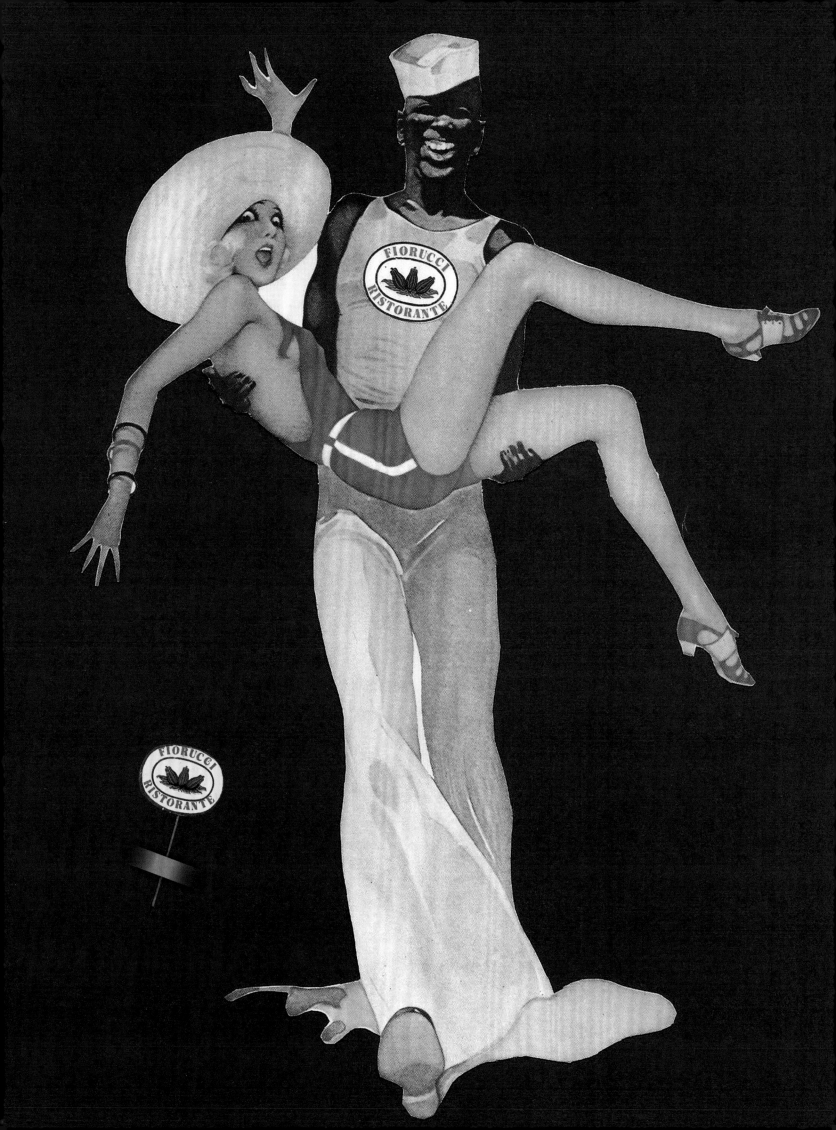

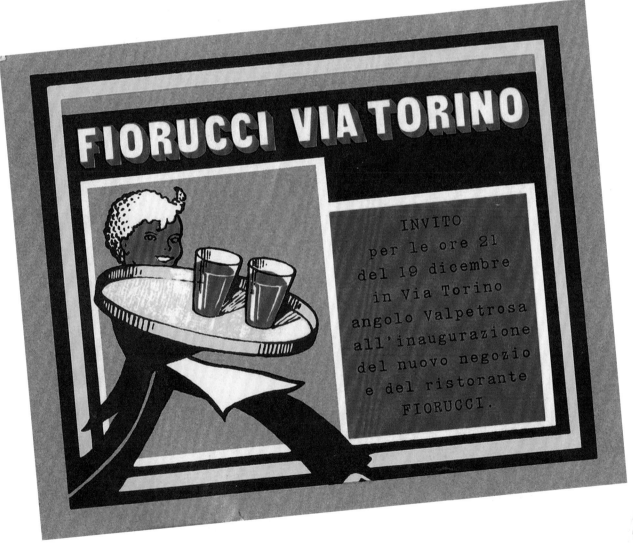

Neon lights placed in the stairwell leading to the restaurant. Invitation for the opening, which came with trading cards representing the various departments. Free pin given out by the restaurant. Left: the cover of the menu.

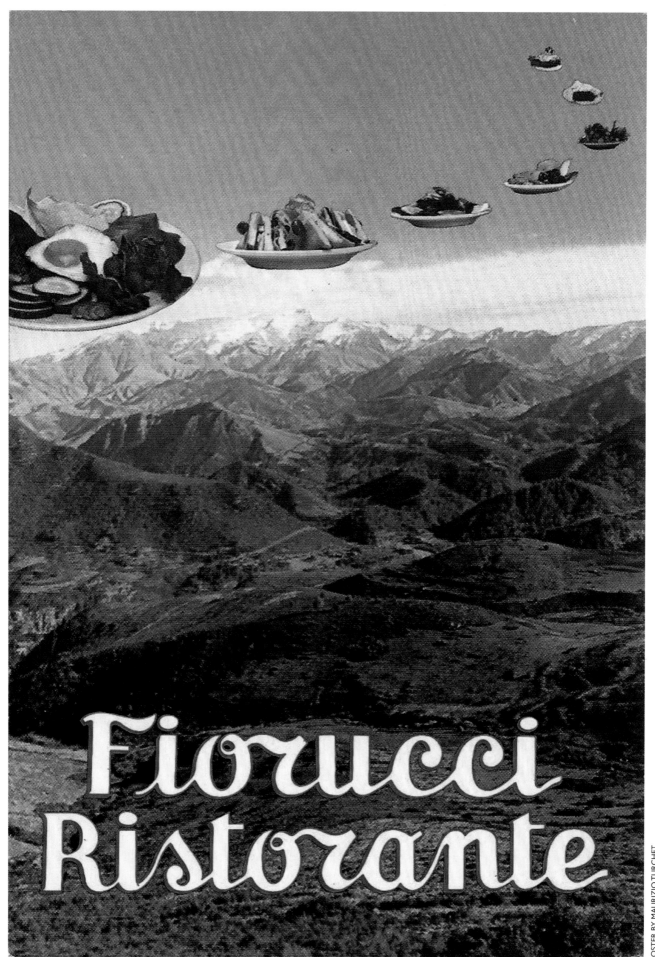

ANGELO CAREDDU

Headed up the restaurant in Via Torino and later worked
in the press office in San Babila and New York City. Elio later
involved him in other ventures

In late summer 1975—the beginning of September—I was in Sardinia and I received
a phone call from Telma Malacrida, Fiorucci's secretary: she told me Elio wanted to
meet me. Mirella Landi from the style office, whom I'd met in Greece the previous
year, had told him about me.

The following day I was at Elio's office in Milan. He told me he had a project and I
might be the right person for it. He wanted to open a restaurant in the new store in
Via Torino, "It's all ready; you just need to organize what's needed to open in three
weeks." And that was the start of my time at Fiorucci.

I was 23. I'd been to catering school, and I had experience running a restaurant,
because I'd opened one with some friends in Kolonaky, the nicest part of Athens.
Despite all this, I immediately realized that running the Via Torino restaurant
wouldn't be as simple as it was in Greece.

Elio told me he didn't want a conventional restaurant; in London he'd seen the Hard
Rock Café, and he was fascinated by the atmosphere there. He sent me to London to
see for myself.

When I got back, we planned the opening.

The restaurant was unique in many ways, starting with Franco Marabelli's design. It
was like being on a suspended terrace looking out at nature—with a huge fountain
and tropical plants—or on a slice of city life, from the windows on Via Torino.

From the store, you went upstairs. First you found yourself in a room packed with
shelves of Idea Books publications; then you came to the cheerful, bright rooms of
the restaurant, which were lit at night by unusual street lamps.

The menu offered hamburgers—the first time in Italy—which were usually served
with baked potatoes. Elio used to fly the potatoes in from England because he said it
was the only place they were the right shape and size!

The restaurant was open until two in the morning, and it attracted all kinds of night-
time customers, from politicians like Bettino Craxi—always surrounded by beauti-
ful women—to Oliviero Toscani. There were designers—Walter Albini and his gang
were frequent visitors—and singers; I remember Lucio Dalla and Amanda Lear at
the start of their careers. Then there were journalists, artists and intellectuals; an
incredible mix of people.

In no time at all the restaurant became the place to be in Milan: we held exhibitions,
performances, there was even an in-house video art series, which had never been
seen outside the classic art venues. These initiatives were curated by Franca Sonci-
ni, who was totally in her element! A famous DJ took care of the music, and he was
excellent. There was nothing like it in those days; the guests had fun, chatted, even
argued, but it usually ended in laughter. It was a huge success.

But like all good things, it had to end, and, after two years, the restaurant closed,
mostly due to bureaucracy and paperwork issues.

So Elio asked me what I'd like to do, and as I didn't really know, he decided for me,
and sent me to the PR office in Galleria Passarella with Franca Soncini. I stayed there
a year and then, when he opened the New York restaurant, Elio wanted me in the
press office in the States, and I worked there for another four years, before leaving
Fiorucci and moving to Condé Nast.

Many years later I went back to Fiorucci in Milan, but it had changed completely, so
I left for good after a short time.

Discount card for
the restaurant.

Plastic Popsicle brooch.

"Fiorucci Restaurant" plates by Richard Ginori (Fiorucci graphics department).

Right: poster designed by Maurizio Turchet.

Martedì 22 aprile ore 18,30............................JUAN HIDALGO
WALTER MARCHETTI
DEMETRIO STATOS
performing CAGE

Martedì 29 aprile ore 18,30............................JUAN HIDALGO
performing HIDALGO

Martedì 6 maggio ore 18,30............................FRANCO BATTIATO
performing BATTIATO

Martedì 13 maggio ore 18,30............................WALTER MARCHETTI
performing MARCHETTI

NUOVA MUSICA MUSICA CONTEMPORANEA MUSICA SPERIMENTALE MUSICA D'AVANGUARDIA MUSICA APERTA MUSICA ESPERIENZA sono tutte definizioni che servono a contrapporre la musica alla musiKa, col kappa. La musiKa integrata e integrante alla musica come esperienza liberatoria. La musiKa obbliga al suo ritmo, e ai suoi stereotipi a cui è essa stessa costretta costringe dentro le catene di ritmi precostituiti e già studiata per la confezione e la commercializzazione. La Musica Nuova è un'esperienza aperta, distrugge la distanza fra musicista ed esecutore della sua musica; fra creatore e prestatore d'opera; fra esecutori e pubblico. Tutti quanti vengono co-rivolti dalle leggi dell'invenzione e dell'improvvisazione di segno musicale. Perché sempre di musica si tratta, non di una confezione ma di un'esperienza. Diceva John Cage, il padre e profeta della Nuova Musica; famoso esperto di micologia, che i funghi gli prendevano assai più tempo della musica, perché i primi possono anche uccidere mentre la musica non ha mai ammazzato nessuno. Con le performances di Nuova Musica si ricrea un margine di rischio anche se, oddio, limitato. Sono soprattutto i rischi dell'immaginazione quelli che si corrono. Non si corre più sul filo delle note e dei righi musicali — poiché la musica non è fatta solo di note,

ma anche di suoni e di rumori. E gli esecutori non sono « anime » — si fa per dire — attaccate ai loro strumenti di cui rappresentano un'estensione, senza corpi. Sono persone reali che agiscono e comunicano sia attraverso degli strumenti musicali canonici, che attraverso strumenti che emettono suoni non codificati, oppure attraverso l'esecutore stesso — voce, corpo, gesti, — in quanto strumento delle sue idee. La comprensione in questa situazione imprevedibile può avvenire solo attraverso la partecipazione.
La ricezione è aperta: Fluxus è il nome d'arte del movimento su cui si innesta la Nuova Musica, a cui appartengono Walter Marchetti e Juan Hidalgo, che nei loro concerti usano anche la tattica della sorpresa. Tattica, teorizzata da Fluxus, per risvegliare dai condizionamenti sonori della cosidetta « musica giovanile » — ossia musica inventata per addomentare sin da giovani nelle spire del serpente a sonagli del consumo passivo e continuato. Battiato, anche lui, si sottrae al Kfuxus che gli ha dato la notorietà: tenta l'innesto che dovrebbe produrre non un nuovo tipo di « fiore » ma, dalla Musica Nuova una Persona Nuova.

DANIELA PALAZZOLI

PORTRAIT OF JOHN CAGE
performers: JUAN HIDALGO
WALTER MARCHETTI
DEMETRIO STATOS

TAMARAN LETTERA-CONCERTO
performer : JUAN HIDALGO

NOVENA, ASSENZE
performer : FRANCO BATTIATO

J'AMERAIS JOUER AVEC UN PIANO QUI AURAIT UNE GROSSE QUEUE
performer : WALTER MARCHETTI

John Cage è nato a Los Angeles, in California nel 1912 sotto il segno della Vergine.

performance
FIORUCCI
via torino angolo via valpetrosa

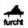
furcht

ALESSANDRO UBERTAZZI

Architect with Tomás Maldonado's Intec studio.
Worked on the Fiorucci Via Torino project, 1973–74

I met Elio when he came to Maldonado's studio; I don't know why he chose us.

The studio specialized in large retail; we'd worked for Rinascente, Upim and Carrefour. When he came to talk to us—he came alone—it was me who saw him. The challenge he'd set himself was to find an innovative retail formula; so we drafted some ideas and discussed them together. He immediately struck me as a man of fierce intelligence, a skilled storyteller, but, above all, extremely quick at grasping the essence of things. I was struck by his lucidity and innovative thinking. He was imaginative, a non-conformist and extremely polite. But nothing came of our meeting, because we didn't present the "innovative" plan and restaurant that Elio and Franco Marabelli wanted. But it went ahead anyway, with Franco Marabelli as creative director and Alain Quesnard and I for the technical aspects.

In talking about Fiorucci, what comes to mind are distinctly different episodes that happened over a long period. I'll start at the end: the last trips we took were to Brazil. I remember the last one, which I enjoyed the most. This was in 2011 or 2012. He came with his sister, who was a very warm companion for him, and I was with my assistant, who is very kind; Elio felt at ease. We traveled around Brazil, sometimes with the four of us speaking in Milanese dialect. We saw a lot of fascinating things. We went into schools and organized workshops; Elio spoke with all the students, discussing their projects. The students had never worked that way before. To them Fiorucci was a god and seeing him there, with his intelligence and modesty, listening to their problems and fine-tuning their ideas, was unforgettable. He told them about the "happy chickens" that he'd seen in farmyards when he was a child. The kids loved the happy chicken theory, and laughed until they cried.

Elio Fiorucci will go down in history for inventing women's jeans, and that's quite something: like the egg of Columbus or the wheel.

The jeans section of the Via Torino store, with aluminum street lamps. Below: tubs of painted wooden ducks, found in a clog store in Amsterdam. They were hand-painted in natural colors. The ducks also appeared on large stickers.

Costume jewelry designer

I remember every detail of my first meeting with Elio Fiorucci. As I was going to his office in Via Torino on that day in 1976, I prepared myself mentally to answer questions I couldn't anticipate. I knew quite a lot about the man—a talent scout for people, fashion, design, music and art... in short, a revolutionary full of ideas.

When you entered his stores, you were instantly transformed: you wanted to be the most fun, outrageous girl in town; normal was boring.

When I reached my destination, I sat opposite him. He examined me with his round black eyes, and told me many things in a few minutes. I was nervous. After a moment I replied, "My jewelry would be delighted to be displayed in a temple that's changing the history of fashion."

PAINTED CERAMIC
BROOCHES, 1978.

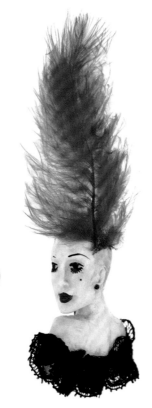

PHOTO GIOVANNI GASTEL

194

CARLO D'AMARIO

CEO of Vivienne Westwood. He worked with Fiorucci between 1974 and 1980, mainly researching vintage products

Elio Fiorucci was a mutual acquaintance of Franca Soncini, whom I'd worked with at King's Jeans. This would be from 1974 to 1979, more or less; I worked with Fiorucci as a researcher and supplier. I'd go around and find spare parts for pinball machines, or I'd travel to India and bring back skirts, rugs… that was my arrangement with Elio. He was the most generous person I've ever known. One day I bumped into him in Resina, in the same warehouse that supplied me with secondhand jeans; nonetheless, he continued to buy them from me.
When we got together, we always exchanged views. One night he called me and said, "Listen, I need to do a joint venture with Montedison"; I didn't know what it was. "I need managers. Come tomorrow, because I need people to balance things out." I didn't want to go. I wanted to be free. But I was curious. Elio explained things to me in the Corsico offices, but I wasn't keen to accept the offer, so he asked me, "How much do you want?" I replied, "A million," thinking he wouldn't agree, but he said "OK."
So I started organizing performances at the Via Torino store. It all went really well—apart from the occasional disaster—and I realized what a creative genius he was.
I remember performances with promotional posters that apparently clashed with the typical Fiorucci "joie de vivre" approach. This poster —designed by Maurizio Turchet—was inspired by the Dadaist movement, and the performances featured artists from the Nova Musica series from Gianni Sassi's (a true genius) historic Cramps record label. In those days I don't think anyone really knew what music performances were (with artists including the then unknown Franco Battiato and John Cage), but Franca (Soncini, ed.) ran with the project and somehow made it work. Elio frequently took on people without specific experience and let them do their thing, and the results weren't always great. He was an alchemist. This lack of hierarchy—more horizontal than vertical—I later took to Vivienne Westwood. Around 1981 or 1982 I left Fiorucci and Elio helped me find a producer/backer for Westwood. He called Galeotti, a partner of Armani's, and arranged a meeting for me. It was incredible, I found a backer thanks to a call from Elio.
I've always seen him as a teacher. All over the world people smiled when they heard the name Elio Fiorucci; they adored his style. This positivity was contagious worldwide, and that's why I repeat that in my view he was a master of "assembly," almost a Warhol, able to bring talent together.

There were no limits to experi
it went beyond limits.
If it wasn't normal, taken for g
This rule applied to textiles.
Fake or real, who's to say?
We overturned all the convent
What went before was before. A

TYVEK

DENIM. TYVEK .LATE
REAL PLASTIC.FAKE LEATHE
LYCRA.METALLIZED.PLASTIC

ntation; indeed,

ted, it was welcomed.

al uses.
r, there was Fiorucci.

Franca Soncini

RUBBER.FAKE FUR.LUREX.
PELUCHE.VINYL.STRETCH.
RTIFICIAL FABRICS.

Elio discovered Tyvek,
a nonwoven fabric
patented by DuPont
that was similar
to paper but 100%
synthetic, made
from high-density
polyethylene fiber.
Tyvek is hard to
tear but easy to cut;
Fiorucci used it to
make jumpsuits and
bomber jackets, which
we presented in Paris
at a stand designed
to look like a gas
station with red and
yellow checks, real
gas pumps bearing
the Fiorucci logo and
models dressed in
the jumpsuits with
various labels.
The stand was
designed exclusively
to present the project
without commercial
purposes. F. M.

198

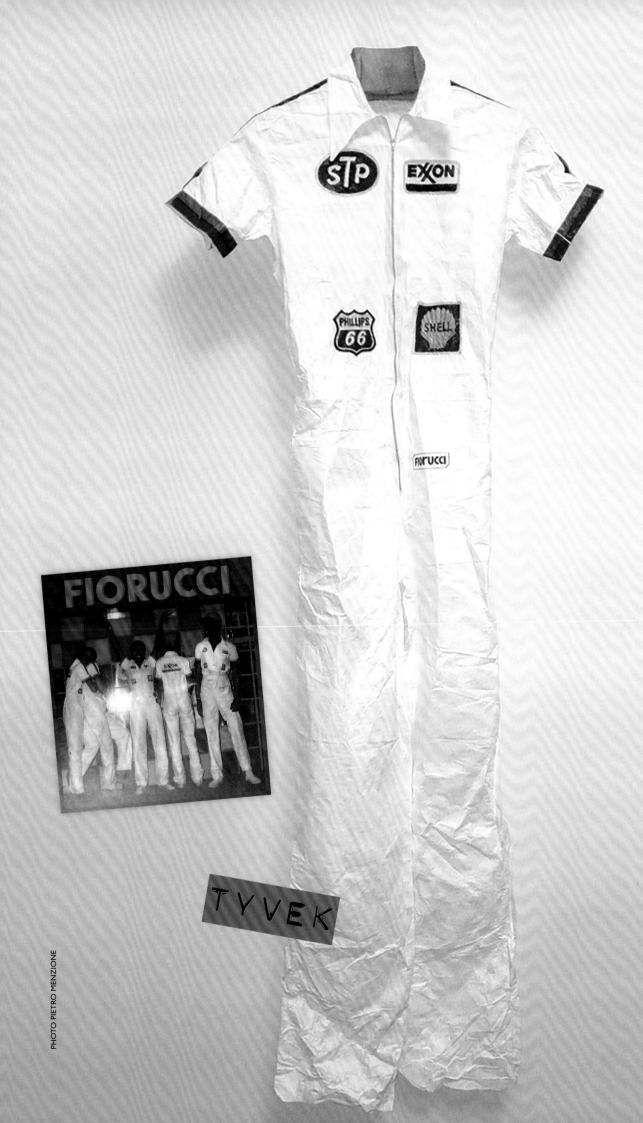

PHOTO PIETRO MENZIONE

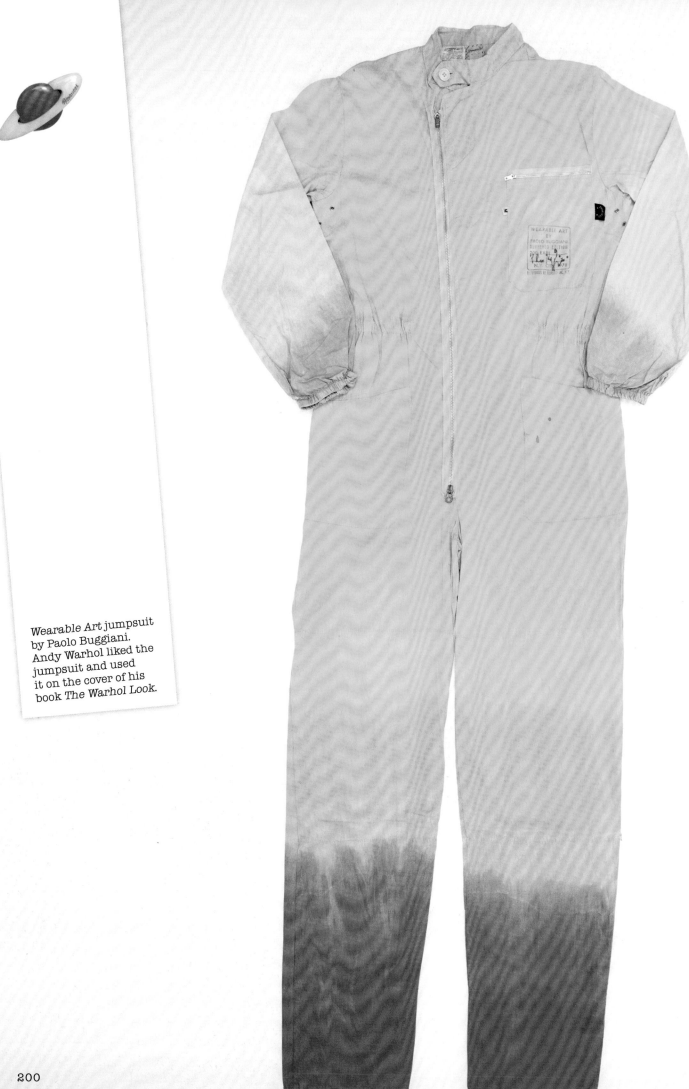

Wearable Art jumpsuit
by Paolo Buggiani.
Andy Warhol liked the
jumpsuit and used
it on the cover of his
book The Warhol Look.

PHOTO PIETRO MENZIONE

JUMPSUIT

I LAVORATORI DI FIORUCCI

Eccoli tutti insieme nella foto, amici clienti collaboratori di Elio Fiorucci (al centro con barba e tuta bianca) che nei suoi punti-vendita milanesi ha dato un contributo determinante all'affermarsi della nuova moda. Jumpsuits, overall, salopettes, il più possibile « veri », unisex e a basso prezzo sono stati i best-sellers dell'estate. Si riconoscono dall'alto: Luca Venturi, giornalista e trova-robe, Nora Scheller, p.r. e perdirobe, Sergio Carpani, industrial designer rug-bista, Mauro Bonfanti, grafico, Giuseppe Tonolli, uno che lavora il cuoio, Tito Pastore, stilista giramondo, Elio Fiorucci, il boss, Lorella Ermini, vendeuse ballerina, Franco Marabelli, art director magliaio, Leo Sangiorgi, illustratore fumettista nonché arcere a tempo perso, Rodolfo, ungherese noto rubacuori.

THE WARHOL LOOK

Fiorucci clothing from Warhol's Collection

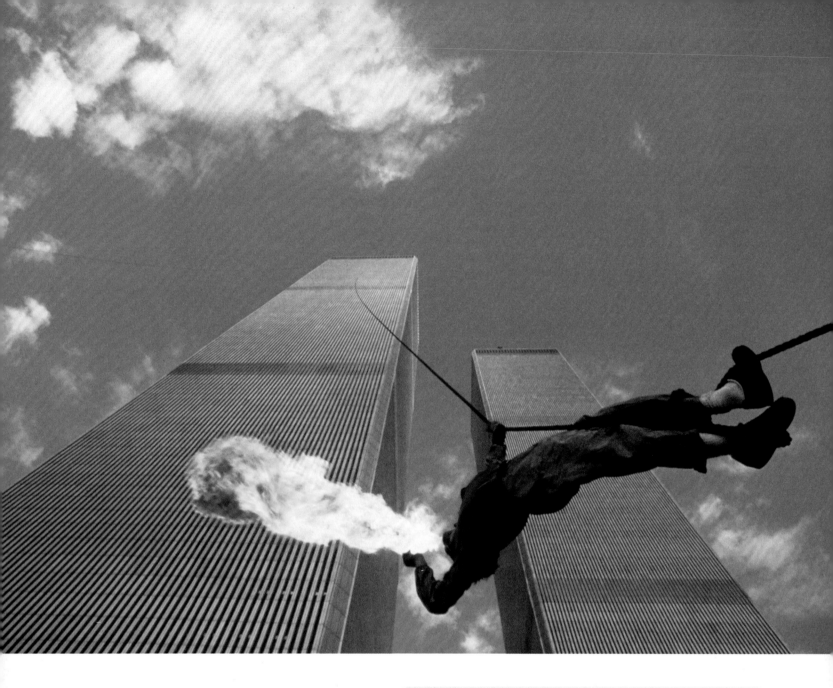

Paolo Buggiani

The artist who invented street art. In 1978, he designed the *Wearable Art* jumpsuits and showed them to Fiorucci, who bought them and sold them as numbered items in Italy and the States. This was a great success that was repeated several times. Buggiani painted the jumpsuits on the balcony of his New York home with Patrizia Govoni, who was working for Fiorucci at the time. Above, a performance at the World Trade Center, NYC, in 1979; a symbolic anti-establishment act with the Fiorucci *Wearable Art* jumpsuit! F. M.

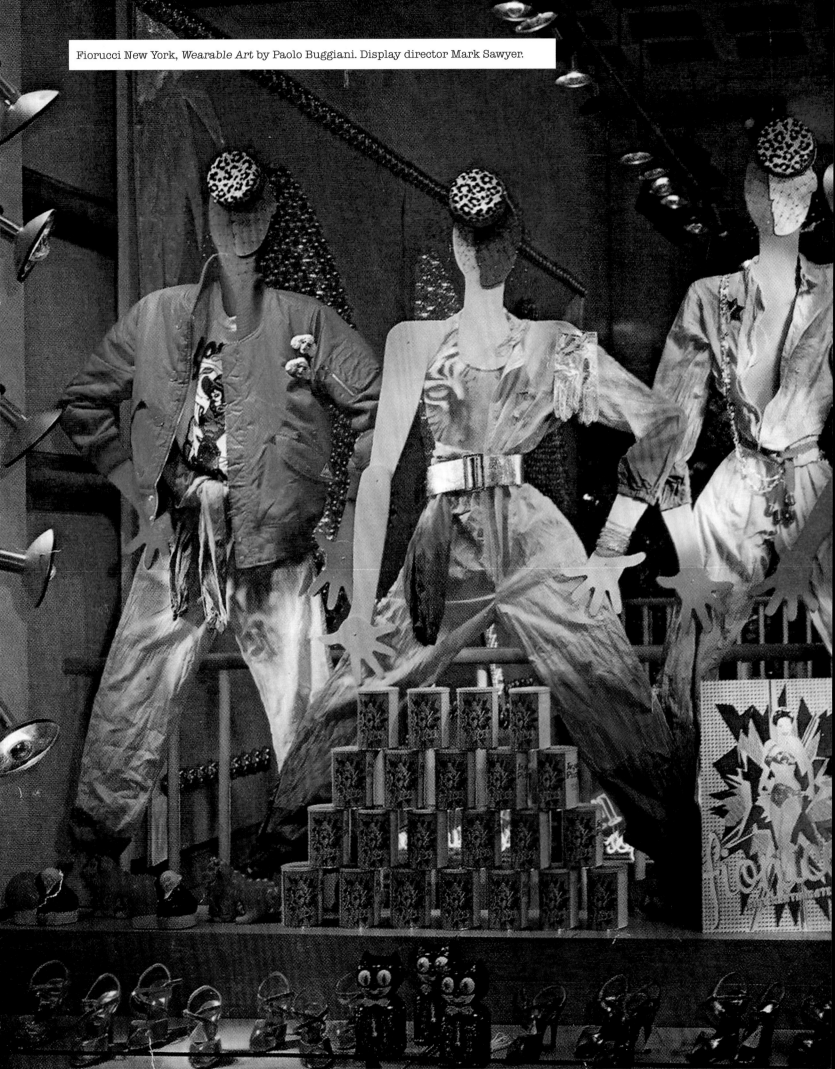

Fiorucci New York, *Wearable Art* by Paolo Buggiani. Display director Mark Sawyer.

AMPELIO BUCCI

Elio's friend and business advisor

I met Elio Fiorucci thanks to an unusual job that came my way in 1968–69. I was working as a marketing consultant for a pharmaceutical company, and I received a request from the marketing director of the Imec sisters, who needed some research into the future of fashion; I accepted the job.

I suggested the Delphi method, which requires the input of experts in the field to make forecasts. So I sought out several professionals, including Fiorucci, and got them together: a brilliant dressmaker—Germana Marucelli—the sociologist Francesco Alberoni, Solbiati, a textile specialist, and then I went to see Elio. There was an extraordinary atmosphere in his office. That's how I met him. He was very keen on this process of reasoning about fashion, because he did everything instinctively.

Soon after we met, he called me and said he wanted to meet me because he'd had a proposal from Montefibre. Brunello Maggiani told us that Montefibre had brought together a large number of firms that produced textiles and wanted to offer its customers services that were not just technical in nature. I discussed it with Fiorucci. We thought about the fashion research and made our suggestions. France already had a style office, Promostyl. Actually, Fiorucci used them for consulting so Elio suggested calling Be Khanh, Emmanuelle Khanh's niece. The team also included Nancy Martin, Ornella Bignami for knitwear, Popi Moreni and me as director and coordinator. There was also Donatella Brustio, the daughter of Brustio of Rinascente, who took care of PR. Maggiani took over two floors of an office building in Corso Vittorio Emanuele, close to Fiorucci. We were on the first floor—the Montefibre Design Center—and upstairs was furniture research, since the fabrics we were dealing with could be used for both. In the offices were Andrea Branzi, Massimo Morozzi and Clino Castelli. Elio did hardly anything. During that period he'd discovered faded jeans, which

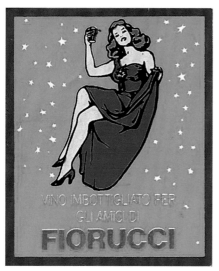

he'd bought in London. When we went to the engineers at Montefibre to propose this faded fabric, they were aghast; their job was to seek to perfect color. They wanted to make eternal fabrics; Elio wanted worn-out ones. It was incredible. Although he was always all over the place, Elio had a sensibility that wasn't about style, but about business. He had a sense of the new. He was curious about everything, from people to materials, objects and music. Later on I lost touch with him a little. But whenever I could, I went to see him and have a chat. This was one of my favorite things to do. The wonderful thing about Elio Fiorucci was that most of his projects weren't done as business, but for the pleasure of doing them.

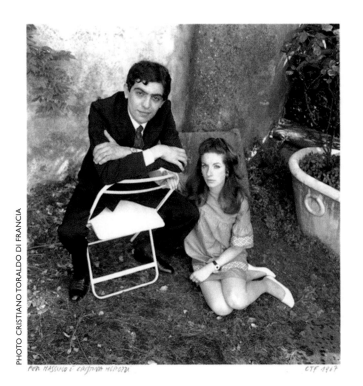

I met Elio Fiorucci when I was 17 or 18. At the time I was going out with Massimo Morozzi, who was part of the Archizoom group. I met Elio in 1967 at Moda Mare Capri: he'd been invited to present the Fiorucci collection, but instead he decided to present Dressing Design by Archizoom, so we all went to Capri. Lucia and Dario Bartolini were also involved in the project, which featured garments with two-dimensional geometric designs and colored stitching. I remember there were also swimsuits that were worn over bodysuits. After that I always saw Elio, either as a customer—since I went often to his store—or socially, at the homes of friends.

Later on, in the 1970s, he asked Massimo and Andrea Branzi to work for the Montefibre Design Center (a Montedison venture; Fiorucci was its director, ed.). At the time, we were living in Florence, and we moved to Milan.

The two of them were also responsible for the interior design of the store in Corso Vittorio Emanuele, while Elio took care of the fashion side, and he'd asked Ampelio Bucci to coordinate the whole thing.

I remember going to Milan to see the store at the end of 1960; it was a kind of shock for me. I used to wear pleated skirts and moccasins, and I changed my style completely. I bought skin-tight jeans, high-heeled shoes and a bomber jacket, and I felt fabulous.

As though I'd been re-born. He came up with some totally explosive things, but he was a quiet person, soft-spoken and never frenzied. So there was this contrast between what he sold and his way of presenting himself. He was always extremely polite; the universe he imagined and created didn't seem to fit with his personality—there was a huge difference.

And even when he got involved in arguments, he always had such a calm way of saying things that were often shocking, but always presented in a straight manner. Always with that little smile, never over the top and always understated.

I was amazed by the contrast between the way he presented himself and the world he'd created, which was made not only of objects, but of explosive, visionary characters. Like Keith Haring, who illustrated the store, and Vivienne Westwood, whom he brought to Galleria Passarella and placed in the window, wearing a bra on top of her dress.

He made his own contribution to the world of jeans, leading to stratospheric success. I believe Elio taught me freedom of thought.

ANDREA BRANZI
Architect, designer and friend

I met Elio Fiorucci in Milan; he was the only person to buy a product designed by the Archizoom team, a really informal modular sofa called Superonda.

To him, fashion was a creative force in which each individual should freely bring their own identity. Fiorucci never designed fashion, but he picked up on it and planned it: his staff traveled the world and brought him products that were reworked. The store also hosted individual makers and small-scale producers who were unknown at the time.

The reason I moved to Milan with Massimo Morozzi—who was part of Archizoom—was that Fiorucci was appointed as an advisor to the Montefibre Design Center, a synthetic fiber manufacturer that wanted to set up a hub for industry, interior design and fabrics. But in Milan we already had relationships with Ettore Sottsass and magazines published by various manufacturers.

The mutual respect and trust between me and Elio continued after Fiorucci was taken over by Montedison; for a short time I worked with the Fiorucci graphics department on the design of financial statements and administrative documents for the board of directors, because Elio wanted even those to give an idea of what Fiorucci was about. At the time, those illustrated financial statements were a novelty in the serious meetings of the board, and seen as a brilliant idea. Then I suggested doing a fashion magazine; the title would be *Taxi* to convey the idea of rapid movement within the fashion world... Fiorucci was enthusiastic and we went to Angelo Rizzoli and Bruno Tassan Din, but the project didn't get the go-ahead. He also thought about opening a restaurant in the garage next door to the Torre di Pisa in Milan. The idea was inspired by the restaurant in the huge Biba store in London. But that didn't happen either. To sum up, the working atmosphere at Fiorucci was truly stimulating; the management style was always based on the unexpected and the interchangeable, with plenty of innovation and energy that drove everything and really changed Milan, which later became famous in Italy and all over the world.

My first job was at Rhodiatoce, where I worked on the development of polyester; then I went to Chatillon and worked with acrylic. After that, Sinteco. Then the magical moment came when Elio Fiorucci contacted the company and proposed setting up a research center, which could be useful in the promotion of synthetic fibers, no longer as commodities, but as something that could be more valuable, and therefore aimed at a wider market.

That was the start of the Montefibre Design Center in the early 1970s.

We found a place in Corso Vittorio Emanuele, a particularly lively, busy area. This research center was the very first of its kind in Italy, and worked not only to develop new products but also to research future trends.

It really was an extremely interesting venture, because, at the time, the only centers were in Paris. There the research was carried out by two women who worked for Galeries Lafayette—I think initially as buyers—and they thought they could do something different, using forecasting to understand what would sell, and seeking to interpret consumer demand.

The Montefibre Design Center was Elio Fiorucci's idea and he had joined forces with Ampelio Bucci for the marketing aspect and worked with Branzi and the Archizoom group for the interior design. It resulted in some really extraordinary projects. For textiles, clothing, fashion, etc.,

they involved international creatives, Nancy Martin and others, Be Khanh and so on, who brought a vision that was more international, not just Italian, and helped us to develop our work. We more or less created genuine style books for the entire textile sector, starting with trends in yarns and colors, and then fabrics and knits...

Once the manufacturers had made their products, we'd take the materials developed in line with our forecasting and carry out a real merchandising operation, contacting buyers and wholesalers... a process that foreshadowed the circular economy we speak of today.

The Montefibre Design Center lasted twenty years. There came a point when the firm decided not to invest more, and, for a brief period, only three or four of us were left. I was focused on developing trends in yarns for knitwear. Elio headed the center for ten years or so, from the beginning to the move to Corso Vittorio Emanuele.

He was always engaged, bringing ideas and advice.

Eventually there was no more work at Design Center, and I left Montefibre for good and decided to start my own business.

One of my first jobs was a consultancy with Elio Fiorucci on knitwear; this was in 1979–80. Cristina Rossi was still in the style office. It was a wonderful experience, and I have great memories of Elio. A fantastic person with a broad vision of the future.

FOULARDS

FIORUCCI

FIORUCCI

215

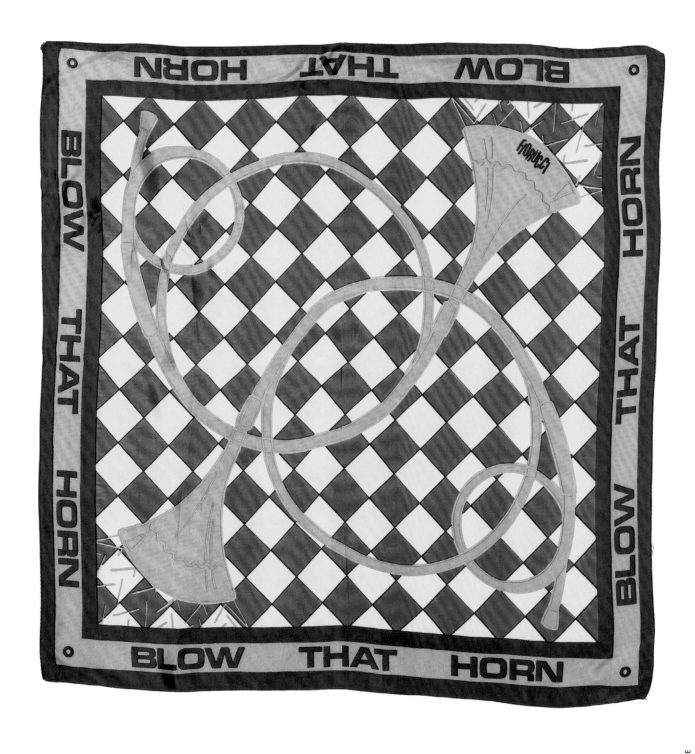

216

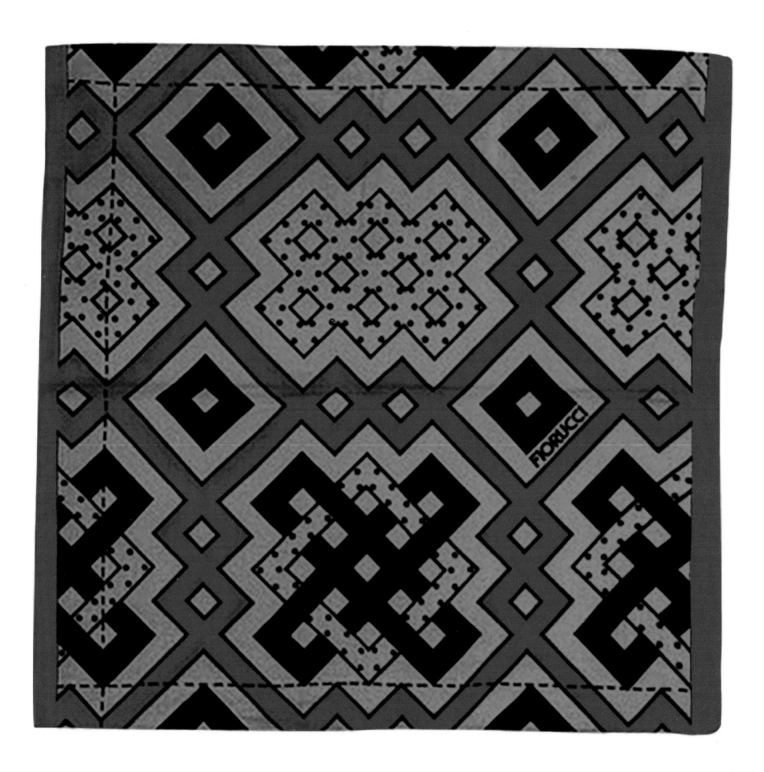

217

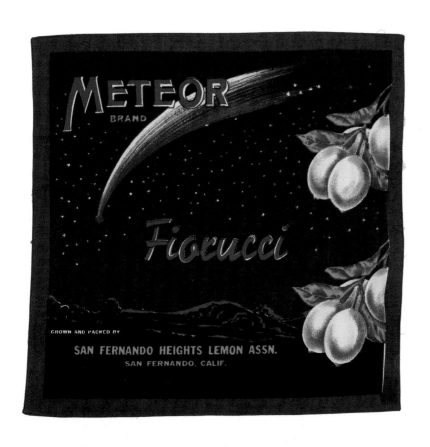

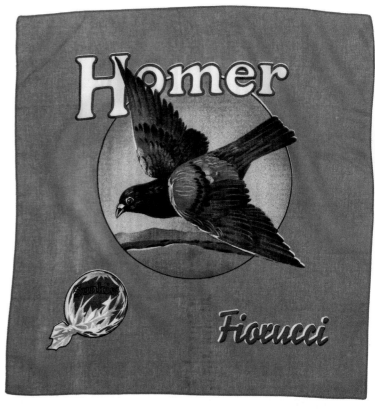

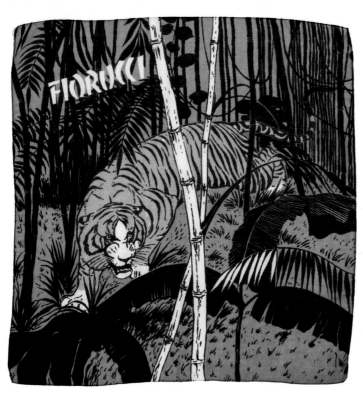

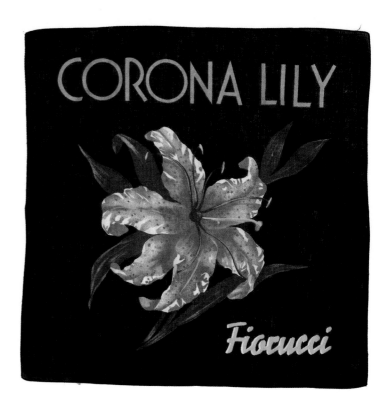

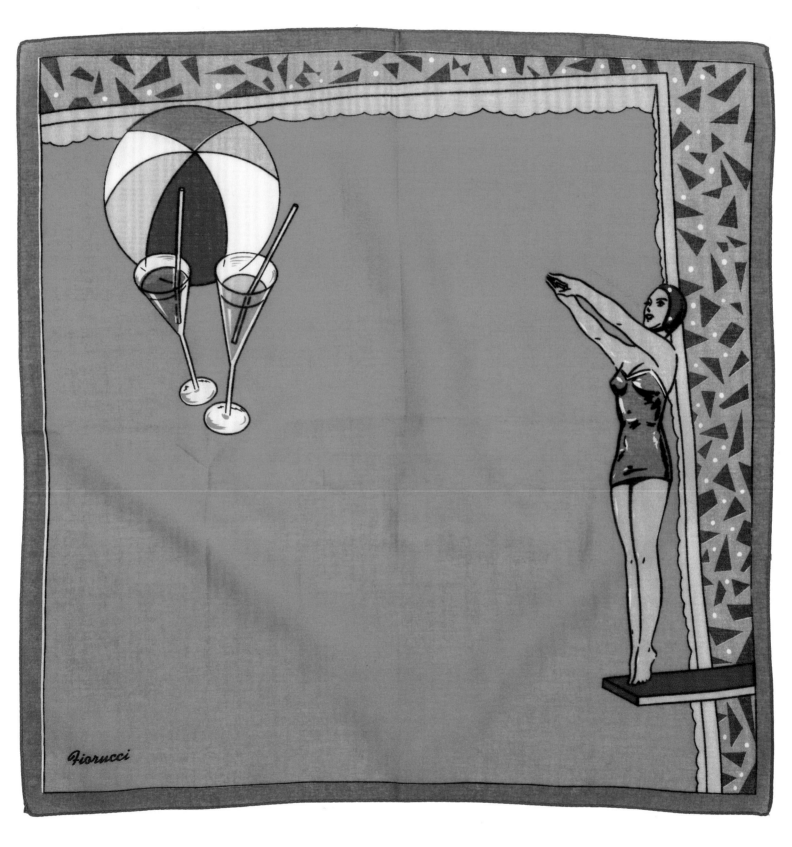

MAURIZIO COSTANZO
Journalist and friend

My friendship with Elio Fiorucci was a wonderful thing. When we met, our children were about ten, or a little older. The two of us took some fabulous trips with our kids. I remember one, to America, and I'm sure all the children have great memories of that. He was a gentle man, as well as being a true artist and a creator. A gentle man with a sense of friendship and tact. I mourned him for a long time, and I miss him still.

SAVERIO COSTANZO

Film director and son of Maurizio Costanzo; knew Elio from childhood. His family and Elio's holidayed together for many years, and the relationship endured

At primary school, my sister and I got called the Fioruccini, because we wore the clothes given to us by Elio and Cristina (Rossi, *ed.*). We mostly saw them in summer in Castiglione della Pescaia, at a house in the Roccamare pine forest. Elio rented a house near ours; I remember his Volvo station wagon, always loaded with crates of fruit. He came in on a wave of excitement. He took us outside to play, play... because with Elio, everything was a game. I remember a dinner for twenty people; my mother was arguing with Elio as she cooked, and she took the bowl of pasta and dumped it on his head. I was shocked, but then the adults started laughing—Elio first—and I realized it was all OK. But I really got to know Elio when we went to Los Angeles. I was ten (in 1985, *ed.*), and we went with his daughter Erica and my sister Camilla.

Visiting California with Elio was the best: he took us everywhere—Disneyland and the roller coasters... he was like a kid, and I had such fun with him, it was like being with someone my own age. My dad, Maurizio, couldn't spend ten minutes with us without going crazy. But Elio was just like a kid, he enjoyed being with us. Then in 1989, he came to see Erica in Roccamare and said to me, "Why don't you come to New York with us?"

So I did, and that was the trip that changed my life. I saw that incredible city for the first time through the eyes of Elio, who meant the world to me in those days.

My family was very Italian in the cultural sense, extremely deep-rooted. My first idea of the world was thanks to Elio, and I owe him a lot for that. He was the one who took me out and showed me, for example, something I still carry inside: he'd tidy hotel rooms and make sure we left them super clean, out of respect for the chambermaids. I was amazed by how popular he was in America: I remember one day, as we were going up an escalator, we saw a Japanese woman going down, wearing a white T-shirt printed with a dollar bill, with Elio Fiorucci's face where George Washington's should be. She couldn't believe it was him, and started to cry.

Another important time when Elio helped me was when he took me to Treviso. When I started university I wanted to join Oliviero Toscani's Fabrica, and Elio was a friend of his.

One day we set out from Milan and went to visit Fabrica. Toscani showed us round the magnificent building, and afterward Elio said something extraordinary, "It's wonderful, Oliviero, but where's the smell of shit? There's no smell, no cows, there's nothing real." Elio always managed to show you a different side of things. And then there was his friendliness, his charm, his voice and his constant smile, and his wonderful scent (Giorgio Beverly Hills, *ed.*).

I've never forgotten him, and I never will.

THERMAL PICNIC BAG.

FLAMINIA MORANDI

Maurizio Costanzo's first wife.
Their children grew up with Erica Fiorucci

I met Elio in 1976. It was the time when the Fiorucci
phenomenon was exploding, and he was in the prime of
life and at his most fertile in creative terms: he was thir-
ty-five. We met at Roccamare. We'd rented two adjoining
houses, and we discovered that in some ways our families
had parallel lives: at the time I was married to Maurizio
Costanzo, who had recently started a minor revolution
in television, breaking old rules and methods and doing
interviews on the fly, live, and bringing together people
who were considered poles apart in those days: a Christian
Democrat politician like Andreotti, for instance, with a racy
actress like Cicciolina. Maurizio himself appeared in the
first episode dressed informally, without a necktie, which
caused a stir. Elio was basically doing a similar thing not
only in the world of fashion but in the way we lived.
It was interesting, that coincidence in our lives. In the
following years we often thought about it, and we spoke to
Elio about it by phone just a year before he passed.
Our children, Erica and Saverio, were more or less the same
age. Camilla, my eldest, was two years older. After that we
spent the summers together for many years, and the kids
continued to be friends, with a strong bond. I became friend-
ly with Elio and Cristina, his partner and Erica's mom, and
we stayed friends forever. We didn't see each other often, but
when we did there was immediately a special connection. We
shared a time that had been really important in our lives.
In those two neighboring houses in Roccamare, we lived
like a tribe, because Elio always had so many people and
family members around him. There were his older daugh-
ters Ersilia and Augusta along with Floria and her kids.
The nanny, friends dropping by. Elio and I agreed on a lot
of things, although at times we had terrible arguments, for
reasons I understand better now than back then.
Elio was like a prophet. Prophets don't tell you the future.
They're people with a highly developed sense of intuition—
the most important sense in a person, bringing together
intelligence, spirit, emotions and passion. Lightning-quick
reactions, instant and sudden ideas. Elio had enormous
respect for nature and animals; he watched what he ate
and was an early health-food nut. He loved to cook garlic:
he'd put the unpeeled cloves in a pan and sauté them.
But there was always a great crowd to feed. I used to go
shopping with Cristina to a meat wholesaler, where we'd
buy quarter of a cow, which was butchered and put in the
freezer to do huge barbecues on summer evenings.
Elio had a fierce hatred of any ideology. He hated anything
that was excessively rigid and structured. Ideologies are

like blinders, they allow you to see reality only through their filter, and he detested that. This was in the middle of the "Years of Lead." I was left-leaning, and we disagreed on this. I had my ideas, but Elio was completely free in his opinions. Here again he was like a prophet, supremely free from all ties, from any framework for interpreting reality. Sometimes he annoyed me, because he seemed almost amoral in his acceptance of any cultural expression, as long as it brought something new and vibrant. With arguments or without, we used to talk about all kinds of things. Those weren't formal dinner parties. Elio was completely indifferent to sophistication for its own sake. Relationships with Elio were always based on a sentimental component. Every dinner with the tribe was a very human event.

So many evenings, so many grape harvests, so many days in Uccellina Park. Elio really loved the Maremma region, which was different in those days. It was a fascinating, primordial place, unspoiled, with the tracks of wild boar on the beach and young cattle, skinny and wild, along the canals.

Uccellina had recently been made a nature reserve. Elio bought a piece of scrubland with two old farmhouses in the Uccellina. We had a mutual friend, a true Maremma woman, although she wasn't—she was from Bolsena. Daniela was passionate about the countryside and about horses. Elio put her in charge of running the farm, which was really difficult, as it produced practically nothing. In the end Elio and Cristina decided to get rid of it, and their relationship broke down at more or less the same time.

Elio was very fond of my children, especially Saverio, who amused him a lot: he used to send us suitcases of "Fioruccino" clothes, which made Camilla and Saverio very happy because all their schoolmates were jealous. I still have photos of them in their Fiorucci jackets with different color sleeves. One summer Elio, Maurizio, Erica, Camilla and Saverio decided to take a trip together to the USA: the two fathers with their kids. Elio took the kids to amusement parks and Maurizio stayed in the hotel watching TV.

That's where he saw that American programs were produced by private companies and then sold to the networks. When he got back to Italy he decided to do the same: he set up a production company, the first one to produce its own programs to sell to networks.

That was the start of "Fascino," which produced the Maurizio Costanzo Show and many other programs for years. So it was thanks to Elio and that trip that Maurizio created the first Italian TV production company.

DANIELA SACERDOTE

Founder, Collistar Cosmetics

I worked in cosmetics for many years. There came a point when I decided I wanted to live in the world's most creative place, which happened to be Milan. I asked Giuseppe Crisci, a friend of my husband's who worked at Fiorucci, to arrange a meeting for me. I told Elio immediately, "I want to come work here. I want to be in the most creative place there is," and he said, "Come! You can help me in so many ways, especially in public relations." The feeling was mutual. I had an office in Galleria Passarella, and one in Corsico. I stayed at Fiorucci for almost a year, and in that time the New York store opened; it was publicized even before the inauguration. Elio was really pleased; a lot of journalists came over from Milan.

One day Elio called me and said he wanted to throw a special three-day party in Paris to coincide with Fashion Week. There were just two weeks to go… and Elio, the creative genius, said to me, "You know what we'll do? We'll print millions of flyers and invade Paris, and then we'll have a party that lasts three days, all day and all night." There was nothing you could do to stop him; when he had an idea in his head he wouldn't even listen to you. So off we went to Paris. The venue was huge: the Salle Wagram seen in the *Last Tango in Paris*. There were people at the party, but not the great crowd Fiorucci had imagined. I went to bed, but later, at 4 a.m., Elio called me and said, "Daniela! I want to close, there aren't enough people." I replied, "You take a plane back to Milan and leave this open for three days. Otherwise it's really bad for your image." And that's what he did. I should say that he listened to me, even though we didn't work together very much. He also came up with a brilliant idea: if a journalist wanted a dress that didn't exist, he'd get it made, on condition it was captioned "Fiorucci Model" in the magazine. And then if anyone came into the store looking for it, they were told it had sold out.

Elio truly was a pioneer. His genius was the order of the day. Apart from the continuous flow of ideas, he really didn't concern himself with reality. He was creativity without the consequences.

One time he said to me, "By the time I have to give a product a code, I've already lost the desire to buy it." And that describes him perfectly.

prêt à porter

FIORUCCI

PARIS 79

Fiorucci
vous attend
au Plateau beaubourg,
"Plateau des enfants"
Atelier des enfants *
le 25 octobre * de 15h. à 20h.
pour vous présenter :
- la Collection printemps, été 78
- et l'exposition : Paris ont Photographie
Les Enfants de Paris ont Photographié
la Mode de
Fiorucci

* mardi 25 octobre 77

17 - PARIS
CENTRE NATIONAL D'ART ET DE CULTURE
GEORGES POMPIDOU
(Arch. R. Piano et R. Rogers)

Editions CHANTAL, 74 rue des Archives
Imprimé en France - Reproduction inte

IRIS
MEXICHROME

EIGH

TIES

CATERINA CASELLI

Singer and music producer

For me, Elio Fiorucci was a friend in the true sense of the word: generous and curious, he created harmony around him and was always extremely attentive and caring to others, just as Cardinal Martini urged us to be. I like to remember Elio at a delicate time in my life: my son Filippo had just graduated in Brussels in international relations, without a clear idea about his future; some of his university friends decided to continue their studies abroad or go into diplomacy. It was 1993. We'd separated from the American company CBS to go our own way in music publishing and record production, our core business. My husband and I wanted to sell our stores, including the original one, Messaggerie Musicali in Milan. We told Filippo about our decision. To our surprise, he said he wanted to stay in Milan and run Messaggerie Musicali himself, if we trusted him to do it.

We believed in him and didn't hesitate to finance him. And Elio Fiorucci generously introduced us to people who helped us a lot.

We were reassured by having Elio nearby; he was truly extraordinary, full of excellent advice he'd gained from his great experience. I get teary just thinking about it. I couldn't believe it when we heard he'd died; most of all I couldn't come to terms with the fact that he was alone, nobody was with him. It was a terrible shock. Elio came to our house so many times; he'd talk with Filippo, and say to me, "I really like talking with your son." He loved young people; like all of us he hoped the new generation would bring greater humanity to the world, and that hope sustained him. His memory keeps me company. He was so lovely to be with! So many times we had lunch together at Girarrosto, chatting about all kinds of things. I learned from him. I've never met anyone who spoke badly of him. There was always a great feeling of positivity around him, from the things he said, the way he thought; he never judged, and he brought out the best in people. Good is more contagious than bad, he said. We all miss him so much.

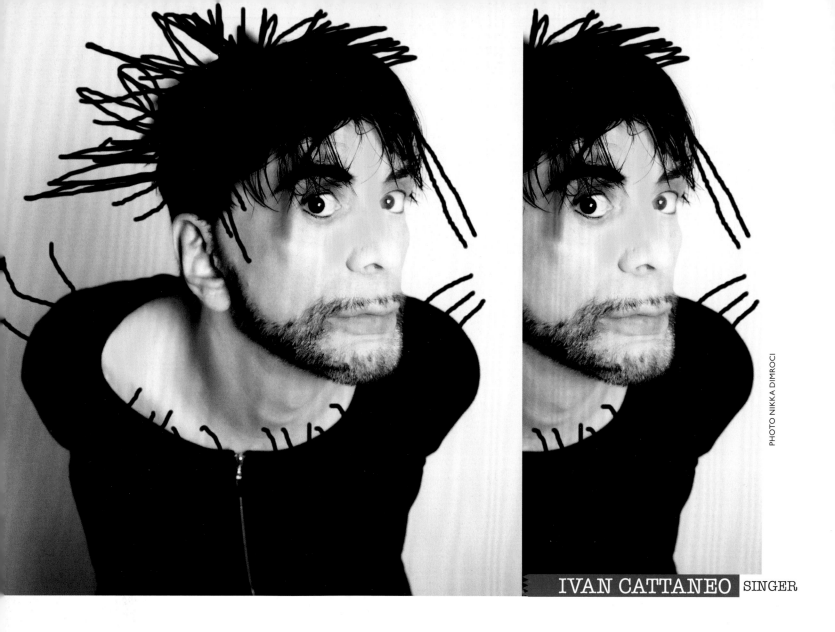

PHOTO NIKKA DIMROCI

IVAN CATTANEO SINGER

I don't remember how I met Elio, but I first heard about Fiorucci in the very early 1970s in Milan. There were two specific stores—one was Fiorucci and the other Fulgenzi—where you could find really unusual stuff—you could call it hippie style. I met Elio by accident in his store, which wasn't as big as it later became. I saw him again at nightclubs and parties, and we became friends. Fiorucci had organized a party at "Le cinemà" disco for the presentation of the Mickey Mouse T-shirts. We went together: Elio, me and Loredana Bertè. When we arrived, the bouncer wanted to let me and Loredana in but not Elio; he had no idea who Fiorucci was! After a lot of argument we finally managed to get the guest of honor into his own party! (Something similar happened in New York at the opening of Studio 54, ed.) I was at the opening of the San Babila store too, when Keith Haring covered the whole place with his graffiti. Later on, when I was working for the music video broadcast *Fuori di Testa*, I went to Corsico to interview Elio in the Fiorucci warehouse/archive where they kept all the samples and curiosities, the clothes and accessories he bought all over the world.

I last saw him at Fashion Week six years ago, in a store in Via Montenapoleone. He was very complimentary; Pinina Garavaglia was there too. It was good to see his smiling face again, it made you feel at ease in any situation. He was a wonderful person, very calm, and a great communicator. He didn't have the stress of modern life; ultimately, considering what he sold, he was a really old-fashioned soul, he seemed very wise.

I went to his funeral in the church of San Carlo, opposite his store. Jo Squillo was with me. I saw Urbano Cairo, Oliviero Toscani, Caterina Caselli, Afef and many other celebrities, but none of the fashion designers were there. Very strange!

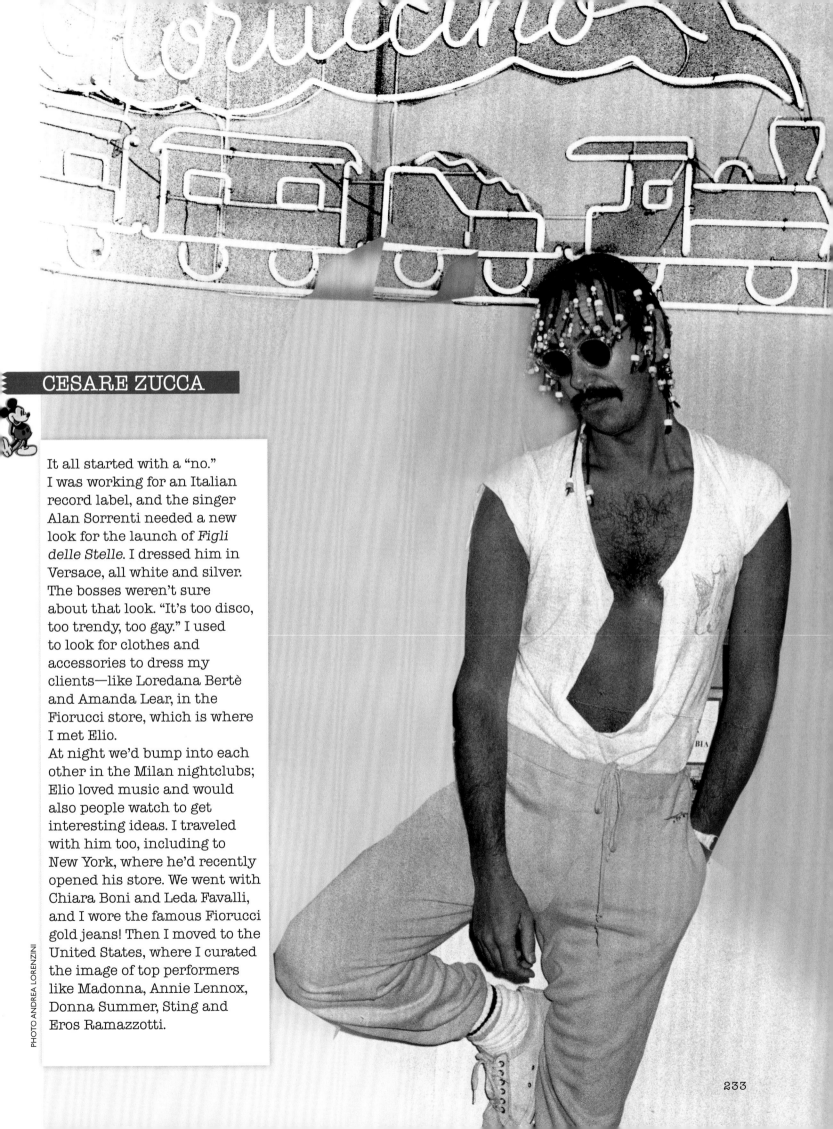

CESARE ZUCCA

PHOTO ANDREA LORENZINI

It all started with a "no."
I was working for an Italian
record label, and the singer
Alan Sorrenti needed a new
look for the launch of *Figli
delle Stelle*. I dressed him in
Versace, all white and silver.
The bosses weren't sure
about that look. "It's too disco,
too trendy, too gay." I used
to look for clothes and
accessories to dress my
clients—like Loredana Bertè
and Amanda Lear, in the
Fiorucci store, which is where
I met Elio.

At night we'd bump into each
other in the Milan nightclubs;
Elio loved music and would
also people watch to get
interesting ideas. I traveled
with him too, including to
New York, where he'd recently
opened his store. We went with
Chiara Boni and Leda Favalli,
and I wore the famous Fiorucci
gold jeans! Then I moved to the
United States, where I curated
the image of top performers
like Madonna, Annie Lennox,
Donna Summer, Sting and
Eros Ramazzotti.

233

ISABELLA TONCHI

Stylist, 1981–86

I was just 18 when I met Elio Fiorucci; it was accidental and funny. But it was he who made me a fashion designer.

I was a student on vacation, with zero knowledge of the fashion world, and I happened to be at a fur fair when Elio stopped me and asked me if I'd made the clothes I was wearing. I replied, "Of course!" And he hired me on the spot for his Milan store. With Elio I got to know about fashion and learned what's been my job for the past thirty-five years. Elio introduced me to Asia, and Japan in particular, where I still work, and taught me that fashion is fun, not just business.

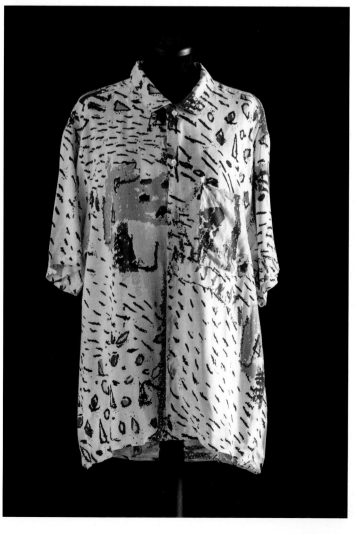

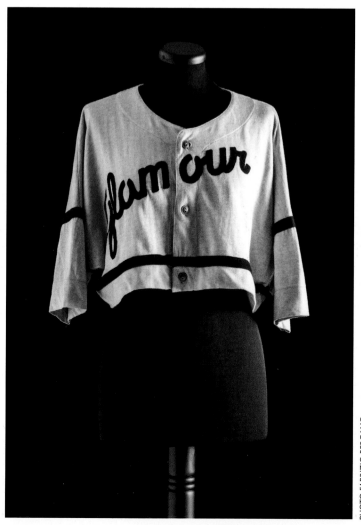

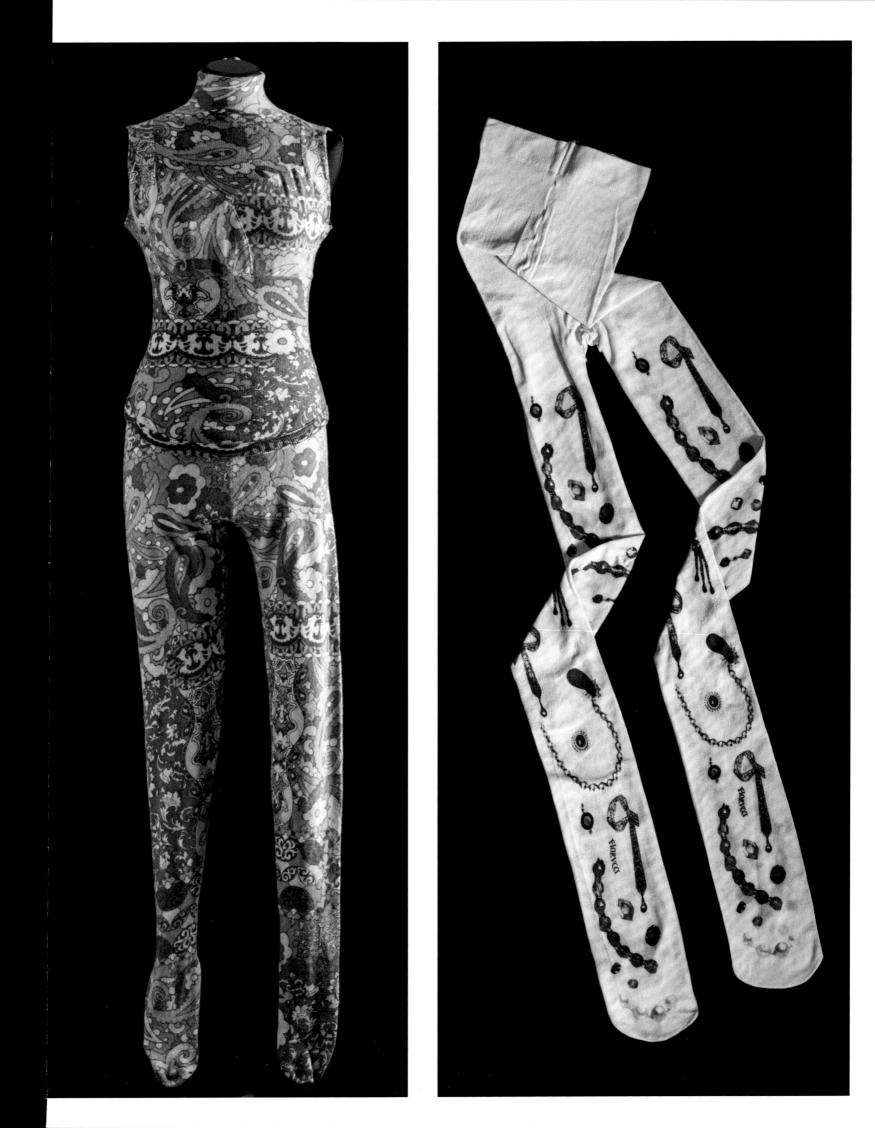

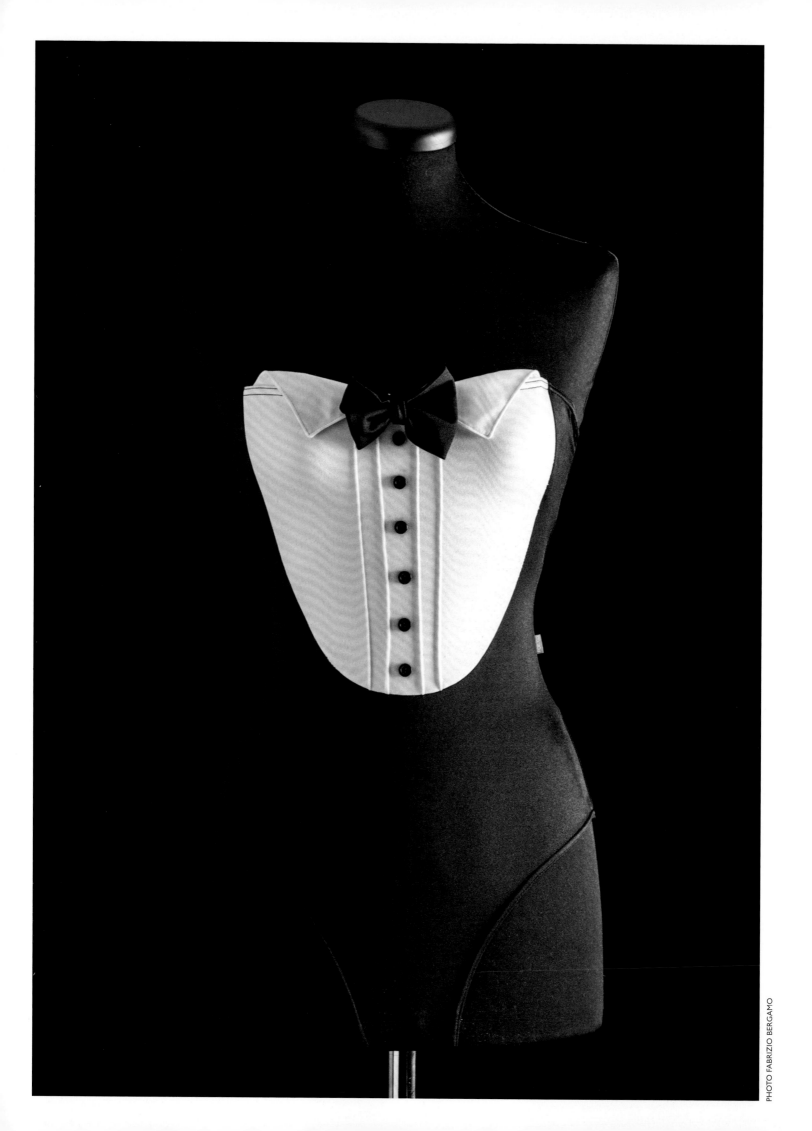

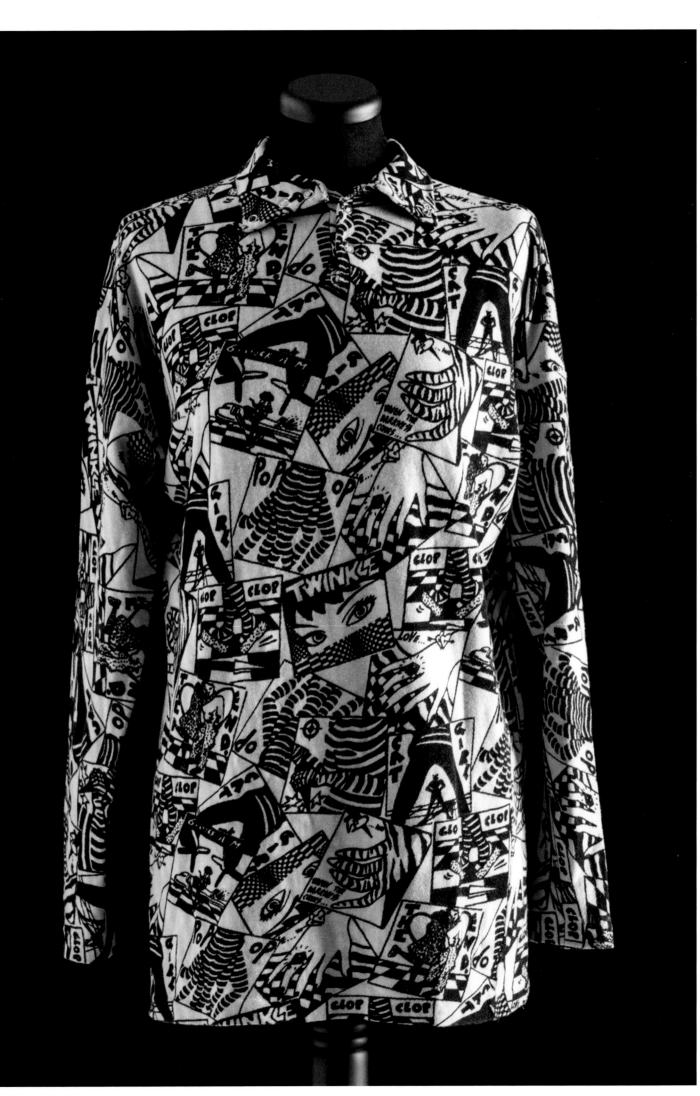

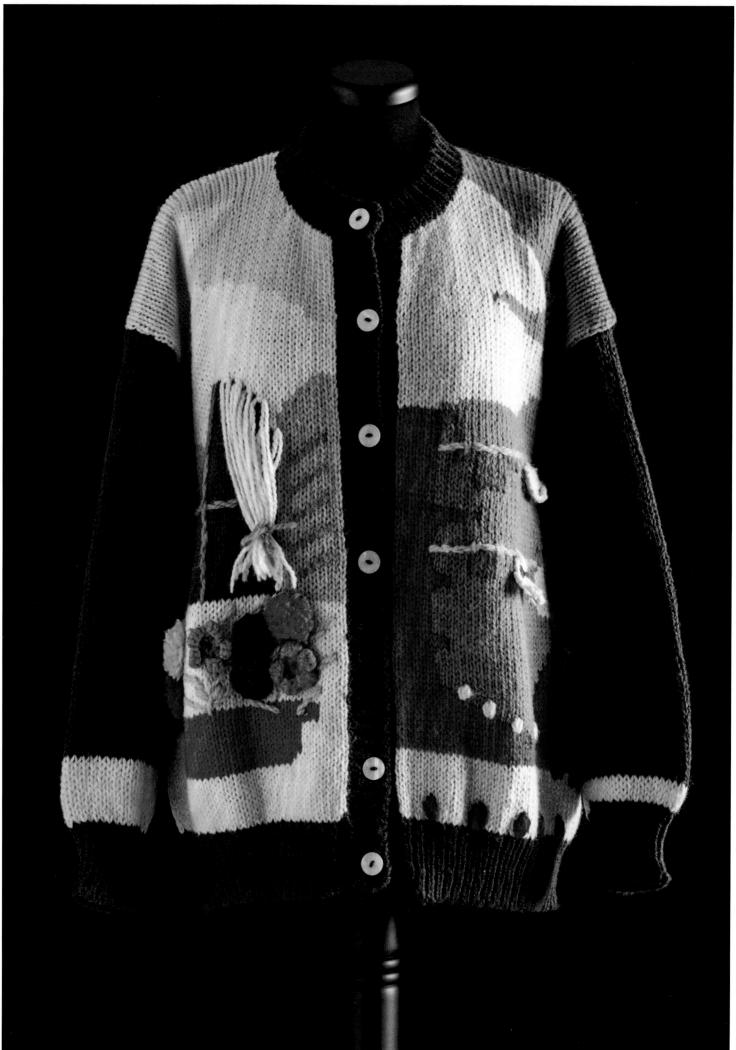

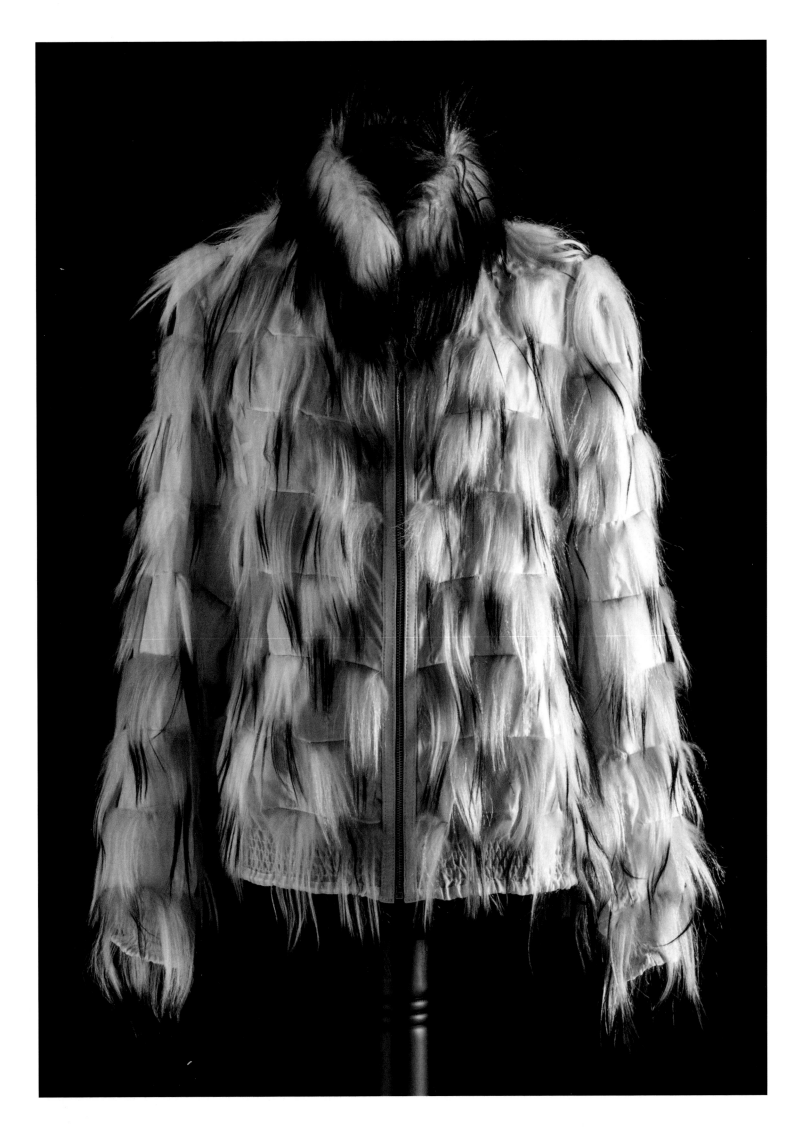

Founder and art director of *i-D magazine*

I'm looking through the shelves in the studio of our London home. Tricia and I have lived in the same house since 1970. Along with many happy memories, it's full of fifty years' worth of stuff. Oliviero Toscani and Donna Jordan used to stay in the room on the top floor; now it's the studio. He would be photographing for *British Vogue* while I was the art director, and one time he asked if I would choose the logo for his poster image with Donna and Pat (Cleveland, *ed.*), wearing Fiorucci black shiny jeans. That spring—around 1976 or 1977—I met Elio for the first time at Oliviero's home in Tuscany.

Now I think Fiorucci was a fairy godfather for *i-D*. I founded the magazine in 1980 as a personal project, which I funded by working as a commercial art director in Europe. I spent a lot of time in Italy, and Milan was where I found many friends and work associates. Fiorucci became a major client, and because he loved *i-D* he encouraged and financially supported the magazine for a year between 1984 and 1985. At that time I was thinking of closing down, because the costs were too high.

I did special advertising in *i-D* for Fiorucci, and worked on the sticker project with Panini (in 1984, *ed.*), and that helped to pay for the first computer for my instant design studio. I was also able to pay assistants, who came straight out of college. One of them was Caryn Franklyn, who became *i-D*'s first fashion editor. There was Robin Derrick, who went on to become art director at *British Vogue*, and Steven Male, who worked as art director with me at *i-D* before moving to *Vogue* in New York.

Elio was an inspirational teacher who rarely spoke English; we communicated by telepathy. His positive energy attracted creative talent like a magnet. His global inquisitiveness collected ideas from all over the world, from Tokyo to Woodstock.

The Fiorucci spirit entered the dictionary of fashion and the minds of a generation that's grown up to work in the industry, from the 1980s to the present day, fifty years on. Love Therapy became his last project, combining kitsch and romance as a mantra for a more peace-loving world. God bless Elio Fiorucci for all the wonderful memories.

Wednesday 7th March 2018

Hi Franca,
I hope you can edit this so it
makes sense in translation.
Please send me a copy and
if you want scanned images from
i-D, I can organise from the studio.
Much Love
Terry

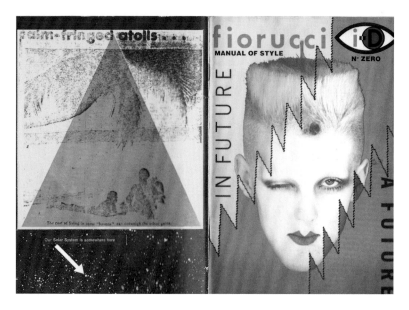

La questione non è che cosa porti ma come lo porti, *straight up* (dalla testa ai piedi)». «Nell'80, quando è uscito il primo numero della rivista, in tutto il mondo c'era un divario fortissimo tra quello che vedevi addosso alla gente per strada e quello che vedevi nelle foto di moda. E, allora come oggi, la moda è molto di più al livello della strada, all'incrocio tra la musica, lo stile di vita, il gusto del vestire eccessivo (dressing up), che è anche molto un gioco, un nuovo gioco di riferimenti». «Per questo decisi che volevo fare una nuova rivista». «Con me nel progetto c'era Al McDowell, il pittore che mi aveva aiutato a fare il mio libro sui punks, *The Pink Punk Book*». «Ho aspettato sei mesi prima di cominciare a lavorare con lui. Non successe niente. Così iniziai da solo. La mia idea era semplice, fermare la gente per strada, era quello che faceva Perry Haines, e chiedere loro delle cose di base: che tipo di musica ti piace, in che tipi di posti vai, che cosa ami, che cosa odi, dove hai trovato i vestiti che hai deciso di indossare; e poi mettere solo foto e didascalie nel giornale senza far alcun lavoro più di redazione sul testo, senza fare nessun lavoro di stile nei vestiti». «A I.D. hanno contribuito così, raccogliendo il materiale, volta per volta persone diverse, 4 o 5 per numero, a volte le stesse per più numeri. Non si trattava di suggerire delle regole, di dire quali sono le cose giuste da indossare, ma di mettere insieme elementi diversi, semmai di evidenziare le contraddizioni». «Per questo noi non abbiamo pubblicato nella rivista delle fotografie di persone normalissime, non ci si deve vestire in modo estremo per forza. Uno deve solo ritrovarsi in quello che indossa (anzi la tendenza ora è *dressing down* invece di *dressing up*)». «Ogni bottone, ogni laccio hanno una storia da raccontare. Unire insieme tutto questo, skinhead, punk, mod, romantic significa parlare di come siamo cresciuti, dell'eredità che indossiamo». «Penso che tra dieci anni si potrà guardare a I.D. come ad uno specchio che riflette fedelmente quello che è accaduto in questi anni. Non in un senso sociologico semmai questo è un giornale che fa della sociologia un gioco». I club, le discoteche dove la maggior parte della gente quale si ritrova, con la loro musica eliminano la conversazione, allora la tua identità esprimi, non attraverso le parole, ma attraverso la testa, i capelli e i cappelli. La danza, e qui il gioco si fa antropologico, nei club è la conquista di un territorio, forse per questo che si è comunicato a portare

«Non è importante che cosa indossi ma come lo indossi».

Terry Jones, 35 anni, professione grafico, fondatore di I.D. (Identity) la rivista di «moda» che qui vi presentiamo non smetterà mai di ripetervelo. Occhi e capelli chiari, viso luminoso, vestito normale che non diresti neppure che è inglese, né lui, né il suo modo di vestire, ti fissa con il suo sguardo pungente e il sorriso appena accennato e già ti sconvolge le carte in tavola, perché tu ti aspetti un tipo dall'aspetto deciso, un po' oltraggioso. Invece lui di oltraggioso ha solo gli occhi con cui guarda le cose e poi le fissa, le fa vivere, attraverso la sua grafica nel giornale. E guai a dirgli che le sue copertine sono un po' giapponesi, per via di quei colori piatti, puliti, sfolgoranti. «Lo credi davvero?». Guai a fissare delle regole, dei riferimenti fissi. «Identity non dice che una cosa è in e una cosa è out».

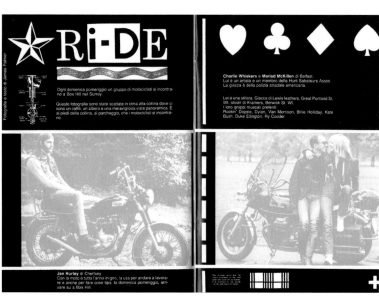

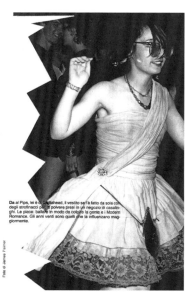

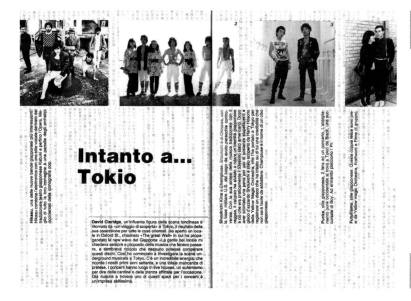

Intanto a... Tokio

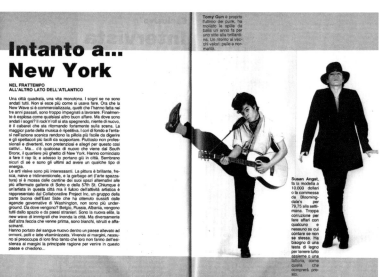

Intanto a... New York

NEL FRATTEMPO ALL'ALTRO LATO DELL'ATLANTICO

Una città quadrata, una vita monotona. I sogni se ne sono andati tutti. Non si esce più come si usava fare. Ora che la New Wave si è commercializzata, quelli che l'hanno fatta nei tre anni passati, sono troppo impegnati a lavorare. Finalmente è esplosa come qualsiasi altro buon affare. Ma dove sono andati i sogni? Il rock'n'roll si sta spegnendo, niente di nuovo, è il cabaret che sta ritornando fortemente sulla scena. La maggior parte della musica è ripetitiva. I cori di fondo e l'enfasi nell'azione scenica rendono la pillola più facile da digerire e gli spettacoli del West Side più facili da sopportare. Piuttosto non professionali e divertenti, sono pretenziosi e allegri per questo così cattivi... Ma... c'è qualcosa di nuovo che viene dal South Bronx, il quartiere più ghetto di New York. Hanno cominciato a fare il rap là; e adesso lo portano giù in città. Sembrano sicuri di sé e sono gli ultimi ad avere un qualche tipo di energia.

Le arti visive sono più interessanti. La pittura è brillante, fresca, naive e tridimensionale. La garbage art (arte spazzatura) si è mossa dalle cantine dei suoi spazi alternativi alle più affermate gallerie di Soho e della 57th St. Chiunque è un'artista in questa città ma l'attività artistica è rappresentata dal Collaborative Project Inc, un gruppo della parte buona dell'East Side che ha ottenuto sussidi dalle agenzie governative di Washington, non sono più underground. Da dove vengono? Belgio, Russia, Albania, vengono tutti dallo spazio e da paesi stranieri. Sono la nuova elite, la new wave di immigrati che inonda la città. Ma diversamente dall'altra feccia che venne prima, sono bianchi, istruiti e affascinanti.

Hanno portato del sangue nuovo dentro un paese allevato ad ormoni, polli e cibi vitaminizzati. Vivendo ai margini, nessuno si preoccupa di loro fino tanto che loro non fanno dell'esistenza ai margini la principale ragione per venire in questo paese e chiedono...

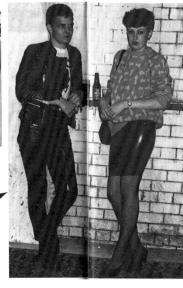

Arianne e Poly. Vengono da Brighton. Poly indossa una giacca di Johnson, Brighton, Arianne giacca di Flip, Londra e pantaloni di Johnson. A loro piace frequentare posti in.

Nik e Diane. Qui al Dungeon club di Stockport. Nik veste pantaloni di pelle fatti su misura, lavora in una fabbrica di abbigliamento. Diane ha acquistato la sua gonna in un sex shop, in Hazel Grove, a Stockport, ha intenzione di ricoprirsi sempre di più con la plastica del sex shop, per tenersi caldo questo inverno. Diane lavora in una agenzia ippica.

Gavin e Crispin di Brighton. Gavin vive a Brighton e lavora da Robot, la sua giacca è di Johnson, 35 Lag, la camicia è di Flip 4 Lag, i jeans sono di Robot, 5 Lag, gli stivali sono di Johnson 30 Lag, il taglio dei capelli è stato fatto da Fredericks. Il suo scheletro l'ha trovato in un negozietto lungo il molo di Brighton. Gli piacciono i Cramps. Crispin lavora da Moonbeam Design. Giacca di Pizaz, Lag 35; T-shirt è di Boy, Kings rd.; scarpe di Robot, Lag 28; taglio di capelli di Fredericks.

I.D. apre i tuoi occhi.

Dick si atteggia a Captain Neville in un abito della collezione di V. Westwood - World's End. Cappello Lag 20, giacca Lag 70, pantaloni Lag 40, camicia Lag 25. «I calzini me li hanno dati gratis. Questo stile pirata fa parte della scena dei Bow Wow Wow, una buona banda».

Jane e Prue. Pantaloni di Deguilles, Ken M'kt Lag 18 ciascuno. Camicie di PX a Lag 30 ciascuna. Scarpe di John Lewis Lag 7. I capelli sono stati disegnati e realizzati da Prue. «Ci piace vestire bene e essere snob e non ci va la gente con i jeans stracciati e la giacca di pelle».

Carl. Jeans presi in S. Molton St. La giacca con cappuccio, giocata sul contrasto bianco e nero, è stata un regalo. Camicia fatta su misura in Kings Rd. Scarpe di Oxfam. Preferenze musicali: David Bowie e Rod Steward. Non gli piacciono: «il calcio, lo odio, non sopporto il freddo, il sole pallido e fiacco, capite cosa voglio dire, amo le donne e odio essere scambiato per una checca».

Il più interessante mercato dell'usato è in Brick Lane alla domenica mattina.

Foto di Thomas Degen

Intanto a... Paris

Quest'autunno invece dei soliti fine settimana in montagna, fatevene una a Parigi. In fondo non è così cara. Per quel che succede e per i personaggi vai avanti a leggere... Oggi le risorse dell'Europa, domani quelle del mondo...

Foto di Philippe Piccoli

Paquita e Keju. Paquita è la geisha del Palace, prima faceva lo spogliarello a Pigalle, poi si è spostata al Palace, il tempio della notte, della Parigi New Wave. Lei ha sempre una risposta pronta. Keju è un giapponese, El Cordobes. Ogni tanto, mentre sta andando a Madrid si ferma a Parigi. Parla soltanto inglese, in questo momento è molto innamorato di Paquita.

Pierre e Gilles. Starsky e Hutch. Pierre è bruno e Gilles è biondo et *ils sont beaux et il sont muscle.* Sono totalmente, completamente impegnati nel loro lavoro. Hanno bisogno uno della creatività dell'altro. Vivono pienamente le loro fantasie. Loro rendono le cose di meno valore belle e poetiche. Arnold, il loro orsacchiotto preferito, qualche volta risponde al telefono.

Eva e Charles. Si amano da morire e si sposeranno a settembre. Charles è un pittore che si sta impegnando molto nella musica. Eva ha 16 anni e va ancora a scuola ma vorrebbe diventare un'attrice famosa. Nata per essere una stella un giorno sarà celebrata sul palcoscenico. Eva vi fa diventare matti. Non porta le mutande, mai. Che carattere.

Irie e Federique. Irie, che ha lavorato per Kenzo per molti anni, ha recentemente lanciato in Giappone una sua linea. Lavora anche come vetrinista nonché nel campo della fotografia e del cinema. Irie ama la pelle degli animali per fare abiti. Ha la febbre della giungla. Federique la la modella da Chanel, lo è diventata la numero 1 in rue Cambon. Tuttavia la sua vita privata rimane un mistero profondo.

Foto di Philippe Piccoli

Niente è IN o OUT, il vestirsi deve essere divertimento! Come questo gioco. Ognuno può ritagliare l'oggetto che desidera e crearsi la propria immagine, la propria identità.

crown

helmet

kilt

plimsoll

dress (dresses)

lady d-i-y?

fiorucci i-D

Numero unico in attesa di autorizzazione.

Direttore:
Elio Fiorucci

Coordinamento generale:
Carlo Tunioli

Copywriter e traduzioni:
Margherita Grenzi, Carlo Tunioli

Segreteria di redazione:
Maria Vittoria Lозito

Editori Fiorucci,
Galleria Passarella 2, Milano - Italy
tel. 02/792452

Fotocomposizione:
Textype di Antonio De Natale, Opera (MI)

Fotolito:
Bassoli, Milano

Stampa:
Grafiche Fratelli Azzimonti

Edizione inglese
Editors/Direttori: Terry Jones
Collaboratori: Perry Haines, Al McDowel,
Moira Bogue, Alix Sharkey.

Fotografi:
James Palmer, Thomas Degen,
Peter Ashworth, David Claridge,
John Carmikon, Steve Dixon,
Martin Grainger, Tamar Hoepfi,
Michel Momy, Philippe Piccoli,
Hugh Johnson, Robin Ridley,
Simon Brown.

Grafica: Terry Jones

i-D would never be possible without the help of many other people, especially: jolly of Better Badges, Tricia, for her patience, Caroline Baker, Steve Johansson and our readers.

In copertina:
fotografia di Scarlett di Thomas Degen;
design di Terry Jones, make-up Pantone.

«Style isn't what - but how you wear clothes. Fashion is no longer IN or OUT.»
Terry Jones

«Fashion in the way you walk, talk, dance and prance»
Perry Haines

«Fuck art - let's dance»
Al McDowell

SYNTAX ERROR

Foto di Thomas Degen

243

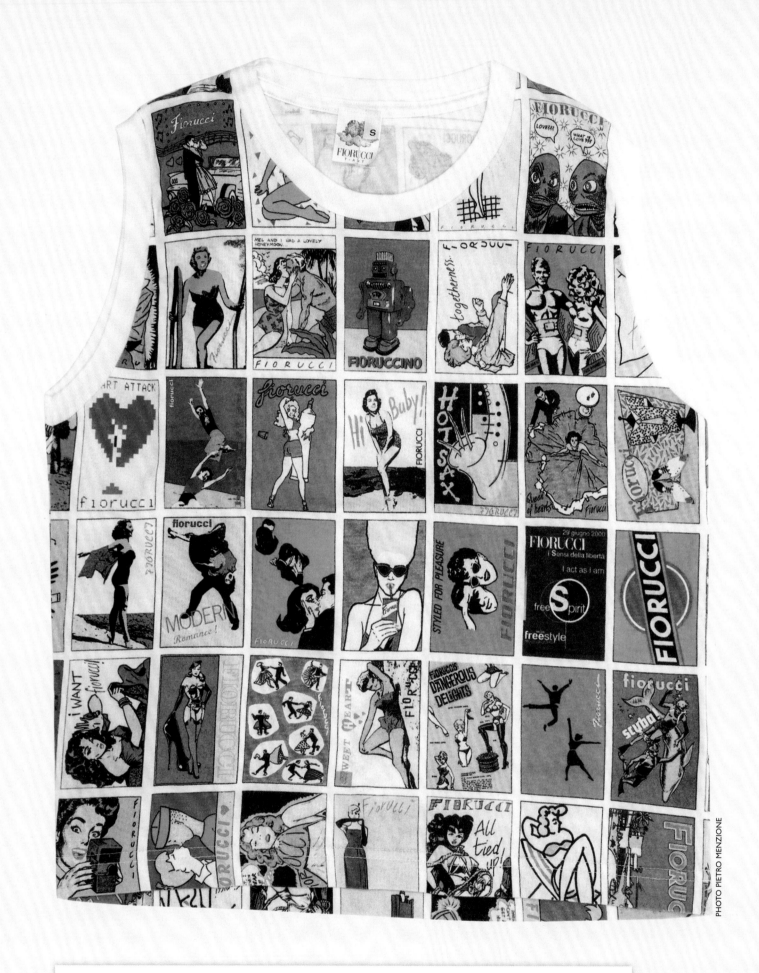

T-shirt printed with images of the Panini trading cards. Produced for the opening of the *Fiorucci Freestyle* exhibition organized by Gianluca Lo Vetro at the Arengario, Milan, in 2000.

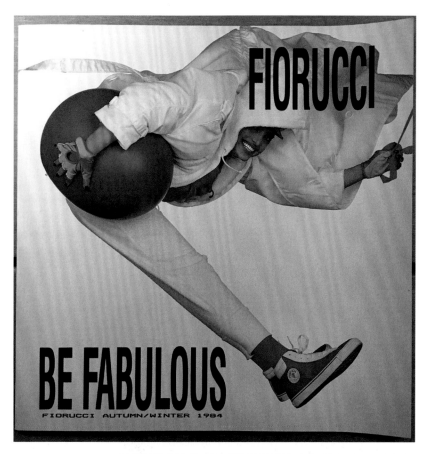

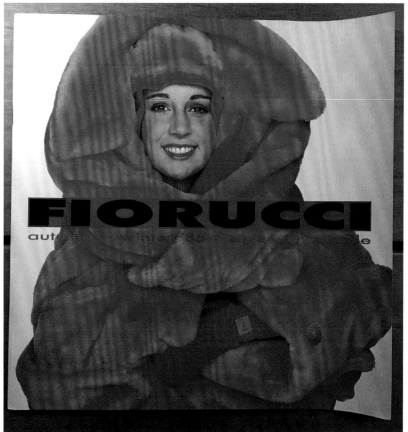

Catalogs for the 1984–85 fall-winter collection.
AD: Terry Jones. Photo Oliviero Toscani.
Styling Maria Vittoria Lozito, Isabella Tonchi.

NICOLETTA POLI

Friend and collaborator

One day in 1970 I went into a store in Piazza San Babila in Milan, owned by a visionary young designer named Elio Fiorucci. We chatted about this and that, and from that came the idea for hot-water bottles shaped like hearts. It was a stroke of genius and immediately led to the production of other hot-water bottles in the shape of strawberries and flowers, and a friendship that lasted a lifetime. The early period of our collaboration was completely crazy, chaotic, creative and exciting, full of unplanned yet joyful trips all over the world in search of ideas and inspiration, prototypes of all kinds, creative objects that cost pennies but were incredible. But little by little the chaos became long-term projects, improvisation became organization and the wild vision became specific goals. In a nutshell, we grew up.

What we had in common was a way of interpreting communication, and a similar kind of imagination; these qualities allowed us to anticipate trends. One example? When they made motorcycle helmets mandatory (in 1986, *ed.*), we had a brilliant idea: we contacted AGV and offered to decorate their helmets with Fiorucci designs to make them super-trendy. It was an enormous success!

But our most extreme and pioneering project was with another classic Italian brand: the legendary Panini of Modena. At the time they only made cards of footballers, cars and topics that appealed to boys and men. But the idea was to make some that were different from the conventional sets. The numbers were extraordinary: more than 150 million trading cards sold with iconic Fiorucci motifs. It was a marketing coup and a project that changed the rules in the market.

We not only worked together, we also became good friends. Our friendship budded in our first meeting and blossomed over the years. The wonderful thing about Fiorucci was that he gave me the opportunity to learn, explore, experiment, take risks and create without limits. It's hard not to feel lucky, growing up at the side of a genius like Elio. Such deep-rooted ties can never be broken. His memory and his visionary spirit live on in the work I do for my communications agency. An homage to my mentor, a tribute to a great friend.

PANINI OF BOLOGNA, FAMOUS FOR ALBUMS OF CARDS FEATURING FOOTBALLERS, WAS COMMISSIONED TO PRINT THE FIORUCCI VERSIONS; 150 MILLION WERE SOLD.

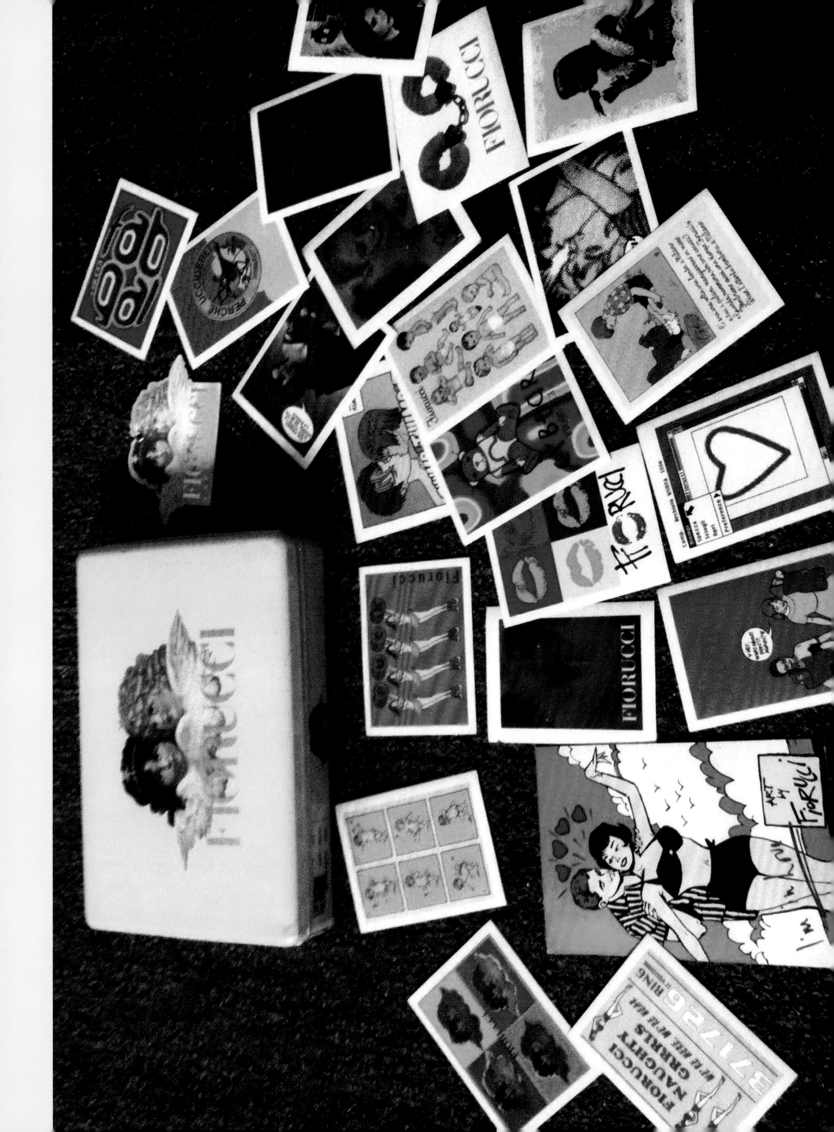

Graphics and photography consultant for Fiorucci after 1981

I was introduced to Elio by Maria Vittoria Lozito, who worked in the Fiorucci style office. He proposed a collaboration to coordinate the creation and printing of catalogs for the fashion collections, with the art director Terry Jones and Oliviero Toscani's photography. Elio also engaged me for special events, like Bob Dylan's concert in Milan. He asked me to contact David Zard, the concert promoter, and get the Fiorucci brand linked with the event, but without becoming a paying sponsor. I called David to find out whether there was already an agreement with a sponsor, and he told me he'd already closed a deal with a well-known candy producer, and the audience would all be given packets of sweets as they went in. The idea I suggested to Elio was to make fluorescent plastic jackets with the Fiorucci logo—the mouth with the lipstick—and give them to all the security guards. Zard was delighted with these freebies from Fiorucci. The audience ate their candy, but what they noticed were the brightly colored jackets, and everyone thought Fiorucci was the sponsor.
Zard also offered to bring Bob Dylan to my house after the concert. Elio was happy, and told his friends to drop in late at night to meet Dylan. He arrived with his band, very late. Elio had ordered pizza and various drinks, but not gin or vodka, which were the only things Dylan wanted. In the end he had to make do with a terrible coffee made in a pot without a proper seal. Dylan didn't say a word all night. I left Fiorucci in mid-1986, when the Classic Nouveau line was launched.

Worked in accessories, textiles and vintage, first for Fiorucci and later for Kenzo in Paris.

I lost my job in 1973 and, on the advice of Camilla, the wife of the painter Valerio Adami, I went to Fiorucci and was hired. I stayed until 1976. I worked with Mirella Clemencigh, and I took care of part of the accessories, textile research and also style, and looking for vintage items in old-fashioned dressmakers': evening gowns, jackets, bow ties and so on. The style office was coordinated by Cristina Rossi, who had two amazing stylists working with her: Tito Pastore and Mirella Landi.
It was a really interesting period in terms of training and opening the mind, because of the people we met and all the things we created. After that, I moved to Paris and worked for Kenzo.
Some years ago I organized a conference for Elio at the Circolo Filologico in Milan, in which I said he was like a prism, transparent but multicolored; he was brilliant, lucid, deep, superficial... it's complicated, trying to explain his multifaceted personality, which is hard to understand immediately. When he died, I said to myself: I have to learn a lesson from Elio Fiorucci's life: modesty. He really was a very modest person, and this attitude could benefit all of us.

ANTONELLA SUPINO

Worked in the Fiorucci style/accessories office; later founded "Baci Da Roma"

I came from a job at King's Jeans. In Rome I took care of the family stores, for which I bought from Fiorucci. One of my stores, on the road to Fiumicino, was inspired by the Fiorucci style, with window displays that were ahead of their time. I thought, "One day Elio will pass by and stop here." That's what happened, and it made me terribly happy.

Elio was on vacation with his family in Uccellina, in the Maremma area, and he invited me to visit. I went with a noisy crowd of friends from Rome, and at his house I found similar people. We were all dressed unconventionally, as we did in those days. I wore a white skirt made of gathered flags; my friends had equally eccentric clothes. Altogether we were an utterly eclectic bunch.

One day I had a call from Fiorucci, asking me to go to Milan for an interview, and that's how I met Cristina Rossi, Tito Pastore and Eliette.

I worked with the firm from 1977 to 1979, curating style and accessories, then I moved back home and opened "Baci da Roma."

In New York, I met Franco Marabelli, who took me to all the "in" places of the day. I have wonderful memories of those evenings. It's been easy for me to talk about my memories, but I'd find it hard to express my respect and my opinion of Elio, because there are no words to describe him, except "he was a genius."

ANNY TALLI NENCIONI

Worked in public relations in 1978–79.

I was lazily browsing a fashion magazine as I waited for my train to Genoa to depart when the door of the compartment burst open and in came Elio Fiorucci, out of breath and loaded with suitcases. He'd almost missed the train. I recognized him immediately, but I didn't show it. It was early 1978 and I was working in a PR agency; I was also involved in fashion. Once the train was underway, he smiled and asked me, "What do think about fashion, do you like it?" It was the start of a long conversation. I told him I knew who he was and that I worked in fashion PR, but I wasn't very happy there. He invited me to go and see him at his offices; what a coincidence, he said, I'm looking for someone to work in communications. No CV, no formal interview: that's how I started.

Little by little I learned about Fiorucci. His decisions were often intuitive; he had a great ability to seize the moment, but he also understood the market. He had enormous faith in himself and in others. I enjoyed my time in Corsico, with the constant coming and going of people, models, photographers, celebrities and customers. In those days, Fiorucci was the ultimate in fashion, with its two smiling little angels looking down on us. Working with him was exciting, but soon the difficulties began. Elio's ideas and projects were brilliant, ambitious; he wanted the very best—the photographer from London, the celebrity from Los Angeles, the trendiest artist, and everyone had to be contacted right away for one project or another. My job was to match the ideas with the budget, but the director general rejected them: too expensive, we have to change, downsize... and Fiorucci would say no, it can't be put off, it has to be done this way. Elio was the creative genius, the executive was responsible for finance. The two didn't communicate directly, and my time was spent organizing, canceling, rescheduling, cutting costs with people who were already contracted, sometimes already there. It was the frontline of a constant battle to fit together pieces that didn't fit. I was stuck between a rock and a hard place in the company, in the tug-of-war between genius and (economic) reason. I left Fiorucci overnight, practically slamming the door behind me. Nevertheless, I remember it as a wonderful formative experience that taught me to work fast and handle crises with creativity. And so I'm grateful to Elio. And I have happy memories of his big smile. Goodbye, Elio.

251

MASSIMO GIACON

Comics artist

I can't say I really knew Elio very well.

Our paths occasionally crossed in Milan, or at friends' parties, and we'd greet each other with a friendly nod, as if we were slightly shy, maybe because we didn't know what to talk about, or maybe because we had too much to talk about.

Elio would have a whole load of interesting stories to tell, but what could I say to him?

I think my first memory of Elio Fiorucci goes back to the 1970s, when everyone started buying his jeans; as a teenager the price was prohibitive, but they were the only ones on the market cut the way I liked them and really cool, nothing like the lumberjack style other labels were producing.

Plus, in the 1970s, left-leaning fashion was frowned upon, and if you moved in certain circles you couldn't wear Fiorucci or cowboy boots, they were considered too frivolous and inappropriate.

In the 1980s, punk and new wave legitimized a lot of styles. You could choose the look you wanted and make it up as you liked, and the Fiorucci stores were like candy stores where you could always find the unexpected accessory that made your style unique. Or unsightly and too eccentric, depending on your point of view.

One of my favorite purchases was a plastic belt with a buckle in the shape of Popeye's head; another was a necktie with the classic Mickey Mouse in shorts, but with graphics somewhere between post-modern and pop art.

I don't have the belt anymore, but the Mickey Mouse tie is still in my collection. I have two photos to prove it. As time went by, right up until they closed, the Fiorucci stores were always an obligatory stop, especially the must-visit store in Piazza San Babila in Milan: a vast bazaar of sensual and brightly colored objects.

You never knew what to expect in a Fiorucci store, and you'd find all kinds of things, from a weird book to leopard-print shoes, purple shoe polish to sex toys.

I have two big regrets, two missed opportunities: the opening of the store entirely decorated by Keith Haring and the opening of the Fiorucci store in New York, where the atmosphere (at least for us provincials who heard the gossip, since there were no mobile phones and you had to rely on word of mouth and a few photos) was one of carefree happiness, the recession was far off on the horizon and the future was fluorescent.

6 ELIO'S CARTOON STORIES

ELIO SHOWCASES

FIORUCCI WAS THE FIRST IN NEW YORK TO START THE TREND FOR WINDOW EVENTS. THE AIM WASN'T TO SIMPLY DISPLAY THE GOODS, BUT TO CREATE A GENUINE SENSORY EXPERIENCE.

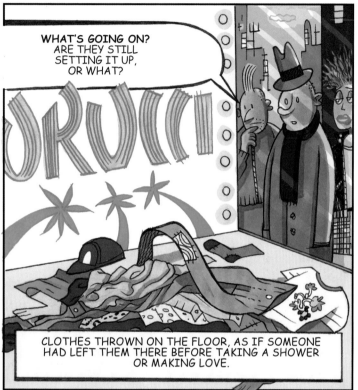

WHAT'S GOING ON? ARE THEY STILL SETTING IT UP, OR WHAT?

CLOTHES THROWN ON THE FLOOR, AS IF SOMEONE HAD LEFT THEM THERE BEFORE TAKING A SHOWER OR MAKING LOVE.

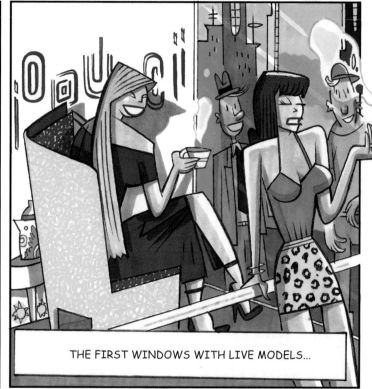

THE FIRST WINDOWS WITH LIVE MODELS...

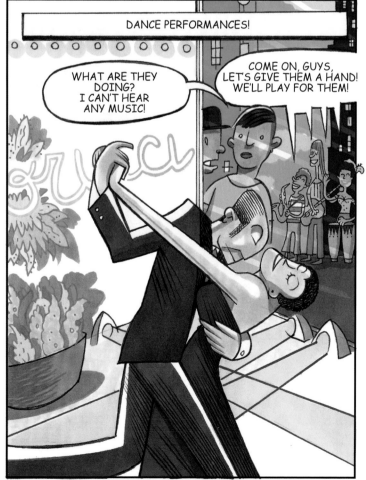

DANCE PERFORMANCES!

WHAT ARE THEY DOING? I CAN'T HEAR ANY MUSIC!

COME ON, GUYS, LET'S GIVE THEM A HAND! WE'LL PLAY FOR THEM!

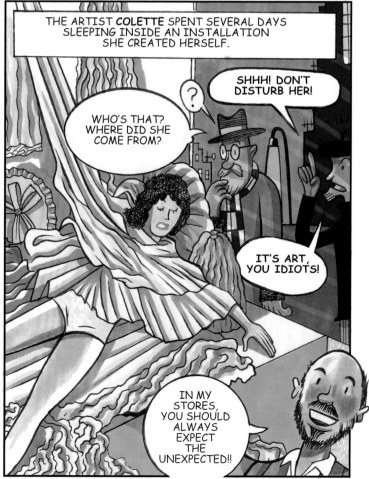

THE ARTIST **COLETTE** SPENT SEVERAL DAYS SLEEPING INSIDE AN INSTALLATION SHE CREATED HERSELF.

SHHH! DON'T DISTURB HER!

WHO'S THAT? WHERE DID SHE COME FROM?

IT'S ART, YOU IDIOTS!

IN MY STORES, YOU SHOULD ALWAYS EXPECT THE UNEXPECTED!!

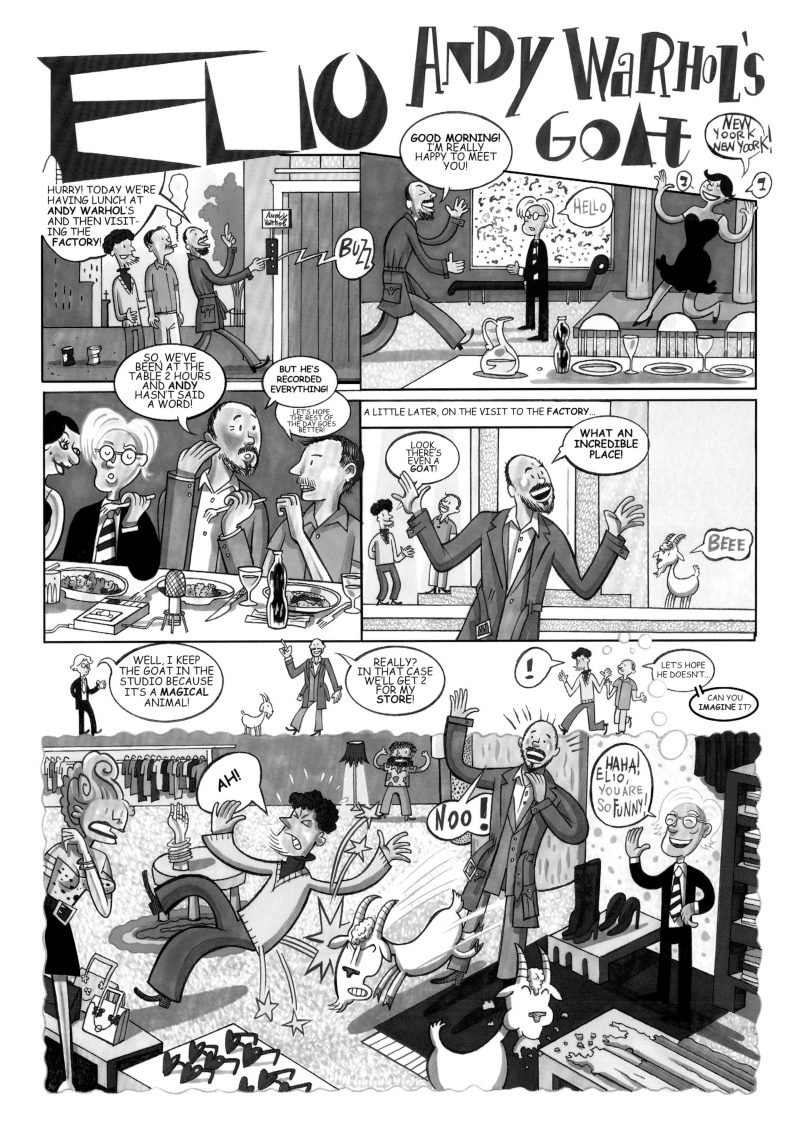

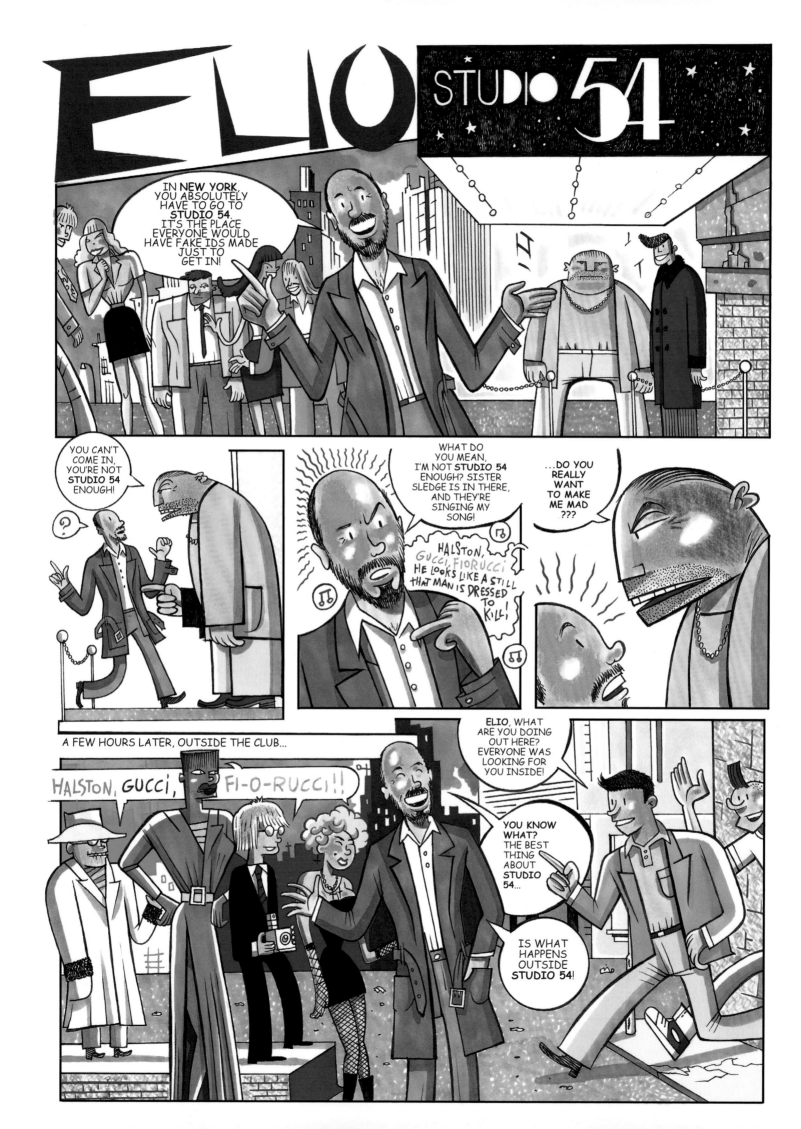

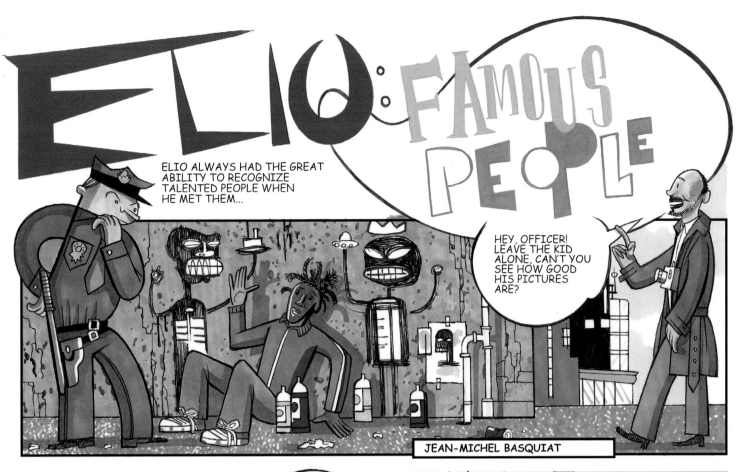

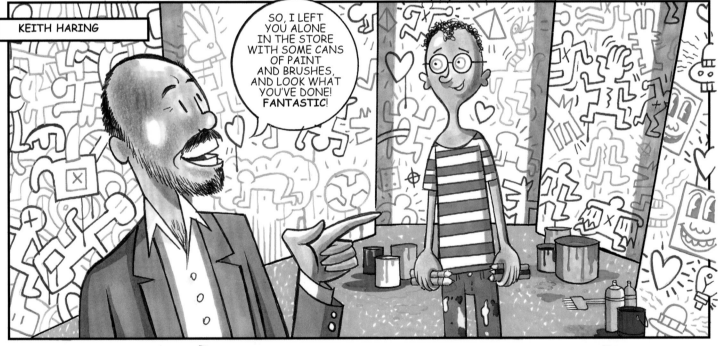

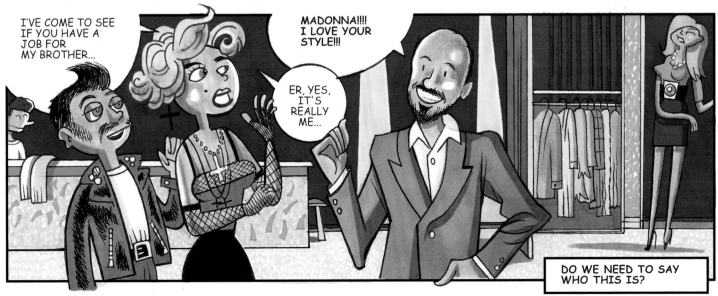

FIRST, THERE WERE BOUTIQUES,
THEN THERE WAS FIORUCCI.
AN ENTIRE GENERATION
WAS WON OVER BY THE ABUNDANCE OF
BEAUTY AND DIVERSITY.
THERE HAD BEEN NOTHING LIKE IT
BEFORE: THE JOYFUL ATMOSPHERE,
THE MUSIC, THE SCENTS,
THE LIGHTS, EVERYTHING MADE YOU
FEEL LIKE YOU WERE PART OF A NEW
EXPERIENCE.

FIORUCCI BECAME THE DESTINATION
FOR SPENDING ONE'S FREE TIME, SO
MUCH SO THAT WE USED TO SAY "WHAT
SHALL WE DO TODAY?"
"LET'S GO TO FIORUCCI."

Franca Soncini

GIOVANNI GASTEL

Photographer

Elio called me in 1980 or 1981; he'd seen my photos in *Donna* and *Mondo Uomo* and he said he'd like to work with me. I went to see him and took two or three photos, which he used for communications, as posters; they were very strong, innovative. One was a composition that I still have, with a woman falling, but taken with 20 x 25 Polaroids. Another was a girl with a rose tattooed on her private parts. It was the first time I'd worked with a makeup artist; when she arrived she asked me how I wanted the face done. I replied that she should draw a rose near the crotch.

Elio was a man overflowing with charm and intelligence. We became lifelong friends. He was a visionary, and what struck me most was his courtesy and the power of his thinking. He immediately impressed me because he asked me to create something we'd find amusing, "something you enjoy."

It was the greatest form of art direction. He'd say to me, "Listen, I'll give you the topic, but do something I'm not expecting." And I have to say he was always kind with me, including when we met on our travels round the world. He was really warm, and this always touched me. He was an extremely generous man, almost out of place, a kind of alien in a world of vipers, knives and bombs. But he was a wonderful angel who brought charm and warmth.

Sadly, I never did a portrait of him. I always asked him, and he'd say, "Yes, yes, we'll do it." I remember we nearly always saw the world in the same way. I continued seeing him until his last days.

PIER PAOLO PITACCO

Art director and artist

I met Elio in the late 1970s, when I started working at *Uomo Vogue* with Flavio Lucchini. I'd recently arrived there, I was twenty-three, and Elio was one of the first famous people I came across. We got on well from the outset and remained friends until his death.

I also worked on some projects for Fiorucci over the years. His world never stopped, it was always moving forward, nearly always ahead of the times in fashion and lifestyle. Elio was always friendly and generous with his time. It's impossible to remember everything he did and represented; instead, I'd like to recall the last time I saw him. It was a few months before his unexpected death. I went to see him at the offices of Love Therapy in Viale Vittorio Veneto, a few floors below his apartment.

He arrived with his usual smile and his eyes full of curiosity and the desire for life that never left him. He took me into a small room—I think it was his personal office—we were alone, and we sat opposite each other across a very small square table, like a table in a bar, where you're practically face-to-face. We talked about many things, but, above all, about feelings, about how people perceive the world and where it was all going.

Then he took out a book, "Here, read this; I give it to special people like you." I read the title. It was *The Power of Kindness*.

CHIARA FERELLA FALDA

Director of communications, Superstudio

I met Elio Fiorucci at Superstudio Più, where I work, at the inauguration of a show, and we greeted each other fondly. At that moment the Fiorucci store in San Babila came to mind and I said to him, "Dear Elio, you know I always feel great regret when I walk past the former Fiorucci store that's not there any longer, because when I went to your store I felt like Holly Golightly in *Breakfast at Tiffany's*; I felt safe. Inside the store I knew nothing bad could happen; it was always a joy, a comfort, a very special atmosphere." I said that to him and he was very touched. He answered, "My dear Chiara, what you said is wonderful, and it's gone straight to my heart."

CARLA MILESI

Artist

Because I'm from Milan, I first knew him at his boutique in Piazza San Babila. Later I saw him in New York in 1978 or 1979. I was at the Hotel Mayfair, where the Fiorucci people stayed, and I remember Elio signing autographs outside the hotel. We saw each other in Milan too, because we had friends in common: Luisa Beccaria, Giorgio Alpeggiani, Alberto Tonti and Maria Vittoria Lozito. Here I'd like to pause and mention something more personal. In 1984, I had a terrible fight with my boyfriend and ran away to New York with Elio. I have to admit I had an amazing time. We were at the Mayfair as usual, and as soon as we arrived we went to the Area nightclub, where we saw Madonna and all the people who used to go to Studio 54. I traveled a lot with Elio, to Argentina and Brazil... what struck me about him was his ability to handle so many interviews with amazing ease. I had a house in Asilah, in Morocco, and he came to see me there. When we went to the market, he always wanted to buy a donkey. He loved the desert and the atmosphere of African countries. I remember he brought Armando Verdiglione to my house several times; a troubling character. Elio was fascinated with unusual people, and sometimes he put up with them. He was really good at bringing people together. He never accepted that anything was impossible.

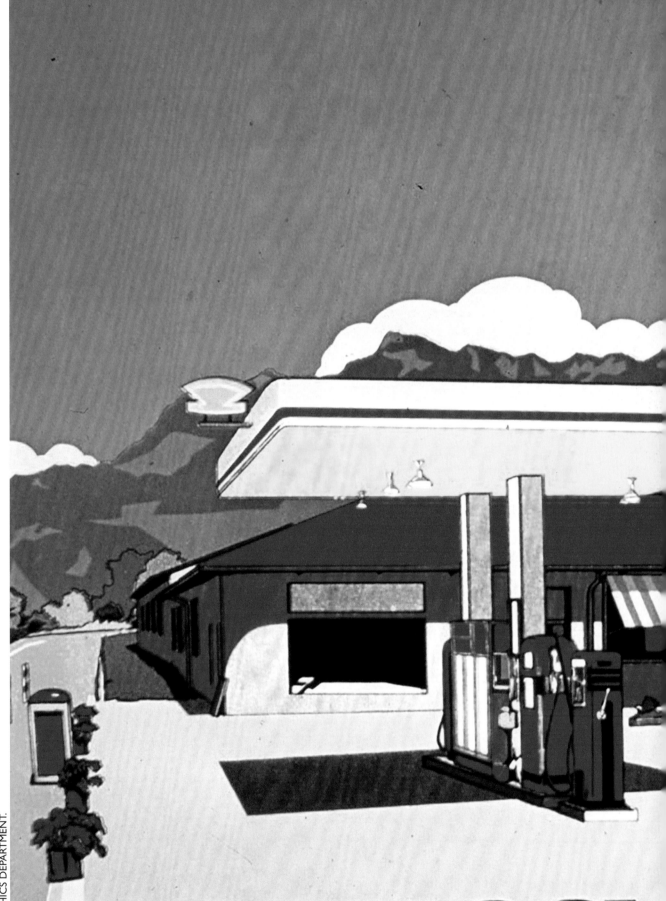

POSTER. FIORUCCI GRAPHICS DEPARTMENT.

SRGNERS

Writer

In the Galleria Passarella store everything was free and easy, fresh and vibrant, playful, passionate, cutting-edge and fascinating. Elio himself is one of the most curious people I've ever met. His unstoppable, insatiable curiosity took him far and brought great rewards. The same curiosity occasionally got him into trouble too as it allowed him to say anything in any situation seemingly with no limitations. This made him an extremely fun person to be with.

I met Elio almost immediately after meeting Ettore (Sottsass, ed.), because at the time they were working together and Ettore had recently finished designing the New York store. It was 1977, and we used to meet at the Torre di Pisa in Via Fiori Chiari, or at his and Cristina's home in Via Trieste.

In all the time I knew him, Elio changed very little, and when I think of him I'd even say he always dressed the same way: informal and regular, not at all showy but verging on subdued: pants and jacket more or less dark, shirt, sweater. As a person, he was transparent, with his wide eyes, his smiling stubbly face, jocular and sly, as if he were constantly plotting a prank or expecting to surprise you or be surprised. Perhaps, this is really how he can be summed up.

For Elio it wasn't difficult to surprise people, and he himself was constantly astonished at life. It was precisely this characteristic that unleashed his imagination and his never-ending quest for all that was "new and fun" in every corner of the world.

Elio was a catalyst. He not only invented and tried new things, he also introduced, "primed the pump" and launched events. He kindled the fire. He brought things and people together and watched, explored and invested, trusted and pushed tirelessly to do, seek, test.

And talking about introducing and trying new things, I'd like to sign off with one last memory of the "good old days." I was with Ettore at Torre di Pisa for lunch when we saw Elio come in. We invited him to join us but he couldn't. Others were waiting for him. But he found time for a quick chat.

As he talked, he was searching his pockets and brought out a little box, took out a pill that looked like an aspirin and offered it to Ettore, saying, "It's fantastic!"

Naturally Ettore took it and swallowed it immediately, before Elio had time (or the desire) to tell him it was a tab of acid.

Thinking about it, I still can't fathom it and I'm astonished, just as I was in the following dreadful twenty-four hours, when I couldn't leave Ettore for a second.

But apart from being curious, Elio was optimistic. He always laughed about that...

documenti di Casabella

SOTTSASS'S SCRAP_BOOK

a cura di Federica Di Castro

MASSIMO IOSA GHINI

Architect and designer

PHOTO GIANNI FRANCELLUCCI

I remember Elio as a friend, so open-minded and curious about the youth of the day. I saw him as a patron, a man who knew how to talk to you, excite you and encourage you to do new things, following his successful example. That was the message he gave me: the idea of having faith in his own creativity, not taking it lightly, but actually seeing it as the key to innovation in his enlightened vision. "You can and must be creative because your imagination is a resource that's not just yours... it's something important... give it to the world."

DESIGN FOR FIORUCCI STORE, WHICH WAS NEVER CARRIED OUT.

ALESSANDRO MENDINI

Architect and designer

I met Elio in Milan; it might have been when Keith Haring decorated the San Babila store in 1983.

After that, as he was interested in design and other movements like Alchimia, we met up. At the time, I was running *Domus*, and he got me involved in countless adventures, some of them surreal. Whenever he thought of impracticable things he'd call me and get me onboard, even though most of the projects came to nothing.

One time, he wanted to run training courses in Corso Vittorio Emanuele by building these super stylish gazebos, and he took me to various council members to present the project. The gazebos could only be temporary, but he wanted them there permanently, and he dug his heels in. But, as I mentioned, most of the projects went by the wayside.

With Alessandro Guerriero at Alchimia, we organized some performances in the store windows with my wooden clothes called "Arredi Vestiti," a sort of garments/furniture worn by models in the window, who occasionally fainted from the weight they were carrying. At one point, we began designing the Verona store, which was going to have a large fountain, but, in the end, it couldn't be done; but the store itself was really interesting. Later on, since I'd worked for Swatch, I designed the Swatch corner in the San Babila store.

A friend of mine, the designer Anna Gili, made a "sonorous dress" which Elio Fiorucci used for a performance at the Seibu department store in Tokyo. Fiorucci was really fascinated by that dress, which was basically made of rigid origami, partly starched fabric and partly brass foil; it made plenty of noise and was worn by a ballerina from the Béjart school.

That was around 1990, and during the same period, Anna was encouraged by Elio to make a dress of flowers directly on the model. Oliviero Toscani photographed that dress.

We would run into each other at roundtable discussions, attending exhibitions, always acting goofy no matter where we were.

Elio disrupted everything, to international acclaim (he invented, *ed.*); a way of changing the concept of the wardrobe. And, as a person, he was absolutely wonderful, a big dreamer who was open to everything.

STORE WINDOW DISPLAY IN SAN BABILA, MILAN. "ARREDI VESTITI," PERFORMANCE WITH MODEL.

ALESSANDRO GUERRIERO

Designer

I don't know how many times I ran into Elio... I'm unable to string together all the valuable things he told me, but there's one I remember clearly, and I'll paraphrase it, the way he said it loudly with his special way of pronouncing the R...

"Many people think the history of design consists of a list of standard products made by industrial technology in response to specific market demands. But I've always believed that the story of design is a story of people, in other words a story of ideas and risky initiatives, in which failure is sometimes more important than success, and things are often designed that no industry has requested and perhaps nobody wants to buy.

But there's an important role to be played by these discarded ideas, because it's the result of that surplus energy that ensures the constant renewal of product styles and types.

What's considered useless is actually valuable: every great civilization has developed by investing in seemingly useless things like art, poetry, music and philosophy: things that nobody asked for and often very few have understood. So uselessness is one of the most essential categories in the world; without it everything comes to a halt."

Today, I can state that much of my life has revolved around failure and uselessness.

ANNA GILI

Artist and designer

I met Elio during a particularly intense period; it was in the 1980s. There was a real, wide-ranging network of friends among artists and designers who were involved in Milan's cultural and artistic life.

In 1986, I performed *Persone Dipinte* at the Alchimia museum, and, in 1987, I did another performance, *Vestito di Fiori*, for a Fiorucci party at the Old Fashion nightclub in Milan. Elio was an exceptionally generous person. He invited me and some other young artists to an exhibition in Tokyo called *Ciao Italia*, where I performed *Abito Sonoro* at the Seibu department store in Ginza, Tokyo.

We usually ran into each other at special events, like the extraordinary Fiorucci happening at San Babila, when Keith Haring painted the whole store with graffiti.

It was an event where art, fashion and design truly came together. At the time, I was working on all of these things, with cultural debates and shows at the Triennale di Milano. I also curated the exhibition *Nuovo Bel Design* in 1992, which led to the birth of new Dutch design and was more popular in Holland than in Italy.

When I saw Elio, we'd converse about the different creative disciplines; he had a brilliant, lightning-quick intelligence. Our meetings also involved Alessandro Guerriero and Alessandro Mendini, the leading avant-garde design gurus.

Later on, Elio embraced the animal rights movement, and there were other opportunities to get together.

Silvia Amodio, an animal-rights photographer and a friend of Elio's, photographed him with a dog for a calendar.

Elio was a wonderful, important person on the scene, and I have very fond memories of him.

ANTONIO CITTERIO
Architect

My earliest memories of Elio are from the beginning of the 1980s, when I was involved with the Sottsass group. It seemed almost impossible that a person could be so down to earth, because other fashion people put on airs. Over time, there were more opportunities to run into one another. I used to see him when he was with Gioia Magnani and later, in more recent years, I often saw him at dinners at Carla Milesi's house. She held dinner parties where she mixed writers, designers, artists, all kinds of people, all somewhat unconventional. People who liked to eat, drink and talk about travel and experiences. People who were good conversationalists. But there I met another Elio; much less entertaining, less charming. He was burdened by the weight of success that had slipped through his fingers—that was the sense I got. I remember the story of how he got the idea of going to London to see Biba, and that was the start of his way of seeing fashion. Another great story is when he called Keith Haring: getting him to decorate the entire store, including furniture, fittings and all the rest, which was a stroke of genius. I don't know where those panels ended up, but I remember Haring being there: Elio had invited me to come and see him work.

Elio's genius lay in his believing and giving space to the people who worked with him. It was his way of encouraging creativity. Sometimes, when he spoke, he put his own creativity aside and listened to others. He was always enthusiastic about what other people said, and he made you want to talk. And, like many brilliant people who have the ability to listen, if someone talked too much, he'd shut them right down.

We were never really friends, and I'm not sure how many friends Elio truly had, in the sense of people who confided in him. He never confided in me, though we once had a deep discussion about the passing of time. In later years, we were having dinner at Carla's and we found ourselves in conversation; he said to me, "I don't feel like having relations with young, attractive women anymore, because when I see my pale old turkey body, I feel so disgusted that it seems like an act of violence to offer it to a toned body so full of vitality." I have to say the thing about the "turkey body" stayed with me; I sometimes think of that when I look in the mirror. However, that was a confidential conversation between two people.

Elio didn't look eighty. In his last years, he seemed a bit more melancholy. Then he had his views on animal rights, which he was very passionate about; he didn't eat meat or fish, first he was vegetarian, and later vegan.

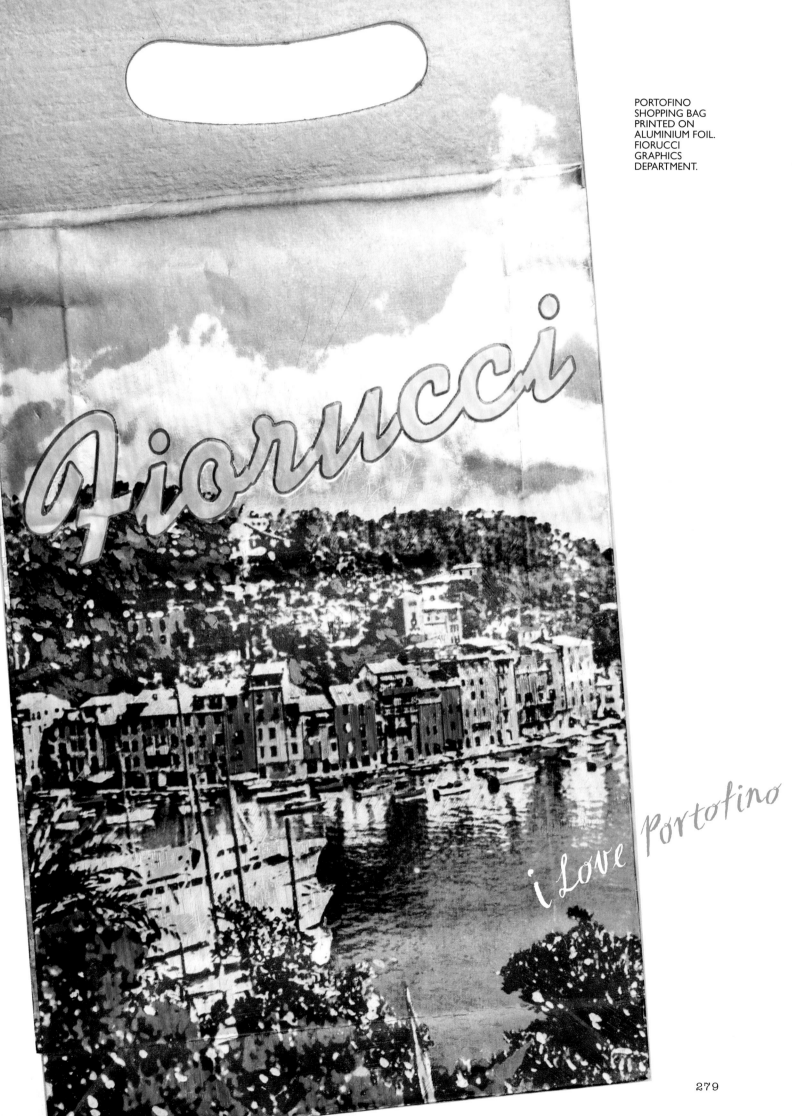

PORTOFINO
SHOPPING BAG
PRINTED ON
ALUMINIUM FOIL.
FIORUCCI
GRAPHICS
DEPARTMENT.

279

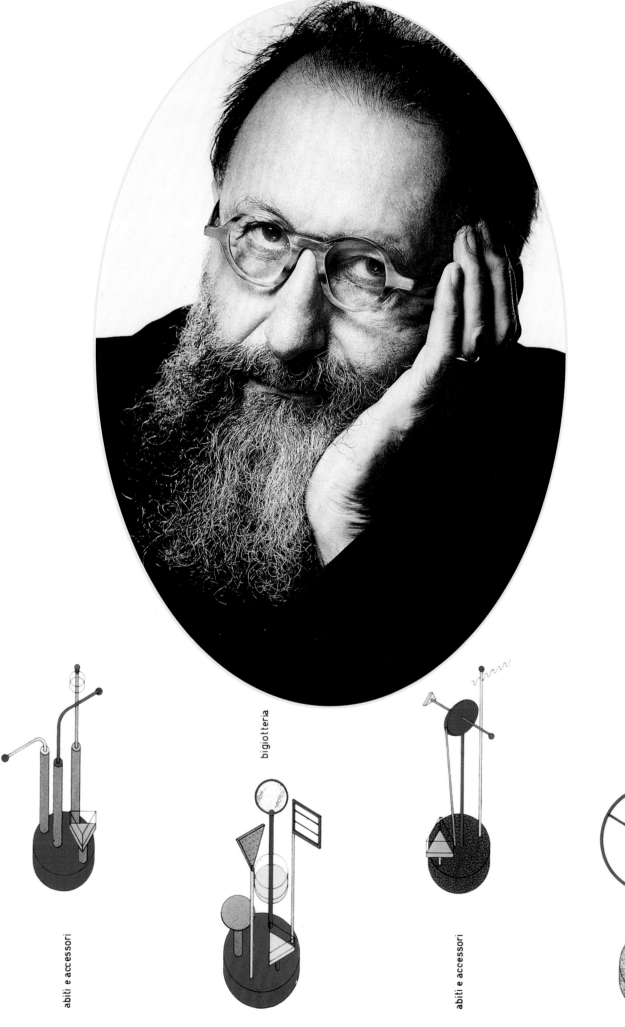

abiti e accessori

bigiotteria

abiti e accessori

appenderia circolare

280

MICHELE DE LUCCHI

Architect, worked on Fiorucci projects

I met Fiorucci as a friend of Ettore Sottsass. Elio was a celebrity in Milan in the 1970s, one of the early players as the city became more international. The Fiorucci store in Galleria Passarella was far from a mere fashion showroom. It was more like an art gallery that hosted sophisticated international events. It attracted the likes of Keith Haring, Andy Warhol and many other names associated with the most cutting-edge art movements. His global success surprised us all and led us to think of Elio not only as a fashion designer, but as the creator of a new way of being for carefree, beautiful people. In those days nobody thought about the environmental issues, and he promoted a modern, metropolitan lifestyle. His creative imagination was full of colors and patterns that represented a new kind of happiness with life. The result was an unmistakable style, expressed in products that were highly figurative.

His brand was also highly figurative. The Fiorucci logo, which changed constantly, was an explosive new phenomenon graphics-wise. By renewing the logo every season, Elio invented a dynamic corporate identity. There were always new fonts and new colors. This conveyed his sense of freedom, enormous joie de vivre and a great ability to use all the available potential in his creations. You just needed to pick up on the stimuli in the world and turn them into iconic products.

Fiorucci was extremely friendly and brilliant, and above all he'd brought together a team of exceptional people, most of whom later disappeared; from his first wife, Cristina Rossi, to the Pastore brothers—designer Tito and PR man Leonardo—Franco Marabelli, Mirella Clemencigh, Giannino Malossi, Pigna, Augusto, Sauro Mainardi, Spago, Oliviero Toscani... all people who traveled among Milan, New York and Tokyo with total ease. His model for the team was widely copied and the "school" had numerous converts, first and foremost, Doug Tompkins with Esprit, which was his second or third big venture (the first was The North Face). Tompkins preferred to employ Japanese or Italian staff.

I have had a few opportunities to closely observe people and organizations as they lived through a golden period. Like with the Montefibre Research Center in the late 1970s, Fiorucci in the same era with Sauro, Pigna, Giannino and Augusto as they launched one of the last true revolutions in graphic design of recent decades, and Oliviero Toscani who took a series of photos that went down in history.

ETTORE SOTTSASS
AND ANDREA BRANZI,
"ALFA ROMEO GIULIETTA
BY FIORUCCI," 1978.

Alfa Romeo Giulietta by Fiorucci

ALDO CIBIC

Architect, worked with Sottsass for Fiorucci after 1981

I arrived in Milan in 1977 at the age of twenty-two with no degree because I'd had the incredible opportunity to work with Ettore Sottsass, who was a legendary figure for me. In those years, we founded Sottsass Associati and Memphis. Ettore had recently worked with Andrea Branzi and Franco Marabelli on the fabulous New York store on 59th Street.
The early projects I was involved in were all for Fiorucci.
The first was a Multivision Room in the Galleria Passarella offices in Milan; after that there were various stores in different cities in Italy and around the world, the most important probably being Amsterdam and Rio de Janeiro.
The furniture was designed in collaboration with Michele De Lucchi, and I supervised the planning and execution of interior decor all over the world.
Elio will always remain one of the most important people in my life.
He was curious and ready to listen to anyone. At a time when anything could happen, he was the man who made things happen: he brought people together and was always generous and willing to create opportunities for others.

ANITA BIANCHETTI

Architect, contributor to the Fiorucci stores and various other projects along with Stefania Sartori and Evelyn Zurel

A girlfriend who worked with Franco Marabelli asked me if I'd be interested in having an interview with him, because they were looking for staff.
I was a conventional architect, but I was intrigued by that extraordinary world, and I was hired immediately. I started in 1974 and stayed until 1981. There was plenty of work, and I introduced Franco to my friends Stefania Sartori and Evelyn Zurel, who were also hired. It was very exciting working in that period. We had a first-floor office in Galleria Passarella: it was lovely, with great views and all these tables stacked with books and materials. Next door was the graphics department, the press office, PR, the style office, the Dxing office and Elio's office. We were all together. Andrea, Marabelli's Great Dane, whom we watched grow up in the office, stayed under the table. I remember the face of a telephone engineer who was lying on the floor to sort out the sockets, and turned around to find Andrea's face. He said to me, "Excuse me, can you move the dog, please?" We designed projects in Italy and Europe—almost 100 of them—as well as continuously renewing the ones in San Babila and Via Torino. We designed neon lighting, stands for trade fairs, window displays and much more. When Benetton came onboard in 1981, Ettore Sottsass was appointed to design standard furniture for Fiorucci and come up with a concept of a typical store. So in this final period I worked on that project, in collaboration with Michele De Lucchi.

AMEI

RICA

1976
NEW YORK

Design by

Ettore Sottsass. Andrea Branzi. Franco Marabelli.

FIORUCCI is COMING

WOMEN'S WEAR DAILY, FRIDAY, APRIL 23, 1976

NEW YORK — Neon lights in the shape of accessories, Italian coffee machines, minimal gray cardboard mobile display cases and an energetic staff arrived from Milan for the Saturday opening of the latest Fiorucci shop, at 123 East 59th St.

Elio Fiorucci opens the first of his 500 shops in Milan in 1967. He has since expanded to include over 36 designers, who constantly create Fiorucci "name tag" accessories and clothes such as the lame vinyl tote, the plastic rain poncho or coat with hood, trenchcoats, umbrellas, and paper jumpsuits.

"We believe in freedom," a store spokesman said. "The point is to constantly have our designer team create a new design each day. At the end of the day, everyone meets in the studio and the design voted as the best of the day is put into immediate production."

Fiorucci will arrive in New York to open the store and will spend a week launching the new shop. Below are some of the Fiorucci accessories and clothes in the unfinished shell of a shop:

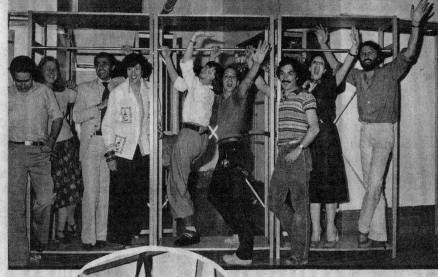

Fiorucci team left to right: Nazzareno Capecchi; Ulla Salovaara; Sandro Lanfranchi; Joan Kaner; Anita Paltrinieri; Tito Pastore; Franco Marabelli; Jeri Feig; Enrico Baroni

A wall of "name-tag" totes in bright-colored or lame vinyls, $14

The plastic yellow poncho for the beach or city, $4; the red and white stripe bikini at $25

The red maillot top, $24, and the denim kilt, $60

Fiorucci's navy cire raincoat, $70; the "name-tag" tote in red vinyl

WWD photos by Nick Machalaba

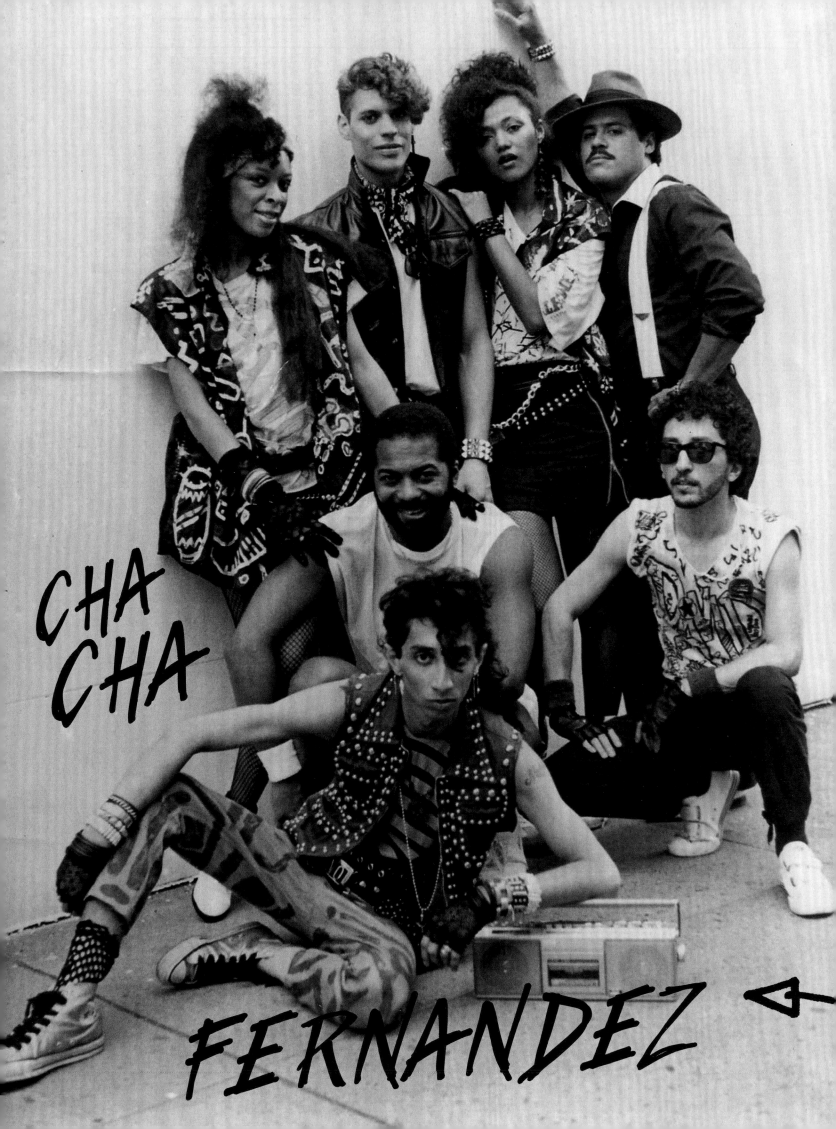

CHA CHA

FERNANDEZ ◁

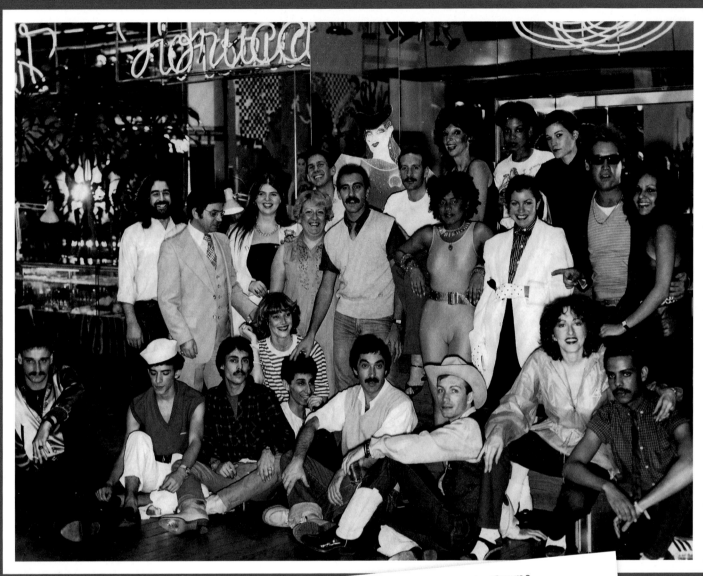

Group photo. Seated on the ground, from left: Luisa Baume, Mark Sawyer, Franco Marabelli, Peggy, Mark Solano. Standing, from left: Angelo Careddu, Piccinini, Reina Sacks, Ann, Maurizio Brunazzi. Back row, from left: Calvin Churchman, Guido, Bernice Sacks.

MARK SAWYER, DISPLAY DIRECTOR OF FIORUCCI,
FOUNDED A MUSICAL GROUP CALLED "CHA CHA FERNANDEZ."

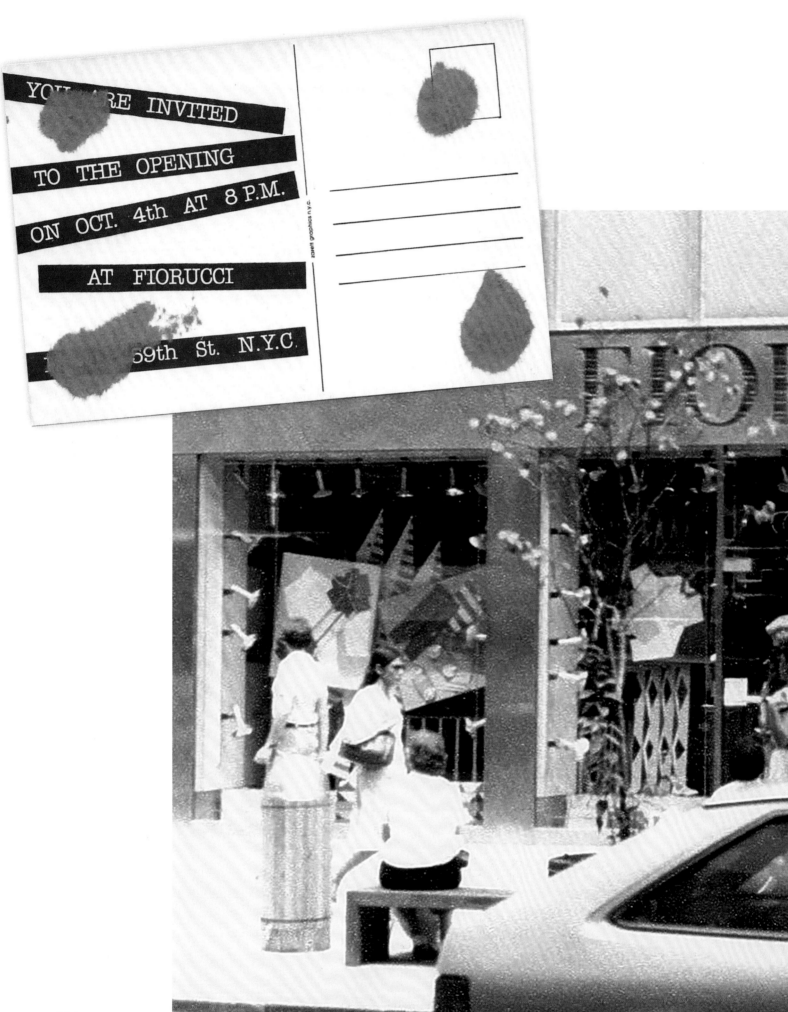

290

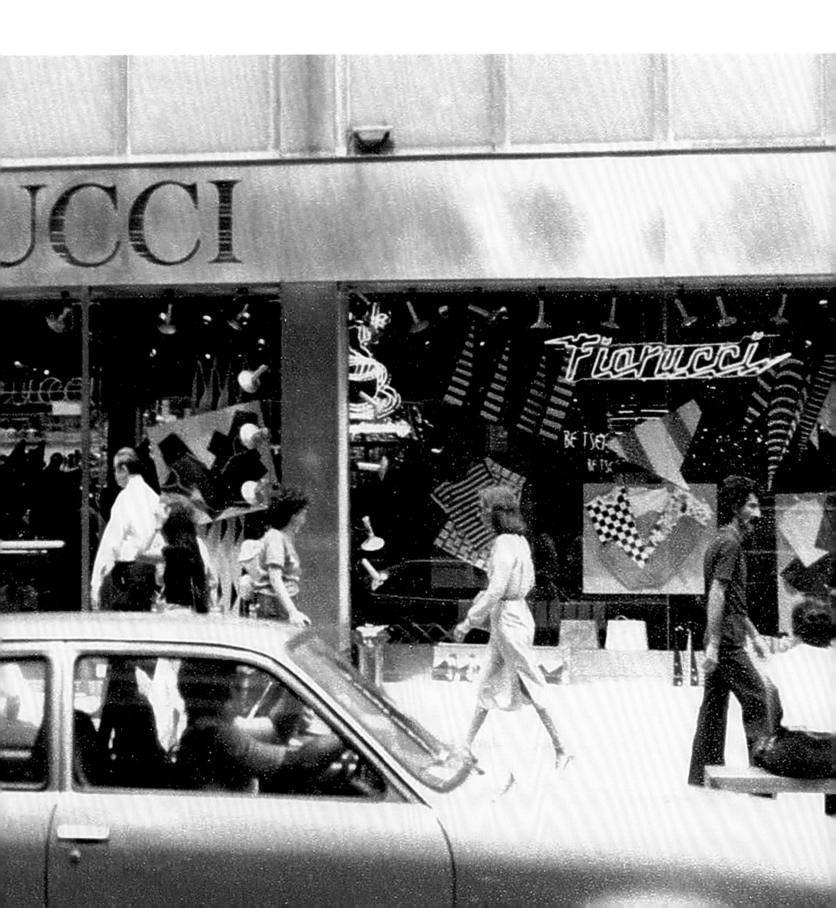

Outside Fiorucci New York, 59th Street and Lexington.

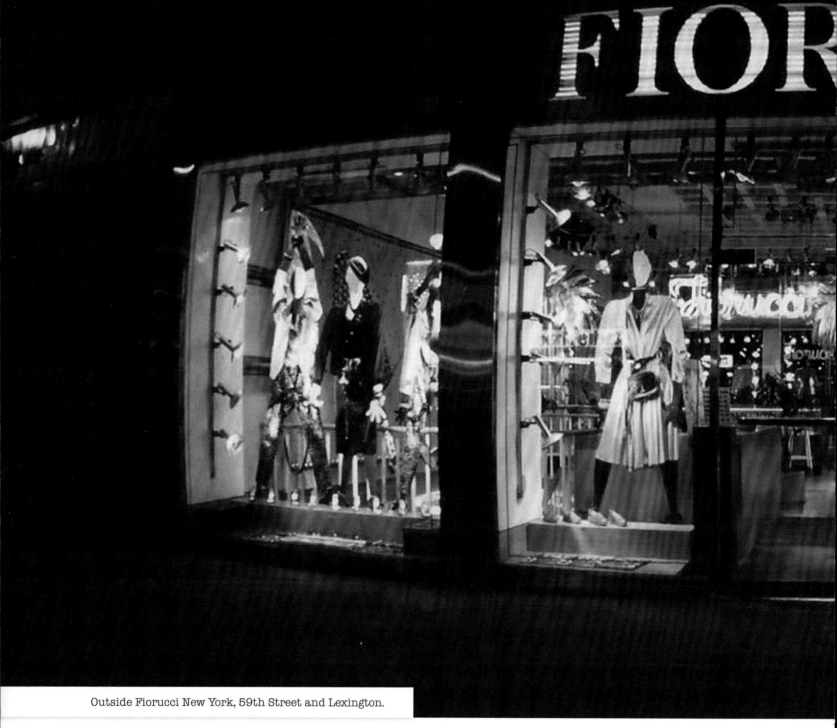

Outside Fiorucci New York, 59th Street and Lexington.

When the store had been open for a few months, Elio sent me to New York as creative director to bring the Fiorucci atmosphere to the site and to give it a boost by creating art events and window displays in the Fiorucci style. I stayed there until 1980 or 1981. At first, Enrico Baroni ran the store, with all his experience of the San Babila store and the respect Elio had for him. He was followed by the first American director, Joan Kaner, who was extremely kind and professional but unfortunately didn't really understand the Fiorucci spirit. Then, for a short time, the store was run by the manager of Via Torino, Maria Grazia Pesatori. Finally there was Italian-born Luisa Baume: dynamic, charming and a lovely person; she stayed a long time. In the store there was a large panel that was decorated each month with different work by graphic designers and artists, including Kit Grover, Laurie Rosenwald, and Priscilla Rattazzi, with photos by Margaux Hemingway, Roberto Carbone and others. We always hired the best DJs to do the music. One of these was Tom Savarese, who even made the customer-service team dance. Cico Colacicco

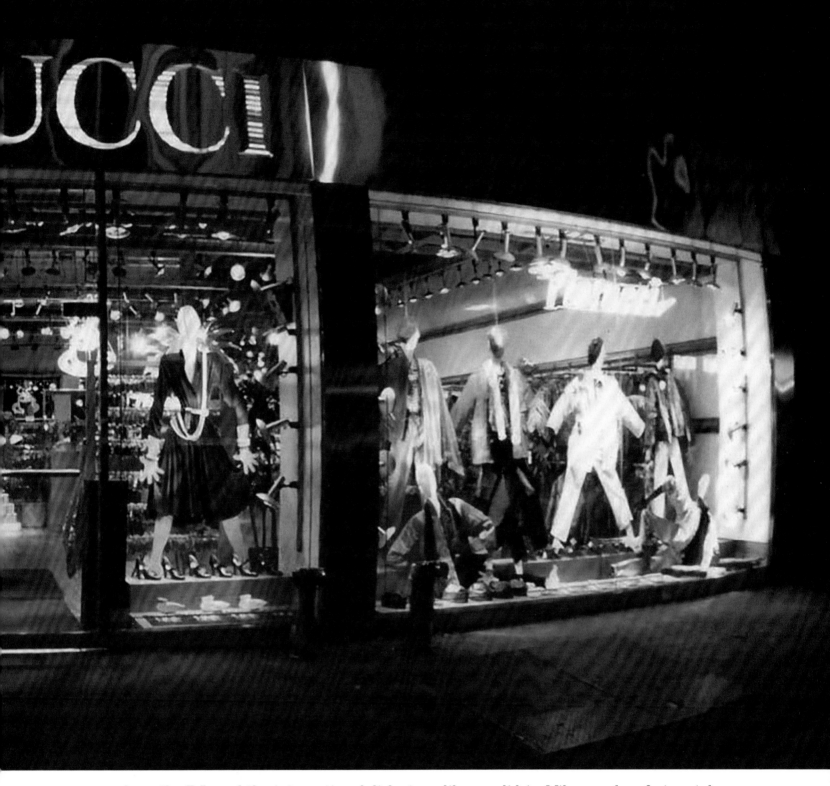

chose the DJs and the international disks to be sold in the store from Via Torino in Milan. One day, Greta Garbo came in, and hardly anyone recognized her. She was dressed very simply and wearing dark glasses. The same day, there was the photographer Bill Cunningham in the store who recognized her immediately and said to me, "Look, Franco, that woman's Greta Garbo." Very boldly and without being obvious, he reached out and took some shots of her from below with a small camera; she didn't notice. In New York we didn't have a permanent photographer like we did in Milan, and unfortunately we missed an incredible collection of celebrities, from Jackie Onassis to Silvana Mangano, Dustin Hoffman, Farrah Fawcett, Diana Ross, Isabella Rossellini, Divine and many others. The Fiorucci offices brought over from Italy Angelo Careddu, who ran the press office, Gianfranco Rossi as general manager, Maurizio Brunazzi as art buyer, Mirella Clemencigh ²and Monica Bolzoni. When I left in 1981, Philip Monaghan took over my job until the store closed in 1986. *F. M.*

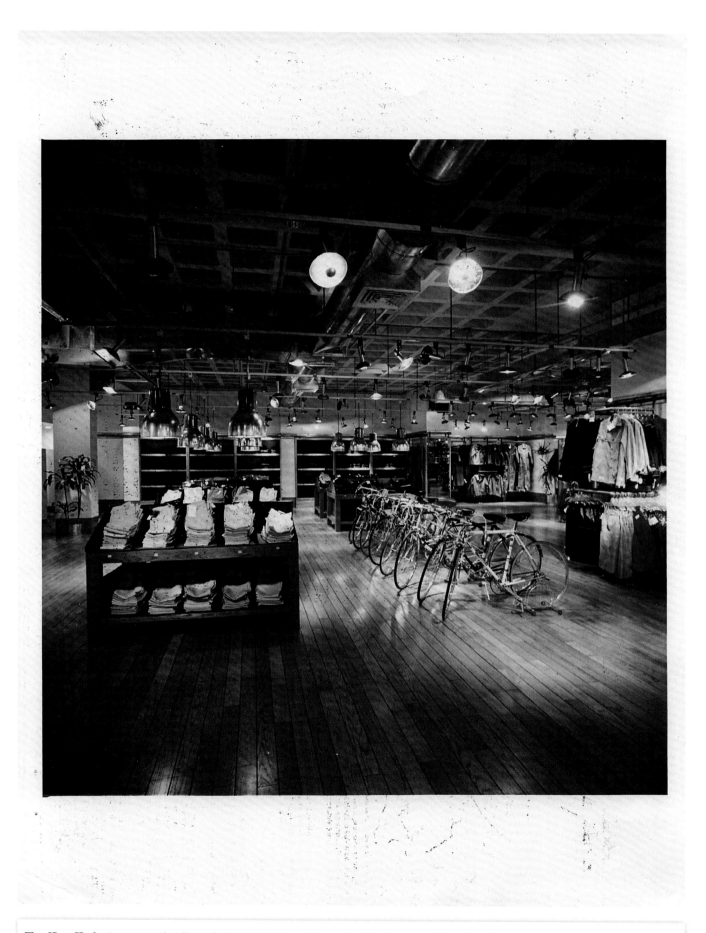

The New York store was the first clothes shop to sell bicycles. The floor and the furniture were made of oak boards, like an American loft, and the lights were imported from Italy. We designed tubing that went all around the perimeter, and the clothes rails were hung on that, so that they could easily be moved; they were interspersed with hanging mirrors

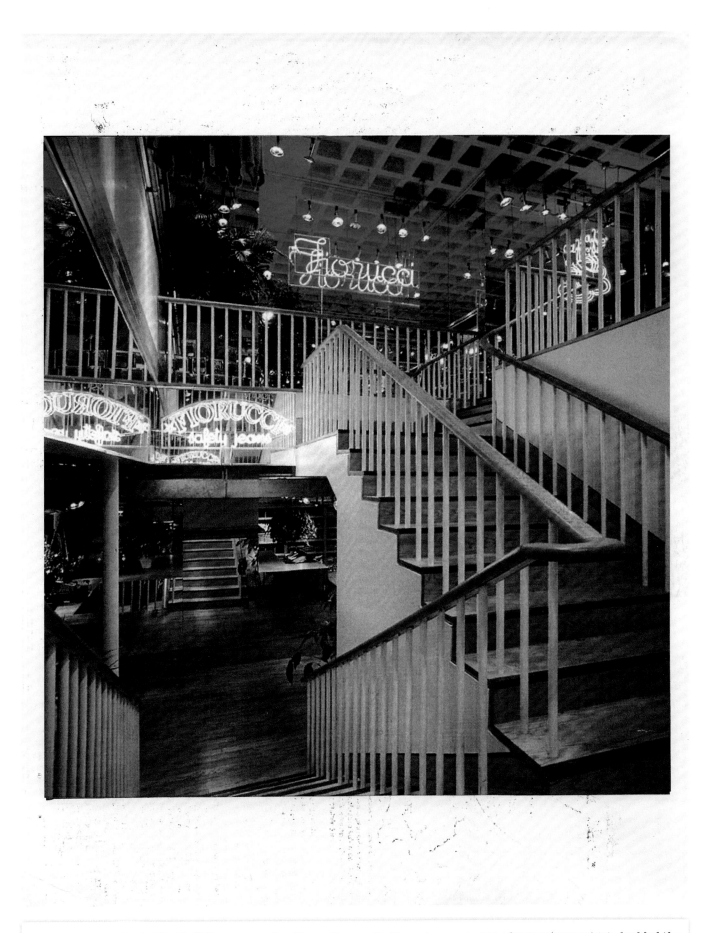

and wooden panels that held all the accessories. The wall opposite the entrance was one huge mirror, which doubled the space; the back wall and the great columns were covered in mirrors and hung with neon lights. Everything was movable, even the fitting rooms, which could be added to or taken away as needed. *F. M.*

PAUL CARANICAS

Artist, Antonio's friend and
Juan Ramos's partner

Antonio Lopez

I met Antonio and Juan in Paris in 1971 when I was studying at the École des Beaux-Arts. Juan and I became a couple in 1972. Since the mid-1960s, he and Antonio had worked as creative partners, producing fashion illustrations for international publishers, designers and fashion houses. In 1976, having spent half a decade on the European fashion scene, they decided to return to New York, where Antonio and Juan both grew up and studied. They set up a large studio on 18th Street and Broadway.

I don't remember exactly how the relationship began with Elio, who invited Antonio and Juan to the New York store immediately after the opening. All three of them shared an interest in avant-garde art, and Elio was enthusiastic about their designs, their vast experience and global mentality. Antonio and Juan soon became in-house advisors, with twice-weekly meetings at the headquarters on 59th Street. They designed clothing and introduced innovative new designers to the store's buyers. They also turned the ground floor windows into stage settings. Antonio always thought of fashion as a dynamic rather than a static thing, and these "live" window displays underlined this idea and communicated it to the thousands of passers-by. Models like Pat Cleveland, Donna Jordan and Vivianne Castaños played and danced in the windows, often surrounded by colorful scenic items and wearing clothes designed by Antonio, Juan and others. Another series of displays featured acrylic mannequins in neon colors, inspired by the Bauhaus artist Oskar Schlemmer, designed by Antonio and Juan and made by their friend Michael Thiele. The windows were nicknamed the "daytime Studio 54" because they embodied the spirit of the nightclub—which was also Elio's aesthetic.

ELIO AND ANTONIO,
AT THE OPENING
OF STUDIO 54.
PHOTO OLIVIERO
TOSCANI.

THE DISPLAY
MANNEQUINS WERE
MADE IN PLEXIGLASS
AND EVOKED THE
BAUHAUS STYLE OF
OSKAR SCHLEMMER,
AS DID THE ADJACENT
DESIGNS.

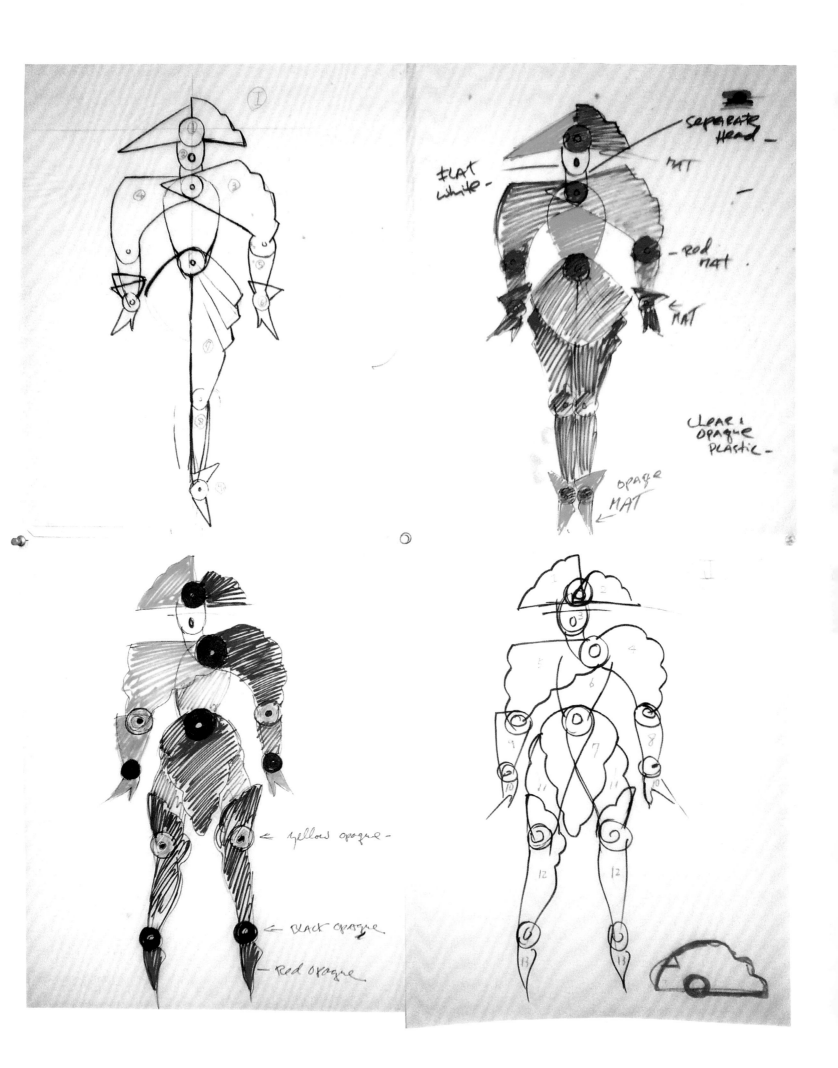

Dear, Fiorucci—

I hope you like the drawings—

Snow— very very very cold— but I was sick! New York is grey, rainy, be in Milano next month. To start the

Been wonderful— + Franco is fantastic— you have a great team— Anjelo works hard/at

we are

working hard to make 77 a great year for all of us—

P.S. Please be sure— that you get back all the original drawings from Esquire magazine— for when we have a show of the work; we have done for you.

But very exciting. And I hope to start the fall collection— Mirella has

Hello! from New York city—

Mirella—
Franco Anjelo—
Juan
Lorenza Lupo—
77

Antonio Lopez

Juan Ramos

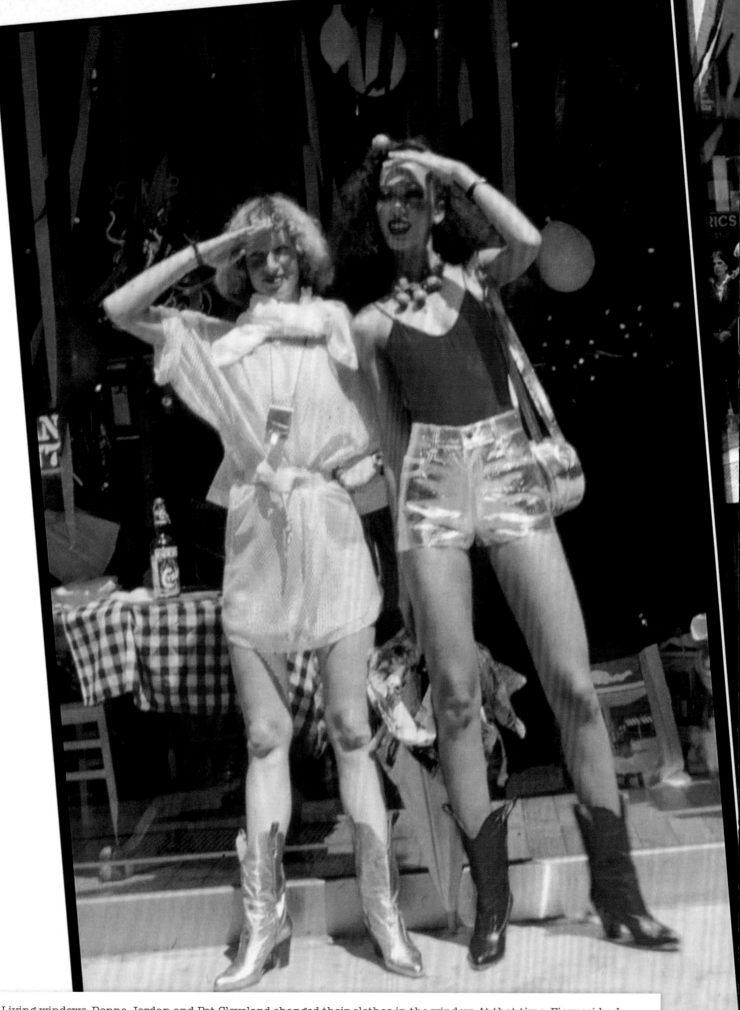

Living windows. Donna Jordan and Pat Cleveland changed their clothes in the window. At that time, Fiorucci had launched a series of items—boots, bags, shorts, jeans—in gold plastic, which was a big success.

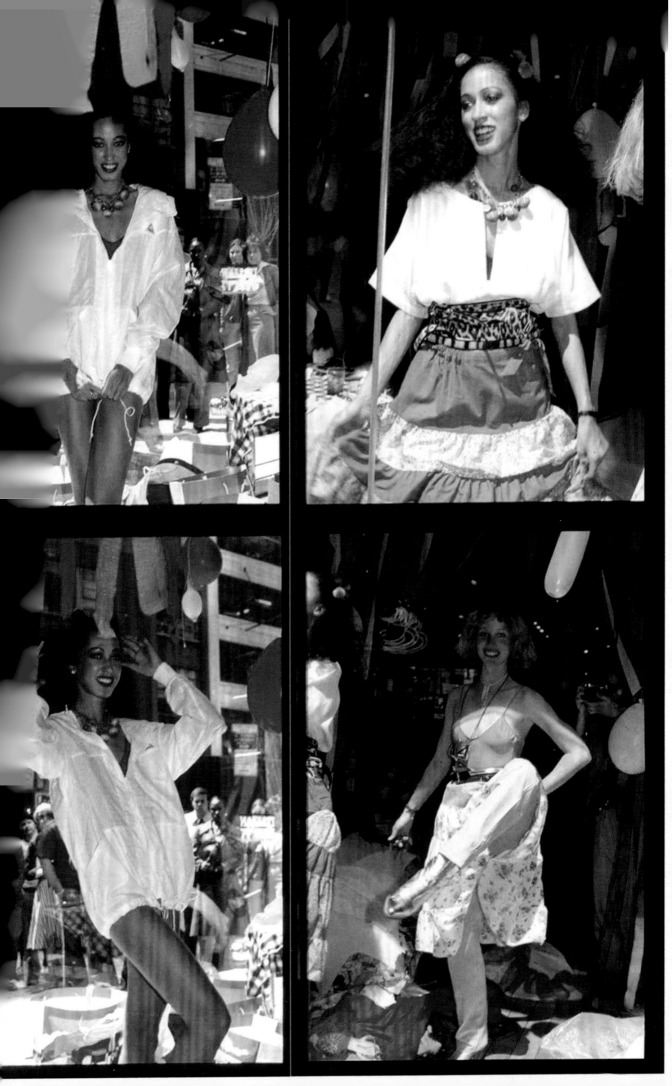

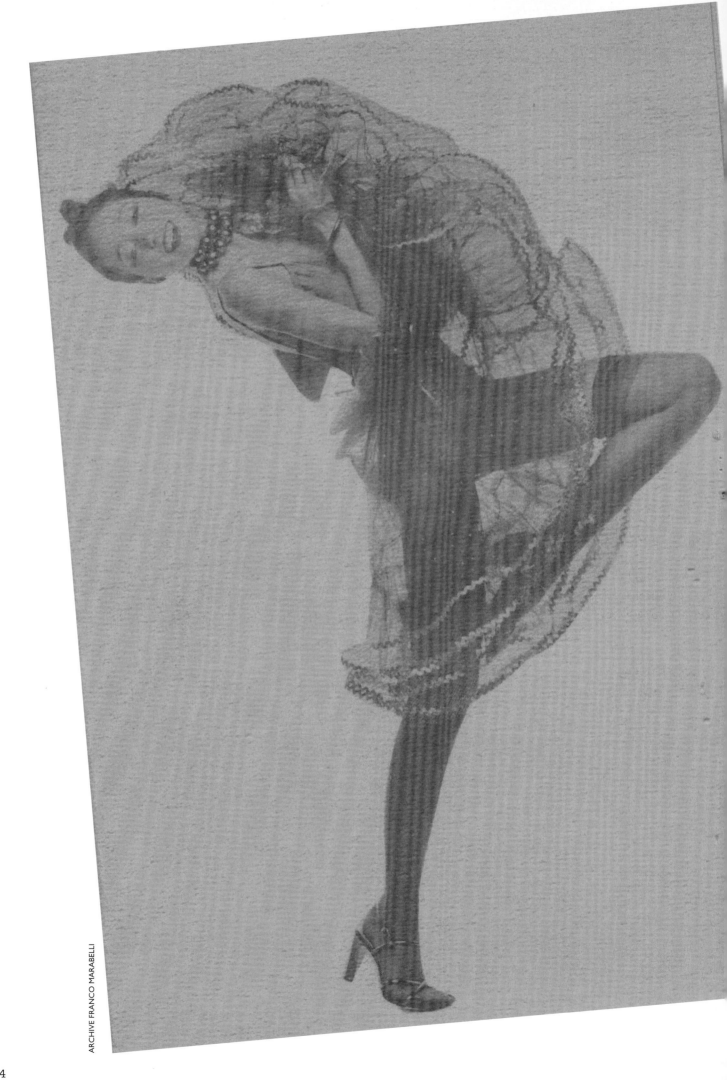

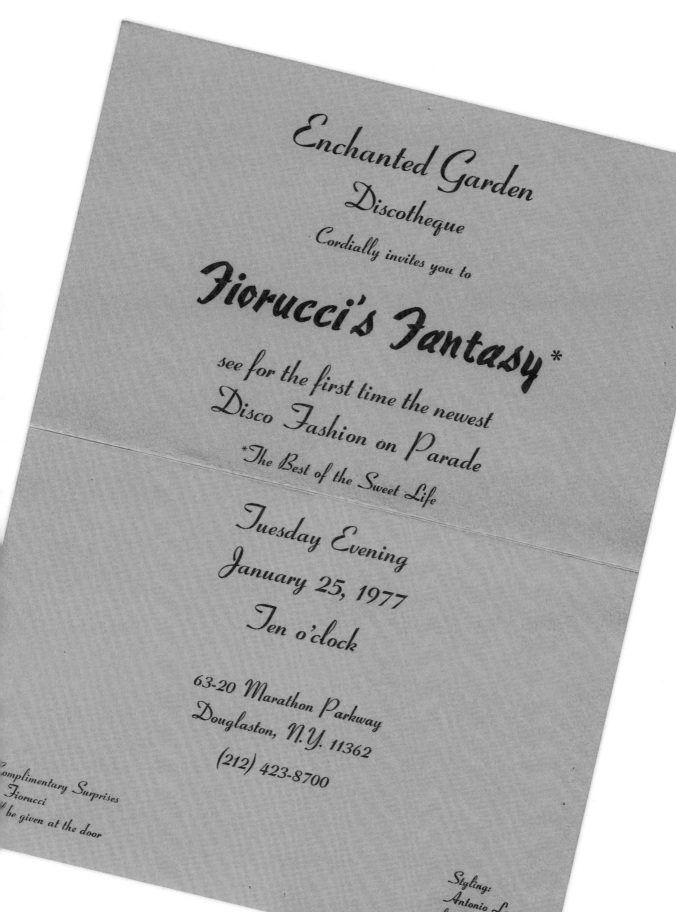

Enchanted Garden
Discotheque

Cordially invites you to

Fiorucci's Fantasy*

see for the first time the newest
Disco Fashion on Parade
*The Best of the Sweet Life

Tuesday Evening
January 25, 1977
Ten o'clock

63-20 Marathon Parkway
Douglaston, N.Y. 11362
(212) 423-8700

Complimentary Surprises
Fiorucci
be given at the door

Styling:
Antonio Lopez
for Fiorucci

PAT CLEVELAND

"Enchanted Garden" invitation for the Fiorucci Fantasy party. The owners of the venue were Steve Rubbel and Ian Schrager, who later opened Studio 54. They met Elio on this occasion and became regular customers of the store.

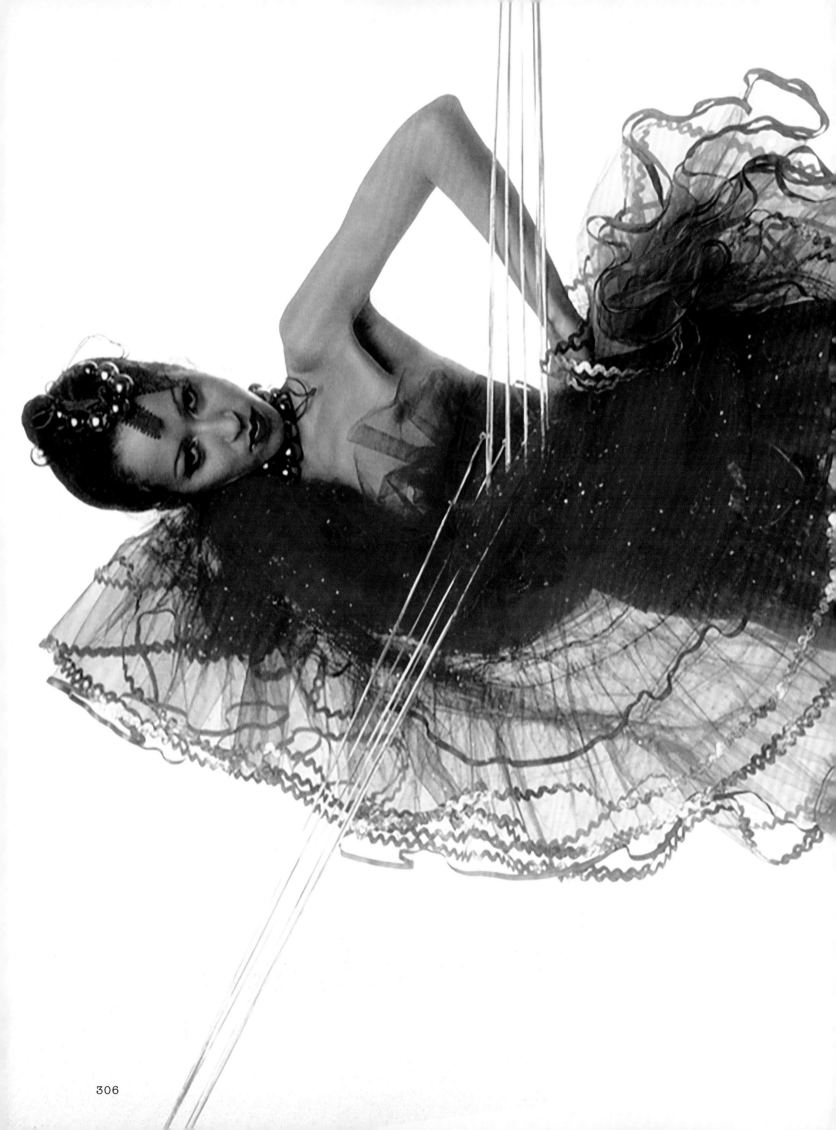

306

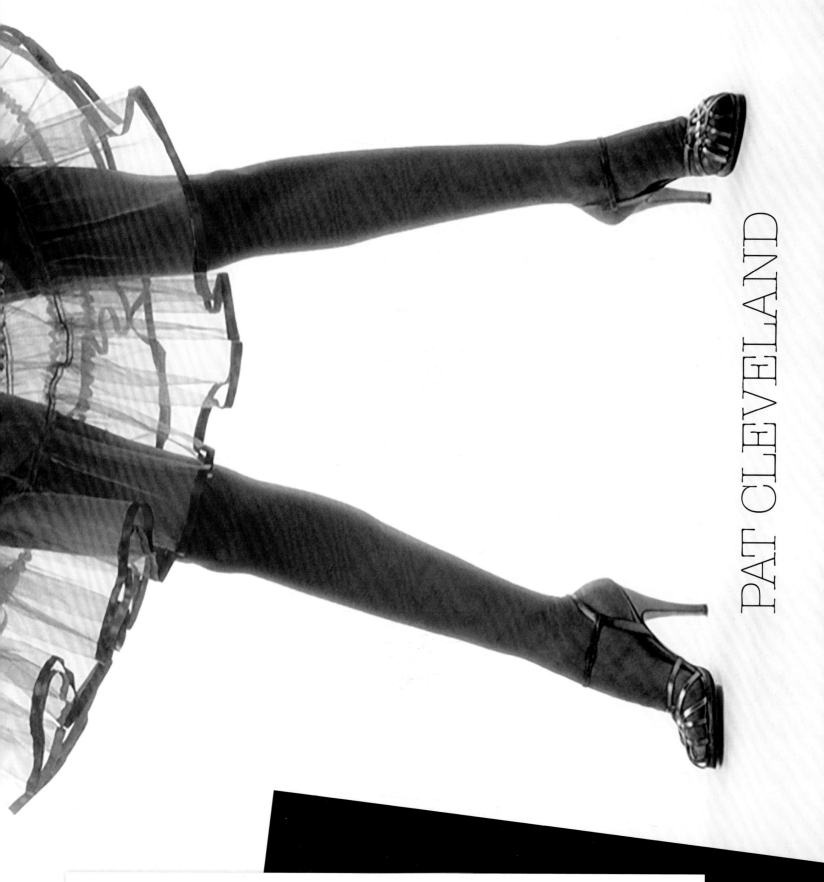

PAT CLEVELAND

Pat Cleveland wearing a tulle skirt with ribbons, designed by Antonio Lopez and made by David Wolfson (1976–'77). It was sold in the Fiorucci store. Courtesy of the Estate of Charles Tracy/Barry Ratoff Executor.

ROSELEE GOLDBERG

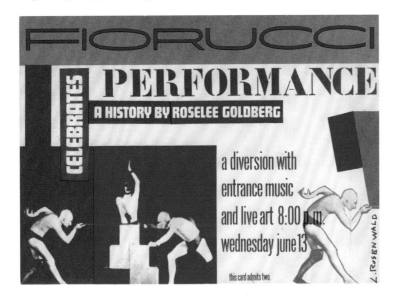

In 1979, there was a party to honor Roselee Goldberg, an art historian, author, critic, curator of performance art and founder of the Performa organization. During the event she presented her book *Performance*. Above, the invitation, designed by Laurie Rosenwald. In the photo, from left: Raina Sacks, Franco Marabelli, Roselee Goldberg.

MAURIZIO BRUNAZZI

Worked as a buyer in Milan and New York

I met Elio Fiorucci in the early 1970s at a lunch in a trattoria in Brera, through the creative director Franco Marabelli. I remember I was wearing bell-bottom jeans, Dutch clogs in wood and leather, and a Hawaiian shirt. During our conversation, Elio asked me if I was available to research ceramics and glass in Tuscany. I agreed and so—in 1974—I began work as a buyer, along with Anna Silei, who was in charge of the housewares and furniture section. We also sourced fragrances for the home and for people, and we discovered some forgotten Italian gems like Valobra and Rancé, as well as Le Jardin Retrouvé from France. We worked in close contact with the style office, which was headed up by Cristina Rossi. In those days, the designers included Tito Pastore, Juan Salvado, Mirella Clemencigh, Dina Vielmi, Mirella Landi and Mimma Gini. After the opening of the store I was often in New York, and I moved there in 1978 as a buyer for Fiorucci Inc.

Every Wednesday, we'd receive young creatives who brought us their ideas, from costume jewelry to printed T-shirts, scarves to accessories. When the products fit in with the Fiorucci spirit, we'd add them to the collection. The research was ongoing; I remember finding wool shawls printed with roses on a black-and-white background, typical of Eastern Europe, in Orchard Street. Gianni Versace used them in one of his shows paired with leather jackets. Another time I found some elasticated bodices with multicolored sequins, which Giorgio Armani bought up and used in a show, worn under jackets. Designers who were making interesting collections found space in the store: hosting new talent was always a thing with Elio. One of these was Betsey Johnson at the start of her career, with a collection made up of striped cotton and Lycra. Then there was Maripol, the photographer, stylist and friend of everyone in New York's alternative scene. She became famous because of the spiral bracelets she designed for Grace Jones and the accessories for Madonna's early looks. When Elio came to New York we'd take him to the trendiest places to look for new talent, new ideas and products that could represent the Fiorucci spirit. When Benetton came along, things changed considerably, and I returned to Italy around 1982 or 1983.

PHOTO PAOLO CARLINI

Heart-shaped sticker created for Valentine's Day. Design by Franco Marabelli. Graphic designer Calvin Churchman.

LAURIE ROSENWALD

Graphic designer, painter and illustrator

Rosenwald was born in New York. She worked for Fiorucci there and in Milan from the late 1970s to the early 1980s. Franco Marabelli had brought her to Fiorucci. At Fiorucci, she created posters, murals, display stands and shopping bags.

Her work demonstrated the value of contrast, fun and surprise; even in digital works, there was always a hand-drawn line, a collage or some organic detail. Her approach to design was influenced by European, Japanese and American commercial culture, and the abstract art of the 1950s and 1960s: Picasso, Matisse, Stuart Davis and Tadanori Yokoo, Saul Steinberg, Tomi Ungerer, Corita and Paul Rand. The result was an intelligent and whimsical sensibility, a love of solid colors, bold lines, rough fonts and a refusal to take anything seriously. She often traveled between New York and Europe, and now spends half her time teaching in Sweden. She also holds a wonderful creativity workshop for firms like Google, Starbucks and Adobe.

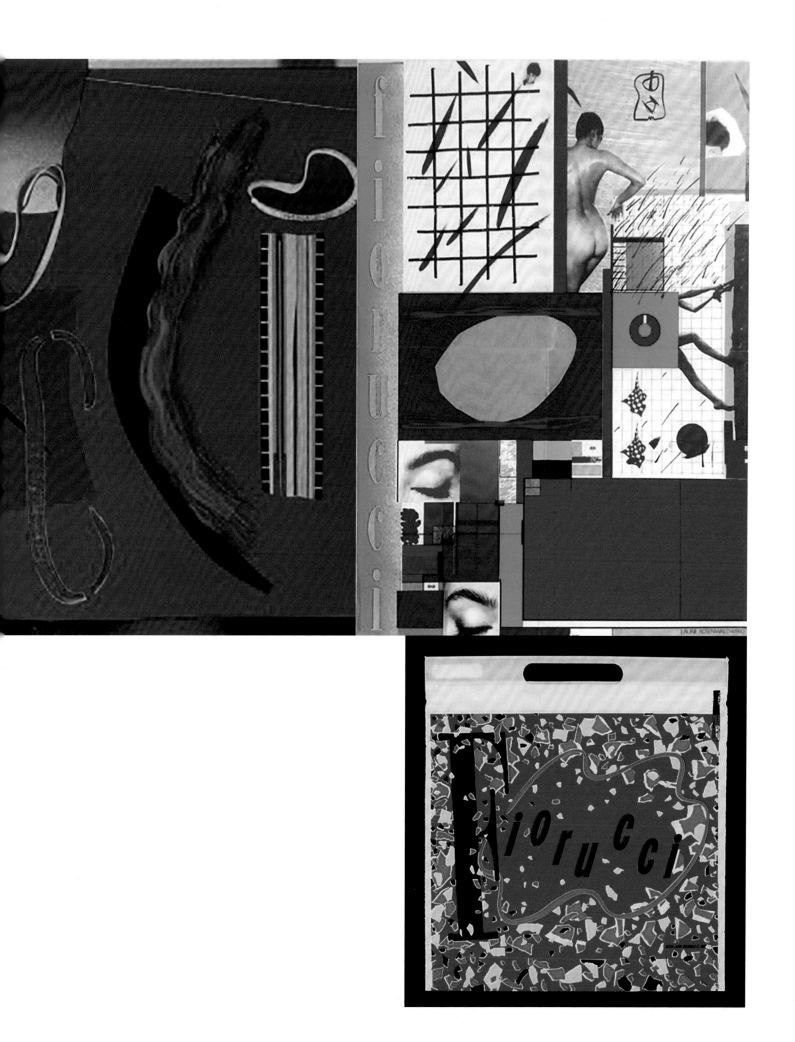

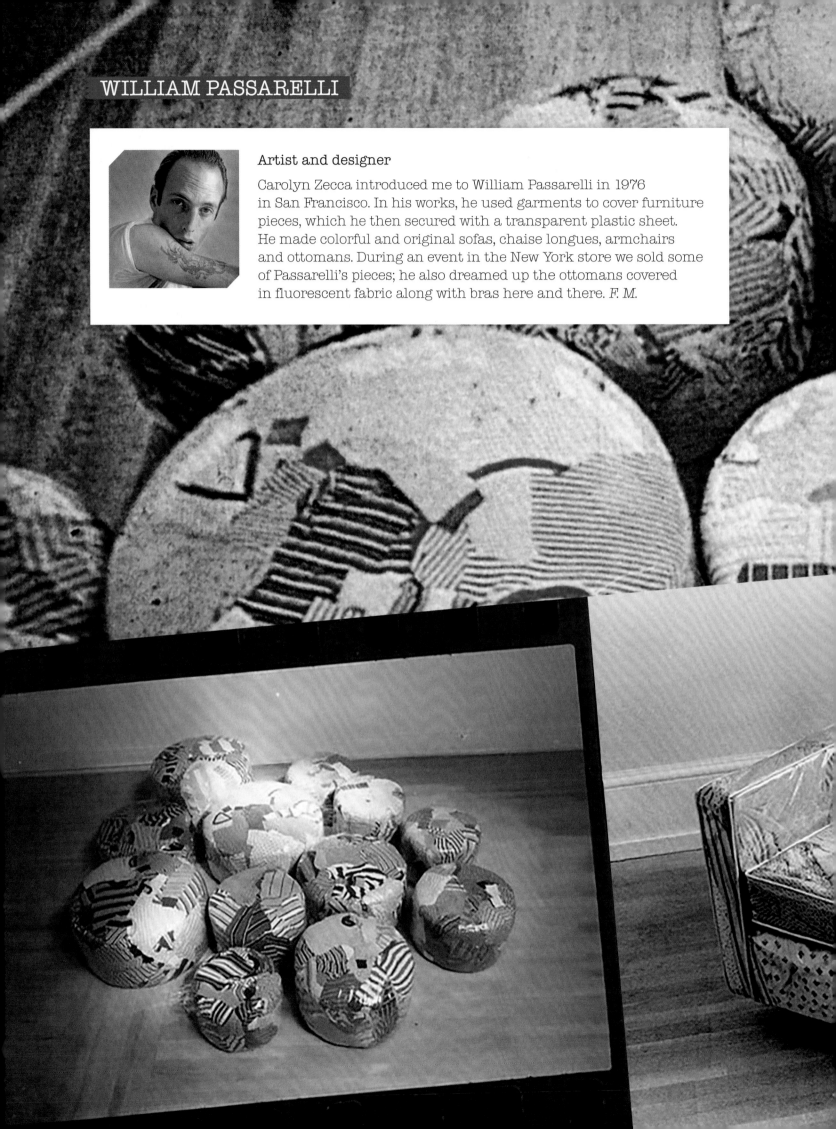

WILLIAM PASSARELLI

Artist and designer

Carolyn Zecca introduced me to William Passarelli in 1976 in San Francisco. In his works, he used garments to cover furniture pieces, which he then secured with a transparent plastic sheet. He made colorful and original sofas, chaise longues, armchairs and ottomans. During an event in the New York store we sold some of Passarelli's pieces; he also dreamed up the ottomans covered in fluorescent fabric along with bras here and there. *F. M.*

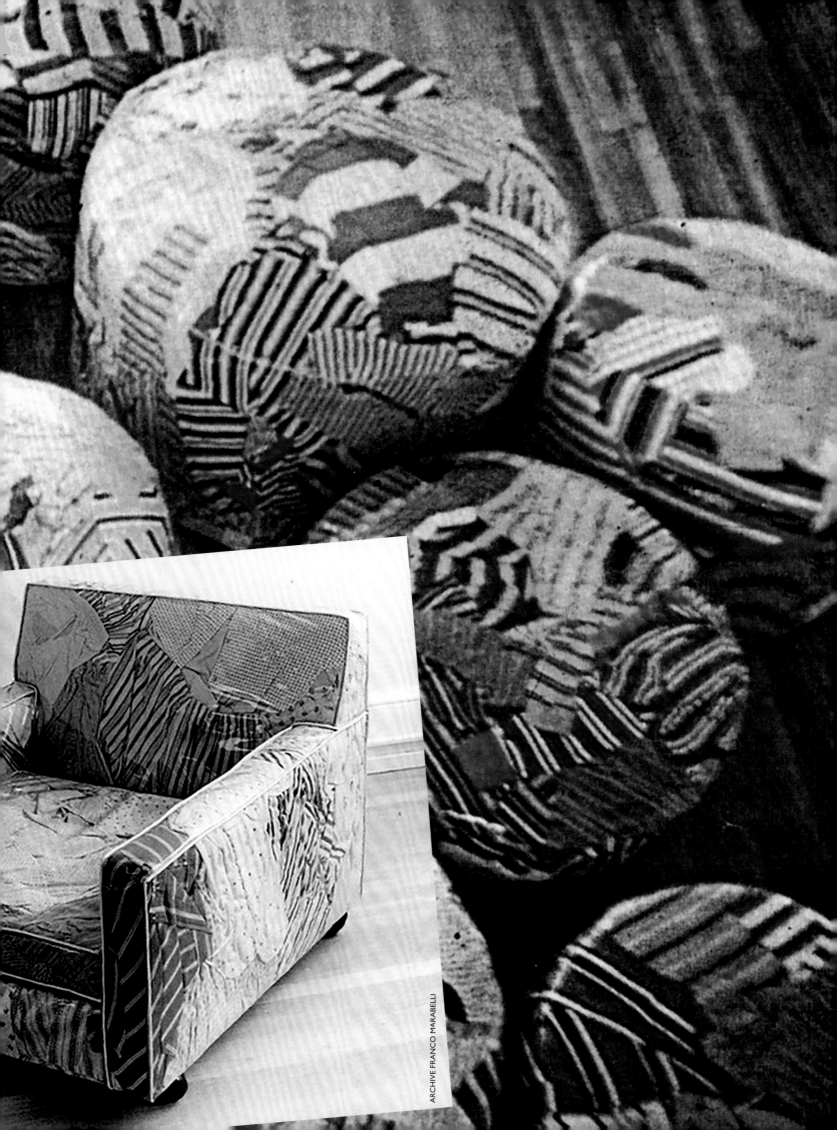

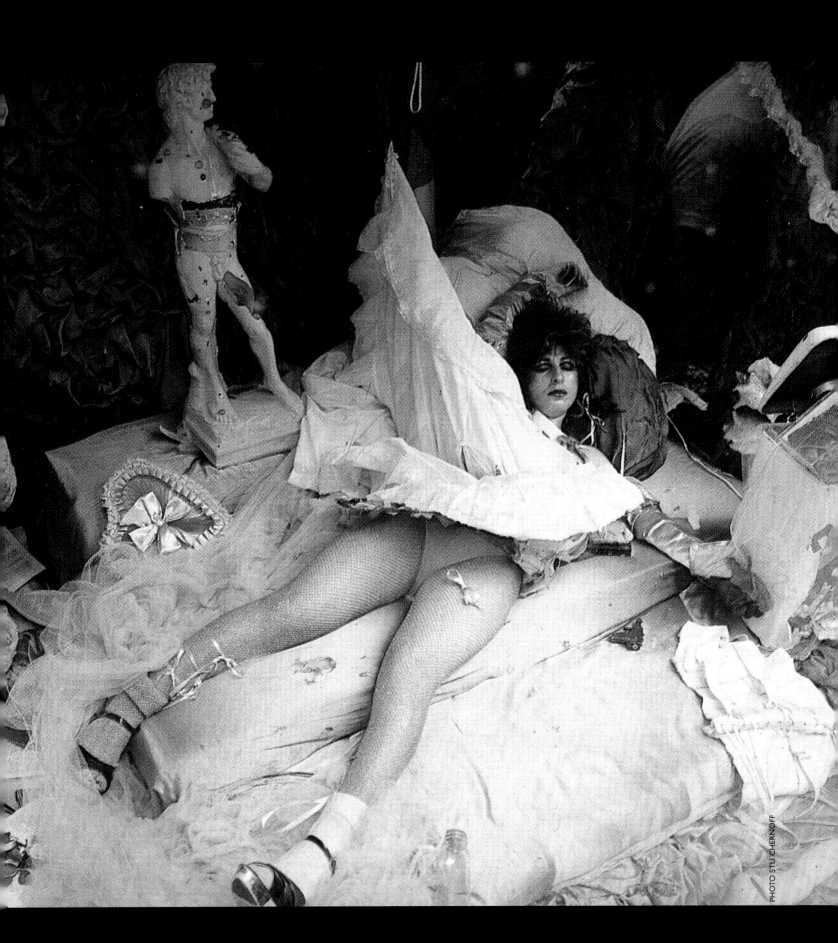

An artist known particularly for her irreverent performances; in 1975, she founded the live art group Justine and the Victorian Punks

When I met Colette she invited me to her home to help her decide how to do her artistic performance in the window display. She lived in a small building near Little Italy. When I went in, I saw a very thick white carpet and all the walls and ceilings were hung with white silk from military parachutes. You felt like you were inside a huge cloud, floating in the air. And that's how she eventually dressed the window.
F. M.

In 1978, I was already famous worldwide for my fabric environments featuring me as the central element, often accompanied by audio elements. Elio was very well-known in the fashion world, but he was also a cultured man who had great respect for artists, and for my work. In 1978, Franco Marabelli asked me to create an event for the window of the trendiest store in New York, and I was thrilled. I'd already started combining my street work and urban spaces, using store windows as huge light boxes.

The Fiorucci store was extremely well-known and in a great location; they gave me complete freedom and a generous budget. As well as flyers and posters about my performance, a grand opening took place. Some time later, the artistic director asked me to prepare a live art performance with Justine and the Victorian Punks. I performed with my visual art band on a stage set up in the store, with a packed audience. The following year, I was commissioned to create a clothing line inspired by my art—The Deadly Feminine Line—which was displayed in 1979. And the rest is history. A lot of people still remember that window display; the Fiorucci staff had photos of themselves taken in my "sleeping tableau."

LEFT: COLETTE'S PERFORMANCE IN THE WINDOW OF THE NEW YORK STORE.

BELOW, AT A BIRTHDAY PARTY IN 1978.

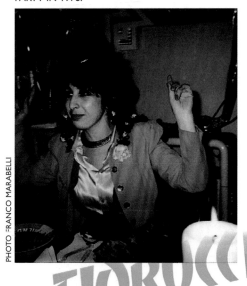

PHOTO: FRANCO MARABELLI

FIORUCCI

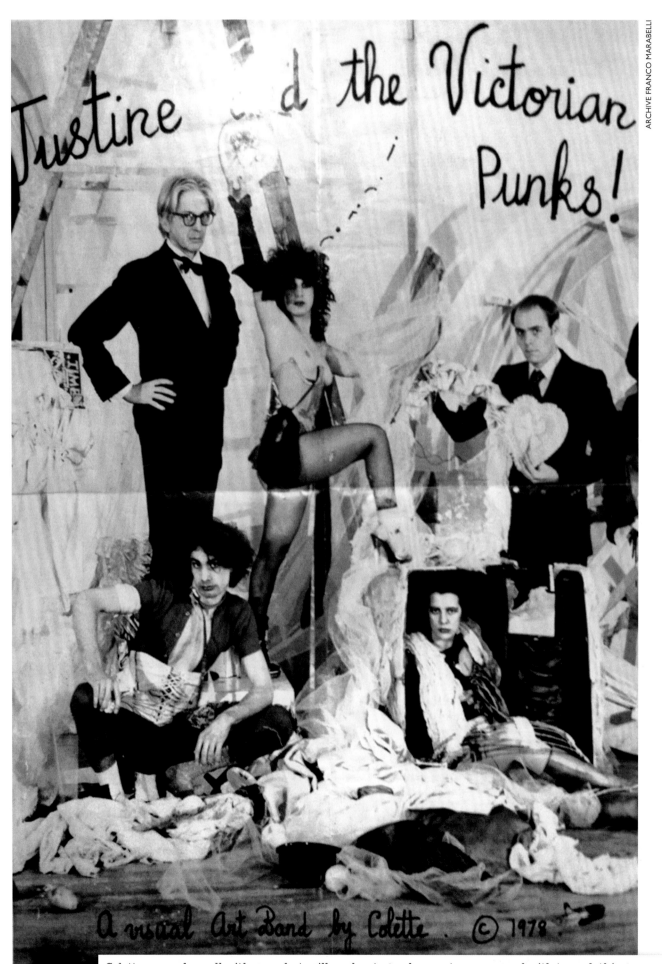

A visual Art Band by Colette. © 1978.

Colette covered a wall with parachute silk and a stage where actors appeared with torn clothing,
wild makeup and various objects. A young girl screamed as she smashed a doll. It was a destructive show
in the punk style of the era: pins, nails, black boots with studs, S&M bracelets...
In the video of the performance, Colette sings *Ancora tu* by Lucio Battisti.

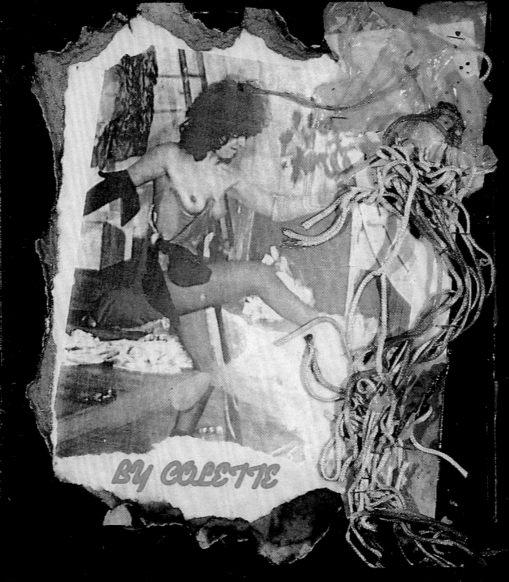

FIORUCCI
PRESENTS

BY COLETTE

JUSTINE
AND THE
VICTORIAN PUNKS

During the show, the two dancers dance and move without music, 1977–78.

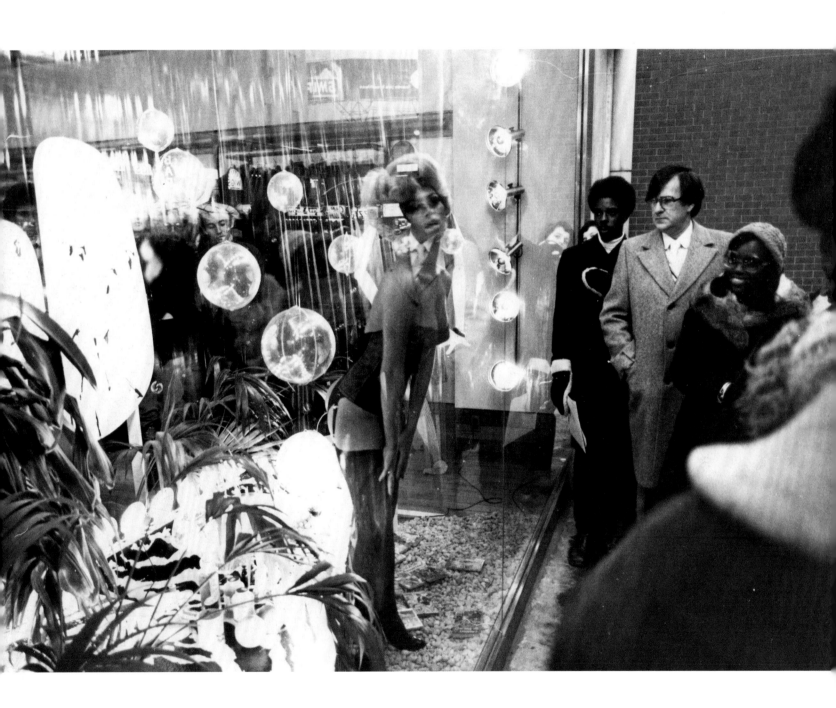

Valentine's Day window, 1978–79.

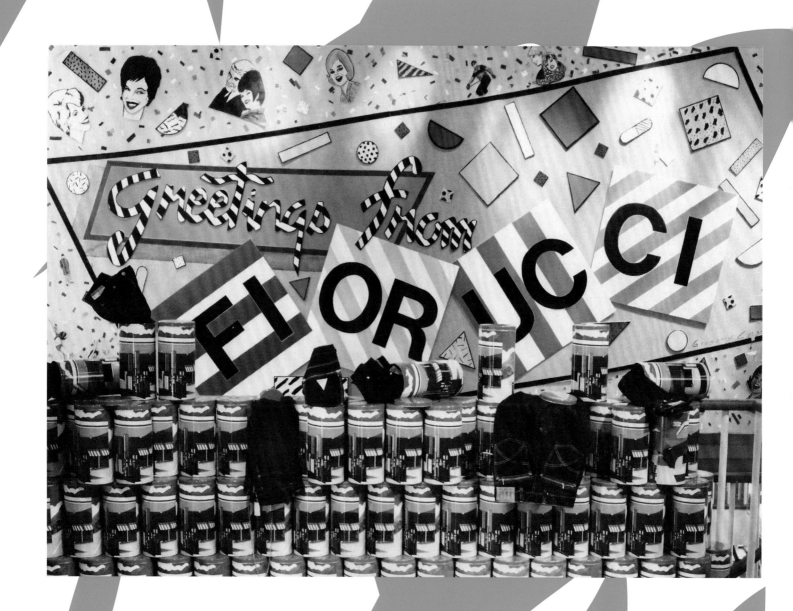

Every month there were different artistic works featured on the wall leading to the basement.
In the photo: graphic design based on tin cans. Customers buying a pair of jeans were given
a free copy.

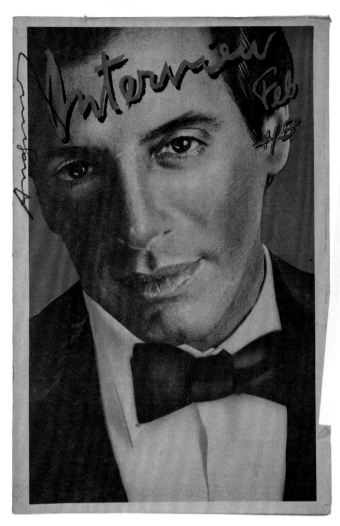

ABOVE, FIBERGLASS CUTOUTS
WITH THE FACES OF IAN SCHRAGER
AND FRANCO MARABELLI.

ON THE COVER OF *INTERVIEW*,
STEVE RUBELL, IAN SCHRAGER'S
PARTNER AT STUDIO 54.

I met Andy Warhol in the Fiorucci store. One day I was invited
to lunch at his house with Elio and Angelo Careddu.
At Warhol's house, we ran into Liza Minnelli's sister Lorna Luft
and two winemakers who had asked Andy to design labels for
their wines. The house was austere; in the dining room there was
a sideboard with ready meals, like a cafeteria buffet. When we
sat down, Andy switched on a small tape recorder, which he set
beside him. He recorded the whole conversation but he hardly
spoke. After lunch, we went to the huge Factory, where young
artists were making copies of his works. As we walked around, a

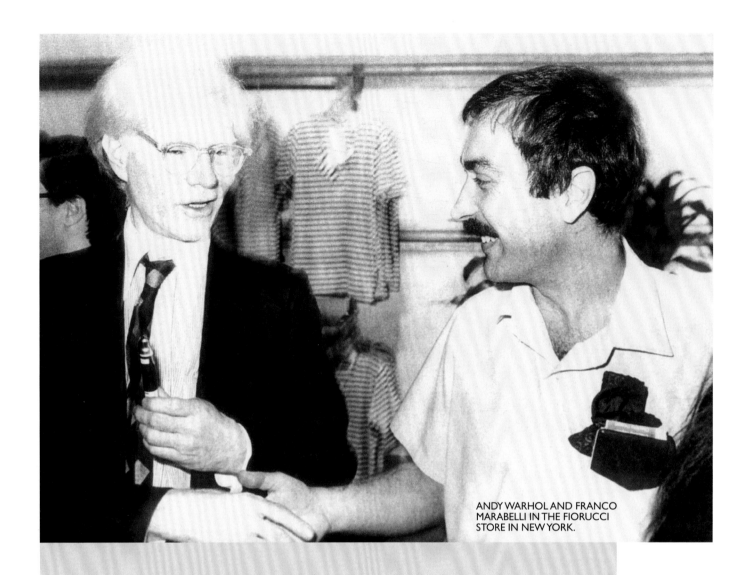

ANDY WARHOL AND FRANCO MARABELLI IN THE FIORUCCI STORE IN NEW YORK.

little goat came up to us. Elio went to pet it and asked Andy what it was doing there. The answer was, "My dear Elio, don't you know the goat is a magical animal?"

Then Elio said to me, "Franco, we have to get some goats in the store too." I replied that we could, but goats are omnivores and they'd tear up the store, not to mention the "gifts" they'd leave all over the place; we'd have to get someone to pick up after them all the time. Elio considered this for a moment and said, "So we can forget about that."

F. M.

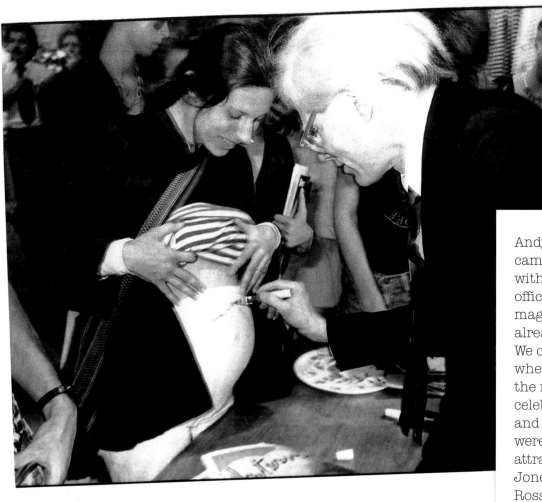

Andy Warhol was a big fan and came to the store often. Along with the Fiorucci public-relations office, we decided to promote his magazine *Interview*, which we already sold in the store.
We created a space in the window where Andy could sign copies of the magazine, along with other celebrities like Truman Capote and Bob Colacello. The events were highly successful and attracted top artists like Grace Jones, Brooke Shields, Isabella Rossellini and Divine. *F. M.*

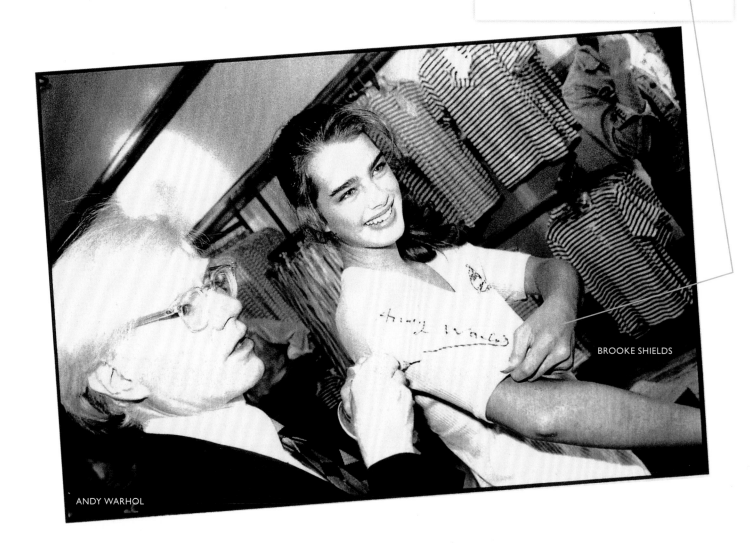

BROOKE SHIELDS

ANDY WARHOL

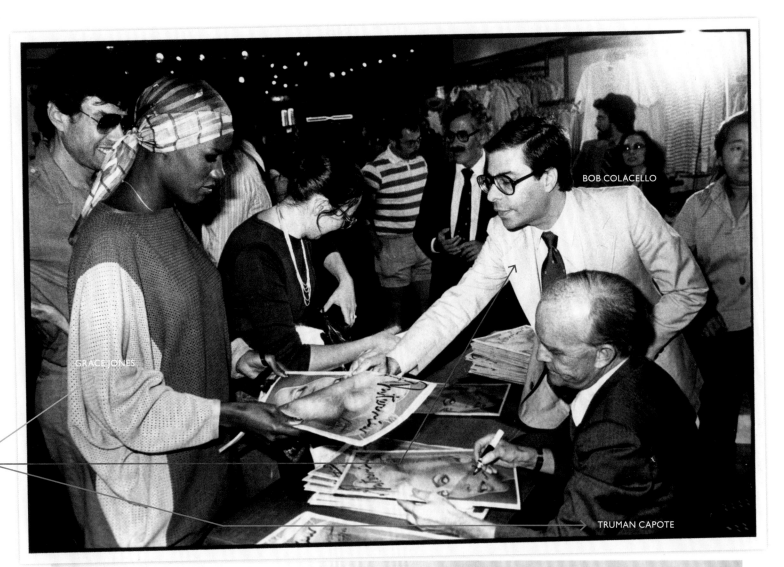

GRACE JONES

BOB COLACELLO

TRUMAN CAPOTE

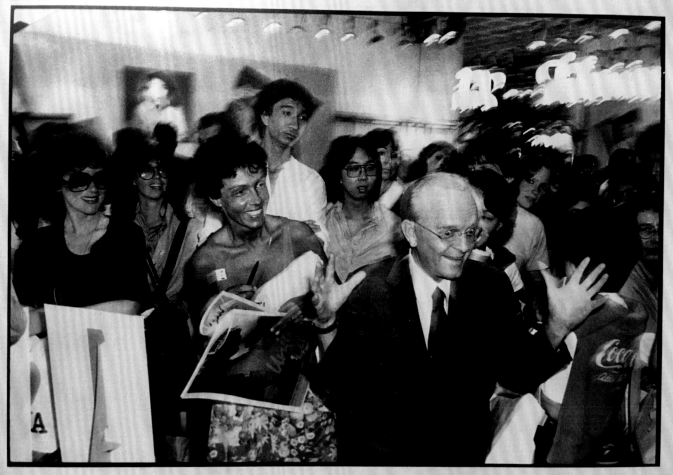

ASK ME ABOUT **FIORUCCI** CUSTOMER SERVICE

PHOTO CHIARA GUSSONI

MONICA BOLZONI
Fashion designer

I met Elio in 1974. Fiorucci was expanding and Elio was looking for staff; I reluctantly turned him down, as I still felt committed to the Parisian firm where I was working. "Remember, my door's always open," he told me. Later, he asked me to take on the Fiorucci megastore in New York, which would soon open. I wasn't keen, but with his kind and somewhat Fellini-like manner, Elio begged me to spend a week in Manhattan anyway.

Those were exciting days in a city buzzing with glamour and underground energy. Meanwhile, the Fiorucci store on 59th Street and Lexington was almost ready and, to publicize the imminent opening, enormous images of King Kong appeared on the windows, with the message, "Fiorucci is coming soon." I did my own personal market research.

I carried a gold PVC shopping bag with the Fiorucci name, and I was constantly stopped in fashionable places—department stores like Bloomingdale's, Henri Bendel, Macy's and the Rizzoli bookstore on Fifth Avenue, "What's Fiorucci?" they'd ask. It was obvious that the store would be a huge success, since it filled a gap in creative shopping that was still empty.

Fiorucci asked me to join the style office, but I wasn't sure about that.

At Fiorucci there were actually too many ideas: the warehouses were full of fascinating objects awaiting their moment. And that was my task! At that meeting with Fiorucci, what I was doing instinctively, and what I'd been working on previously, became an actual profession: fashion coordinator. Elio proved to be an enlightened entrepreneur; he gave me the freedom to experiment, and respected my need for independence.

And so I was ready to even take on America, first the New York megastore, with its fascinating hybridization of fashion, art and lifestyle, and then subsequent stores, in particular the theater/store in Los Angeles.

The end of the 1970s marked a period of a sort of depression. Even America began to feel nostalgia for lost traditions.

It was important to return to Italy, to creative craftsmanship and Milanese fashion. I had the feeling I was coming from the future. For me, Fiorucci meant having the courage to be bold, to swim against the tide; he opened the horizons to playfulness, experimentation and a rapport with art.

In particular, I learned the importance of the street, the window as a device for interacting with the world. All of this found a natural outlet in my work with "Bianca e Blu," a modular design project dedicated to women and their bodies. The year was 1980.

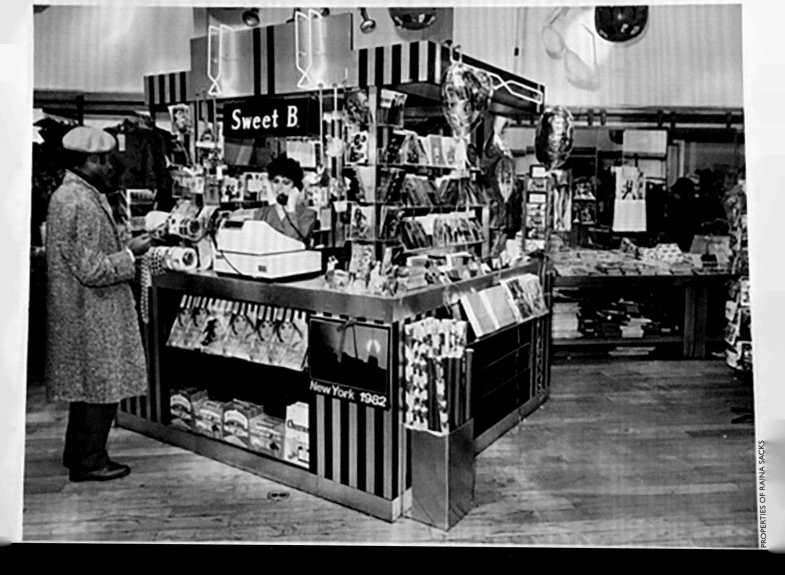

Newsstand inside the Fiorucci store selling newspapers, magazines, books, postcards and gadgets. The style was copied from American diners, with black and chrome.

Fiorucci was the only clothing store in New York
that sold Italian coffee.
There was always a long line, and the first "barista"
was Bernice Sacks, a charming woman who had
studied singing and jazz dance. She used to make
homemade cookies and sell them to the customers.
The original counter was all in wood, like the floor,
but later they decided to have it decorated by the
artist Laurie Rosenwald.

Bernice Martelle

Free espresso
coffee for all !!!

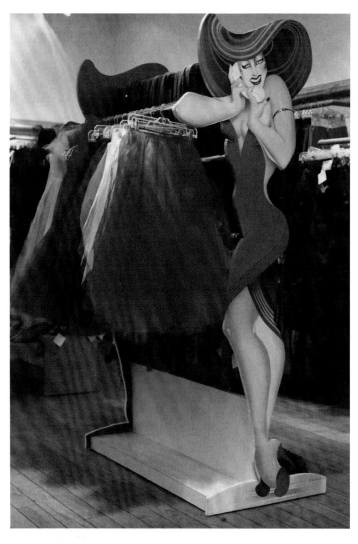
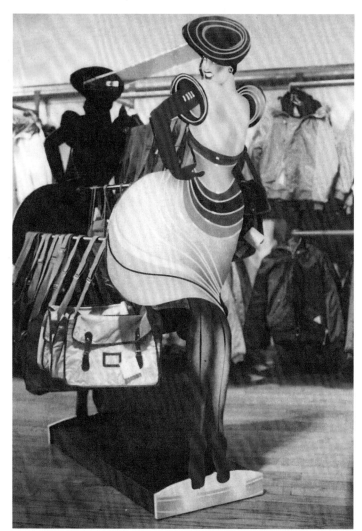
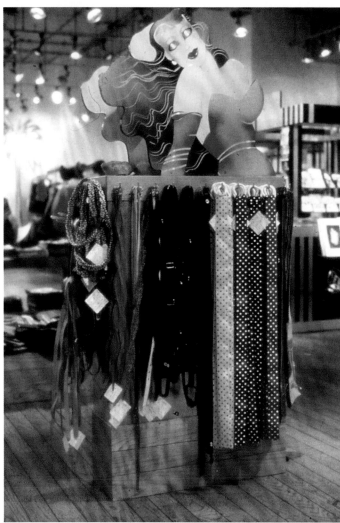
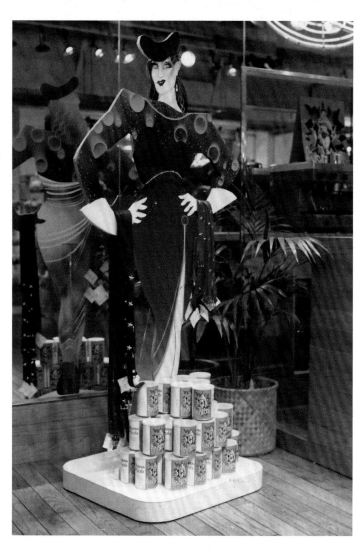

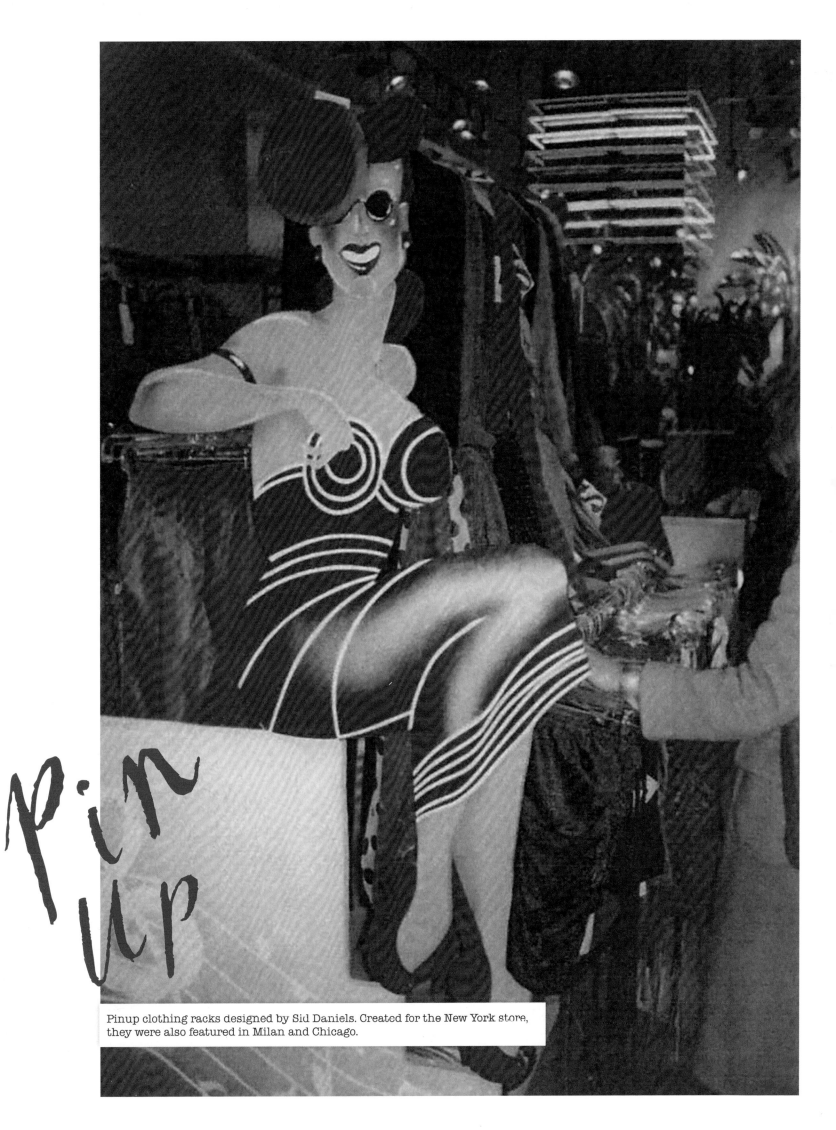

Pin up

Pinup clothing racks designed by Sid Daniels. Created for the New York store, they were also featured in Milan and Chicago.

A window display with a replica of a 1950s-style kitchen, featuring a girl preparing spaghetti and other Italian dishes. Concept by Franco Marabelli, design by Calvin Churchman.

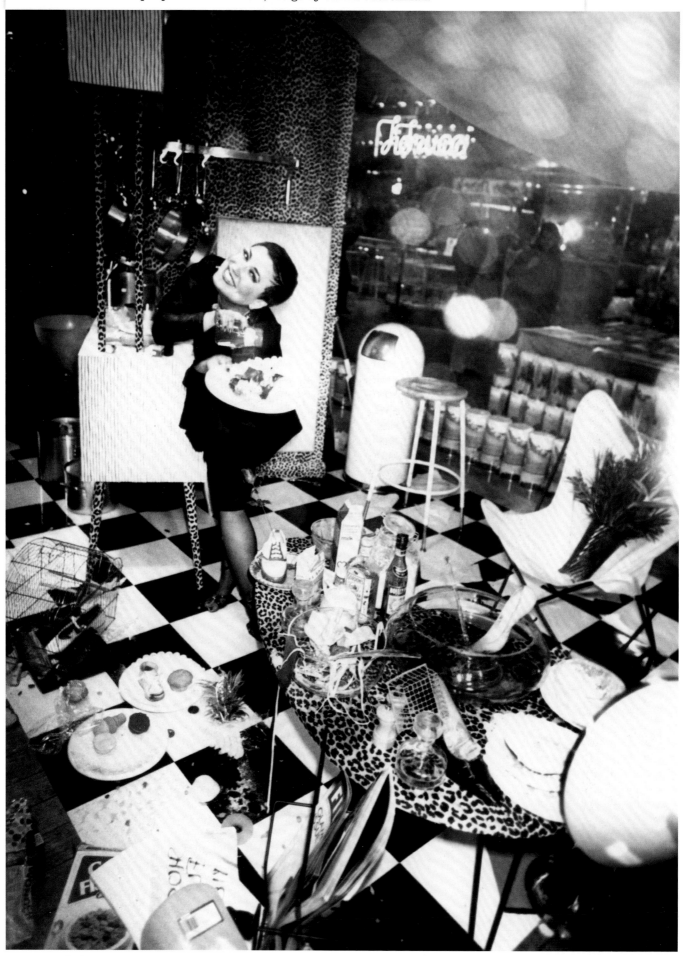

In window for Valentine's Day, a Brazilian model wearing a blond wig and heavy makeup lay in a zebra-striped bathtub, reading and drinking champagne.

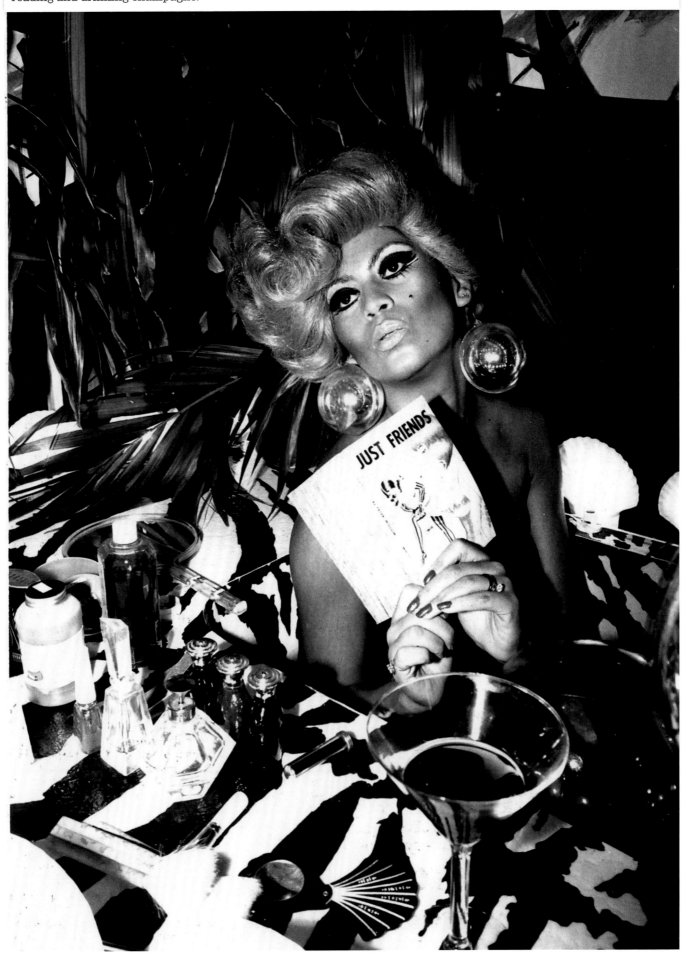

FIORUCCI

SPECIAL

$

ABSOLUTELY NO RETURNS OR EXCHANGES

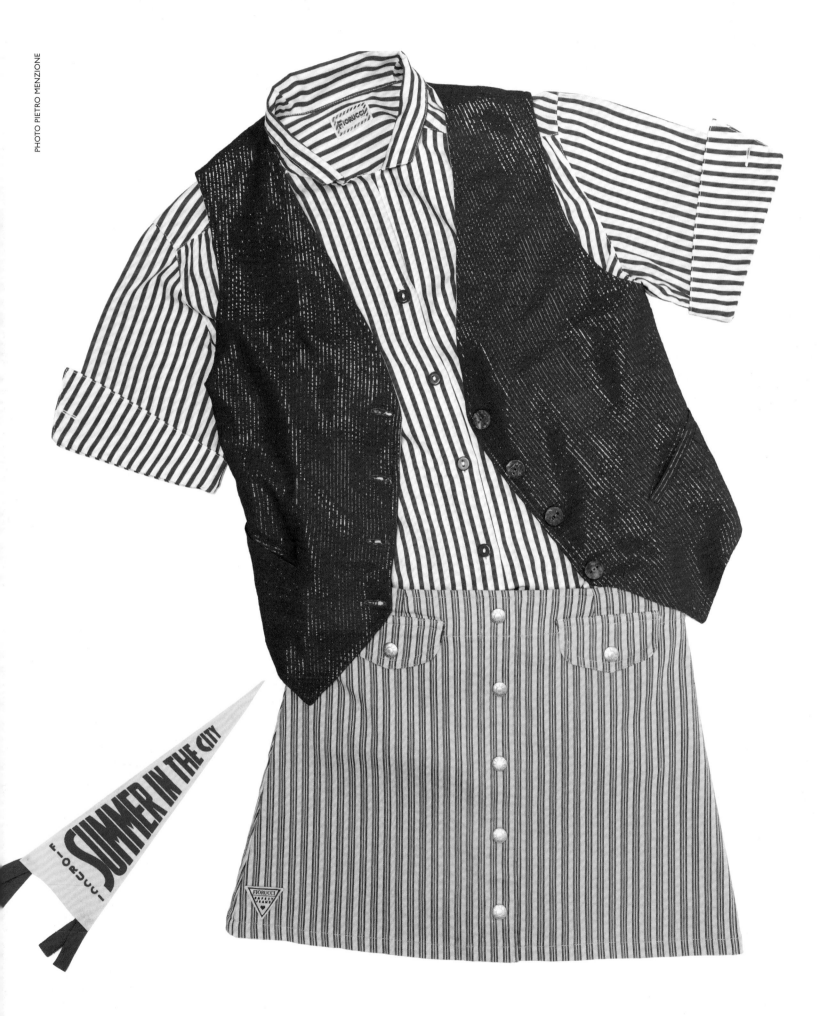

RAIMONDA LANZA DI TRABIA

Princess. Passionate fisherwoman

In the 1970s, I attended the Collegio delle Orsoline in Cortina d'Ampezzo: it was a privilege to study in such a beautiful place and be able to go skiing after school... it was certainly somewhat off the beaten path, however the school's approach was extremely modern for the period but a bit cut off from the world because everything that was happening in the big cities—Rome, Milan, Paris—was far away... Milan under armed guard, funeral processions in the streets, squads of riot police with shields and smoke bombs in Piazza San Babila, the universities occupied... news of all that (thank goodness there weren't any mobile phones or internet in those days) reached us with a delay, and anyhow it all seemed softened by the soft snow of Cortina! In those days, Fiorucci was for Milan what Carnaby Street was to London and Warhol's Factory to New York; I remember that arriving in Milan from Cortina for the holidays was like the country mouse coming to town. And what a joy it was to hurry to the Fiorucci store in Galleria Passarella: the colorful T-shirts, the blue jeans, the bright hippie dresses—the first to appear in Italy in those years—it all took us into an aesthetic universe that foreshadowed the new styles of the next thirty years, and which Elio Fiorucci had imagined before anyone else!

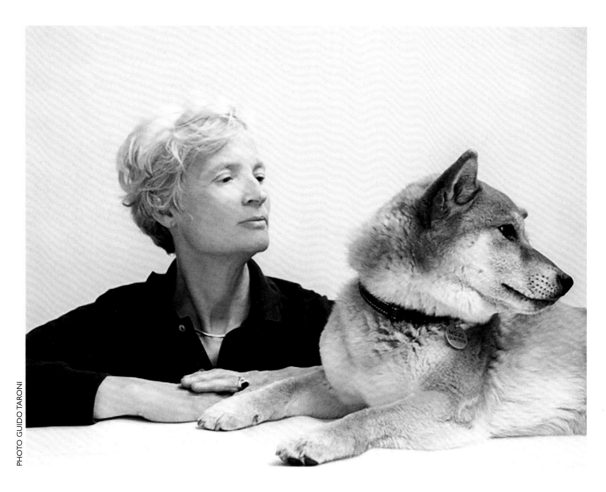

PHOTO GUIDO TARONI

If I think of New York in the mid-1970s, there was really nothing, especially nothing from Italy, in a single store. The fabulous, joyful store that opened in 1976 on 59th Street, next door to Bloomingdale's, made Elio Fiorucci a pioneer and a creative genius.

Before Benetton, before Gap, before Urban Outfitters and before Uniqlo, there was Fiorucci! And the company wasn't listed on the Stock Exchange. I believe Fiorucci was the first Italian fashion brand to arrive in New York with its own store. And—I repeat—in New York in 1976 there was hardly anything Italian, apart from maybe the occasional brand in the department stores. New York became a *cool* city after 1977, and Fiorucci realized that before anyone else.

In the New York store I met Franco Marabelli, who told me about the idea of mannequins with images of Margaux Hemingway. This was before people like her charged huge amounts of money; it was something we all did for nothing, for fun, because she was a friend of my brother's and she did it as a favor. I remember she was really flexible and lovely, we had a lot of fun doing those photos.

Window display in the New York store: cut-outs with Margaux Hemingway.

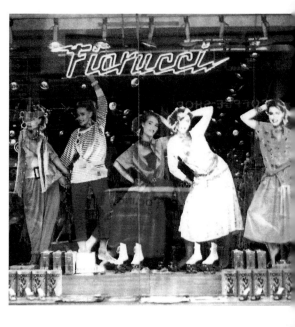

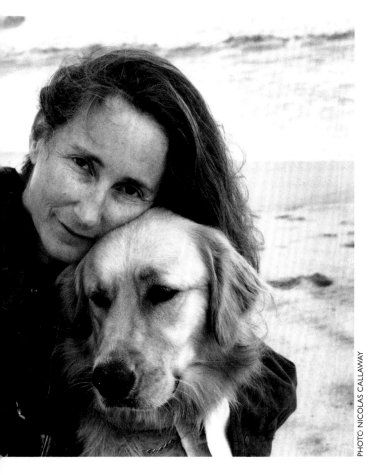

PHOTO NICOLAS CALLAWAY

PHOTO PRISCILLA RATTAZZI

Franco Marabelli
Art Director

fiorucci

125 EAST 59TH ST., NEW YORK, N.Y. 10022 212/751-1404

CON-EDISON ILLUMINATA A GIORNO.
23 DICEMBRE 79 - NON SI RESPIRA IN
QUESTA CASA - 2 CASE - 2 CITTÀ -
2 LINGUE - 2 LOCALI - 2 PERSONE -

Jack Rabbit
BRAND

A Div
Denve

NUMBE

maglietta con coniglio.

Pages from Franco Marabelli's
diary, a notebook full of ideas and notes,
travel and memorabilia, 1976–80.

RECEIVED

```
⚕
64778 FIORU HX

FIORUCCI NYK
ATT: FRANCO

THIS IS SANTA MARTA HOW ARE YOU DOING ?
IM FINE EVERYONE SENDS LOVE .   TAKE CARE.
LOVE, CHA-CHA
MARK

MISS YOU==
```

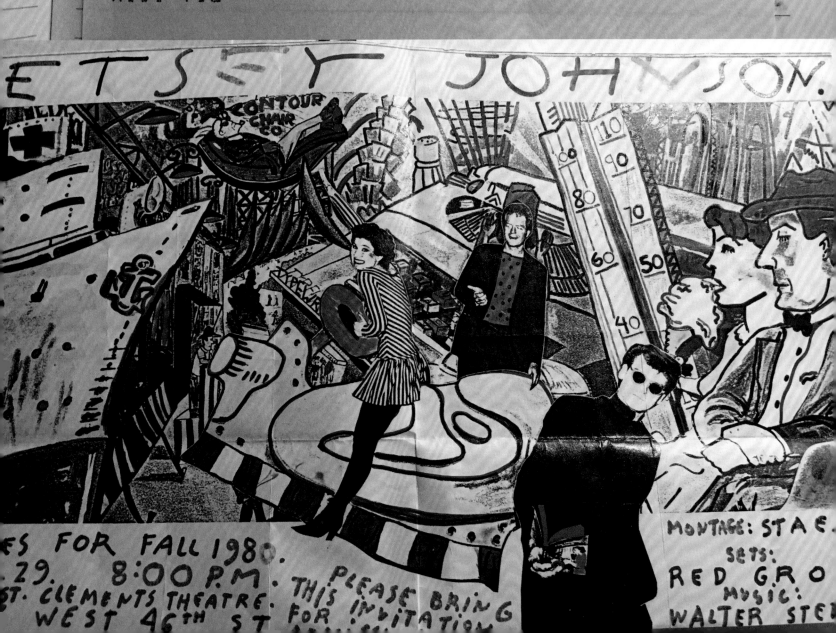

ETSEY JOHNSON.

...ES FOR FALL 1980.
...29. 8:00 P.M
ST. CLEMENTS THEATRE.
WEST 46th ST
PLEASE BRING
THIS INVITATION
FOR INVITATION

MONTAGE: STAE
SETS:
RED GRO
MUSIC:
WALTER STE

STAMPINI CON TOPOLINO eee.

KREUZER - GERMANY.

Rullino - FARE TANTI DISEGNI -

KREUZER -

2連ミサイル発射・3アクション付

キングロボ

JOEY ARIAS

Began as a sales assistant, but thanks to his personality he soon became a celebrity, sought out by customers and famous people.
He then became an artist, working with Klaus Nomi and David Bowie

I was born in North Carolina. My dad was in the army; when I was little we moved to Los Angeles. In 1976 I arrived at a friend's house in New York, and he said "Joey, they've opened a store called Fiorucci. You're gonna love it!" I must have been nineteen. I remember the store made an enormous impression on me because it was so different from all the others in town. The music was new and fantastic, the window displays were original. I'd never seen anything like it. I'd be shopping and I'd think "I love this store!"
I already identified with the atmosphere of freedom and extravagance. One day, some customers asked me if I could help them. The manager came and asked what was happening. I told her the customers had asked me for advice. You couldn't tell who the sales assistants were, because they were dressed in a particular, over-the-top way; it was hard to know whom to ask.
I suddenly had the desire to work at Fiorucci. A friend of mine introduced me to the manager, Joan Kaner, who said to me, "Dressed like that, you're like the embodiment of the Fiorucci concept, and I think customers will enjoy dealing with you, with your courteous manner and your smile." I accepted the offer gladly, and, soon afterwards, I got a call, "Joan Kaner here. Can you start Monday?" At the time, I was living in Soho with my friend Kim, and I screamed with joy, "Oh my God, I got a job at Fiorucci!"
Unlike the other sales assistants who walked, I ran to and fro like a cartoon character, trying to take care of as many customers as possible. Even Elio complimented me on my efficiency and courtesy. I worked really hard. Even now, wherever I go I'm "Joey Fiorucci."
Everyone came to the store: The Mamas and the Papas, Divine... film stars and celebrities came in, like Jacqueline Kennedy, and they were sent my way, "Joey will help you." We had Fellini, Silvana Mangano, Dalí, David Bowie, Dustin Hoffman, Donna Summer and Diana Ross, who came in one day while one of her songs was playing and said, "Here I am, Diana Ross at Fiorucci!"
Joan Kaner used to say, "This is our number-one salesperson." I was very young and had a lot to learn: the creative director Franco Marabelli was my teacher. I also planned some music performances in the store. I wanted to discover what the Fiorucci store, clothes and aesthetic meant for New York. Franco showed me everything: how to arrange the garments, make sure everything was in a certain order, how best to display accessories. It was fantastic, I felt really at home.
I remember Maripol brought Madonna into the store, and Madonna asked if her brother could work with us. So Christopher Ciccone became a sales assistant. Years later Madonna performed at Studio 54 to mark the fifteenth anniversary of the Fiorucci store.
When I introduced Klaus Nomi, who sang like a soprano, to Franco Marabelli at Max's Kansas City, Franco said, "Joey, we have to do a show with Klaus." It was the beginning of New Wave. We put on three events, and there was also an exhibition of Kenny Scharf's paintings. And that was how the art began. Keith Haring and Jean-Michel Basquiat were jealous, because there was a show at the famous Fiorucci store. There was art there twenty-four hours a day; it was an exciting concept of fashion. Studio 54 picked up on the idea. It was well known that celebrities went to Fiorucci, and that there was nothing else like

RIGHT, JOEY ARIAS'S BOOK, 2002.

JOEY ARIAS

ARIAS

THE ART OF CONVERSATION

it in New York. Antonio Lopez with his crazy plexiglass mannequins, Pat Cleveland, Andy Warhol signing copies of *Interview*, Grace Jones, Truman Capote. The photographer Bill Cunningham was a frequent visitor, and he used to say "This is the best store in the world!" So did Patricia Field. A lot of designers came. Karl Lagerfeld, Betsey Johnson. It was incredible. We often saw Cher, Victor Hugo and Marc Jacobs, who was a young kid: he'd say "I love the Fiorucci store."

One day Gloria Vanderbilt asked me, "Which jeans sell the most?" I showed her the new stretch jeans, and she bought everything. Six months later, she launched "Gloria Vanderbilt Jeans": she'd copied Fiorucci. Calvin Klein also asked me which were the best jeans. I showed him all the products, he bought something like $500 worth of jeans, and six months later along came "Calvin Klein Jeans," but they were all Fiorucci jeans. Everyone copied the products for their own interests. So many designers came and bought jeans to copy them and create their own fashion empires. They stole our way of displaying the products too.

Klaus Nomi and I were even on *Saturday Night Live* with David Bowie, wearing Fiorucci clothes. When I went to work on the Monday after, there was a line outside waiting for autographs. I couldn't sell clothes because people wanted me to sign them. So I began performing at Studio 54 and other venues.

JOEY
WITH ELIO.

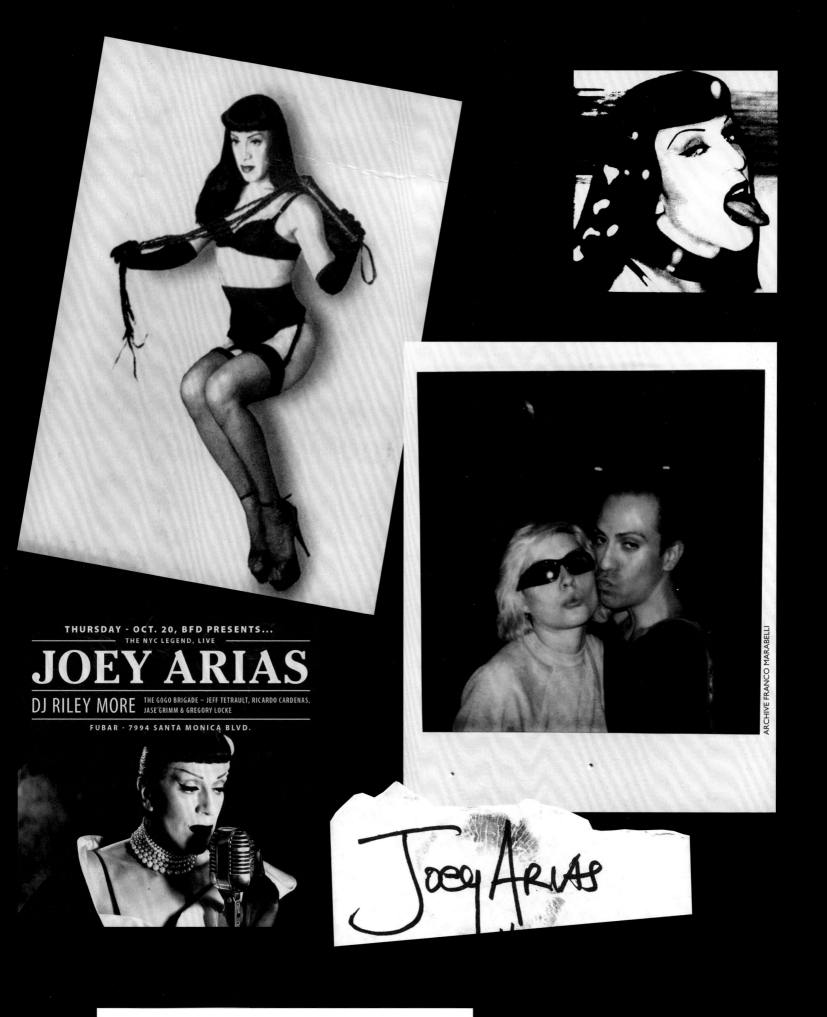

THURSDAY - OCT. 20, BFD PRESENTS...
THE NYC LEGEND, LIVE

JOEY ARIAS

DJ RILEY MORE THE GOGO BRIGADE – JEFF TETRAULT, RICARDO CARDENAS, JASE GRIMM & GREGORY LOCKE

FUBAR - 7994 SANTA MONICA BLVD.

Top, Joey plays Bettie Page in one of his shows.
In the Polaroid, with Debbie Harry in the Fiorucci store.

KENNY SCHARF

I don't remember how I met Kenny Scharf, but I immediately liked his paintings with the 1950s-style figures, and I asked him to show them in the store during the time Klaus Nomi was performing there. They were small, unframed canvases in shades of pink, green, yellow and black. The

paintings were displayed at the entrance to the store, and that truly served to launch the artist. Later on, Kenny was asked to decorate some rooms of the new Palladium nightclub opened by the former owners of Studio 54, Steve Rubell and Ian Schrager. *F. M.*

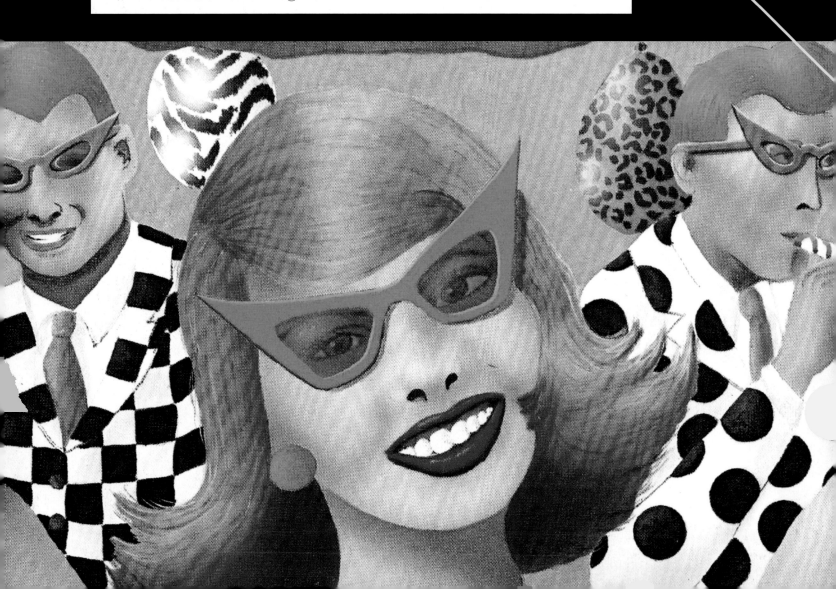

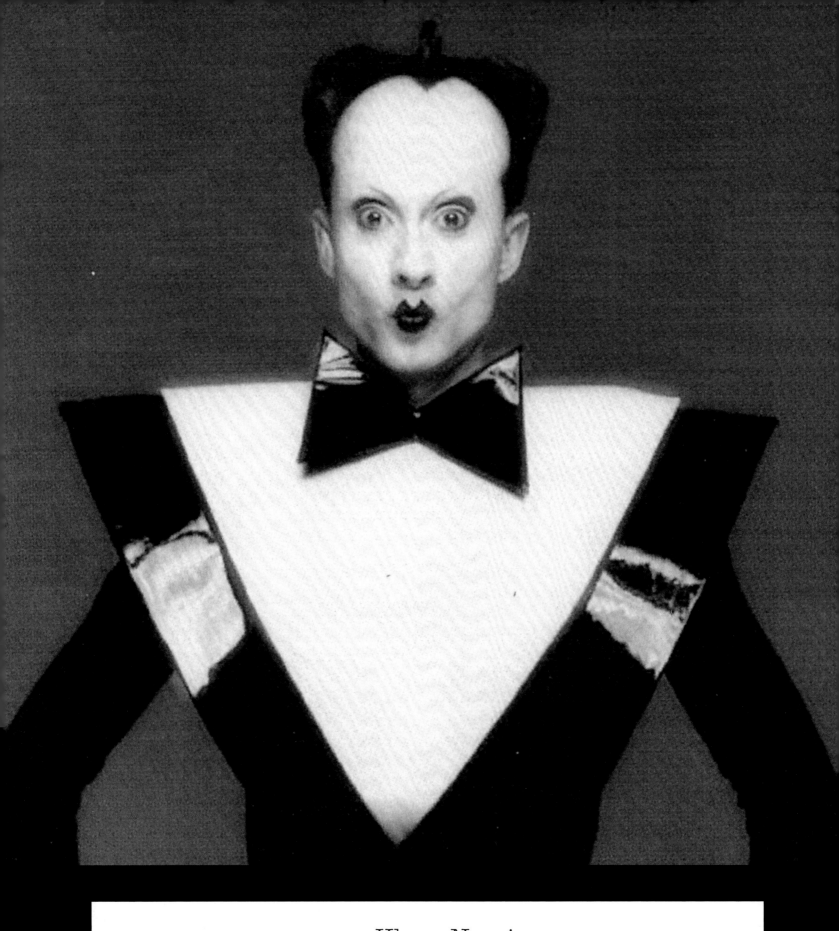

It was Joey Arias who introduced me to Klaus Nomi. We went to hear him sing at Max's Kansas City in New York, a venue famous for its unusual performers. When he started singing in his soprano voice, it was thrilling. I contacted him and he agreed to perform in the store for three nights. On those nights, we removed all the clothes from the ground floor and created a simple optical stage setting; Klaus came out of a small door lit by a spotlight and

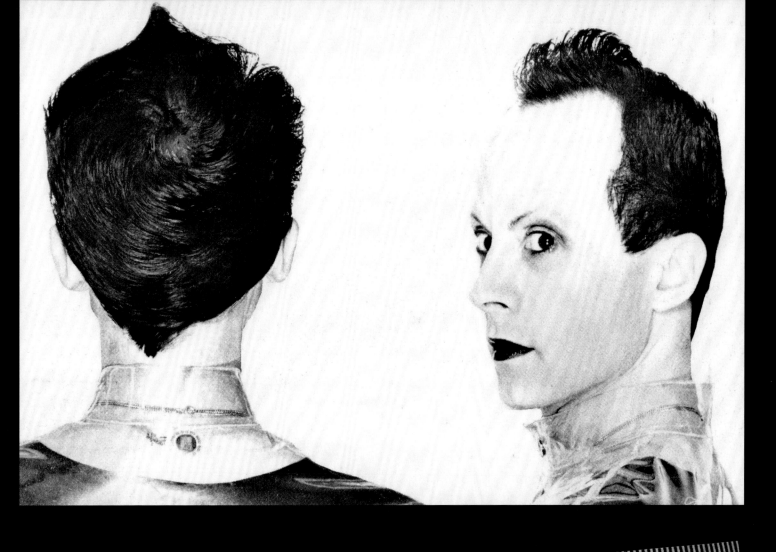

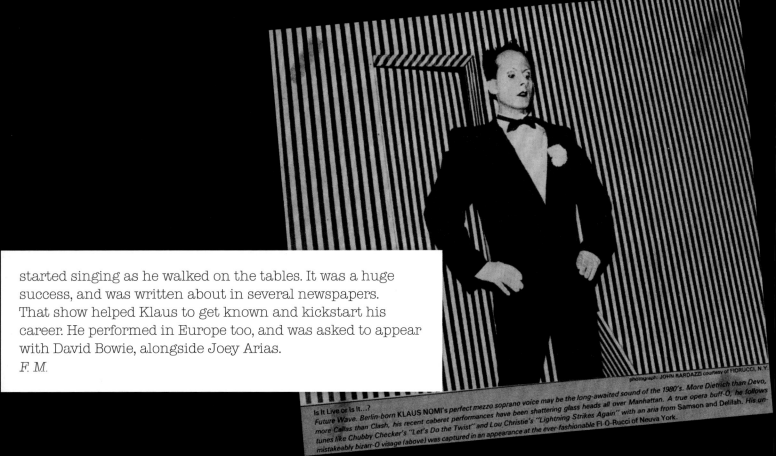

started singing as he walked on the tables. It was a huge success, and was written about in several newspapers. That show helped Klaus to get known and kickstart his career. He performed in Europe too, and was asked to appear with David Bowie, alongside Joey Arias.

F. M.

Is It Live or Is It...?
Future Wave. Berlin-born KLAUS NOMI's perfect mezzo soprano voice may be the long-awaited sound of the 1980's. More Dietrich than Devo, more Callas than Clash, his recent cabaret performances have been shattering glass heads all over Manhattan. A true opera buff-O, he follows tunes like Chubby Checker's "Let's Do the Twist" and Lou Christie's "Lightning Strikes Again" with an aria from Samson and Delilah. His unmistakeably bizarr-O visage (above) was captured in an appearance at the ever-fashionable FI-O-Rucci of Neuva York.

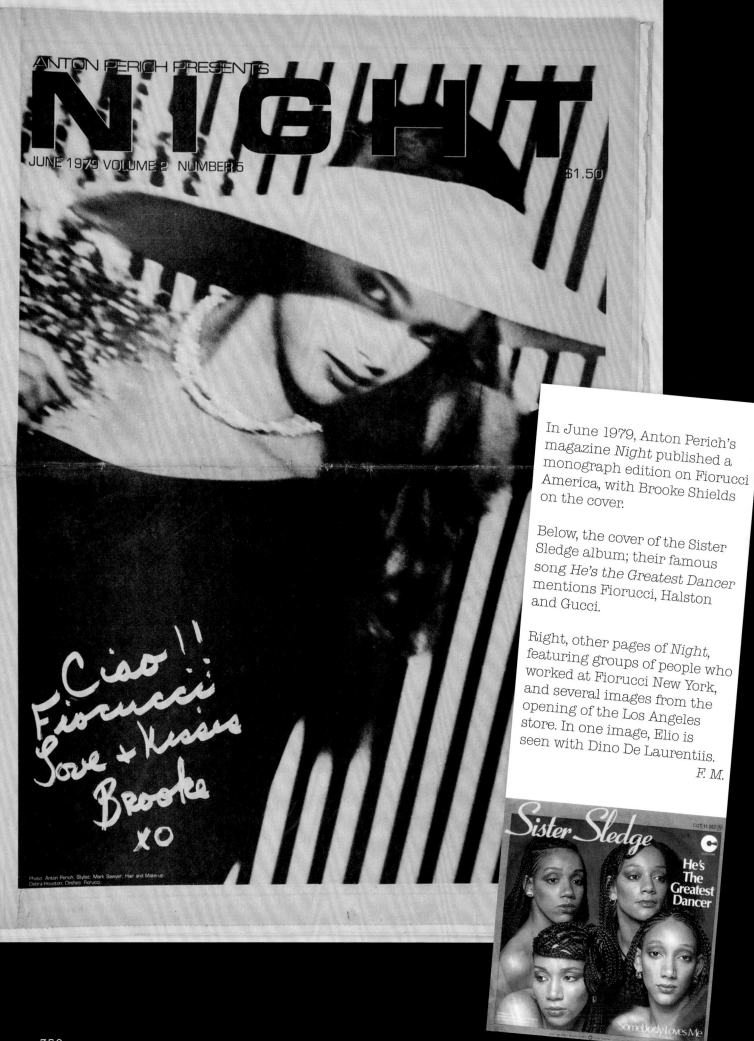

ANTON PERICH PRESENTS

NIGHT

JUNE 1979 VOLUME 2 NUMBER 5 $1.50

Ciao!!
Fiorucci
Love + Kisses
Brooke
xo

Photo: Anton Perich; Stylist: Mark Sawyer; Hair and Make-up: Debra Houston; Clothes: Fiorucci.

In June 1979, Anton Perich's magazine *Night* published a monograph edition on Fiorucci America, with Brooke Shields on the cover.

Below, the cover of the Sister Sledge album; their famous song *He's the Greatest Dancer* mentions Fiorucci, Halston and Gucci.

Right, other pages of *Night*, featuring groups of people who worked at Fiorucci New York, and several images from the opening of the Los Angeles store. In one image, Elio is seen with Dino De Laurentiis.

F. M.

Sister Sledge

COT 11 257 (N)

He's
The
Greatest
Dancer

Somebody Loves Me

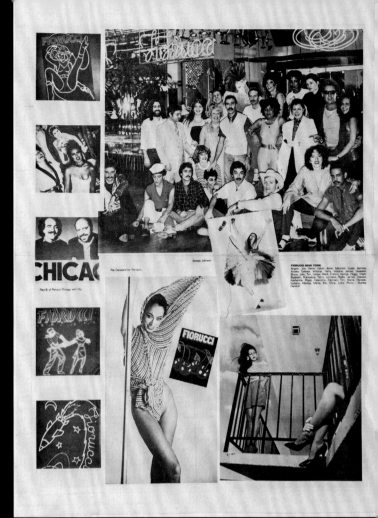

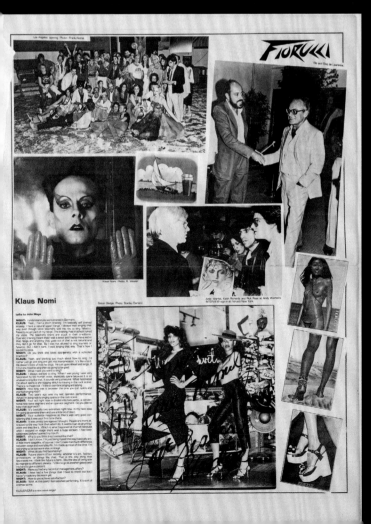

Klaus Nomi

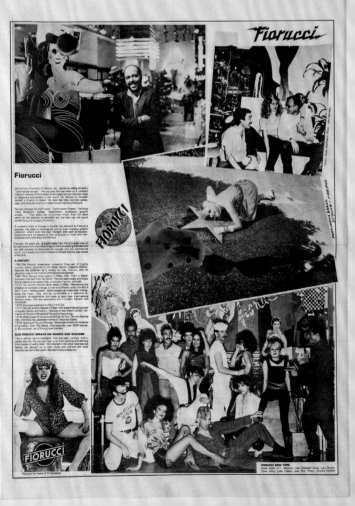

Fiorucci

PEOPLE AND EVENTS

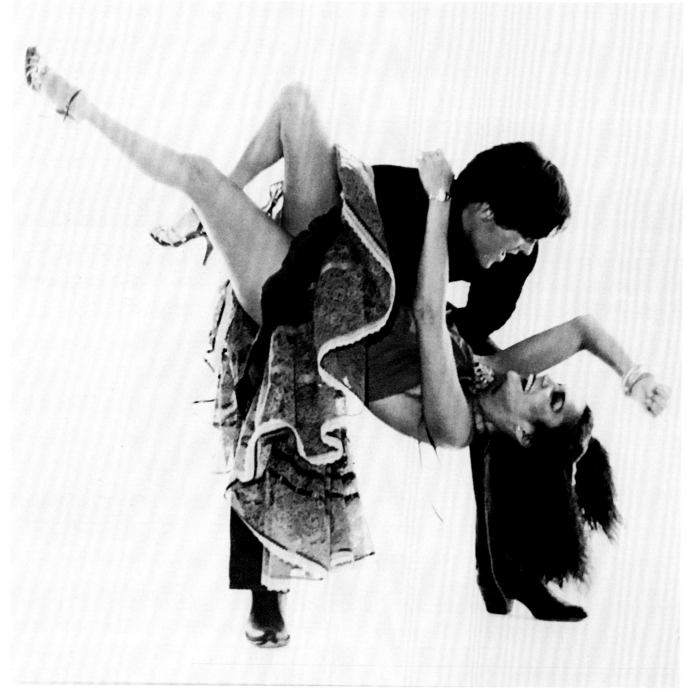

CARMEN D'ALESSIO,
DANCING.

I met Elio at the store on 59th Street; it was a gathering place for a group of friends who worked in fashion. They were fun people; there was music and entertainment, I used to drink coffee and meet up with Andy Warhol, Joey Arias, the sales assistants—who were all so charming—Princess Volkonsky, Antonio Lopez, Franco Marabelli. Pop artists, creatives, artists; you could meet them there every afternoon, without an appointment.

I'm a huge fan of Elio's; to me he remains the most innovative, inventive person— I've never met anyone who created such witty, creative and against-the-grain fashions.

Fiorucci was a creative hub, with so many people working alongside him. I remember when Maripol had a small display in the New York store: at the time she was selling her rubber accessories and other items. When she met Madonna, she created a look for her, and the song *Like a Virgin* made her famous. I'd planned a party at Studio 54 and Maripol brought Madonna, decked out in all the accessories and crucifixes Maripol sold at Fiorucci.

PHOTO FRANCO MARABELLI

353

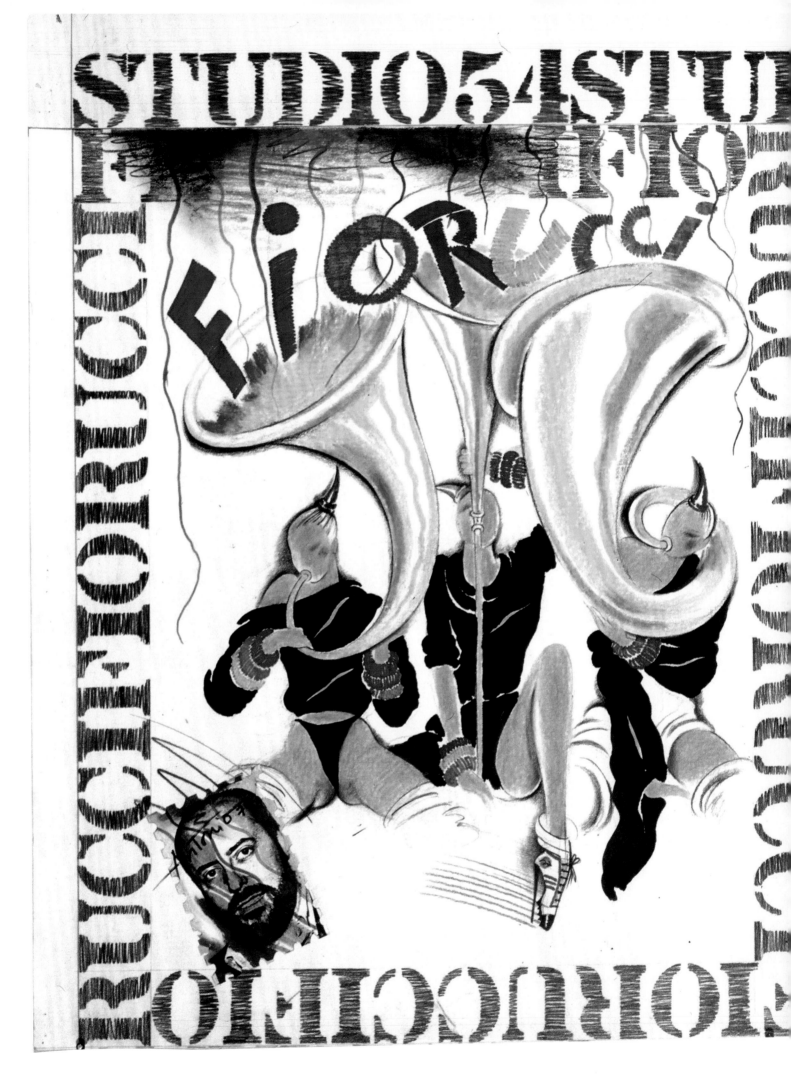

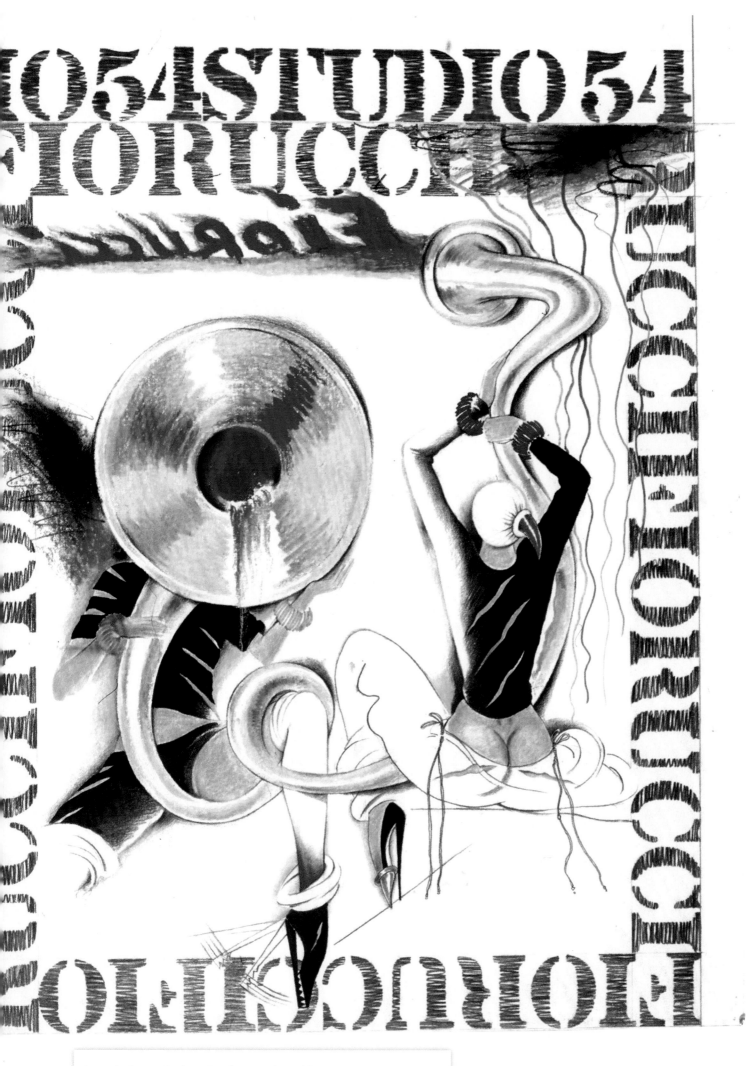

Antonio Lopez designs for the opening of Studio 54.

I met Elio in Milan, and I remember the opening of the Via Torino store (1974, ed.) with the restaurant, which had a fabulous atmosphere. I often went there with my husband Fabio (Bellotti, ed.) and we'd meet up with the cool crowd of the times. The most incredible event was when Keith Haring—already very famous—came to Milan to do his "action painting" in the San Babila store, and he and his assistant Little Angel transformed the place with his astonishing graffiti, the uninterrupted line that's his trademark and his quick way of working. I knew Keith from New York because I'd been living there for years, and I was his Milan friend; that's how a TV station that filmed the event asked me to interview him (it's still on YouTube). Another key place in Milan was the Torre di Pisa restaurant: it was our kind of food and Fabio was friendly with Ettore Sottsass, Barbara Radice, and Marco Zanini, Aldo Cibic and all the Memphis group as well as Douglas Tompkins, the owner of Esprit. He used to take me to have lunch at their table (at the time Fabio produced fabrics for Memphis, among other things); Oliviero Toscani and Elio were always there. You see, Elio had the ability to be in the right places and talk to the people who could open up new horizons for experimentation and ideas of all kinds.

I lived in New York and Milan, and I already knew and worked with Andy Warhol when Fiorucci opened his incredible store opposite Bloomingdale's, designed by Sottsass and Branzi. We took Andy, who was extremely inquisitive and would go anywhere—as he wrote, "I will go to the opening of anything, including a toilet seat"—and he had a great time distributing "Andy Warhol's *Interview*" which he generously signed for everyone. Maripol, who worked for Fiorucci and was a friend of Madonna's, for whom she had created several looks, brought her to the store and introduced her to Elio. Very soon everyone was gravitating there, and the store earned the nickname "the daytime Studio 54." There was music, you could dance, shop, browse and drink real Italian espresso, something completely new that couldn't be found in any other store. It became a gathering place for the underground and the young artists that revolved around Warhol, from Jean-Michel Basquiat to Keith Haring and Kenny Scharf, but visitors also included Truman Capote, Jackie Onassis, Bianca Jagger, Grace Jones, and other performers, transgender people. I remember the friendliness and joie de vivre of Joey Arias, who worked in customer service before he found fame as a performer, drag artist and cabaret singer; he's still performing on stages today.

At Fiorucci there was a unique atmosphere, created by all these very cool people. At night, I'd go to Studio 54 with my friends, like Richard Bernstein, who did all the covers for *Interview* magazine, the revolutionary fashion designer Stephen Burrows and Grace Jones; the celebrities and the Fiorucci staff managed to plan a party there in honor of Elio. Elio wasn't a designer but he had an incredible instinct, he knew how to follow the right path, he had sensitive feelers that picked up on and focused on change.

He was in tune with the moment; Elio was well aware that he had perfect timing. He embraced the world of pop art and disco culture. He was a communicator with an incredible sensibility, an aesthetic sense that pushed the limits, and amazing creativity. He loved freedom. He was always so kind and sweet. He was a self-made man, but his mind ran the gamut. A lot of people loved him very much.

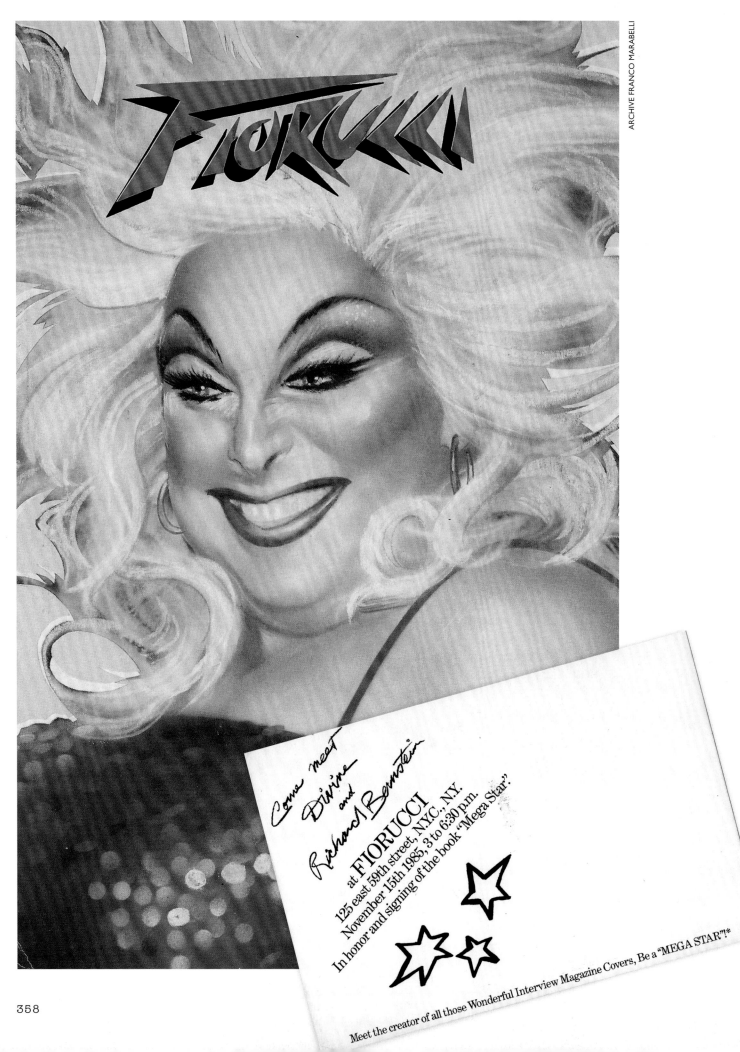

Come meet
Divine
and
Richard Bernstein

FIORUCCI
at FIORUCCI
125 east 59th street, N.Y.C. N.Y.
November 15th 1985, 3 to 6:30 p.m.
In honor and signing of the book "Mega Star".

Meet the creator of all those Wonderful Interview Magazine Covers, Be a "MEGA STAR"!*

358

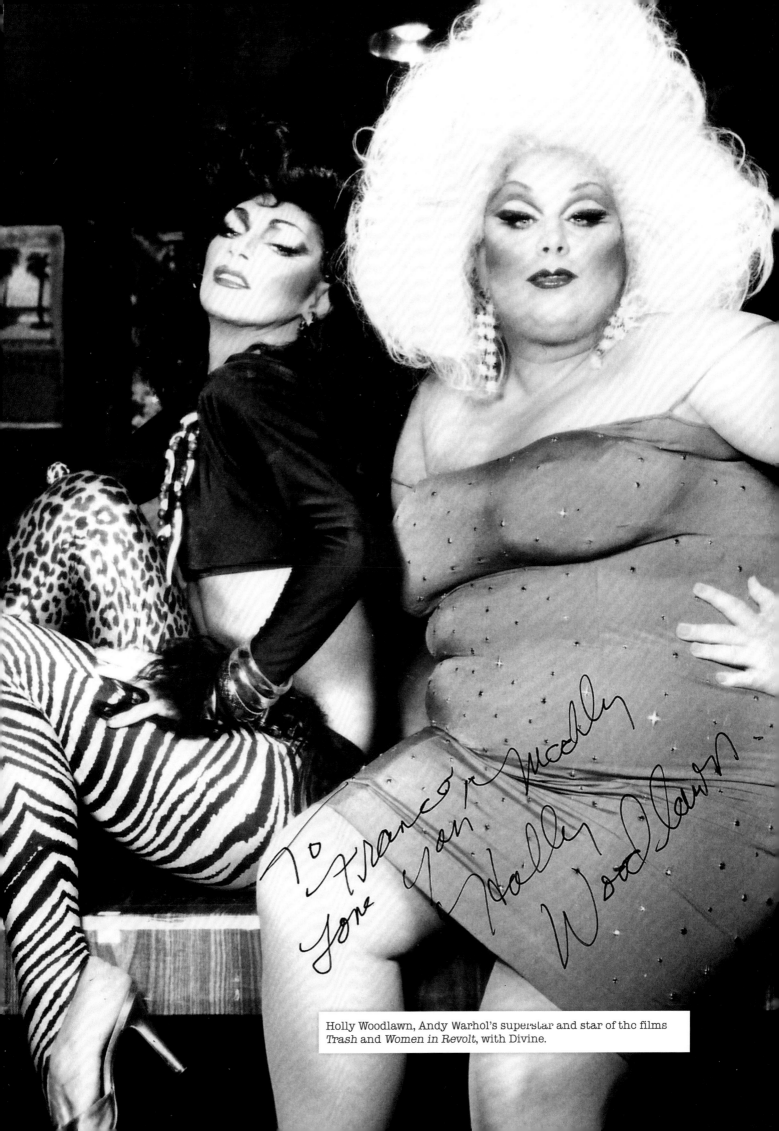

To Francois Modly
love Ian Holly
Woodlawn

Holly Woodlawn, Andy Warhol's superstar and star of the films
Trash and *Women in Revolt*, with Divine.

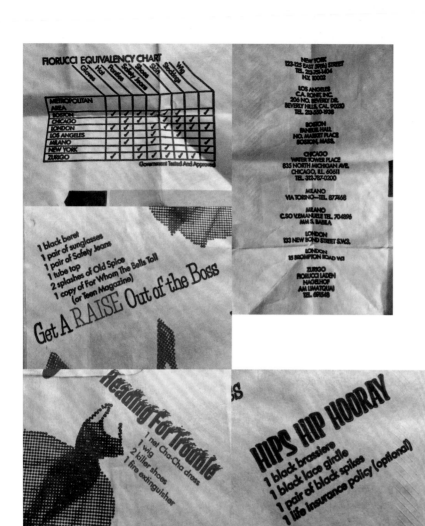

I saw the brown paper bag with a red mesh where you could see the potatoes in a supermarket in New York, and I thought we could use the idea for Fiorucci. The fabric of the garments could be seen through the red mesh. I called the firm that produced it and we looked at three different formats.
We had the idea of using 1950s-style motifs and lettering on all sides of the bag. We printed a huge number to get the lowest possible cost, so they were sent to the two Milan stores as well.

Art director Franco Marabelli.
Graphic design Calvin Churchman.
F. M.

POTATOES BAGS

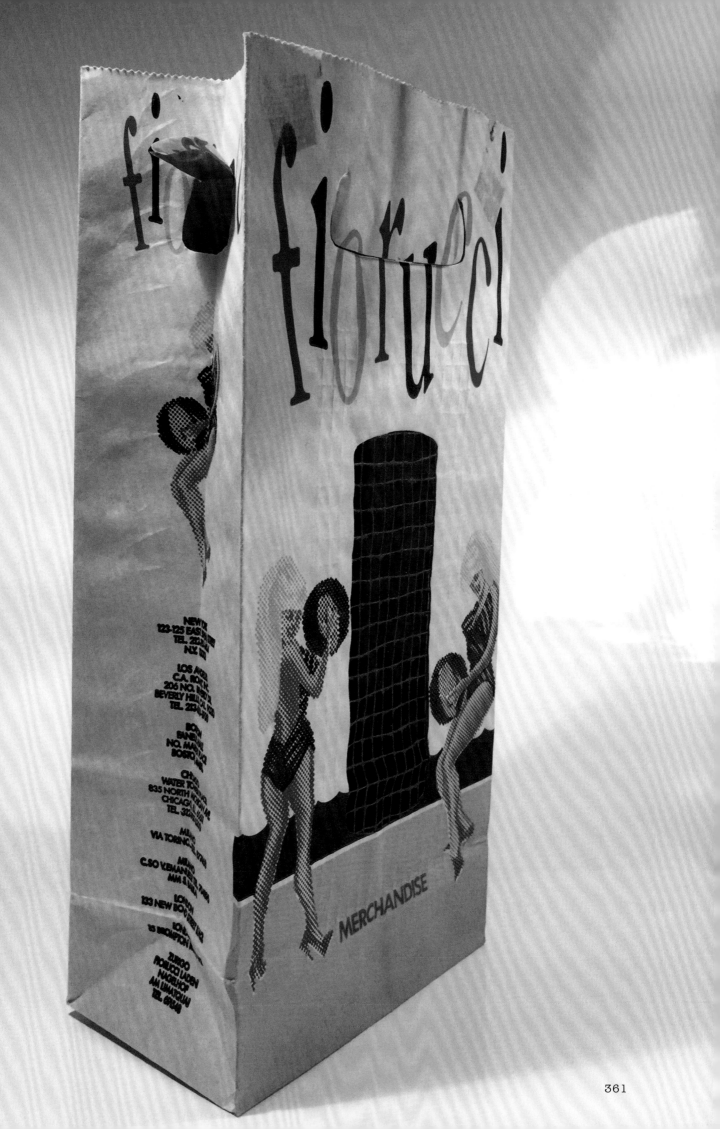

361

EDWIGE, MARIPOL, AND
BIANCA JAGGER, STUDIO 54.
POLAROID SELFIE.
NEW YORK, CIRCA 1978.

MARIPOL AND
HER SON LINO.

MARIPOL,
2019.

PHOTO ANTHONY FITCH FOR POLAROID

PHOTO JOHNNY KNAPP

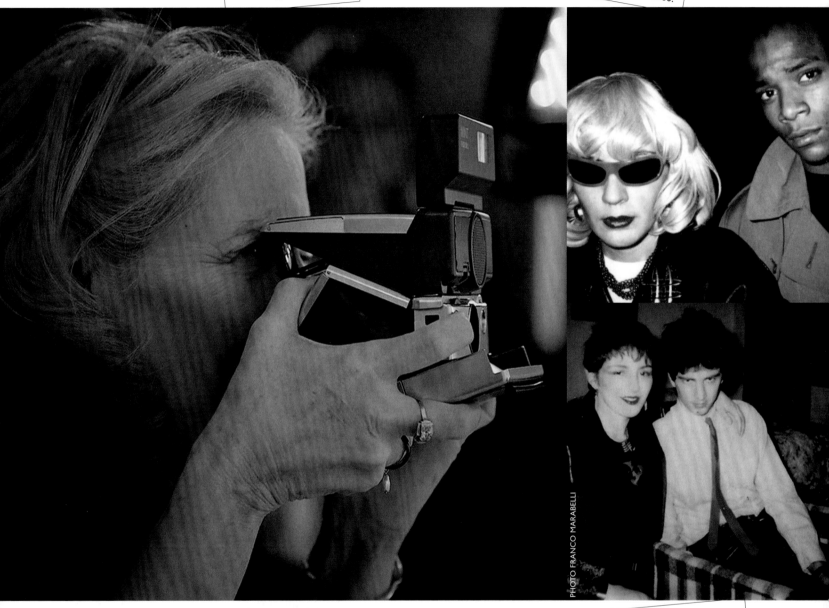

MARIPOL
WITH HER POLAROID
SXT 70.

MARIPOL AND JEAN-
MICHEL BASQUIAT,
NEW YORK, CIRCA 1980.

PHOTO FRANCO MARABELLI

MARIPOL AND
EDO BERTOGLIO,
NEW YORK, 1978.

MARIPOL

Photographer and image maker

A dear friend of Elio's. Maripol had a space in the Fiorucci store in New York, where she displayed her accessories, costume jewelry and other items she created or found on her travels around the world. Maripol knew many artists, photographers and interesting people. It was she who introduced Elio to Madonna, whose look she had created. She was friends with Grace Jones, Andy Warhol, Jean-Michel Basquiat, Jean-Paul Goude and many other famous people in the late 1970s.

1978 LOS ANGELES OPENING

Project by
Franco Marabelli

On the side: the opening, which was attended by actors, singers and celebrities.

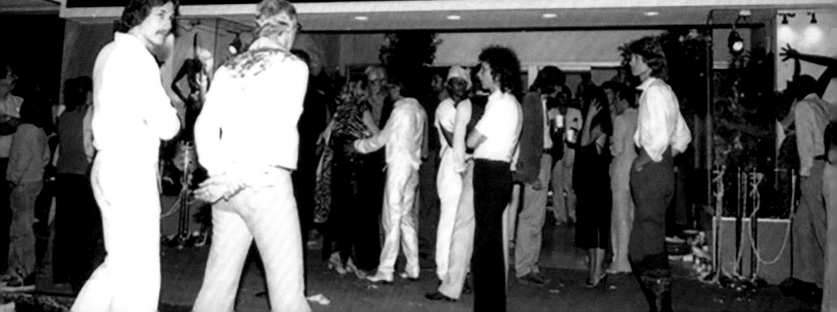

Beverly Drive

It was a theater on Beverly Drive
with a dome in the style of an Indian
temple, interiors decorated with large
1940s-style frescoes of tropical plants
and animals, particularly elephants;
a combination of different designs.
We left everything as it was and put
furniture in. We added neon lights like in
all the other Fiorucci stores.
The entrance was like a low tunnel with
glass walls, then you came out into this
huge space with an impressively high
ceiling. The acoustics were perfect for
the disco music that was all the rage
at the time. *F. M.*

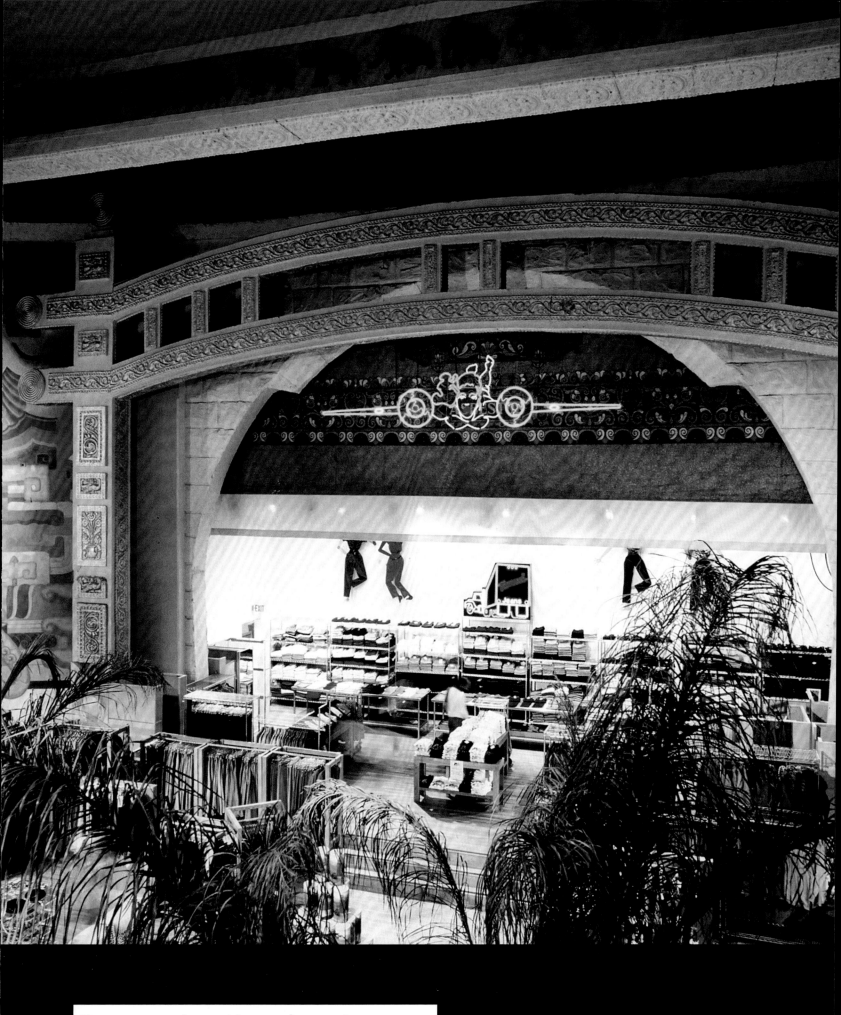

The space was used as a set for several scenes of
Robert Greenwald's film *Xanadu*, starring Olivia Newton-John.

ROBERTO RABANNE
AND GIRLFRIEND

NIVES PLACCHI

CRISTINA RO

ELIO WITH CRISTINA ROSSI

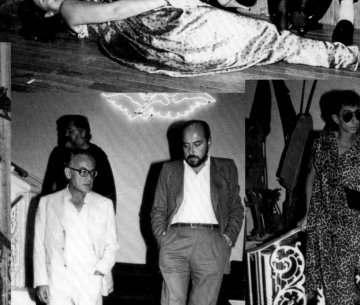

GAY AND DRAG CREW

LOS ANGELES
OPENING

DINO DE LAURENTIIS
AND ELIO FIORUCCI

MARK SAWYER

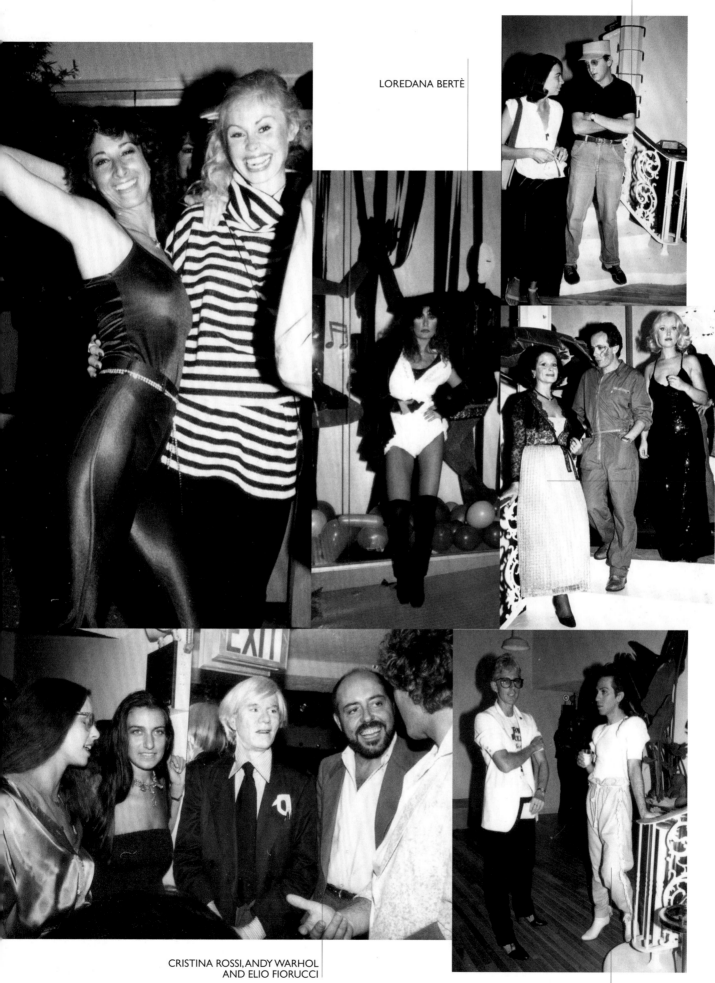

CICCO COLACICCO

LOREDANA BERTÈ

NICOLETTA
ORSOMANDO,
LEONARDO
PASTORE, AND
ROBERTA GIUSTI

CRISTINA ROSSI, ANDY WARHOL
AND ELIO FIORUCCI

JOEY ARIAS

369

CAROLYN ZECCA

A friend of Elio's who worked in PR for the Los Angeles store

I was leaving the Fiorucci store in Milan, wearing a secondhand miniskirt made of fabric from Guatemala that I'd bought in San Francisco, where I lived. Angelo Careddu, who worked at Fiorucci, noticed me and came up to me, saying my skirt was lovely and he wanted to borrow it. He gave me another from the store, and a few days later I went back to collect mine. That's how we met and became friends.

In 1975, Angelo called me from New York and told me he was coming to California with Elio Fiorucci and Franco Marabelli to look for premises to open a store in San Francisco or Los Angeles.

We didn't find anything they liked in San Francisco, but in Los Angeles there was a place available; a 1940s theater with an Indian-style dome. It was on Beverly Drive, Beverly Hills, and we were captivated.

When it opened, there was a Hollywood party, attended by Andy Warhol, Dino De Laurentiis and a lot of actors and singers, including Loredana Bertè and other Italian stars.

After the opening, I was surprised to be contacted by the owners and asked to take care of PR for the store, so I moved to Los Angeles.

At the start, the store worked really well, hosting spectacular events and performances, but despite the fact that people were talking about it, it didn't last long. I left towards the end of the 1980s, and the store closed soon after.

Elio engaged me again to open a second store with his sister Driade and Umberto Ceciarelli (Monica Vitti's brother, *ed.*). The space was much smaller—it was on Santa Monica Boulevard in Beverly Hills—but the concept was wrong and it was very different to the previous store. The goods were there, but the Fiorucci spirit was lacking.

PHOTO PIETRO TENZIONE CLOTHES ARCHIVE FRANCO MARABELLI

PHOTO NATALIE MEYJES

9 9 7 9 1 0

FIOR

★ CHI

A GATHERIN

4 M

ADM

1979
WATER
TOWER

UCCI
AGO ★
OF THE ARTS
AY
4
ONE

0 1 9 7 9

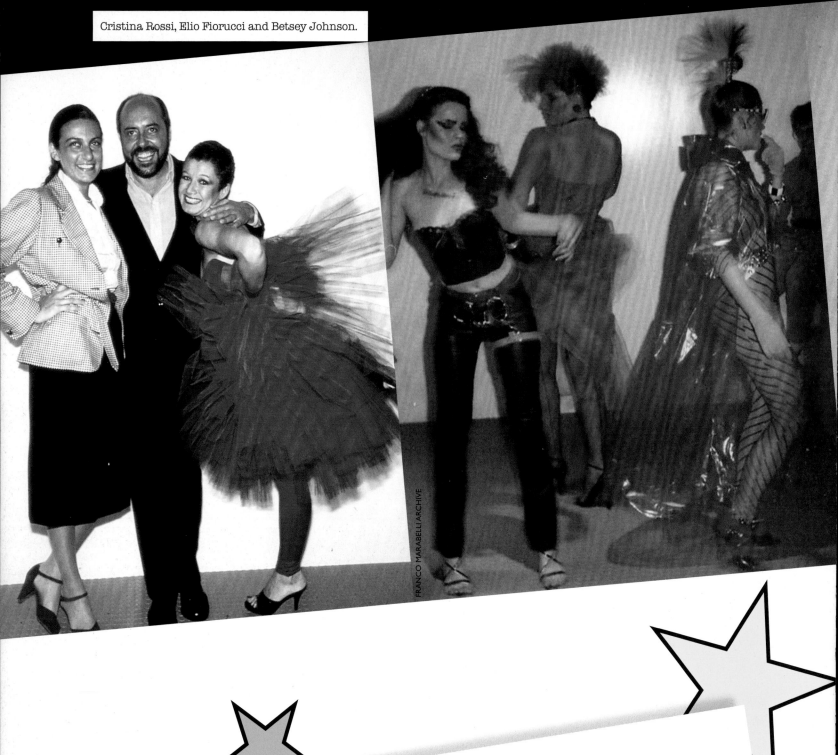

Cristina Rossi, Elio Fiorucci and Betsey Johnson.

FRANCO MARABELLI ARCHIVE

NOTE: Fiorucci does not discriminate against the unique and unusual. For information call: 266-1967

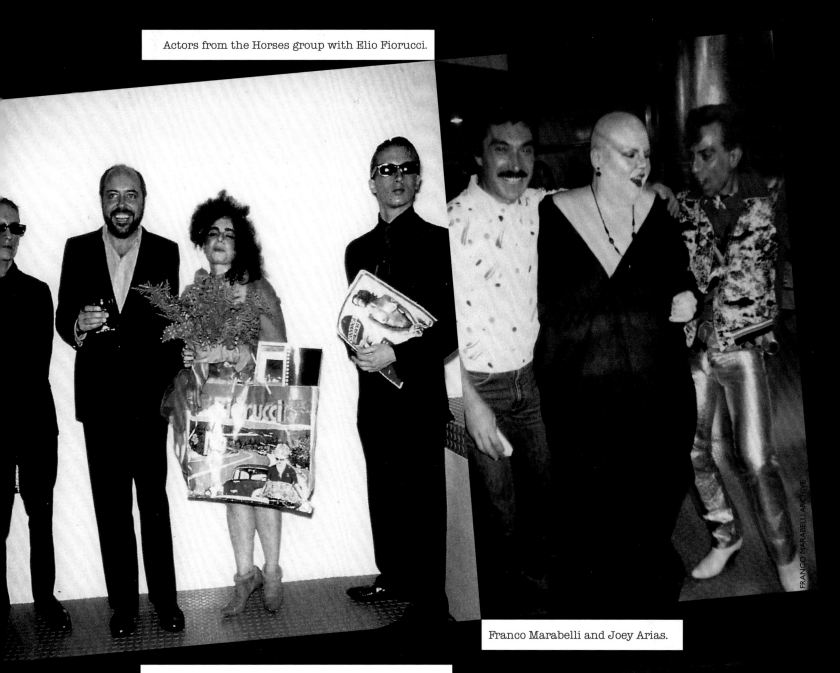

Actors from the Horses group with Elio Fiorucci.

Franco Marabelli and Joey Arias.

FRANCO MARABELLI ARCHIVE

Invitation for the opening, designed by Sid Daniels.

Paul b _ presents

FIORUCCI

Chicago

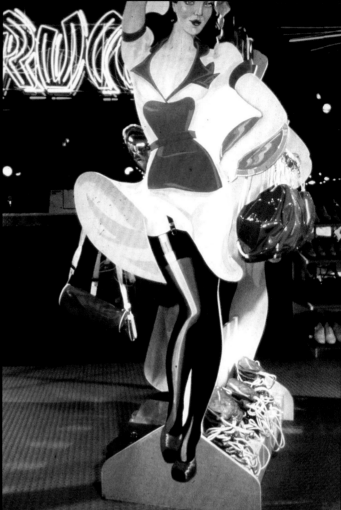
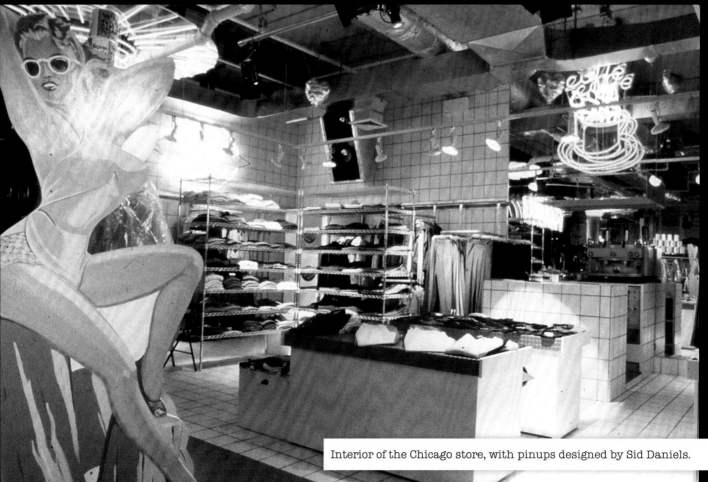

Interior of the Chicago store, with pinups designed by Sid Daniels.

Actress from the Horses group dressed as a Fiorucci fan.

THE EXPANSION OF FIORUCCI ALSO CONTINUED IN EUROPE. THE FIRST LONDON STORE OPENED IN 1984 IN KING'S ROAD, FOLLOWED BY ANOTHER IN BROMPTON ROAD. OTHER 100% FIORUCCI STORES WERE OPENED IN ZURICH, ATHENS, AMSTERDAM AND FLORENCE, FOLLOWED BY OTHER PLACES.

LIEBES
LEBEN

Roswitha Hecke/Bilder mit Irene/Rogner & Bernhard

PHOTO ROSWITHA HECKE

Irene Staub, a well-known figure
in Zurich in the 1970s and 1980s.
I designed a Fiorucci store in a small
square in the old town of Zurich.
There was a beautiful woman outside
the store doing her "business."
We became friends, because she
appreciated Fiorucci and she dressed
in an original way, beyond fashion, truly
avant-garde. I asked her to wear Fiorucci
clothes for a magazine article, and she
was delighted. We found garments that
were appropriate for her personality, and
the article was published in an Italian
magazine. She wore clothes in leather,
gold, silver, plastic and plenty
of accessories. She became famous
all over Switzerland, and her friend
Roswitha Hecke published a book about
her. I heard she met Mick Jagger,
Maria Schneider and other actors
and celebrities. F. M.

Komosutra
Fiorucci

Irene Staub, 25, wurde in Zwinglis braver Stadt Zürich gesellschaftsfähig, nachdem sie vor Auserwählten des Schweizer Jet-Sets kostbare Abendroben vorgeführt hatte: Sie posierte als Mannequin auf dem Laufsteg der „Villa Egli". Beim anschließenden gemeinsamen Umtrunk stieß die Blondine, Champagner im Glas, mit den Damen aus der feinen Gesellschaft an. Nach der Darbietung aber verließ Irene Staub eilig die Villa, um ihren gewohnten Nachtdienst aufzunehmen: Als „Lady Shiva" ist sie nämlich Nummer eins unter den Straßenmädchen von Zürich („Ich mach' alles, auch mit Peitsche"). Irene, die auf eigenes Risiko und ohne Beschützer arbeitet, hat sich den besten Standplatz erobert und spricht am Rüdenplatz an der Limmat mögliche Kunden an: „Ich bekomme pro Leistung mindestens eine dreistellige Summe." Nach dem Erfolg bei der Modenschau wurde Irene Staub die Rolle in einem Musical angeboten: „So 'ne Art Irma La Douce, nur eben echter." Eben.

RENE STAUB
CHOFFELGASSE 4
01 ZURICH
- 47 1039

GOLD ANKLE BOOTS. PROPERTY OF RAINA SACKS. PHOTO FRANCO MARABELLI.

ALL WE NEED
IS LOVE —
— SEX —
6.12.78

GOLD

385

ELIO THE SOLDIER

Elio did his military service at the Aeronautica flying school in Piazza Novelli, Milan, where he checked vehicles and personnel entering and exiting.

ELIO'S CARS

In the early 1970s, I drove around with Elio in his yellow Porsche. His driving scared me a little. He was distracted and didn't keep his eyes on the road. The dark gold Volvo station wagon. The blue Mercedes.

ELIO'S APPOINTMENTS

He was always late. He used to double or triple schedule appointments; his secretary didn't know what to do. If someone came to see him without an appointment, he'd receive them and ask them to wait a moment; the moment became hours and hours, but everyone waited!

It must have been truly difficult being Elio's secretary, in spite of his courtesy and kindness. There weren't many who lasted. But Telma Malacrida managed to keep him under control with her cheerful smile and intelligence, and she established friendly relationships with everyone who worked at Fiorucci or who contacted Elio.

ELIO'S FOOD OBSESSIONS

He had many: when he found something he liked, he had to eat exorbitant amounts of it. He decided to eat salad made only with basil, which gave him terrible heartburn. Huge pans of whole heads of fried garlic. Endless vitamin-packed smoothies. Vitamins, supplements, pills he found on his travels.
F. M.

387

SPEC
PROJ

IAL
ECTS

JEAN-MICHEL BASQUIAT

DOWNTOWN 81

DEBORAH HARRY
KID CREOLE
& THE COCONUTS
JAMES WHITE
& THE BLACKS
COATI MUNDI
HERNANDEZ
TUXEDOMOON
WALTER STEDING
THE PLASTICS
DNA
GRAY

LIKE AN IC
EAST

DIRECTORS
FORTNIGHT
CANNES 2000

The legendary artist Jean-Michel Basquiat was only nineteen when he starred in *Downtown 81*, an "unknown classic" about the music and arts scene in the early 1980s. An artist evicted from his apartment tries to sell one of his paintings, surrounded by rappers, strippers and figures in the art world.

"Every detail is pure magic." Maurizio Porro, *Corriere della Sera*

New York Beat Film presents *Downtown 81*, with Jean-Michel Basquiat.
Director of photography: John McNulty
Artistic director: Maripol
Director: Edo Bertoglio
Producers: Fiorucci and Angelo Rizzoli

ELIO FIORUCCI

VOUS PRESENTERA
NEW YORK EN DIRECT ET EN AVANT PREMIERE

AVEC
MADONNA
NEW YORK CITY BREAKERS

MAGICIEN DEL PLATINES, SCRATCHEUR DE «ROCK IT»
D.J. D. ST.

LE LUNDI 17 OCTOBRE A 22 H.

AU
LE SQUARE

4, SQUARE HENRI DELORMEL
75014 PARIS

RELATION PUBLIQUES FIORUCCI:

Peter Dechelette, 103 Rue Lamarck, 75018 Paris, Tel. 259 73 40

Fiorucci, Galleria Passerella 2, 20122 Milano, Tel. 79 24 52

Fiorucci Inc. 125 East 59th St. New York, N.Y. 10022, Tel. 212/751-1404

Invitation valable pour 2 personnes

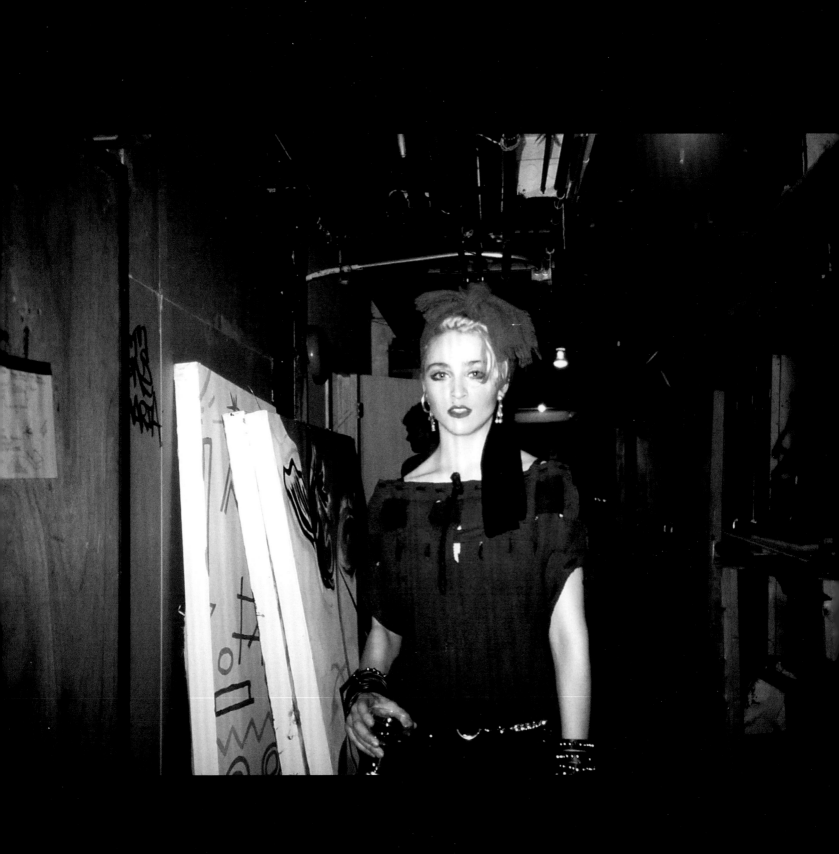

Madonna, who was friends with Elio, performed at a Fiorucci party in Paris and also at Studio 54, for the 15th anniversary of the New York store.

Action Painting
unique in the world!

Tito Pastore set up the meeting between
Elio and Keith Haring. Since the store
was due to be renovated anyway, it was
decided that Haring would do his Action
Painting all over: walls, furniture, the
lot. We just removed the clothes.
He did an extraordinary job.
The opening night was attended by
a crowd of intellectuals, artists and
journalists. As much of Haring's work
as possible was rescued to be preserved
or sold. *F. M.*

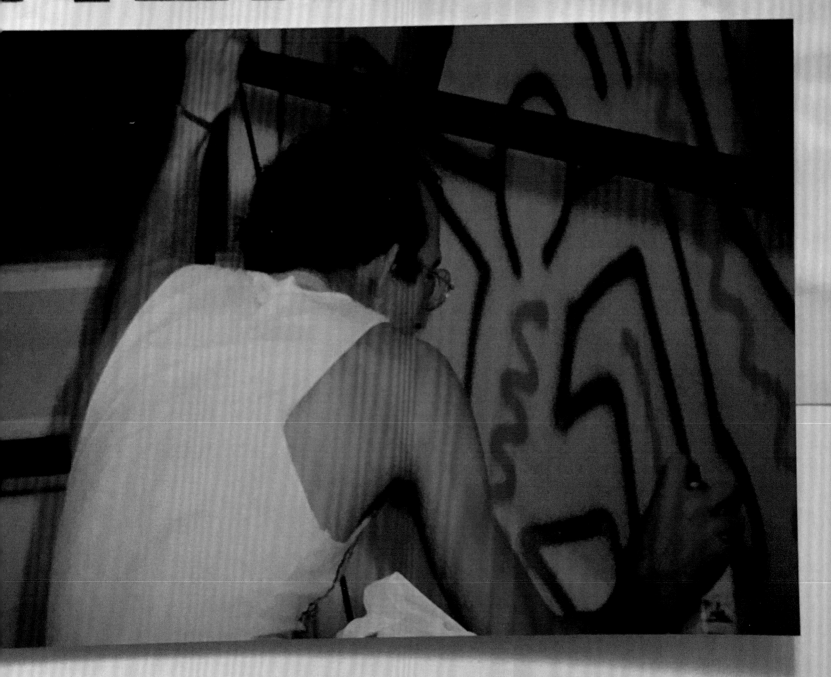

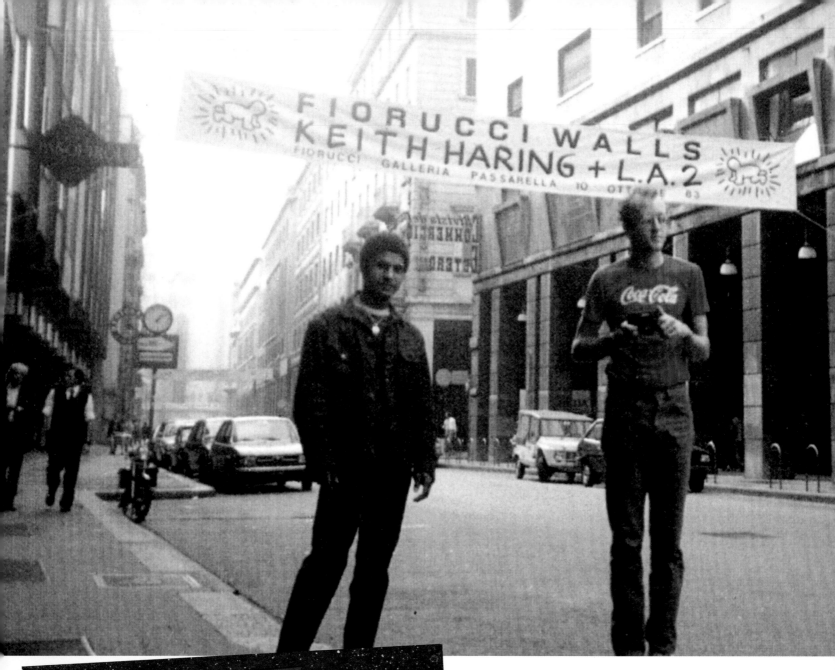

I received 10,000 DOLLARS U.S.
on Oct. 10 - 1983 for walls
painted at Fiorucci, Milano.

Keith Haring
Oct. 10-83

Left, Keith Haring with Angel Ortiz (LA II), who helped him with the project.

The unusual "payment receipt" issued by Keith Haring.

Window of the San Babila store with a part of Haring's painting.

Right, Keith at work and photographed with Elio.

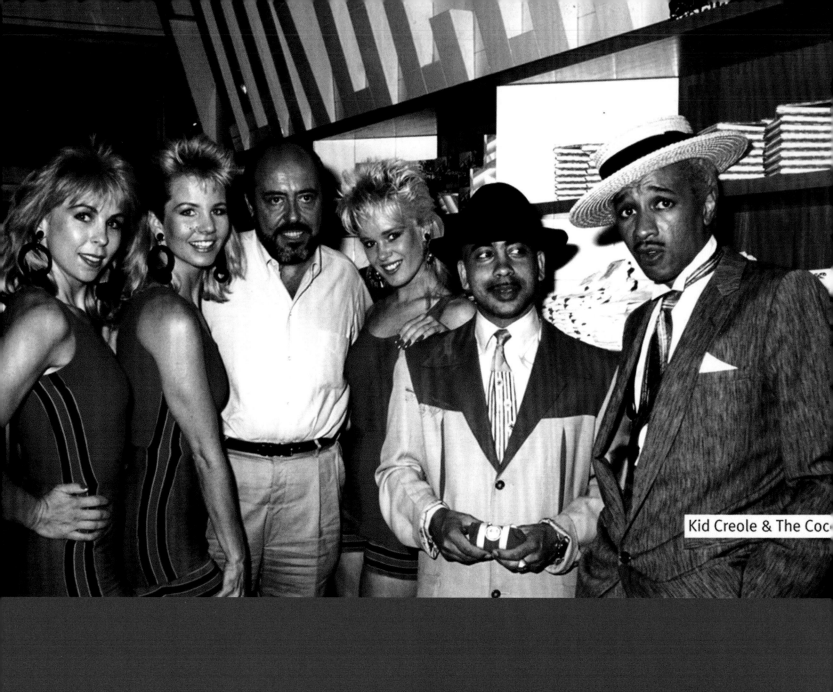

Kid Creole & The Coc

The entrance to the San Babila store, renovated after Keith Haring did his part.
I designed huge three-dimensional lettering using white tiles, a material I subsequently
used in the Miami store. *F. M.*
In the photo: Elio with Kid Creole & the Coconuts, 1984.

The Fiorucci stand at MilanoVendeModa, 1984 and 1985. This was the first time Fiorucci attended the event, where he presented products by all his licensees. In the photo, the stand's reception area.

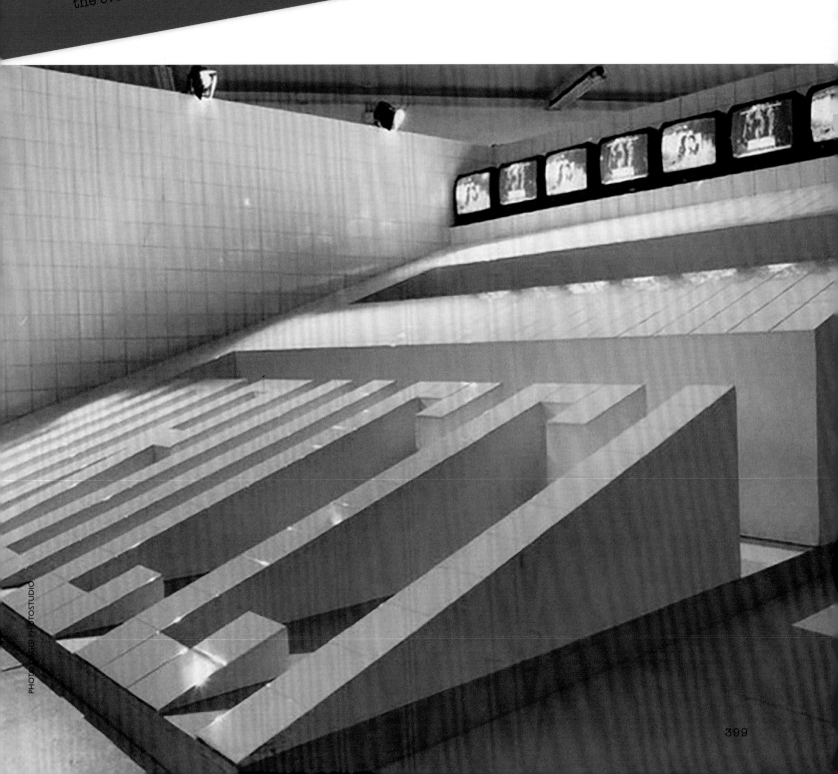

NG
ALS

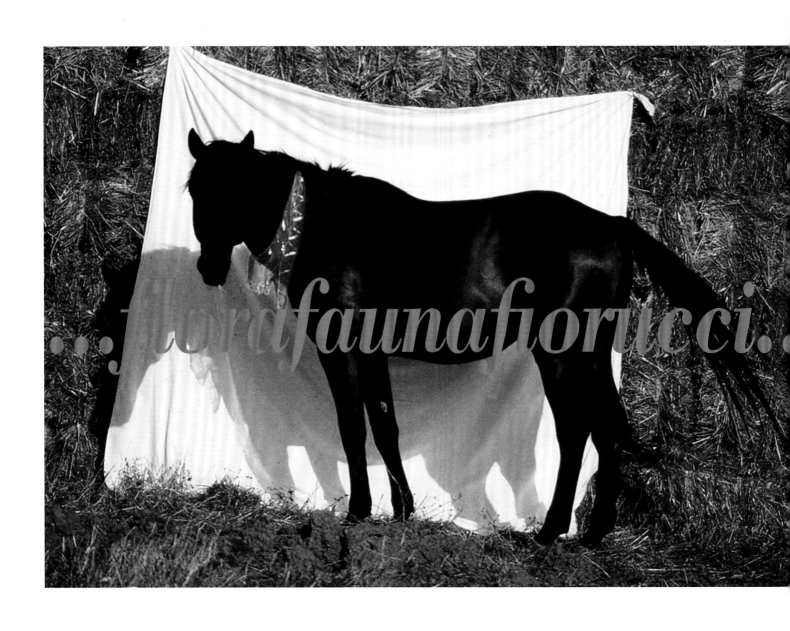

Elio and animals

Elio and I came to animal rights and vegetarianism by different routes. It was a shared interest and pleasure, and we began to work together on animal-oriented projects. We used to exchange knowledge and information about animal rights groups and individuals working for animals of any species.

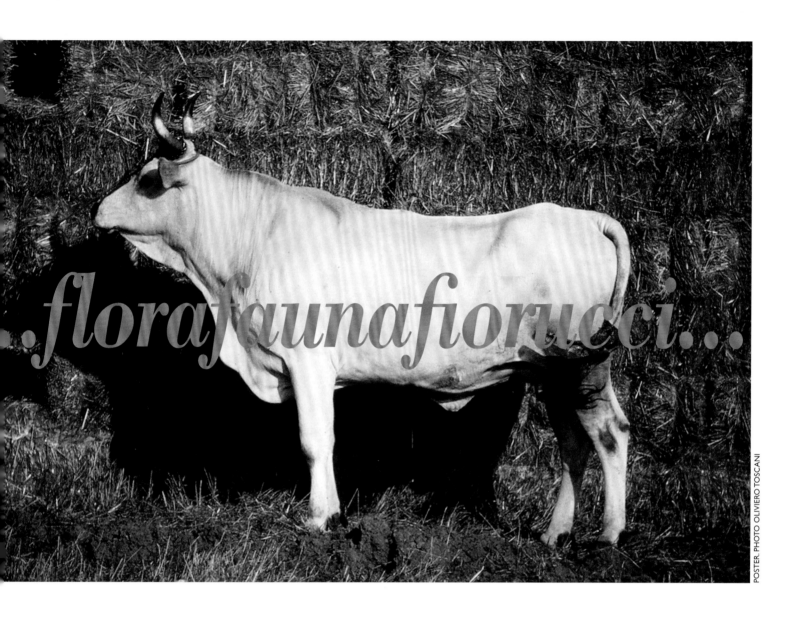

I'd developed an initiative I called ANIMANIMALI, which
Elio shared; we proposed it to several people, but we never managed
to get it off the ground. Elio allowed me to bring my Great Dane to the
office, and he made friends with everyone. I'd never heard of a company
that would do that.
 F. M.

Anti-fur demonstration in Piazza del Duomo in collaboration with Animal Amnesty, 2014.

SANTO FIORELLO
Ginsenita
Patrono degli uccellini

GIFTED WITH
EXTRAORDINARY
INTELLIGENCE
AND A POWERFUL
IMAGINATION,

HE ALWAYS LOOKED
TO THE FUTURE,

AN UNSTOPPABLE
SEARCHER
AND A BRILLIANT
EXPERIMENTER.

Franca Soncini

Journalist, photographer and documentary filmmaker

PHOTO FRANCESCA POZZI

I met Elio Fiorucci at the MIA in Milan, a photography fair where I was exhibiting some of my images on the subject of animals. I was thrilled when I saw him arrive, because, for me (and I'm sure for everyone of my generation) his store was my favorite place for any kind of meeting.

As a child, I was a misunderstood animal-lover. My battles fell on deaf ears—it was a time when we weren't yet culturally ready for certain topics. I had the anti-hunting stickers Fiorucci had made with Lipu in a drawer in my bedroom, and they were prized possessions. They were so precious that I never stuck them anywhere because I didn't want to damage them. In middle school, I managed to persuade my mother to buy me a Fiorucci sweater, which I absolutely loved, because it was so colorful. We moved several times and many things got lost, but not that sweater; it's still in my wardrobe.

I'd never imagined that such a seemingly untouchable person, a real icon, could be interested in me and my work. But our shared interest in nature and animals brought us together, and from that day on we began a friendship that lasted until his death. Elio had a deep love for animals and would do anything to defend them; he told me he'd inherited this from his father, who showed him as a small boy the dedication of birds building their nests and taking care of their babies.

Reflecting on a project of mine about elderly dogs, Elio wrote, "Animals live in a parallel world that often overlaps with ours. I only want to raise awareness, because it takes courage and consistency to effect change and it needs to be done here and now: the planet is showing unmistakable signs of suffering. Our intelligence certainly doesn't give us the right to believe ourselves superior to animals just because they're weaker than us and can't talk and defend themselves. They're sensitive creatures, they feel pain, they suffer. With our stupid delusion of omnipotence we've clearly lost our sense of proportion, moving away from the teaching that forms the base of all relationships and all religions: respect for others, for differences. By doing this, we have shown a complete lack of morality, and, for many years, we didn't worry about the consequences of our actions. I'd like to reintroduce two words, which are seldom used today, into our everyday vocabulary. The first is 'waste.' Because our excesses have a negative impact on the equilibrium of the planet, limiting the resources for everyone. So let's attempt to develop a deontological code for the rules of harmonious coexistence and fair sharing, a written statement of our duty towards animals, nature and the environment. Towards our neighbors. By doing this, we'll automatically rediscover the value of my second word: 'empathy.'"

PHOTO PIETRO MENZIONE

my fellow beings
I don't eat

COCHI PONZONI

Actor and singer

I met Elio Fiorucci several times in different cities, on TV shows where we were both guests. As we waited for the show to begin, we'd chat about this and that.

What struck me—apart from his friendliness and the fact that he was extremely well-read—was his love for certain animals, like cows and chickens: I'd actually written a song about the latter, which had been unexpectedly successful. One day Elio asked me, "Why did you say the chicken isn't an intelligent animal? In my opinion it truly is." I answered, "Look, it's nothing to do with the chicken's intelligence. It's that when I was a child, the doorwoman in our building had a chicken that used to scratch about in the yard. I would often see it when I came home: it would stand there and look at me with these little eyes that showed no intelligence, at least that's what I thought in those days."

And that's where I got the idea for the song. *You Can Tell by the Way it Looks at People*, because it has crossed eyes—and that's where it came from. When Paolo Villaggio and I were doing TV together, there was a trick where he hypnotized a chicken, explaining, "If you turn a chicken upside down and draw a line with chalk, it stays still." It sounds absurd, but it's true. And Villaggio, who is certainly not a magician, did the experiment live on a show we were doing together, and it worked. I told Elio about this and he said "Yes, of course. Even chickens have a brain," and we joked about it too, something ridiculous and surreal, because Elio was a very funny man. After that, we talked about cows and he told me he had a passion for them; I said "Let's say I've also found illumination," although I didn't become a vegetarian.

PLASTIC GOOSE LAMP BOUGHT IN 1973 AND SOLD IN THE SAN BABILA STORE.
FOR THE OCCASION, A WINDOW DISPLAYED ONLY GEESE.

FIORUCCI "COW-EFFECT"
SUITCASE.

"OUTDOOR LIFE"
SHOPPING BAG,
AFTER 1982.

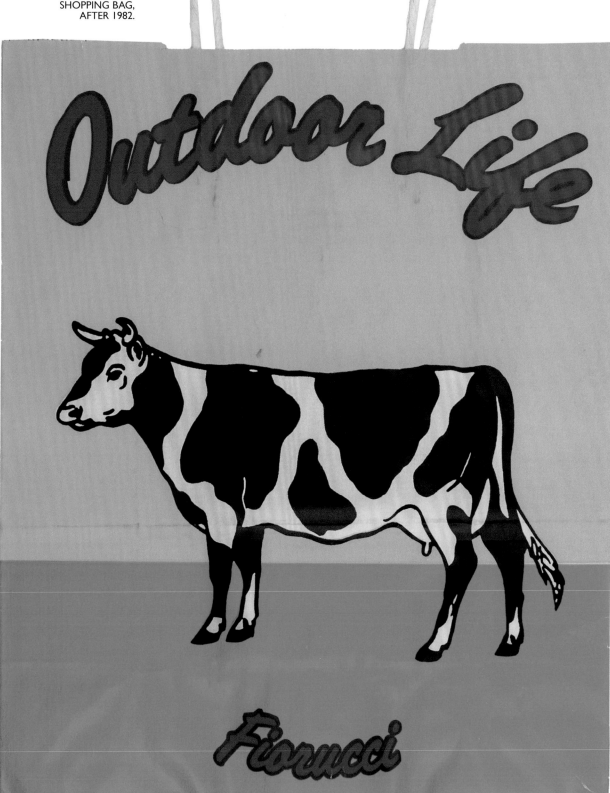

PHOTO MATTEO OSSO

GIUSI FERRÈ

Fashion and lifestyle journalist

I met Elio in the early 1980s, when I was working at *Epoca*. He'd promoted an initiative with Brigitte Bardot and we received an invitation at the editorial office: a gorgeous old black-and-white photo, printed very large.

The editor asked me to do a front-page story for the magazine. I went there and, among other things, tried to contact people who knew Brigitte Bardot. I also spoke to Franco Interlenghi, who had made a film with her in Rome, and didn't have very fond memories of her. Finally, I went to see Elio and asked him why he had chosen to work with her. He said, "It's a decision I made based on animal liberation." Then he said, "Why don't we go and see her at the weekend? If you come, you can meet her in person and write your article." We didn't go in the end, but I was struck by his kind offer—he was just saying "Come with me, let's do this together." I ran into him again, always on professional occasions, and he always had such a gentle manner, so charming.

He was the first person to talk to me at length about the LIPU, for example. He was such a big fan. Then he told me about CBM, "They're angels, a group of doctors who go round the world curing children's eyes." His mind was open to everything. You could listen to him talk about any subject and he always had something interesting to say, but always with a certain amount of modesty. Another thing that always struck me about Elio was the way he dressed, always slightly formal.

And he was always a bit distracted, magnificently distracted. He was so different to everyone else in fashion. Fiorucci truly was a man who had a fascinating aesthetic of freedom; he had a way of listening to everything, choosing and bringing things and people together without any hierarchy.

He had the ability to discover extraordinary people almost without realizing it, maybe because they were naturally attracted to him. And, at the same time, he himself had this bourgeois air about him, which was very strange if you think about it. And his voice, always extremely soft. I never heard him yell... He was always surrounded by creative people and beautiful girls. He had an image that was both very free and very Milanese, as I see it, with his gray pants. Nevertheless, I think he was someone who could make you suffer. I've always thought that. Yet he had this gentleness that carried you away. That was his charm. Absolutely.

PHOTO PIETRO MENZIONE

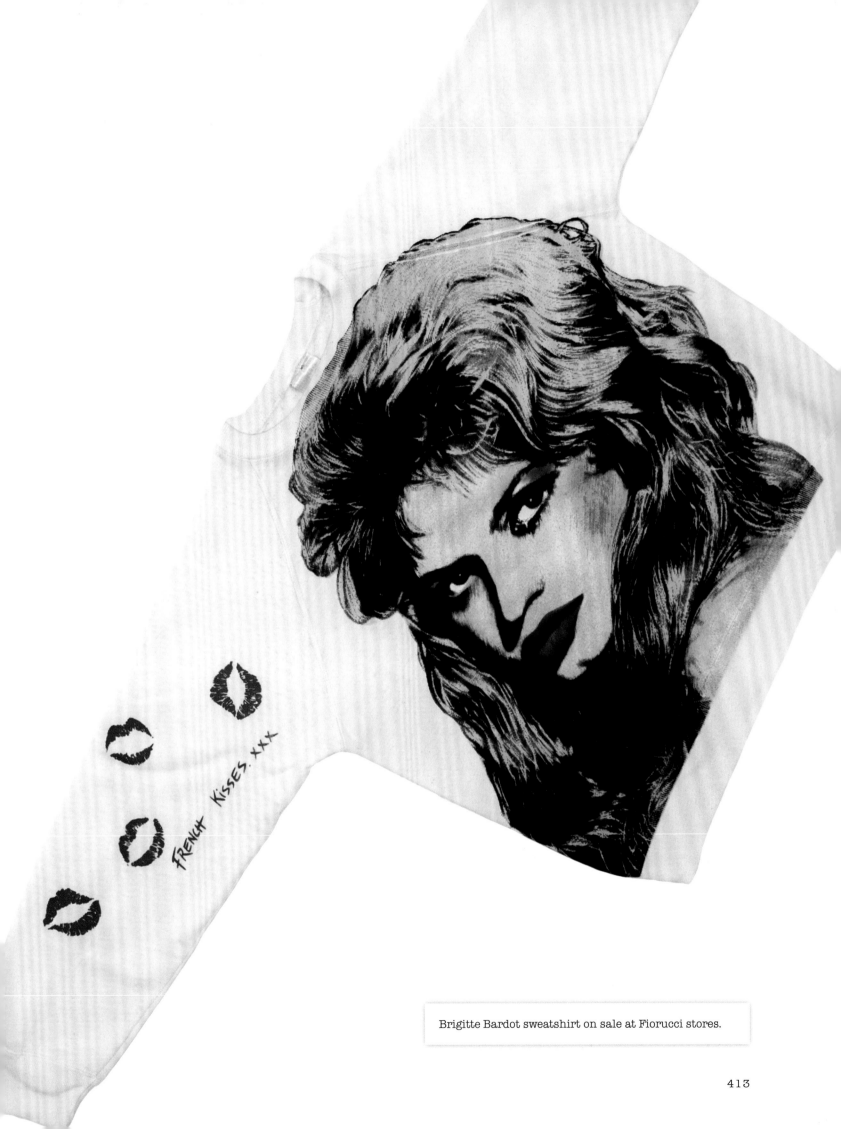

Brigitte Bardot sweatshirt on sale at Fiorucci stores.

413

Elio's

FAM

Elio's father, Vincenzo, was from Rome
and his mother, Argentina Bonazzola,
was from a small village, Sueglio.
He had four siblings: Virginio,
Valeria, Floria and Driade.
When Elio's father died, his mother
suffered from depression
and the children were brought up by
their grandmother.
Elio attended middle school
then decided to go straight to work in
the shoe store in Corso Buenos Aires,
where he enjoyed interacting with
customers.
He married Cesarina Boccaletti and
had two daughters: Ersilia, who lives
in Milan, and Augusta, who lives
in Paris (both are married).

F. M.

Fiorucci enfant… le premier Fioruccino.

In the large photo, Elio in Roccamare with his daughter, Erica. Cristina Rossi, Elio's partner in life and—along with him—the soul of Fiorucci, gave him a daughter, Erica, who lives in London.

My brother Elio was born in Milan in 1935, the third child of a family of
shoe merchants who had a store at Corso Buenos Aires 60. When the war
broke out, he wasn't even five. During a nighttime air raid in September
1941, a bomb grazed the house in Via Tamagno. That was when our father
Vincenzo and our mother Argentina decided to abandon their home and
their business and get out. They escaped with three small children in the
darkness of the curfew lit only by burning buildings, running to the end of
Via Padova, where by chance they found a tram to Crescenzago. They first
went to relatives of my grandmother's in Trezzo sull'Adda, and then to the
home of some acquaintances in Piona, a hamlet of Colico on Lake Como.

EVACUATED TO THE COUNTRY

In Piona, a little corner of paradise far from the noise of war, life returned
to "normal." In the mornings, they all went to school, and Elio attended
the local primary. Distracted by the animals that casually passed by the
windows and enchanted by the wonderful spectacle of nature, he didn't
even hear the teacher's reprimands. "It felt like a punishment to have to sit
still: anything that was happening outside, in the street, was a thousand
times more interesting, more alive, than what went on in the classroom."
In the afternoons, everyone did their bit to help at home. My brother Virginio,
who was born in 1930, my sister Valeria, who was born in 1933, and Elio
helped around the house and took care of me. I was a few months old. Elio
loved animals and was always in the barn or the chicken coop tending to
them. He told me that after school in the summer he used
to round up the geese, put himself at the front and they'd
follow obediently for almost a kilometer until they came
to the shore of the lake, where they'd swim together. On
the return trip, the little caravan would stop in a large
meadow where there were blackberries and mulberries
and the geese, who love that kind of fruit, came home
with their bellies full and very satisfied. "Many years
later, having dinner with Andy Warhol at the Factory, I
told him my aunt used to give me salt in exchange for
fetching the goats and bringing them back to the barn.
A few months later, Andy Warhol and Bob Colacello invit-
ed me to their home. They showed me their collection of
nineteenth-century English landscape paintings, includ-
ing their favorite, a goat on a promontory, surrounded by
hills and woods. It looked just like Piona."

AFTER THE WAR

The Valtellina region didn't suffer as badly from the war
as other places, and the time we spent there had a posi-
tive effect on us for life, not least because of the arrival of
our new baby sister, Driade, in 1944. In September 1945,
the war ended, and for us children so did our vacation—
that's what it felt like—and we could go home to the city.

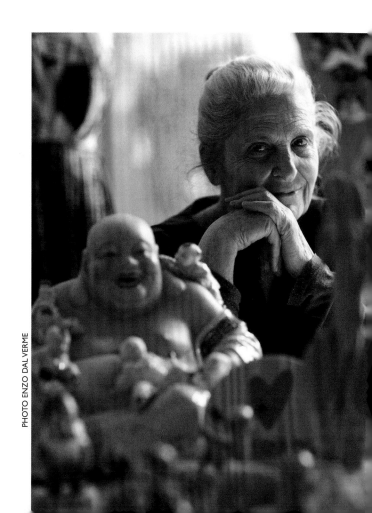

PHOTO ENZO DAL VERME

Our return to Milan, which had been destroyed by the bombings, was a shock, but as luck would have it, both the house and the store were intact. With numerous difficulties and sacrifices, work began again, and so did school: our eldest brother Virginio was studying architecture, Valeria had had to leave school to help the family, and Elio, always an unmotivated student, scraped through three years of business high school. My mother despaired, because he was intelligent, but didn't apply himself. Then dad, who was quite strict, gave him an ultimatum, "In this family you either work or you study," and Elio chose to work, without a qualm.

FAMILY BEGINNINGS

It was 1951, Elio was sixteen, and he joined the family business full time. There were five of us and we were very close, a lovely family. We never stopped, and there was always something to do. All of us—Virginio, Valeria, Elio, Driade and I—always studied in the morning and worked in the afternoon.

The tiny store at Corso Buenos Aires 60, which we'd owned since the 1930s, sold slippers, which in those days were a secondary item, almost a luxury. Nowadays there aren't any stores selling only slippers, but in the days when cleaning was done with elbow grease, when you came in the house you took off your outdoor shoes and put your slippers on. It was the custom, for hygiene reasons, in every home. We sold quite a bit. I remember it was crazy at Christmas—giving slippers as a gift was a loving thing to do. In those days, there were no bags, and we wrapped the cardboard boxes in pink paper tied with string.

Elio loved dressing the windows, and he was good at it. He had a special and extremely precise eye. He could spot the tiniest faults that might get by someone else, but he didn't lose sight of the whole picture. His style was simple, usually geometric, with all the slippers lined up and a special model in the center. But it could take him a whole day to finish a single window a few meters wide.

We had a great clientele, and there was always a good relationship with the customers; we took good care of them. Elio in particular had his customers who were fond of him, maybe a little in love with him: when they came they only wanted him—he was always smiling and polite, his hair slicked back with a little wax. Now it wasn't only mom or dad at the till, but one of us children, all grown up. We no longer sold only the lovely warm felt and wool slippers which we had made in Friuli, but also leather versions and slippers with pompoms, 1940s diva-style, or with a low heel, which were very unusual. Elio was very good at seeing unexplored niches in the market, and thanks to these small-scale productions that inspired his creativity and his ability to interact with the manufacturers—no more cloth shoes for nuns or rounded soles for walking with a plaster cast—now we sold genuine footwear made to his own design. The little shop with its storeroom in the courtyard could no longer contain our new commercial ambitions, and a few years later, in 1955, the business expanded, with two new stores in Corso XXII Marzo and Via Buonarroti. My older brothers

married, and by 1960 the family was growing. Everyone was involved in the business because the economic boom, which began before 1960, was slowly bringing affluence all over Italy, creating a demand for "recreational" footwear, especially for young people. Your clothes could be made by your mom by recycling old ones, but shoes had to be bought. So clothes stayed the colors and materials of recycled workwear or army uniforms, but very soon this would change too. Elio got his wife Cesarina involved, and together they opened a shoe store at the end of Via Torino, where they also tried selling clothes. Elio's profound love for shoes, their design and manufacturing techniques, would last all his life, initially in his direct collaboration with artisans in Vigevano and Parabiago for hides and leather, and then in 1970 with the first producers of molded plastic shoes, for which he held a number of innovative patents. In Via Torino, the clothing was a big success, and from that experience, Elio realized that although there was still much to be done in shoes, fashion clothing was a new field, and yet to be explored. Those were the days of mail order, and Elio guessed that if you want to sell more you have to be in touch with the specialized press, and at the same time he found that fashion journalists are hungry for news. And that was the start of a lasting love affair with editors and journalists which would continue for over twenty years.

The family suffered a serious setback with the death of dad Vincenzo in 1962, but his wife took over the running of the business; she was less authoritarian and more inclined to trust her children and give them freedom: Valeria left the business to take care of her family; Driade went to Oxford to perfect her English. Meanwhile clothing was the new frontier and Paris was its capital: for almost ten years until 1972, Elio and my future husband Umberto went there often to discover new trends and make connections. At the same time, Italian TV—conservative as it was—couldn't prevent the spread of the scandalous British culture: Mods, the Beatles and the miniskirt. Elio set out to visit his sister in Oxford, but he never got there: he stayed in London, enraptured by the ongoing fashion revolution, by the huge Biba store and, above all, by the miniskirt. As ever, he returned with loaded suitcases, but mostly with an idea in his head: the libertarian culture revolution he'd seen in London would soon be coming to Italy, and he wanted it in his store. It was essential to find a new store which would break with the past in both form and content. Fortunately there happened to be one free right in the center of Milan, on the corner of Corso Vittorio Emanuele and Galleria Passarella. It was May 31, 1967, and for the next forty years it would be "See you at Fiorucci." You can learn the rest by reading books on the history of fashion/lifestyle/art/design/architecture/photography/advertising/music, but what he wanted above all else was "freedom for all."

ERSILIA FIORUCCI
Elio and Cesarina's eldest daughter

The most wonderful thing to do with dad was to travel. He traveled light, with only a few things: a couple of striped shirts, his swimming trunks, a dark blue cashmere cardigan—although he always came home with bags full of samples and objects he'd bought on his travels. He always booked comfortable hotels. He said sleeping in a clean, welcoming room made you see a place in a positive light. He was an insatiable walker, and often he didn't even stop to eat. In the evening, before returning to the hotel, he'd buy fruit and some cheese, which he'd eat in his room while watching TV—which was always on, even at home. His curiosity took him to the most remote places in the world. He loved mountains and lakes, which reminded him of his childhood, but he also loved cities like London and New York, so full of energy and on the cutting edge of fashion and style. But the places he would have liked to stay were perhaps hot countries, like the desert of Namibia or the beaches of Brazil, or a tropical ocean spot. Wherever he went, he unearthed original objects, books and clothes, which he took back to Milan and used as inspiration for the new collections. He had a passion for street markets, places of exchange where ideas and cultures meet. Dad considered himself more a businessman than a designer, and his own father undoubtedly taught him a lot in that sense. My grandfather passed down an idea of freedom. Freedom from conventions, freedom from obligation and freedom of thought, but always within the limits of respect and love for others, including animals. Dad had no prejudice and was fascinated by other cultures. The only foreign language he spoke was French, and a little English in his later years, but he managed to communicate with everyone, from the farmer selling his products at the market to the CEO of a major company.

He had a lot of faith in others. One day at the Chatuchak market in Bangkok, he bought some bags to sell in the Milan store. He paid for the entire order up front, gave the vendor the Italian address where he wanted the goods sent, and went back to the hotel. When I asked him if he wasn't afraid they would cheat him, he smiled and told me the bags would arrive. And they did.

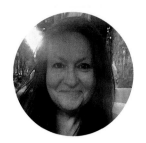

I was lucky enough to have a truly special dad, not only because he created an internationally famous brand having started out as a shop boy in his family slipper business, but because he was a unique man, super sensitive and very wise. Thanks to his innate curiosity, my dad had a wonderful and extremely satisfying life. He was a hard worker, always searching for inspiration and bright colors; a tireless walker, constantly seeking the new, the different, the meaning behind things. He transmitted love, kindness and generosity; everyone loved him and still remembers him with affection. His smile conveyed the wonder of life; his attentive, intense look, sometimes critical, conveyed intelligence. He was ahead in everything, he always had a fair and appropriate comment, he was always at the forefront.

As his daughter, he gave me so much—not in the sense of time, as his time was always limited— but in quality and depth. So many wonderful memories that make my life today sweeter; so many lovely things discovered together. Sometimes we could be transfixed for hours looking at an ants' nest. He preached peace. To him disagreement, lack of harmony, was terribly unpleasant; it was important to feel that others loved him.

As an advisor in my life choices he always sought to protect me and my children, and was able to give me fair advice while respecting who I was.

He was fascinated by the animal world and felt enormously grateful to Mother Nature. He was greedy for everything the earth could offer, gluttonous like a child and often over the top. He thought excess could be beneficial. I used to love watching him carefully peeling fruit and then tasting it and enjoying it together, always making a point to talk about the magic and perfection of nature, and all it gives us. Particularly the genome of the peach, which he mentioned frequently. He had lovely hands which were always soft. I'd give anything for their reassuring caress, for a hug from him. He could make me laugh; he gave me the strength to be myself, to not take myself too seriously. He'd laugh at silly little things, sometimes he couldn't stop, remembering stories from the past. He passed on his love of travel—it was always a fantastic experience with him— as children we'd set off to discover new countries where tourism hadn't yet arrived. He always wanted to hear my impressions of my trips. I have one regret: not going with him to India, a country that fascinated and impressed him.

He gave me the secret of feeling comfortable and at ease wherever I am, whatever the circumstances.

To him, communication was essential; he spoke to everyone and was interested in their lives, he listened to people. He talked with major businessmen, philosophers and shopkeepers, always attentive and with equal respect, always listening. He started conversations with the poor and the homeless.

He was candid, cheerful, elegant, modest... so classy, in so many different ways.

I'm proud to be his daughter and when I miss him I console myself by thinking that he's the root of who I am...

MAGALI PRIOU

Elio's granddaughter (Augusta's daughter)

I can't speak about Elio Fiorucci as the creator who charmed—and continues to charm—fashion lovers, because I don't really know that side of him. He shared his private life with us, as a grandfather and not as a designer.

My grandfather always amazed and intrigued me, because he was a paradox: the places he loved were full of color, the clothes he created were gaudy, yet his house was simple, white, immaculate, and he always dressed in blue, in materials that made him even seem even softer.

Only his red and yellow glasses reminded me he wasn't a grandfather like any other. He taught me what it means to be profoundly elegant.

I'm happy to have had such a candid person as an example; he believed in angels, in people who make you feel good and at ease wherever you are, and that's exactly what he was for the people around him. He was very present—often from a distance, but he always made you feel he was close in spirit.

I remember when I was little, and I broke my leg in the mountains. He came the next day—he'd traveled more than fifteen hours so I could feel how much he loved me.

My grandfather was one of those people who make you feel safe and warm; when he took my hand I felt invincible, and I remember as a child I used to like stroking his head and his hair, always soft, shiny and perfumed. Learning to live without him was—and still is—a huge upheaval in our lives, especially my mother's. My grandfather helped to make me the person I am today, above all, he influenced the decisions I make every day: I remind myself that he always told me to have confidence in myself.

"Hey, maybe there's an angel at your side." Now I really feel the angel was him all along.

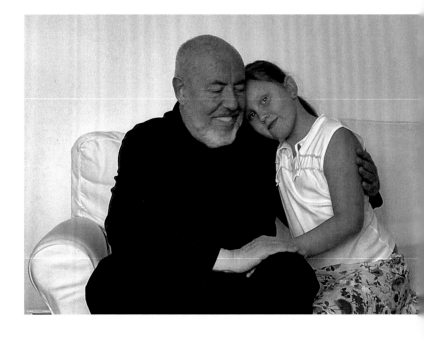

Souvenir from a trip to the Niger desert, 2000. "The only place I'd go if I stopped working. But a fishing village would do as well."

I was undecided as to whether to include these two
pages, but I decided to do it because I believe
his friends and people who loved him
would like to know where he lies and
maybe go and say hello.

I was also intrigued by the fact that his name
appears on the road sign for the village.
Here, where his mother Argentina was born, Elio
spent the war years surrounded by nature, animals
and the landscape, which always stayed with him.
He spoke to me about those memories at his home,
a few days before he left us.
He spoke of the smell of the earth, which
changed with the seasons; of his trips to the lake, where
he swam with the geese that had followed him there,
and of other fond memories.
I think this photo taken from behind is the last image
of him.

Goodbye, dear Elio.
Thanks for everything you've given us.

Franco

SU EgLIO

View of Lake Como from the village
where Elio spent his early childhood
and where he is buried.

Right, Elio from behind in his home
in Milan, taken a few days before
he left us.

PHOTO FRANCO MARABELLI

ACKNOWLEDGMENTS

I first started thinking
about this book with my
friend Gisella Borioli,
who used her experience
and professionalism
to help me lay the
foundations to begin this
adventure.

Special thanks to:

Marco Finazzi
Fabio Mantovan
Renata Molho
Pier Paolo Pitacco
Franca Soncini

HEARTFELT THANKS

Agostino Guenzi
Alvise Norfo
Anita Bianchetti
Anita Paltrinieri
Andrea Zani
Antonella Antonelli
Antonella Supino
Elio Fiorucci archive
courtesy of Floria Fiorucci
Attilio Concari
Augusto Vignall
Barry Ratoff
Carlo Pioli

FIORUCCI

Cecilia Parenti
Cristina Morozzi
Cristina Pizzo
Carmen D'Alessio
Erica Fiorucci
Flavia Celada
Chiara Ferella Falda
Clino Castelli
Giorgiana Ravizza
Giulia Biscontin
Giulia Dal Mas
Guglielmo Pelizzoni
Isabella Sasso
Italo Lupi
Janie and Stephen
Schaffer
Joey Arias
Leda Favalli
Lino Colombo
Lucia Pescador
Massimo Giacon
Michael D'Esposito
Nanni Strada
Oliviero Toscani
Paolo Buggiani
Paolo Lavezzari
Paul Caranicas
Philip Monaghan
Pietro Nocita

Priscilla Rattazzi
Raffaella Rocchi
Raimonda Lanza di Trabia
Raina Sacks
Rosanna Zoia
Sara Bodini
Sara Nannicini
Silvia Amodio
Stefania Sartori
Vittoria Lombardini

Thanks also to
all the colleagues
and friends who
were interviewed
or sent their personal
stories.

BACKERS

Ampelio Bucci
Carolyn Zecca
Isabella Tonchi
Luciana and Augusto
Reina – Illva Saronno
Holding Luisa and Alain
Baume
"Madame X"
Michele De Lucchi
Patrizia and Giuseppe
Sisti
Salvatore Moschella
Silvano Ponzi
Stefano Franceschini
– Passepartout

THANKS

COVER:
TRANSPARENT PLASTIC
JEANS WITH FIORUCCI
LOGO BY ROBERTO
PIERACCINI, 1978.
PHOTO
PIETRO MENZIONE

THE ARMCHAIR
USED BY ELIO IN
HIS OFFICE IN
GALLERIA PASSARELLA
PHOTO AND PROPERTY OF
FRANCESCO DE MOLFETTA

Graphic Design
Pier Paolo Pitacco

Translation by
Traduzioni Madrelingua®

© The Andy Warhol Foundation for the Visual Arts Inc., BY SIAE 2020
© 2020 Mondadori Libri S.p.A.

Distributed in English throughout the World
by Rizzoli International Publications Inc.
300 Park Avenue South
New York, NY 10010, USA

ISBN: 978-88-918304-7-0
2020 2021 2022 2023 / 10 9 8 7 6 5 4 3 2 1

First edition: March 2021

This volume was printed at L.E.G.O. S.p.A., Vicenza
Printed in Italy

UNDER THE PATRONAGE OF

Camera Nazionale
della Moda Italiana

HE ALWAYS DRESSED
LIKE A BRITISH
PROFESSOR!
WHITE SHIRT,
ROUND-NECKED SWEATER
AND NAVY OR GRAY PANTS,
LODEN COAT AND CLASSIC SHOES

Franca Soncini